The Network

DEBBY AND LESTER,
ART + POLITICS +
TECHNOLOGY.

ENJOY!

The Network

Portrait Conversations by Lincoln Schatz

Introduction by Anne Collins Goodyear, National Portrait Gallery

Smithsonian Books
Washington, D.C.

"The Network" is a portrait of people, ideas, and power in Washington, D.C., produced from May 2011 to June 2012. This book is a translation, of a kind, of "The Network" from video into an analog format. Each sitter's essay is an edited and substantially shortened version of the full transcript of our conversation. The images accompanying the essays are video stills from the portraits.

Contents

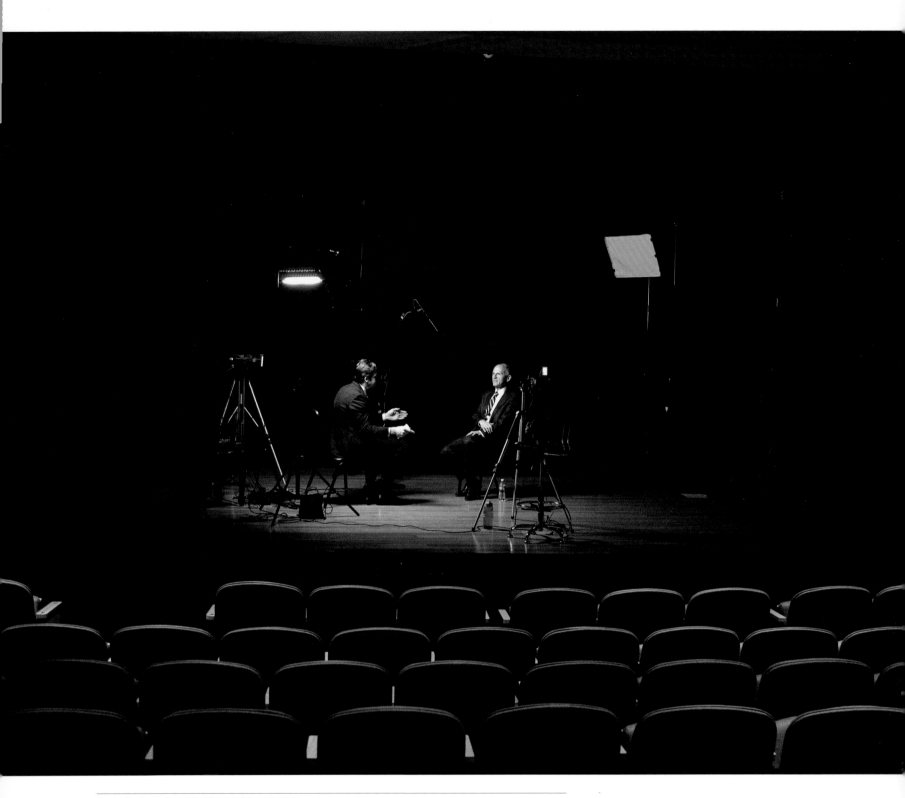

Production image from "The Network," Jan. 25, 2012.

Artist's Statement

Lincoln Schatz

Washington, D.C., is famously a company town whose sole industry is government in all its manifold forms, whether charged with the conduct of war, the provision of health care, the exploration of outer space, or even the maintenance of our national museums. But even if it is not always apparent to those of us who live and work outside the Beltway, there is much more going on in the nation's capital than government alone. Surrounding it are the worlds of culture and the arts, of business and industry, of education and research. All are populated by men and women whose work informs and in turn is informed by what happens each day on Capitol Hill and down the street at the White House.

It is those men and women, working within and around the federal government, whom you will meet in the pages of this book. In the great conversation that is Washington, it is their voices, and those of their colleagues and peers, that drive the discussion about how life should be lived inside the United States and in the world today: about where effort should be made, money spent, innovation fostered, change effected. Some of the figures you will encounter here are warriors, others judges, others physicians. Still others are politicians. Many are reformers, driven by visions of Camelot, of a shining light on the hill, of great societies real and potential. Many others are explorers and researchers, looking deep beneath the oceans, into the cosmos, and within our cells.

Whatever their various job descriptions and titles, the people of Washington are interested in—indeed, fascinated by—the same questions and concerns that emerge again and again in the conversations recorded in "The Network," the basis for this book. What should the role of the federal government be? How can the military adapt to a changing world in which standing armies are fewer and sometimes less powerful than shadowy groups on the edges of nations? How can governments at all levels be made more responsible to the real needs of citizens, and how can they be streamlined for efficiency and cost effectiveness? Where do the arts fit in a society seemingly concerned with purely practical matters? How does the United States properly engage the world? How does democracy work, and can it be maintained? What does it mean to serve? Questions touching on education, technology, open access, equity, social justice, health care, the environment, the media, and many other matters come from every quarter in these pages, and sometimes from speakers whose interest in them might seem a touch surprising.

Washington is a company town, to be sure—but *The Network* also captures a capital in transition, a place of sharp divisions and increasing rigidity. Indeed, many of the speakers here express regret for the loss of the way things used to be, with party affiliations standing secondary to a shared vision of national purpose, with aisles regularly crossed, and with cordial disagreement more common than pitched battle. Given that so many of the speakers hope for a return to those ways, perhaps we can all look forward to a less rancorous and more decorous future. Perhaps in that longing for a return to collegiality and conversation lie the seeds of solutions to the many problems our nation faces—problems people in this book contend with each day.

The day after Barack Obama was elected president in 2008, I visited the Corcoran Gallery of Art in Washington to see the "Portraits of Power" exhibition by Richard Avedon. As I viewed Avedon's monolithic black-and-white prints, I contemplated how I would make video portraits of contemporary powerbrokers, innovators, and policymakers— portraits in which the subjects would discuss their lives and ideas. I conceived of software that would sort through the portrait conversations, identify topics, and continuously recombine the video.

My vision for "The Network" was born. I sought to focus on persons who set the agenda in American politics, business, science, technology, and culture from inside the Beltway. During the portrait sittings, we would discuss their legacies, challenges, and aspirations (or anything else they deemed noteworthy). Through these conversations, I hoped to discover the influences, the motivations, and the objectives that united these highly influential people—or that set them apart. My goal was to portray a network of people and the spheres in which they operated.

I envisioned multiple perspectives for each subject, juxtaposed on screen and controlled by software that would recombine the portraits based on topics of discussion. For example, the software could select a phrase such as "judicial independence" and then sequentially play excerpts from several separate portraits in which the sitters addressed the topic. This process would continue indefinitely as the software randomly chose both the topics and the playback sequences. Through it, I cede control to my software, which continuously selects and combines video based on a series of parameters; there is no beginning or end, but instead a river of narrative.

As I started talking about the project in Washington, my advisors regularly suggested numerous people as ideal candidates for inclusion in "The Network." I invited several of them to participate in the project and solicited referrals from them as well. Some made personal introductions on my behalf. Others offered specific names or made broad suggestions such as "a career federal employee," "someone from the Department of Energy," "a media type," "a scientist," or "someone in the military." Inspired by Yochai Benkler's *The Wealth of Networks: How Social Production Transforms Markets and Freedom*, I endeavored to understand how people confer reputation to others. Adopting this strategy, I reasoned, would create a unique organic map of Washington. "The Network" evolved into a portrait of people, ideas, and power in Washington in the period from May 2011 to June 2012.

As I filmed each portrait, I engaged each subject in a dialogue that radiated in all directions, with the subjects given wide latitude to chart the course of the discussion. Each portrait—all but two filmed in Washington—was scheduled as a forty-five minute session though many ran longer on-camera, and others continued off-camera. For example, retired Supreme Court Justice Sandra Day O'Connor spent an hour and twenty minutes discussing law, civics, and her life. Having filmed eighty-nine remarkable individuals, I realized the fallacy of attempting to reduce any one particular person to a simple ideology or position. Each person's story was nuanced and unique, though common themes often emerged in the telling.

Back in our Chicago studio, we edited the video, removing my questions and splicing the portrait into cohesive sections that maintained the integrity of the conversation and the context of the commentary. The book that is now before you is a translation, of a kind, of "The Network" from video into an analog format. Each sitter's essay is an edited and substantially shortened version of the full transcript of our conversation. The images accompanying the essays are video stills from the portraits.

"The Network," then, offers a new form of portraiture, one in which every experience contextualizes and informs what came before and what will follow. Each moment informs the next, and there is no single narrative—just as no single narrative can encompass the complexity of the many lives and voices contained in this book.

For all that complexity, the result of our work was everything I hoped it would be. The narrative in "The Network" is constantly rewritten, allowing new understandings to emerge—understandings about power, politics, education, technology, innovation, art, and countless other topics, the subjects of all those questions that people in Washington ask themselves each day. Not the least among them is what it means to be an American.

Working "The Network"

Anne Collins Goodyear, National Portrait Gallery

All the world's a stage, And all the men and women merely players: They have their exits and their entrances; And one man in his time plays many parts.

—William Shakespeare, *As You Like It*

As though emulating Shakespeare's famous observation, from May 2011 until May 2012, professional after professional stepped on to the darkened stage of the Nan E. McEvoy Auditorium of the Smithsonian Institution's National Portrait Gallery. Each "player" dressed professionally, sometimes with a splash of color, prepared to describe his or her role in the political culture of Washington, D.C., in an interview with artist Lincoln Schatz.

These men and women constitute the faces of "The Network." The voices, faces, and gestures recorded during interviews with the artist provide the substance of the generative video work that resulted and this publication that accompanies it.

"Work the network," my classmates and I were advised as undergraduates, particularly as commencement approached. In the early 1990s, this jaunty aphorism referred specifically to a web of alumni resources and people to whom we could turn as we began to make our way in the world. Twenty years later, the phrase brings to mind not only an interconnected array of individuals, but also a much broader set of informational frameworks—technical, political, social, and scientific in nature. As we begin to ponder the term, the very nature of what we mean by "network" itself begins to shift from a matter of certainty to one that generates a host of questions. Is it noun, verb, or adjective? Do we shape it, or does it shape us? As Pit Schultz has claimed, "It is important to see today that the

underlying technologies, the network, become a manifestation of an ideology itself."[1]

The word "network" has roots in the sixteenth century—the very moment at which Shakespeare was honing his craft—as the *Oxford English Dictionary* apprises us, referring to physical structures "in which threads, wires, etc., are crossed or interlaced in the fashion of a net." Lincoln Schatz invites us to explore the term's wide-ranging connotations and significances as we meditate on how the metaphor implicit in his title applies to his intricate eighty-nine-sitter portrait. As noun, "network" describes a closely interconnected group of individuals active in a wide array of politically influential pursuits, including legislation, diplomacy, technology, medicine, law, culture, and the military. As verb, "network" speaks to the manner in which power is developed and exercised today. As adjective ("networked"), the term also testifies to the integration of information and even to the structure of this digital artwork itself, which, as an electronic entity, interlaces the depiction of each sitter with others in a generative, ever-changing fashion.

Indeed, Schatz's intriguing portrait, which the artist has dubbed "a group portrait capturing a moment in time,"[2] might even be considered an attempt to construe in visual terms an ontology of "the network" today as political, technical, and informational entity. This interpretation is indebted to Alexander R. Galloway and Eugene

Thacker's *The Exploit: A Theory of Networks*, an insightful meditation upon the deep implications of networks for exerting political control, resistance, and, implicitly, shaping the very structural metaphors through which we organize, carry out, and comprehend every aspect our lives. Their work in turn refers in important ways to the pioneering work of cultural theorists Gilles Deleuze and Félix Guattari, who in the late 1970s and early 1980s described a new, nonhierarchical approach to the organization of information and the understanding of cultural structures. The model they adopted was the rhizome, or a system of radiating roots (in contrast to the vertical tree) as a means of accounting for the radical interconnectedness of information, power, and systems of exchange. Their work, perhaps best known through their book *A Thousand Plateaus: Capitalism and Schizophrenia*, provides an essential tool for describing the broad-reaching implications of a networked society, and it similarly plays a foundation role in the conception of this essay and the importance of Schatz's own work.

Implicit in "The Network" are three intersecting dimensions: the dynamic interrelationship of a series of highly "connected," and therefore influential, individuals; detailed investigations of the perspectives of each of these actors; and finally, the construction of an informational structure—the artwork—capable of putting these individuals, the issues they espouse, and their confluence into action. This short essay describes

the process behind the creation of the work—its aspirations and models, its status as a reflection of a political system, its function as a form of portraiture, its implications for constructing a history of our era, and finally, its status as a work of fine art.

Process: Building "The Network"

The problem of "control" in networks is always doubled by two perspectives: one from within the network and one from without the network. Networks are, in this sense, the horizon of control.
—Alexander Galloway and Eugene Thacker[3]

In observing Lincoln Schatz construct and develop "The Network" over a period of roughly two years, from the summer of 2010 to the present, I became increasingly fascinated not only by the group of individuals who took part in the project as sitters but also by all those in the background who made possible those sittings—the network behind the network, as it were. What exactly is the "horizon of control" described by this work? Who is present? Who is absent, and why?

As Schatz has observed about the process, it developed organically very much as a "referral network." The artist, and others working on his behalf, reached out to friends and acquaintances active in, or well acquainted with, the political matrix in Washington. The ball began rolling slowly, gradually accelerating as more individuals began to participate, ultimately requiring the artist to add more days of filming to his schedule.

Perhaps appropriately, in retrospect, the first serious conversations to recruit sitters took place in mid-April 2011, precisely as the nation watched tensely to see if the government would be subjected to a shutdown, as Democrats and Republicans, both parties entrenched in their positions, battled over the details of the long-

overdue federal budget. As in a well-scripted drama, a deal was negotiated in the final hour, and an expensive crisis was averted. That event provides a revealing backdrop to the interstices of power that Schatz aims to coax into public view, rendering visible the women and men who shape public policy, often hidden in plain sight.

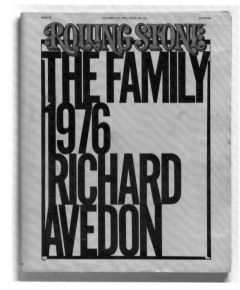

Richard Avedon, "The Family," Rolling Stone, October 21, 1976, National Portrait Gallery, Washington, D.C.

In April 2011, despite a few names, "The Network" was as yet still mostly occluded, still a concept that awaited fleshing out. The networking was just beginning. The roots of the project, however, stretch farther back, to November 2008, when Schatz paid a visit to Washington the day after the historic election in which Barack Hussein Obama became the first African American president of the United States. The atmosphere continued to hold a palpable charge, as happens in those rare moments when one is cognizant of bearing witness to history. Schatz and I met that day. While we had come together to discuss contemporary art and portraiture, politics and history quickly infused the conversation.

Down the street, at the Corcoran Gallery of Art, hung an exhibition of the work of Richard Avedon.

Entitled "Portraits of Power," the show, which ran from September 13, 2008, to January 25, 2009, explored the matrix of the photographer's forays into influence, and those who wielded it. Included in the show, organized by curator Paul Roth, was "The Family," a portfolio made by Richard Avedon for *Rolling Stone* during the run-up to the bicentennial election of 1976, a test of the transfer of power in an era that had just witnessed the crisis of Watergate. In an extraordinary gesture of intuition—or perhaps luck—Avedon placed Mark Felt, then a little-known former FBI agent, next to Rosemary Wood, Nixon's secretary and one of his greatest supporters. The significance of this powerful pairing would only become apparent in 2005, when Mark Felt revealed his intervention in an investigation by Bob Woodward and Carl Bernstein of the *Washington Post*. Mark Felt had secretly played the role of Deep Throat, feeding confidential information to the reporters, whose stories eventually helped lead to Nixon's unseating.

Richard Avedon, "The Family," Rolling Stone, October 21, 1976: Photographs of Shirley Chisholm, George McGovern, Mark Felt, and Rose Mary Wood, National Portrait Gallery, Washington, D.C.

In yet the wake of another historic election, Avedon's portfolio seemed to beg two related questions: What role could a multiple-sitter

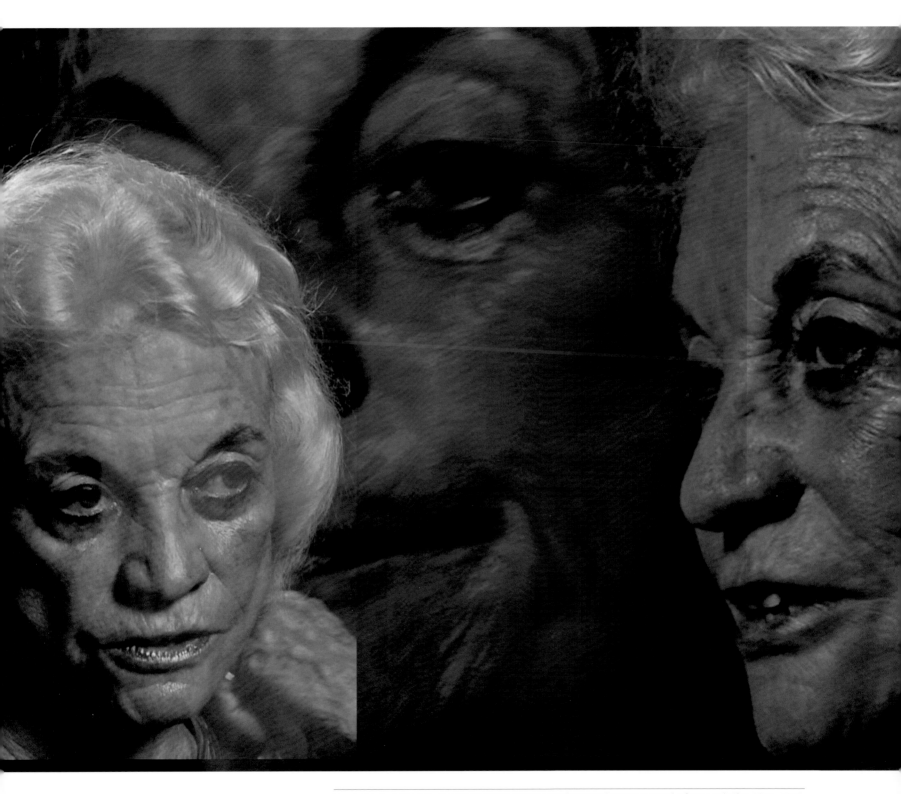

Lincoln Schatz, Video stills depicting Sandra Day O'Connor, "The Network," Computational software and video, 2011–2012, National Portrait Gallery, Washington, D.C.

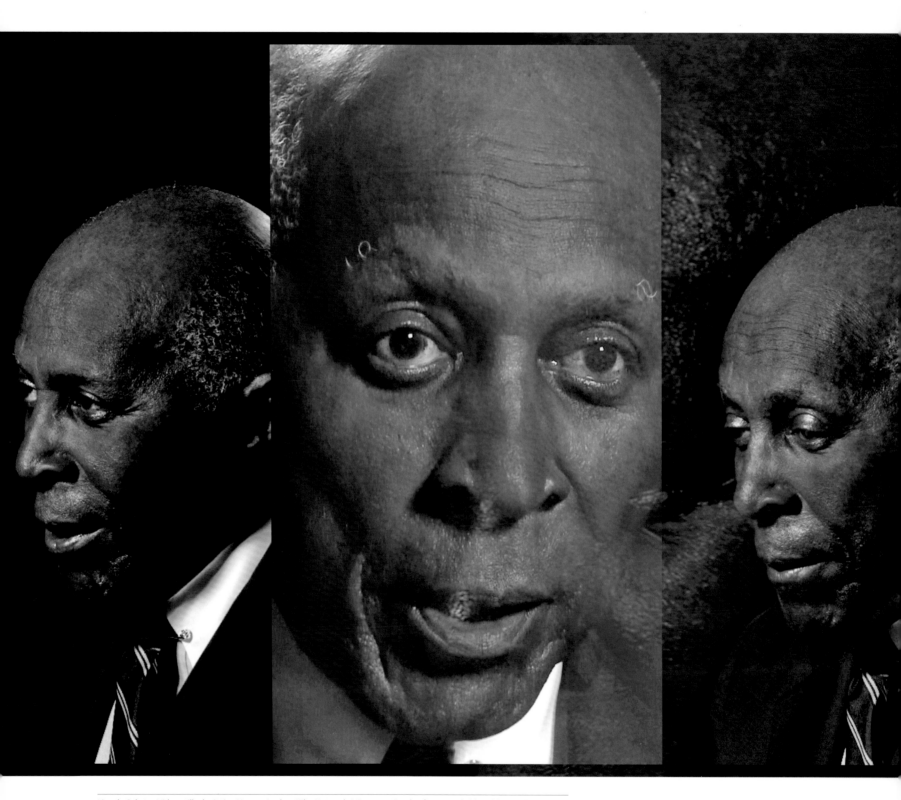

Lincoln Schatz, Video stills depicting Vernon Jordan, "The Network," Computational software and video, 2011–2012, National Portrait Gallery, Washington, D.C.

portrait made today of the nation's insiders reveal about the exercise, and cultivation of power and influence? And what hidden stories could be recorded, and ferreted out, even if the denouement would inevitably remain something to be savored by future generations?

Unlike Avedon, who worked at the behest of *Rolling Stone* Editor and Publisher Jann Wenner, Schatz did not undertake his portrait on commission.[4] Instead, "The Network" represents a project of the artist's own volition, an attempt to define, in contemporary terms, a "portrait of influence." As Schatz explains, three primary considerations led him to include specific individuals in the project: "Are they relevant? Are they setting the agenda? Are their thoughts part of the discussions today?" Critical to the artist was his ability to assess the direct impact of his sitters on contemporary policy.

Yet, if Schatz did not have an editor to satisfy, like Avedon, he strived to achieve a balanced and inclusive perspective of the practice of power. As writer Renata Adler, who served as editor of "The Family," noted, it was critical to the success of the photo essay, published in *Rolling Stone* magazine, "that no person or element of the issues should 'tilt.' There would be no obvious villains in it, no polemical or even unattractive photos. Above all, nothing to 'tilt' ideologically. The object was to ignore, even obliterate—on this ideally suited newsprint—the conventional notions, the received ideas, the cliché sensibilities of the left and right."[5]

The same might be said of Schatz's approach. Schatz portrays eighty-nine (to the sixty-nine in "The Family") sitters in "The Network." It includes prominent voices from the right and the left. As demonstrated by the portraits published in this book, the sitters' professional backgrounds include diplomacy, law, religious leadership, journalism, cultural leadership, political leadership, medicine, and science. The multiple-sitter portrait captures the perspectives of individuals ranging in age from their thirties into their nineties, and each

sitter brings a unique, yet perhaps also strangely representative, point of view to the project.

As Galloway and Thacker observe, no one node of a network controls the whole; instead power and influence is dispersed across the structure, which is not necessarily to say that it is equalized or stable.[6] We find present in "The Network" politicians from both sides of the aisle, such as House Majority Leader Eric Cantor and Minority Leader Nancy Pelosi; jurists including Supreme Court Justices Sandra Day O'Connor and John Paul Stevens and Judge David Tatel; political advisors Vernon Jordan and Karl Rove; cultural figures such as National Endowment of the Humanities Chairman Jim Leach, National Endowment for the Humanities Chairman Rocco Landesman, and Secretary of the Smithsonian Wayne Clough; business leaders like Ted Leonsis; scientists including Nobel laureate Harold Varmus and National Institute of Health Director Francis Collins; military leaders and strategists such as Chairman of the Joint Chiefs of Staff Martin E. Dempsey, Army Chief of Staff General Raymond T. Odierno, and Under Secretary of Defense for Policy Michèle Flournoy; experts in new technology, such as computer scientist and Internet pioneer Vint Cerf, the first federal chief technology officer of the United States, Aneesh Chopra, and Federal Communications Commission Chairman Julius Genachowski; diplomatic officers such as the State Department's special representative to Muslim communities, Farah Pandith, and its senior advisor for innovation, Alec Ross. Numerous cabinet secretaries are also represented, including Secretary of Energy Steven Chu, Secretary of Housing and Urban Development Shaun Donovan, Secretary of Transportation Ray LaHood, Secretary of Homeland Security Janet Napolitano, Secretary of Labor Hilda Solis, and Secretary of Health and Human Services Kathleen Sebelius.

"The Network" operates through a diverse array of strands of connections, each of which calls forth another. As Galloway and Thacker have observed: "Networks are not a threat to American power. In fact, the opposite is true: Networks are

the medium through which America derives its sovereignty."[7]

Portraiture: "The Network" as People

To become singular, one must become plural.
—Alexander Galloway and Eugene Thacker[8]

Unlike Avedon, who chose a single image to represent each of his subjects, Schatz intersperses video files of sitters addressing specific topics culled from an interview with the artist. If Avedon's sitters noted brevity as one aspect of Avedon's signature style, each of Schatz's sitters agreed to detailed conversation, lasting approximately forty-five minutes, sometimes more, sometimes less. In each instance, Schatz asked his sitters to describe their professional credentials and position, their path to their current post, as well as to reflect upon the issues and experiences that defined them publicly and personally.

Like the many other talented creators of portraits, Schatz sought to put his sitters at ease, dressing professionally in a suit and tie,[9] describing the process and goals of the project, and explaining the network of connections that had brought the sitter to the artist's attention. Schatz's studio assistant, Beth Marrier, with mirror in hand to greet portrait subjects, gently reminded each sitter that he or she need not answer any questions that were uncomfortable and that filming could be stopped at any moment. The goal was not to engage in "gotcha" investigation, but instead to let each sitter develop his or her own narrative.

As Schatz interviewed his subjects, always exhibiting great familiarity with his sitter's accomplishments, Marrier and fellow studio assistant James Murray recorded each sitter with three cameras. During each interview, Marrier and Murray adjusted the camera's focus, zooming in and panning out. Lighting and color also shift, with

illumination sometimes suffusing the face, and other times throwing it into sharp relief. As Schatz observes, the effect is to produce "the illusion of many other cameras." In a manner reminiscent of Philippe de Champaigne's three-view portrait of Cardinal de Richelieu (1642), multiple images of Schatz's subjects appear on screen simultaneously. Chromatic images are interspersed with black-and-white renditions of each subject, these moving pictures fading in and out on the screen as clips of each sitter's commentary play. But unlike the impression of wholeness created by the painting by Champaigne, who wished to map the cardinal's face, carefully recording his physiognomy in preparation for a sculpture, the effect of the Schatz methods is instead, with its moving pictures, to emphasize the diversity of each of sitter personally, suggesting that no one unique image can possibly distill all that represents a single subject. With such a multifaceted view, Schatz evokes the multiplicity of the contemporary, networked self, inherently dispersed across technological, political, and social structures, a self in flux.

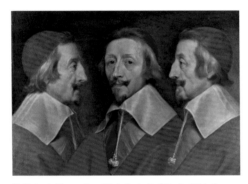

Phillippe de Champaigne, Triple Portrait of Cardinal Richelieu, *probably 1642; oil on canvas, 58.7 x 72.8 cm, National Gallery, London*

"*To become singular, one must become plural,*" write Galloway and Thacker, as noted. Although their observation pertains to the consolidation of power by nation-states, it arguably applies to individuals as well. For it is precisely in representing oneself to diverse audiences through multiple means, representing something in one context,

something else in another, being one thing and then another, and evolving over time that one accrues and deploys influence. As Deleuze and Guattari have described the experience of authorship in a rhizomatic, interconnected culture—in terms reminiscent of Shakespeare's observation concerning the "players" upon life's stage—"each of us was several . . . We are no longer ourselves . . . We have been aided, inspired, multiplied."[10]

History: "The Network" and Narrative

Networks are reconfigurable in new ways and at all scales. Perhaps this is what it means to be a network, to be capable of radically heterogeneous transformation and reconfiguration.
—Alexander Galloway and Eugene Thacker[11]

If Schatz's individual portraits suggest changeability, rather than stasis, "The Network" taken as a whole similarly resists an easily defined narrative. As Schatz notes, "There is a lot of randomness in terms of what is expressed—what happens to be expressed" at any given moment. Narratives may shift depending upon what questions he happened to put to his subject in the course of an interview, or even depending upon what issues happened to be pressing upon his sitter's mind at a given moment.

Such variability is preserved in the portrait itself. Schatz and his assistants have distilled each interview into fragments, expressions of particular ideas, each of which is meta-tagged, or electronically labeled, by the artist and his team according to what happens to be expressed—legal issues, September 11, health care, technology, and so forth. A software program continually recombines these comments according to topics rather than sitters, yielding a generative, ever-changing rendition of information.

One remark may inflect the next in surprising and revealing fashions, as happened one day in March 2012 when Republican political strategist Karl Rove happened to sit shortly before White House Press Secretary Jay Carney did. Both men reflected upon their experiences during September 11. Each, in different capacities, had accompanied President George W. Bush on a trip to Sarasota, Florida, where he was speaking about the importance of reading with second graders at the Emma E. Booker Elementary School. Rove described his perspective as confidant to the president, seated beside him on Air Force One as he grappled with the implications of the attack.

Yet, if such an interconnection of perspectives happened due to a fluke of scheduling, an infinite number of other combinations is possible. As Schatz observes, "The idea of something being fixed is a fiction." Indeed, he stresses that it is not his purpose to tell a story. Instead, he provides the components of a narrative, ready to be constructed by the viewer who will inevitably develop his or her own interpretations as networked software continually reintegrates aspects of the numerous observations captured during each interview. This compositional dimension of the artwork elegantly reflects the very nature of a network itself.

"The Network" as Artwork

The future will find you.
—General Martin E. Dempsey, chairman of the Joint Chiefs of Staff[12]

Past meets present repeatedly in "The Network," as sitters reflect upon the events that shaped them. By extension, a vague future, for which these portraits are destined, is always implied. What does it mean to shape the future through present actions? What does it mean to capture them? A hint of the profound philosophical implications of the intersecting narratives put

into motion by Schatz, which will continually put past, present, and the imaginary future into play is provided by reflections on the structure of rhizomes, or nodal networks, offered by Deleuze and Guattari:

Let us summarize the principal characteristics of a rhizome: Unlike trees or their roots, the rhizome connects any point to any other point, and its traits are not necessarily linked to traits of the same nature . . . The rhizome operates by variation, expansion, conquest, capture, offshoots. Unlike the graphic arts, drawing, or photography, unlike tracings, the rhizome pertains to a map that must be produced, constructed, a map that is always detachable, connectable, reversible, modifiable, and has multiple entryways and exits and its own lines of flight . . . In contrast to centered (even polycentric) systems with hierarchical modes of communication and preestablished paths, the rhizome is an acentered, organizing memory or central automaton, defined solely by a circulation of states.[13]

Deleuze and Guattari testify to the importance of multiple points of entry and departure for a representation of a rhizomatic system suggesting that the fixed arts, "graphic arts, drawing, or photography" are unequal to the task. Schatz's ever-shifting, perpetually regenerative software-driven, dynamic representation of his subjects beautifully correlates to the "acentered, organizing memory or central automaton, defined solely by a circulation of states" envisioned by the theorists to transcribe the organizational matrix that they presciently foresaw even before vast interlinked systems of communications devices became a ubiquitous, self-evident reality. As we reflect upon the past's touching upon present and, ultimately, the future, it is worth noting the suggestive parallels between the theatrical world of shifting identities, the multiple "exits and entrances" conceived by Shakespeare, and the rhizome Deleuze and Guattari envisioned four centuries after him.

Visual technologies developed over the past forty years—film, video, and now digitally produced recordings and animations—have transformed portraiture, contributing both to shifting notions of identity and to a renewed appreciation of the metaphorical significance of materials themselves. Schatz's computational software, driving an array of tagged video files, both reflects and arguably shapes a contemporary world of infinite possibility, a universe in which meaning is not prescribed but derived from a host of ever-recombinable tiles of information, readily accessible to produce new narratives.

Schatz's "The Network," as a digitally generated, time-based, programmed artwork can be networked around the globe for diverse audiences, now makes its home in Washington, D.C., in the historic Smithsonian Institution's National Portrait Gallery, a museum dedicated to describing history through highlighting the individuals who helped shape it. Schatz's work suggests the importance of work and influence aggregated with that of others to produce lasting results with deep impact. The artwork intersects in vital ways with the stories captured in the analog work published in this volume—a series of stills, fastened to a page, and interspersed with the personal histories of the individuals who make up the network that Schatz has sought to emulate and describe through his art.

Through statements included in this book, each sitter describes his or her own story and aspirations. Through his integration of these personal perspectives and insights, Lincoln Schatz captures the diversity, resilience, and nuance of the interconnections that transform these individuals into "The Network." It portrays the political culture of Washington, D.C., today, documenting the issues, concerns, and histories that shape the American capitol at this, another transformative moment for our nation. Its multiple narratives will continue to take shape and to be reshaped as "The Network" continues to configure and reconfigure itself, reflecting contemporary culture and promising new insights for the future.

Notes

[1] Alexander R. Galloway and Eugene Thacker, *The Exploit: A Theory of Networks* (Minneapolis: University of Minnesota Press, 2007), 13.

[2] Author's interview with Lincoln Schatz, May 17, 2012. All subsequent quotations from the artist included here are from this source.

[3] Galloway and Thacker, *The Exploit*, 36.

[4] Paul Roth, "Family Tree: Richard Avedon, Politics, and Power: 1969–1976, A Chronicle," in *Richard Avedon: Portraits of Power*, ed. Paul Roth (Göttingen: Steidel, 2008), 263–276, esp. 273.

[5] Renata Adler, "Introduction," in *Richard Avedon: Portraits of Power*, 12.

[6] Galloway and Thacker, *The Exploit*, esp. 18 and 112.

[7] Ibid., 20–21.

[8] Ibid., 9.

[9] As Paul Roth observes, Avedon also did so for "The Family." Roth, "Family Tree," 266.

[10] Gilles Deleuze and Félix Guattari, *A Thousand Plateaus: Capitalism and Schizophrenia*, trans. Brian Massumi (Minneapolis: University of Minnesota Press, 1987), 3.

[11] Galloway and Thacker, *The Exploit*, 60–61.

[12] General Martin E. Dempsey in conversation with Lincoln Schatz, May 17, 2012.

[13] Deleuze and Guattari, *A Thousand Plateaus*, 21.

"Every man's work, whether it be literature or music or pictures or architecture or anything else, is always a portrait of himself."

Samuel Butler, *The Way of All Flesh*

I'm Haley Barbour.

I'm the former governor of Mississippi, former chairman of the Republican National Committee, and former director of the Office of Political Affairs for the White House.

But I'm back now. I do a lot of speaking around the country, mostly about politics and leadership. I founded a lobbying firm here in Washington twenty-some years ago, and I have an office at a law firm in Jackson, Mississippi.

My father and my grandfather were elected officials, both Democrats. My dad was a prosecutor, and his father was a judge. When my oldest brother came home from the army in 1965, he had become a Goldwater Republican. He ran for mayor of our hometown a couple years later, and I helped him. That same year, I dropped out of college and ran thirty counties in Mississippi for the Nixon campaign. I turned twenty-one during the 1968 election. I then became executive director of the Republican Party in Mississippi. I was a Reagan supporter in 1976, but after the convention, the Ford people asked me to run seven states. I moved up the ladder as a staffer, and then became political director of the White House in the second Reagan administration. That's really how I got started in Washington.

It was heady stuff for a boy from Yazoo City, Mississippi, to go to work at the White House every day. In 1985 and 1986, we were trying to keep the Senate, and, as always under Reagan, trying to add more Republican governors. Reagan believed that governors were the most important people in the government. Mitch Daniels, who is now the governor of Indiana, was my boss.

Andy Card, who was later George Bush's chief of staff, ran intergovernmental affairs and I ran political affairs. It was a strong team, and the people were good to work with.

The job of the political director of the White House is, first of all, to try to make the president's political friends feel that they're included. It's also to make sure that we are working legislatively and politically with Republican senators and House members, trying to do things that make it easier for them to get elected. In the Reagan White House, politics was policy. President Reagan believed that good policy is good politics. The right thing might not be popular today, but if it's good policy, at the end of the day, it will be good politics. When the president did something that wasn't necessarily popular at the start, we spent a lot of our time making our people understand why he did what he did and teaching them how to talk about it.

One difficult decision, for instance, was when Reagan vetoed the textile bill. There was a lot of protectionism in the country, and the country was shedding jobs in the textile industry because of imports. Congress passed a textile bill that was quite protectionist, and the president vetoed it—and on Christmas Eve, after Congress had gone home. Reagan never thought twice about it, even though the bill had strong support in the South. He just said, "We're for open markets and free and fair trade, and this is protectionism, so I'm vetoing it. Now, what else do you want to talk to me about?"

Reagan rightly understood that open markets were the best thing for the most people, not only in the United States but also in the rest of the world. Those policies have been proven correct over and over. Bill Clinton followed essentially the same policies on trade that Reagan did, despite the enmity of the labor unions, which were very big supporters of his. Reagan had the advantage of having grown up during the Depression, and he saw what happened when you had really bad protectionism such as the Smoot-Hawley Tariff Act.

Haley Reeves Barbour

The former governor of Mississippi, Haley Barbour has been involved with the Republican Party since his youth. During his tenure as chairman of the Republican National Committee, Republicans gained control of Congress for the first time in forty years. He actively seeks to find ways to work with those from other parties.

I started lobbying in 1987, after I left the White House. I continued to live in Mississippi, but I worked here in Washington. I knew that after the Democrats won the Senate back, even with Reagan in the White House, a lot of the president's supporters were going to need help. I had gotten to know a lot of them while I was at the White House, because part of the political job was to brief our friends. One of my first clients was a cooperative called American Rice, in Houston. One of the board members was from Mississippi, and he recommended that they hire me. The other one was a labor union, Marine Engineers Beneficial Association. Both of them stayed with the firm while I was chair of the Republican National Committee. I didn't continue to lobby while I was chairman, since I thought people needed to understand that if I was talking to them, I was talking to them as chairman, not on behalf of a client. As a lobbyist, I have almost exclusively represented people on policy matters, not on appropriations. There's a large industry in Washington that lobbies for appropriations. Generally, we lobby on healthcare policy, financial policy, and energy policy for big companies or big trade associations.

Politics has changed in the time since I first came to Washington. For instance, Jim Eastland was a senator from Mississippi from 1941 to 1978. My grandfather was his father's lawyer. When I was a college boy in the 1960s, I'd come up here to Washington and go by Senator Eastland's office. Courtney Pace, who ran the office, would say, "Haley, come back about 5:30 p.m.," because the senator liked to take a drink. He was conservative, a segregationist, but there at his office, Teddy Kennedy would come to have a drink with him, along with Chris Dodd, right next to Roman Hruska, a right-wing Republican from Nebraska. There were Republicans, Democrats, liberals, conservatives, all standing around Eastland's office, having a drink and visiting. Their families were friends. You don't see that anymore. So many of the members don't live here, particularly on the House side. They go home every week, and their families aren't here. They don't have any

kind of social connection with other members of Congress. That's a problem. It's easier to figure out how to find common ground, or you're certainly more willing to try, with people you like. I have a huge admiration for Chris Dodd, for instance, even though he is way to the left of me. I like him. If he and I were in the Senate together, we would try to figure out, "Okay, what can we agree on that would be productive? Let's at least do that." You don't see that cooperation much these days.

The redistricting process has added to the toxicity and lack of comity here in Washington. In the last twenty years we have seen the drawing of districts so that only a small percentage are really competitive; most districts are safe either for the Democrats or for the Republicans. The safe Democratic districts tend to nominate the most liberal Democrats, while the safe Republican districts tend to nominate the most conservative Republicans. As you get more and more of those people, you get more and more space between, and fewer and fewer people in the middle. The Senate is quite different from the House in that you don't have a redistricting process, but those are the realities of the House today.

"Generally, we lobby on healthcare policy, financial policy, and energy policy for big companies or big trade associations."

Ronald Reagan passed his economic plan, social security reform, immigration reform, and the 1986 tax reform bill, four controversial, complex pieces of legislation, with a big Democratic majority in the House. Bill Clinton passed welfare reform and the first balanced budget in a generation with a Republican Congress. They did what it took to get that done, despite the fact that their party didn't control the government.

I'm Robert Barnett.

I'm a senior partner at Williams & Connolly, a Washington, D.C., law firm founded by Edward Bennett Williams.

I grew up in Waukegan, Illinois, and went to the University of Wisconsin and then to the University of Chicago Law School. I had the great honor of clerking for Judge John Minor Wisdom on the US Court of Appeals for the Fifth Circuit in New Orleans, one of the great appellate judges of all times. I clerked for Justice Byron White on the US Supreme Court, a man who served for more than thirty years there. I worked on the Hill for then senator and later vice president Walter Mondale, and in 1975, I went to my current law firm.

I really liked Walter Mondale, and I spent two years working with him on a wide variety of issues. In 1976, Jimmy Carter picked Mondale to serve as his vice presidential candidate on the Democratic Party ticket, and most of us who had worked for Mondale left our respective jobs, moved to Atlanta, where the campaign was headquartered, and served as campaign staff. That was the first of eight presidential campaigns that I've had the opportunity to work on.

I will always remember the first case I had when I went to the firm. Edward Bennett Williams called me and said, "There's a problem at a local hospital." We represented it as outside counsel. A gentleman had died, and there were two wives claiming his body. Both claims seemed to be legitimate. You could split the body in half, but you didn't know who would get the top and who would get the bottom. We didn't want to get into that. A colleague and I came up with the idea to release the body to the funeral home, which got the hospital off the hook and left the problem to someone else.

Robert B. Barnett

A veteran of eight presidential campaigns, Robert Barnett, a celebrated Washington, D.C., attorney, has helped to shape the narratives that have defined American politics over the last forty years. He represents clients across the full range of the political spectrum, including presidents Clinton, Bush, and Obama; five secretaries of state; and dozens of prominent politicians.

At Williams & Connolly, we practice all over the world, but we have one office. Most firms today have offices everywhere. We've always kept a single office. Everybody here is also "homegrown." By that, I mean that attorneys start in junior positions and work their way up. Firms buy firms, steal partners, bring in lateral partners from government or industry. We have a different model. We specialize in hard-fought problems: litigation, deals, government investigations, disputes, arbitrations. The skills that one develops by being homegrown at the firm are then applied to the challenges that clients bring to us.

"I have the interesting situation where I represent Sarah Palin and Hillary Clinton, and I represent George W. Bush and Barack Obama."

I also represent authors. In 1984, the Democratic Party selected Walter Mondale as its nominee for president, and he picked Geraldine Ferraro to be his running mate. Mondale asked me to run the team to get her ready for the vice presidential debate with George H. W. Bush. I played Bush in the rehearsals, and she stood toe to toe with me in these rehearsals. Even though the ticket lost, Gerry was extremely popular and sought after. She was smart and feisty and beautiful, and one of the things that I helped her do, as her counsel then, was arrange a book deal. I had not done a book deal, and so I interviewed agents, hired one, and worked with that individual to place the book. It got, at the time, the highest advance ever paid for that type of book and went on to be a bestseller. When David Stockman, who was Ronald Reagan's budget director, left the administration, he wanted to do a book. He retained me, and I've been doing those types of deals since 1985.

Some political leaders use a book as a launching pad. Some use a book as an opportunity to promulgate a message. Others use a book as a way to make money because, when you're in office, it's hard to support a family and multiple houses and the different things you have to do. In most instances, a public figure can do a book deal and earn money from it legally. Still others use it as a way to define and shape legacy and to reflect on what they've done and why they think it's important, and yet others use it as an opportunity to talk about the future and to propagate things that they care about after leaving office. Political people who write books have a variety of goals, and what you try to do is help them shape a book, get a deal, and publicize the book in a way that will accomplish their aims.

Representing authors is only a small part of what I do, perhaps 10 percent of my time. People think that it's more, because I do get a lot of publicity from these books. Most of my practice is in the guts of what the firm does, whether it's investigations, deals, litigations, grand juries, or disputes. I never gave that up. But the book work helps the firm, because you get to know people as clients in the publishing context who then will refer you to others for litigation or will themselves be subject to litigation or have to do a large business deal. It introduces the firm to a wide variety of people who then might have legal needs in the future. And as I get older, I want to do what I want to do, as long as it's nonfattening and ethical and makes some money for the institution.

Hillary Clinton has a history with our law firm. Edward Bennett Williams, who was her teacher at Yale, offered her a position several times, but she didn't want to practice in Washington. She obviously had other things in mind. I got to know her by attending something called Renaissance Weekend, a yearly gathering that used to be held at Hilton Head and is now held in Charleston. There are panels and discussions, along with activities for kids. Bill, Hillary, and Chelsea came there, and we spent time together.

I got to know Bill Clinton a little better when I was doing the prep for Michael Dukakis for the debates in 1988, and Bill came to Boston as one of the public figures who attended some of these rehearsals and talked to the press. I became their lawyer in 1992, after he got the presidential nomination. I worked with him on his debates, and he has said, on many occasions, that the three debates in 1992 were the things that best introduced him to the American people and had a profound effect on his election as president.

I have the interesting situation where I represent Sarah Palin and Hillary Clinton, and I represent George W. Bush and Barack Obama. My politics are obvious: I'm a Mondale/Clinton/Obama Democrat. But clients don't come to me for political advice. They come to me for legal advice, or to do business deals, or whatever. When you go to a dentist, you don't ask him or her about political leanings. You generally don't do that with a lawyer either. I won't represent what I consider the purveyors of hate. I won't represent people who I think are wildly fringe and don't have much to say. That's my choice. But I have clients all over the political spectrum and, as a result, I've gotten to know people I wouldn't otherwise have met, and I have a great time, when we're not doing our business, debating them or discussing their views and arguing about them. It's an interesting exercise, and an opportunity to learn what other people think. I'm blessed.

I'm Xavier Becerra.

I am fortunate to have been a member of Congress for the last twenty years.

My father was born in the United States but grew up in Mexico. He married a woman from Mexico and brought her to the United States. I could

Congressman Xavier Becerra

The son of immigrants from Mexico, Xavier Becerra was born in Sacramento, California. Since 1992, he has served the people of Los Angeles in the US House of Representatives. As the highest-ranking Latino in Congress, he has used his position to promote better health care, immigration reform, and taxpayer rights.

have been born in Mexico and never known this life. My dad worked in the fields. He was a road construction worker most of his life. He also picked crops. He cleaned the hulls of ships in the harbor of Los Angeles. He fixed the brakes on Southern Pacific railroad cars. He canned tomatoes for Campbell's Soup. He would come home every day covered in mud, sweat, and blood. But he never complained. My mother, as soon as the kids were in school, went to work as well. She was as bright as they come, and she was able to find work just about anywhere, even though her English was limited. We never had much. I grew up in a very small home. I never lacked anything that I needed, but I never had a lot of the things that my friends had. It was a pretty regular life, what I thought was middle-income, until the day I went to the Bay Area to enroll at Stanford University. Driving through Palo Alto, I began to realize that I didn't grow up middle-class. But it was a good life, and the foundation that my parents gave me has worked very well to help my wife and me with our kids. We feel very good and grounded about who our children are and who we have all become.

When I applied to Stanford, I wanted to be a chemical engineer. But at Stanford I became involved in a program called Barrio Assistance, which helped children in East Palo Alto, an economically depressed area with lots of immigrant kids who didn't know English very well. I saw that they needed more than just tutors; they needed somebody to bat for them. I realized that because I love advocacy, maybe law school was the place I really wanted to go. Law school or politics— when the window opened, I jumped through it. I was working for the state attorney general's office at that point, in 1990. I had worked for a state legislator previously and had maintained friendships and communications with a lot of the constituents whom I'd gotten to know while working for him. I decided to run for the state legislature. We built up a nice team of volunteers, and, before you know it, we had knocked off the favorites and I was in the state assembly. Then I ran for Congress.

I've been focused on several important issues. One is immigration. The debate around its reform has been distorted. I think the American public is way ahead of the politicians on immigration. For years, poll after poll has shown that most Americans have some basic ideas about how to reform a broken immigration system. One is to control our borders. We have a right, as a sovereign country, to determine who comes in and who goes out. Do that. That means we have to have more Border Patrol presence, which we can do without violating human rights. Second, we need to patrol the workplace. If we can do so, we will reduce the magnet that brings people across the border without documents. Third, the tough one, the one that gets distorted the most, is to recognize that, for the longest time, this country accepted people into this country without documents to do work that we didn't want to do. In fact, were it not for the fact that the borders were so open when my father was young, he might have been, at one point, an undocumented immigrant. But because there was no requirement for my grandfather to have passports and visas and all the rest, he crossed easily into the United States, where my father was born. We need to deal with those three things: the border, the workplace, and the recognition that we've got ten million or

so individuals in this country who have made their lives here, and we're not going to kick all those folks out. If we deal with immigration reform that way, we'll fix the system in a heartbeat. That's the prescription that the American public has been giving us for a long time. It's the politicians who have distorted the ability to fix our broken immigration system.

"I've been focused on several important issues. One is immigration. The debate around its reform has been distorted. I think the American public is way ahead of the politicians on immigration."

Another issue is welfare and tax reform. Before Social Security, three-quarters of all seniors were retiring into poverty. Then came Medicare and the big effort made by President Johnson in the 1960s to pass healthcare reform for seniors. We passed the GI Bill right after World War II to help all those returning soldiers have a stake in America. It's those kinds of things that lift people out of poverty. I don't think it should be an effort just for the poor. Americans buy into legislation most if it's for all Americans. When you try to accommodate a special class of people, whether through tax breaks for the wealthy or welfare for folks who have been poor for a long time, people wonder, "Well, why?"

Every year, millions of Americans take it upon themselves to file their tax returns. There are very few people I know who believe the tax code is fair, fewer who believe it's simple, and fewer still who believe that we should leave it the way it is. We must give our people the belief that we're paying taxes for the right reasons. And so I put together a taxpayer bill of rights, because there were simple things not being done with respect to knowing

how much you really should pay in taxes, how to get someone to help you prepare your taxes, what your rights are if you're going to be audited. There should be a bill of rights that you have tucked under your arm so that if someone comes up to you and tries to abuse you, you can just pull it out and say, "You can't do that to me when it comes to taxes."

My dad would tell me stories that when he was younger, he couldn't walk into some restaurants because of the signs that said, "No dogs or Mexicans allowed." Now I get to walk my parents through the doors of the White House. It's a leap. My mom often says to me, "Why don't you find a different job that lets you have more time for your family so we can see you more? Don't you get tired of all the bickering and the fighting politically? You could earn more money as well!" I tell her, "I love what I do. No one forces me to do this." Early in my life, the window opened, and I was fortunate enough to jump through it. The window doesn't stay open for you, so you've got to know when to jump. I have to be judicious, but I'm still prepared to jump through the next one.

I'm Bob Bennett.

I'm a lawyer here in Washington, but my practice takes me all over. I handle political cases, white-collar criminal cases, and security cases. When people or companies get in trouble, I like to feel that I can help them.

I often think that growing up in the streets of Brooklyn has been more helpful to me in the pugnacious world that we live in than my degrees

from Harvard and Georgetown. I was going to be a doctor. I had two uncles who were well-known doctors. One founded Project Hope, and the other was Jacqueline Kennedy's obstetrician and gynecologist. But I took pre-med and could not stand it. I used to cut labs and go down to the federal court here and watch cases. I got out of pre-med and went to law school. I clerked for a federal judge here in Washington, then became a federal prosecutor.

You see the real world when you're a prosecutor. In Washington, a federal prosecutor handles robbery, rapes, and murders as well as federal crimes because of the uniqueness of the jurisdiction. I saw people in pain, people in trouble, people brutalizing other people. It was a real eye-opener for me.

Then I went onto private practice and focused on white-collar matters. I was a good strategist and had developed a pretty good instinct as to when to go forward on a case and when not to. As a result, people started coming to me. I've had some high-profile clients, among them two secretaries of defense and a sitting president. I've also always had a good instinct for business, and I tell young lawyers that it's not all that mysterious: Answer your phone. Keep track of your colleagues and where they are, because many of them now are heading companies.

Still, there's no substitute for having a high-profile case and winning it. The first case that brought me to attention was *United States of America v. Dominic Paolucci*. The allegation was that Dr. Paolucci offered a consulting agreement to an admiral for post-retirement life, in return for which the Navy gave a contract to his company. The admiral was the seventh-highest ranking in the Navy at the time. I learned a wonderful lesson through the case. Dr. Paolucci said he never trusted anybody who didn't sit down to drink and eat with him. That's how he got his cut of a man, he would say. We went to a little Italian restaurant in Virginia, and he described the problem and asked me to take the case. I said, "Well, doctor, the way you describe it, it's very interesting, with

wonderful issues." He gave me a look and said, "Young man, this is not an educational experience for me. They want to put me in jail."

We went to trial, and he was acquitted. That led to my representing a lot of major defense contractors who were coming under investigation for overcharging. And that led to other things. I was counsel to the Special Ethics Committee and the Keating Five, and then, several years ago, President Clinton hired me.

You get these opportunities, but you have to win when you get them. High-profile people are concerned about their reputations. Clark Clifford, for instance: It wasn't good enough for him to just let the process go. He wanted his friends and his colleagues to know that he wasn't guilty. And he wasn't; we ultimately got the case dismissed. When you represent the president of the United States, you have to deal with the media. In the Lewinsky case, the White House communications office was not handling it. The president felt a need to have someone who was comfortable dealing with the press and the media, which takes different skills from those a normal lawyer has.

We didn't ask that he not go to trial, but simply that it be delayed. A major criticism of me back then was that I should have allowed the president to enter a default judgment against himself rather than fight the case. Well, the White House wasn't about to do that. There were strange things going on—Paula Jones, for example, waited until the last day of the statute of limitations running to file her complaint. This was a sordid, nasty, mean-spirited business. I wasn't just handling a legal case, but a political case as well.

What a lot of people forget is that the goal when I was hired was to get this put on ice until the 1996 election. If the president had not responded, the judge would find a judgment against him. That could have beaten him in the election.

Let's say you're a high-profile politician. You've got an election coming up, or you're trying to

raise money. If you don't deal with the media and respond to things of this sort, you'll die of a million cuts. If you're an executive or a head of a big company, and you don't respond to this stuff and say, "I'm not guilty—but please stick with me for two years until we have the trial," it just doesn't work. You have to get out there affirmatively. You have to get out there with certain themes that give your constituents confidence that you're honest, and that you're not being fairly charged.

We were able to get the thing on hold until after the 1996 election, and ultimately the president prevailed. The country was quite lucky that he was someone who could compartmentalize. Once I was talking with him and said, "Mr. President, I have to go." Usually you let the president end the conversation. But, I explained, "I've got to call the judge. We have a conference." He said, "Yeah, I've got to get back to Iraq." I thought, "Are we crazy? He's got to get back to Iraq, and here I am taking his time."

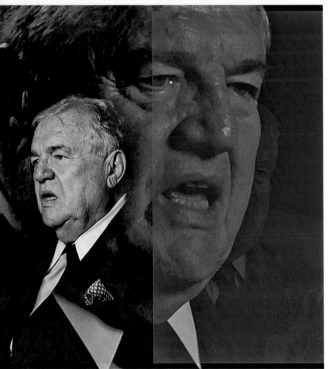

Robert S. Bennett
Bob Bennett is a partner in the Washington, D.C., firm of Hogan Lovells. His extensive experience includes representing two former secretaries of defense, Clark Clifford and Caspar Weinberger, serving as President Bill Clinton's personal attorney in the Paula Jones case, and representing Judith Miller in the CIA leak investigation.

I also represented Judith Miller of the *New York Times*. She had refused to disclose a source on a big political story—we now know it was Scooter Libby—and the judge had said, "You have a chance to talk; otherwise you're going to jail." The prosecutor wanted to see her notes. I said to him, "Look, I'll go through those diaries, and I promise you as an officer of the court that I'll give you everything that is related to your investigation." He accepted my word. I don't want to sound too self-serving, but I tell young lawyers that's why it's important to have a good reputation and never break the ethics rules. That way, you can be trusted in such matters.

In the end, Judith Miller served eighty-three days in jail. I talked to Mr. Libby's lawyer, and he said, "We don't want her to be in jail. I waive. She's authorized to speak." She was released.

I've enjoyed my life and work. That doesn't mean I haven't made mistakes, but generally I wouldn't change a thing.

I am Tom Boggs— Tommy Boggs, Thomas Hale Boggs Jr.

I am a lawyer, lobbyist in Washington, and chairman of a firm that employs almost six hundred professionals.

We have offices in Washington, New York, Dallas, Denver, and Anchorage and in the Middle East. We practice public-policy law, litigation, and commercial law. That's what I do.

I was born three days after my father, Hale Boggs of Louisiana, was elected to Congress.

I was born into a political family, and I grew up in a political environment. My older sister Barbara, who became the mayor of Princeton, New Jersey, would say, "You know, you go to our neighbors' houses and you see antiques and oriental rugs and fine artifacts. You come to our house and you see Jack Kennedy, Sam Rayburn, different types of artifacts." That was true. I have stayed in that milieu most of my life, more on the outside than the inside, but certainly part of the process.

I was torn between whether I really wanted to be in public life or private life. When I was twenty-nine, I decided to run for Congress from what was then a large district in Maryland. I lost, by not very many votes. Running for public office is not an easy thing to do, and you have a great appreciation for people who are able to do it if you have done it once or twice yourself.

When I first registered to lobby, in 1968 or 1969, there were fewer than a hundred registered lobbies. If you check the Internet today, there are somewhere in the range of fourteen thousand to eighteen thousand, depending on how you define registered lobbies. It's a totally different demographic today for the influence business. The reason for that, primarily, is that in 1970 about fifteen people ran the government. I mean that the president, whether Republican or Democratic, the Speaker of the House, the majority leader, and a handful of committee chairmen and department secretaries actually ran the government. There was no one other than those people whom you had to convince about an idea or a project. Today, there are thousands of people who run the government. There are all kinds of reasons for that, but it happened. As a result, the influence industry has changed dramatically.

The other thing that changed was that, back then, the only real source of information that people relied upon was the government. Today, information coming from the media, from private sources, from social networking people you never heard of, is far more important than information coming from the government.

In terms of national lobbyists and Washington lobbyists, it's actually a very professional, very clean business. There are probably county governments out there where you still find shenanigans going on between zoning lawyers and county commissioners, but that really doesn't exist much in Washington. First of all, it's transparent. People basically know what you are doing or try to find out what you are doing because you are competing with someone who is trying to do something else. The days of broads and cigars have been replaced by the days of Blackberries.

From about 1971 or '72 through the mid-1970s, I represented something called the Boating Industry Association, and one of the major companies in it was the Chrysler Corporation. In 1978 the Chrysler Corporation came to us and said that it was going to go out of business without federal help—and that was the Chrysler bailout. At almost the same time, we did the Alaska Pipeline, and those two projects in the late 1970s put us on the map.

We had a pretty good coalition for Chrysler, but we still had a hard time getting it passed because the concept of Uncle Sam bailing out a private company was alien. Even more liberal members of the Democratic Congress basically were saying that the federal government shouldn't bail out a private corporation. That's important, because the best lobbyist in Washington is a member of Congress who agrees with you and is willing to lobby for you. He may not want to play a front role if he has a constituency that is against what you are trying to get him to do, but your best bet is still to try to convince a member to be your lobbyist.

One of the real differences in Washington today and the Washington when I grew up was that back then members of Congress took twelve trips over a year, most members of Congress lived in Washington, and most of their families lived in Washington. We went to school together. We knew each other. We liked each other. We didn't really know that this kid was Republican and this kid was Democrat, and families got to know each other and respect each other. That had a huge impact

in terms of people trying to work across the aisles. That's a much better environment than the current one, where basically 90 percent of the members of the House don't live here; they're here four or five days a week and then commute back home.

The irony is that when Republicans are in the White House, we generally have more business, even though some people would identify us more as a Democratic firm than a Republican firm. That's probably not quite the case anymore, but it is certainly historically accurate. When the Republicans are in the White House, they spend money trying to stop stuff. When Democrats are in the White House, there is less money spent on trying to stop stuff than on trying to get stuff done. I have been doing this for forty years, and I can give you that assessment.

The main thing we do is, when you come to us, we tell you whether or not you have a doable proposition. Even as sophisticated as American business has become—and not just business but also trade associations and labor unions and all kinds of interest groups—businesspeople don't necessarily have a concept of whether or not their great idea is doable or not doable under our federal system. Our first task is to try to convince them that their ideas may not be doable. If they are not, we see if there is something else that may work in a different way. For a loan guarantee, for instance, you may try for a tax subsidy, or rather than doing anything in Congress you may try to get a regulation changed at the Department of the Treasury.

My father was a great believer in the art of the possible, which was Sam Rayburn's favorite line. Coming from the South, somewhat hindered by southern politics, and becoming more and more liberal as he became a more senior politician, the art of the possible became a very difficult assignment for him. I live by the same rules. I try to make sure that the task we take on, whether it is growing the law firm or solving the client's problem, is something that is possible.

Thomas Hale Boggs Jr.
Born into a political family in Louisiana, with a mother and father who both served in Congress, Tom Boggs has built a career as lobbyist and lawyer focused on the intersection between government and business. He helped negotiate the government rescue of Chrysler in 1979 and continues to focus on regulatory issues.

I'm Bill Bratton.

I'm chairman of Kroll Advisory Solutions, based in New York City, one of the world's largest risk management firms. But for most of my life, I worked in the public sector in law enforcement.

I was fortunate to begin that work during a time of profound changes in American policing. Some of them were generated by the federal government in response to the societal upheaval of the 1960s during the antiwar and civil rights movements. It was a time of social enlightenment unparalleled in American history. There was a major effort to have police departments focus on becoming more professional, improving research, raising the education levels of police officers and becoming more sensitive to the communities they served.

Shortly after joining the Boston police force, I received a scholarship to attend a four-year college and enroll in a program sponsored by the federal government. That helped to shape the rest of my policing life, in that I didn't get wrapped in the blue cocoon, where you see the world solely from a police officer's point of view. Every day I attended college, kids just a few years younger than me were demonstrating against the war or for civil rights. Often, after class, I'd be wearing my blue uniform, while my classmates would be on the other side of the police barrier. I was able to see the policing world I was now in from the inside, but I was also sensitive to how police were being seen from the outside.

I came to recognize that as police officers, we could do something about the causes of crime.

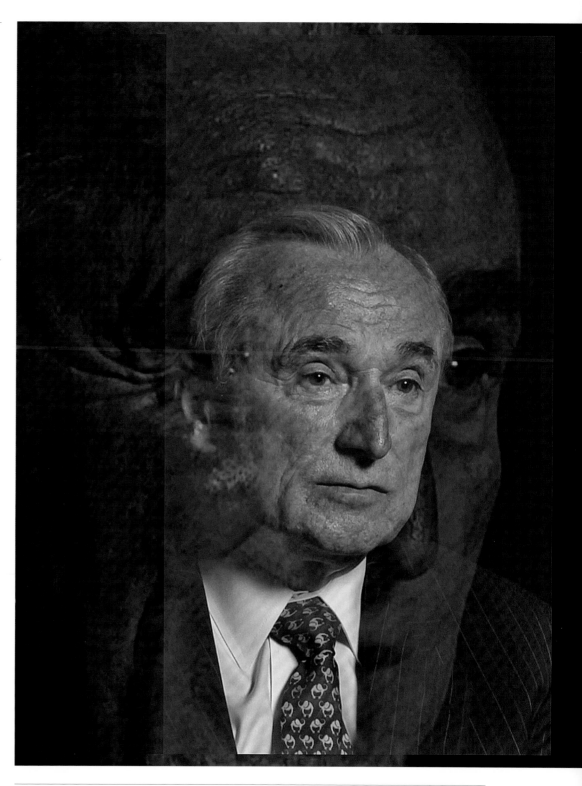

William J. Bratton
Bill Bratton is the Chairman of Kroll Advisory Solutions, a global leader in risk mitigation and response. He built his career in law enforcement, developing innovative ways to avert and address crime. He has served as chief of the Los Angeles Police Department and commissioner of the New York Police Department and Boston Police Department.

Society believed that those causes were things like the economy, racism, and poverty. Those were influences, but not causes. We lost our way when we focused our goals on the reaction and response to crime rather than focusing our goals and attention on what police had been created for in the first place: preventing crime.

"Policing was doomed to fail until we began reaching out to the community and businesses, working with political leadership to focus on priorities and problems with the objective of sharing a goal that everybody could agree on: preventing crime."

Over the next forty years, I served in a number of different assignments in Boston, New York, and Los Angeles. While working in law enforcement, I realized how important community outreach was, particularly with minority communities so that police were not seen as oppressors, but instead working alongside them to solve problems. One way we accomplished that was with the "broken windows" strategy first advanced by two professors, James Q. Wilson and George Kelling. They conducted an experiment in Palo Alto where a new car was placed in a distressed neighborhood. Nothing happened to it. Then someone broke a window, and within a short period of time the broken window was a sign to the criminal element in that neighborhood that the car was not being taken care of. It was soon stripped down.

The idea is that we need to pay attention to the small things. A broken window for instance, allows the criminal element to think that a building is something ripe for attack. In neighborhoods where graffiti is allowed to grow, where gangs are active, where cars are abandoned, that sends a message that residents don't care. As a result, criminals are able to operate freely, and escalating levels of disorder and crime ultimately destroy whole communities.

If you weed the garden, the garden is going to be healthy. Repair those broken windows. Don't allow graffiti. Don't allow prostitution. In the 1970s, police officers were excused from and had no desire to deal with such problems, because there were so many of them and because the public wanted them to focus on serious crime. Serious crime is more exciting to go after than chasing a prostitute off the corner or chasing a fare evader in the subway. The broken windows strategy, though, fit perfectly into problem-oriented policing that we developed, and it became a very valuable and significant tool.

One of the accomplishments I'm most proud of as I look back on my years in Boston, New York City, and Los Angeles is how closely and effectively the police worked with the community to solve problems, and specifically to address racial and ethnic tensions between the community and the police. New York experienced approximately two thousand murders in 1991. Eighty to ninety percent of victims were minorities. This year, New York will experience about five hundred murders. Over the past twenty years, that amounts to thirty thousand young men and women who would have died had we not found a way to be effective in preventing violent crime. The people who would have killed them would have ended up in jail. So sixty thousand individual lives have been positively affected by the police force finding a way to reduce violence. Multiply that by the number of families and communities that would otherwise have been affected, and you see how profound that is. Police didn't do it alone. By working collaboratively in expanding partnerships, they made the streets and neighborhoods much safer.

As chief of the Los Angeles Police Department and commissioner of police in both New York and Boston, I strove to put community policing and preventive policing into practice. That worked because several things happened. Police officers accepted the idea that they could do something about crime. Politicians accepted the idea that money spent on policing should be seen as not a cost but an investment. Citizens accepted the idea that if police make a city safe, businesses will invest, jobs will be created, taxes will be paid, and there will be less fear among that city's residents. The concept of a police force being a catalyst that causes so many good things to happen is still something that's not fully recognized. I'd like to think that the prominent leadership positions I had in American policing and my comfort with standing on bully pulpits to talk about what we were doing helped to move that concept forward. Even so, the importance of police in a democratic society is still not widely understood, prioritized, or appreciated.

Policing was doomed to fail until we began reaching out to the community and businesses, working with political leadership to focus on priorities and problems with the objective of sharing a goal that everybody could agree on: preventing crime. Successful collaboration in achieving that goal was essential.

After the events of 9/11, America's police forces had to respond to new challenges. Homeland security was dependent on hometown security and the collaborations that local police had forged with their communities. The reports done on 9/11 clearly show that law enforcement and intelligence agencies such as the FBI and CIA had sufficient information to act prior to 9/11. If they had shared information, we might have been able to prevent what occurred on that day.

In the years since then, we have learned that federal law enforcement and intelligence agencies, as well as local police forces must network and share information across traditional boundaries. One result is that today in the United States there are more than sixty "fusion" centers where local police, the FBI, and other government agencies come together to gather and analyze information received from a wide variety of sources and create actionable intelligence. That has helped to prevent scores of planned attacks against our country.

When you collaborate, you win. When you don't, you lose. America's not about losing. It's about winning. We have showed that we can win the fight against crime, terrorism, and fear.

I'm Marcus Brauchli.

I'm the executive editor of the *Washington Post*.

I started in journalism when I was young. We didn't watch a lot of TV in my house. The only television we were allowed to watch was the news, so I waited until my father came home at night, and we watched it together. When the Watergate hearings came on television, when I was twelve, I first took a strong interest in journalism. I grew up in Boulder, Colorado, and by the time I was in high school, I was working in newspapers, for the weekly newspaper in town and my high school newspaper,

and sending pictures to the *Denver Post*. By then I was pretty well focused on what I wanted to do. I subscribed to the *Wall Street Journal* because it was the one newspaper you could get in Boulder that had national and international news, if with a somewhat economic bent.

I thought I'd probably go to the University of Colorado. I was taking classes there when I was still in high school, but I also thought maybe I should try to go to one of the good journalism schools, such as the University of Missouri or Northwestern. One day the summer before my senior year in high school, I was talking to an English professor at the University of Colorado, a friend of my parents, and he said, "Kid, you don't want to study journalism. Journalism is something you can learn. You want to study literature, you want to study humanities, or you want to study sciences. You want to know something deeper, and you want to understand the world. You'll figure out the journalism." He strongly encouraged me to apply to better schools. I did, but I still had this idea that I might want to go a place where there was a good journalism school. So I applied to Columbia University. I didn't know that at Columbia journalism was only for graduate students, though, and when I found that there were no programs in the journalism school for undergraduates, it was a little disappointing. But I went, and I found other ways of doing journalism by working for magazines and newspapers in New York.

I did an internship in Parkersburg, West Virginia, the summer after my freshman year. Their federal court reporter had quit, so I went and spent the summer there, and then came back to New York and kept working for the college paper. The following summer, I worked at the Jacksonville *Times-Union*. Northern Florida in 1981 was an interesting place to do journalism. I had a lot of friends there, one of whom persuaded me that I really should just spend more time doing journalism, not worry about this college thing, so I took a year off, went back to Colorado, and worked for a TV station on weekends, producing the news. During the week, I worked for the

Denver Post. I spent the last three months of that year in Mexico, came back to New York, and got a job working at the *New York Times* as a copy boy. I think I lasted two weeks before I got fired, because they put me on a schedule I didn't want to be on, and I complained to my supervisor, who said, "You work your schedule around the *New York Times*. It doesn't work its schedule around you." I stopped being on the schedule.

"We provide a broad overlay and authoritative, original coverage of broader issues."

I got a phone call about a week later, at my apartment, from the assistant editor of the *New York Times*, who said he wanted me to be the Columbia stringer as well as a copy boy. I said, "Well, sorry, Mr. Sulzberger, but I've been fired," and he said, "Don't worry about that." I came in, and then I worked for a while on the foreign desk at the *Times*. In the summer of 1983, I was at Orly Airport in Paris when a bomb went off in a terrorist attack. A lot of people were killed. I wrote it for the *Times*, and it was on the front page when I came back to New York. I thought, this is what really what I want to do, but the *Times* thought that I really should be working as a copy boy, so I started applying for jobs internationally. The International News Service hired me at the end of 1983, and I applied for jobs as they came open. One was at the Hong Kong bureau. I went to the editor and said, "I've always wanted to go to Hong Kong and work in Asia," and then I went home and looked at a map to see where Hong Kong was.

I got there in September 1984, right before the Sino-British Declaration of Hong Kong was signed, which established the return of Hong Kong to Chinese sovereignty after more than one hundred years in British hands. I didn't know much about it, and so we were kind of winging it, but it was good experience. I stayed there for three years.

Marcus W. Brauchli
The executive editor of the *Washington Post*, Marcus Brauchli began his career as a foreign correspondent, eventually becoming managing editor of the *Wall Street Journal*. At the *Post*, he has had to steer the publication through a time of profound change that demands the development of new models for journalism.

In 1987, they offered me a job covering Scandinavia, which is about as far afield as you could go from Hong Kong.

I came into the business at the tail end of what was the golden era of journalism in America, where news organizations made huge profit margins and foreign correspondents didn't need to be experts but did need to be able to write, be willing to travel, and have an adventurous spirit. Then newspapers began to consolidate, and eventually they became monopolies and were corporatized, bought by chains and giant media conglomerates. Newspapers and news organizations spun off a lot of money, and the people who ran them were very powerful. The amount of information people had about the world was far less than we have today, but journalists had incredible access. If you arrived in a country and you were a correspondent for the *Washington Post*, you would see the prime minister, the foreign minister, or some other dignitary immediately. Doors opened. Today it's different, and one of the fascinating differences between what news is today and what it was when I started is that there is vastly more information, and the information is often quite good. It's much deeper, and so it's much harder to navigate through this information. You don't have people who are writing surface stories anymore. You have people who are writing in great depth and with great expertise. There's a lot more specialization.

We try to bring depth and perspective to our work. We provide a broad overlay and authoritative, original coverage of broader issues. People increasingly are looking for perspective and guidance to understand this chaos of information, and to the extent that we can, we hire people who are thoughtful, are analytic, have a deep understanding of often incredibly complicated subjects, and can translate that complexity into understandable prose. We can add real value, and so we've allowed ourselves more latitude in the analytic space. We entertain, but in the end, we are providing an invaluable service, giving people a framework to understand their world and make decisions about it.

I'm Norman Brownstein.

I'm from Denver, Colorado. I'm a lawyer, the chairman of the firm Brownstein, Hyatt, Farber, and Schreck. It's a regional firm in twelve cities in the West, but we have an emphasis on policy issues in Washington.

My trajectory into law was a bit unusual. I wanted to be a dentist. I did very well on the mental part of being a dentist but very poorly on the dexterity part, and I was advised by the then-dean of the dental school that I was better at dropping the chalk than carving it. He said that I should take classes in sculpture. I did that for two days and did not do well, and I decided to embark on a different career. That's how I got into law.

I decided to go into private practice because I liked the independence, and I felt that lawyers had the opportunity to make a big difference in anything they did. Survival was my first quest. I started out doing everything imaginable to make a fee—and most of the time I didn't even make the fee, but I got a lot of experience. I worked twelve hours a day in the office. My other partners gravitated to tax and corporate law, and then we expanded, hiring people to do litigation. I tried that for a while, and I won the cases I should have lost and lost the cases I should have won, and I decided that real estate was going to be a better path.

After twenty-five years of robust real estate practice on a national level, I wanted to do other things. In 1976, I met a congressman named Tim Wirth, who became a senator and later undersecretary of state for global affairs, finally heading the UN Foundation. I once asked him, "How can I, somebody from the American Jewish community, make a difference?" He said, "You know, you could do a lot by getting involved in politics." I knew nothing about politics and didn't care about politics. I had just gotten married, and I needed to focus. But I started to think about what he had said, and I began to get involved with as many political leaders in the country as I could, both Democrats and Republicans, focusing on the American relationship with Israel. I went on the board of AIPAC, the American/Israel Public Affairs Committee, in 1983. I devoted my political focus to that issue, but then, in the late 1980s, because of my involvement in real estate and business, I became exposed to issues that were national in scope involving financial institutions and issues related to taxes and business.

I started a lobbying office here in Washington in the mid-1990s. I started out with two other people, a Senate Republican chief of staff and a Democratic assistant secretary of the treasury. We grew to where we are today, the fifth largest lobbying firm in the country. I still focus most of my attention to the American-Israeli relationship, which doesn't get solved or resolved easily.

Norman Brownstein
Norm Brownstein is an attorney and chairman of the board of Brownstein Hyatt Farber Schreck, which he helped found.
A specialist in real estate law, whose practice also involves commercial, educational, and charitable organizations, he has
distinguished himself as a lobbyist, with a special interest in issues involving Israel.

I'm reading a book called *Eisenhower in 1956*, which has a great discussion about American foreign policy during that time, with the problems and our involvement in the Middle East being strikingly similar to today. Things don't change in the Middle East. The hymnbook is the same, though the chorus is a little different.

I've had the privilege of being involved in every major decision that has affected Israel in the last twenty-five years. The AIPACs of the world, the evangelical Christian community, the general business community—there are so many interest groups that affect that relationship. I am frustrated at where we are today because it's very difficult for the US government to be an even hand in the region. But John Foster Dulles and Dwight Eisenhower found it difficult in 1956 to balance the table, too. I believe that Israel wants peace more than anything else, but I don't see exactly whom Israel can make peace with. It's a different kind of peace with Hamas. It's a different kind of peace with Syria. We have had peace with Jordan and Egypt since the 1990s, but all of a sudden, with the disruption going on now in the Middle East, we don't even know if the new government in Egypt is going to honor the pact. I'm nervous about what's going on there, but I'm hopeful.

Our firm also represents many aspects of business and education and charitable organizations. Several years ago, for instance, people in Congress were talking about changing the laws involving foundations, because they thought there were a lot of abuses there. The changes would have prevented a philanthropist in Colorado from providing full-ride scholarship programs to students who could not otherwise afford to go to college in the state. We were able to structure a law that allowed the bank that this philanthropist owned to stay private; it is now the largest bank in Colorado. It also allowed scholarship funds, primarily stock in the bank, to be put into his foundation. It may now be the largest scholarship program in the United States.

Getting such legislation through is usually a two-year effort, at a minimum. You start by learning about the issue, then do your research to see how this issue fits into law and what you would have to do to get it changed. Then you embark on a campaign with your client. First of all, you see if other people are similarly situated so that you can expand the scope of your advocacy with different companies and different points of view. Once you've got that resolved, you go and you try to find the congressman or senator who is most focused on the issue. If you had an issue regarding health, for instance, you didn't need to be from Massachusetts—Ted Kennedy would be interested. If you have an issue regarding the military, Carl Levin is somebody you need to know, because he's the chairman of the Armed Services Committee. If you have anything involving vitamins, Orrin Hatch is the greatest advocate. It depends on the issue. But generally, you first go to your hometown senator or hometown congressman, you explain the effect on your business, the effect of this law on the state or the locale, and with luck, you can convince him or her to be a supporter. Then you reach out to members of the relevant committee of the Senate or House. You educate the staff, you educate the members, and you figure out what role the administration plays, whether it's Treasury, Health and Human Services, Commerce, Interior, or whatever. Once you've done all that, then you draft the bill. You figure out whether it is a provision in another bill or a stand-alone bill, and ultimately you try to get the bill introduced and passed. The president signs it, and everybody's happy.

We advocate points of view that people in political life may not otherwise hear, and that helps them understand a position. Imagine if we had a political structure where nobody listened to anybody except their advisors and their staffs. For me, it's a great satisfaction to be proactive versus reactive. Being a lobbyist is something that is not fashionable today, but I think it is an unbelievably great aspect of democracy.

I'm Eric Cantor.

I'm a member of Congress, representing the people of the Seventh District of Virginia, which is largely based in the metropolitan Richmond area. I have served for just about a year as the House majority leader.

I was raised in a family in suburban Richmond. My father was a lawyer and a developer, which I became as well. My mother participated a lot in the organized Jewish community in the Richmond area and volunteered for all kinds of organizations. One of their friends was Dick Obenshain, who won a U.S. Senate nomination from Virginia in 1978. Shortly after his nomination, he died in a plane crash, and our party went to former Senator John Warner and asked him to be our candidate. It was around that time that my parents became involved in politics. That was their first trip to a state convention. The state was increasingly suburbanizing, and with that demographic change it experienced a political change. With the ascendancy of Ronald Reagan, Virginia was increasingly becoming Republican at the local level. My parents got involved with the Reagan campaign and other campaigns at the state and local levels. I was in high school at the time, and I became involved in the political process.

I went to college and law school, then worked in law and real estate. In the early 1990s, there was an open seat in the House of Delegates, and I decided to run. I went on to serve in that body for nine years. I was focused on economic development, business, and tax issues. I then ran for Congress. Two years into my service in

Washington, I was selected to become chief deputy whip by Roy Blunt, who's now a senator from Missouri. I was privileged to have his confidence and to be his partner in trying to help shape the votes on the floor and the process of legislating. From that experience, I was exposed to what leadership in the House means. It is often a wild ride. Later I became the minority whip after our party lost the majority, and then, just a year ago, I became the majority leader.

People like to talk to my wife, who grew up as a Democrat, and say, "How do you live with him?" She always says, "If I expect Eric to respect my views, I should also respect his, even though I don't agree all the time." I think it makes sense that no two people are going to agree on everything all the time. The trick is how you become accustomed to transcending differences and coming together where you can for the good. The trick is to try to come together so you can raise a family one that then becomes part of the community that you live in—in a productive way.

The same principles apply in the House. We may differ tremendously. But I think of just last night, the State of the Union address. Part of the job of majority leader is to escort the president into Congress. I found myself asking about the First Lady and his kids, and he in turn asked me about our kids and where they were going to school. With all the differences and all the stories in the media, we are still human beings. We all share the unbelievable blessing of this country and the promise that it holds for our kids. So I think that's how you have to maintain a sense of bringing people together.

When you see the picture of the Statue of Liberty, what do you think about? You think about unbridled optimism and freedom. That's the kind of America that I believe we want. We want one that offers the opportunity for everyone like my grandmother, who fled tsarist Russia and provided for her kids, sending them to school, college, and law school so that they could have a better life than she did. That is the quintessential American promise.

My grandmother didn't have a lot of tools at her disposal. She didn't have government programs to do what she did. I think that the job of the government is to be there for people to help them develop the tools necessary so that they, too, can ascend the ladder of success in America. The government's responsibility first and foremost is to protect us. Obviously, from a national security standpoint that is written in the Constitution, but beyond that, in a limited and responsible way. Its job is to provide the support for those that don't have it so that they, too, can assume the upward mobility that America is about.

What we've seen lately is a federal government that has developed a resistance to trying to do the right thing and is instead just throwing money at things, expecting it to solve the problems. We can't afford that anymore. Now is the time to bring business skills back to the equation and establish priorities. We are questioning and reexamining government programs and looking at how to get rid of them if the mission is no longer valid—or, if we determine that the mission is valid, how to make it so that they operate according to that mission.

I don't believe in divisive rhetoric or policies. I believe that all of us as Americans are in it together. I agree with President Obama that we have wealth disparity in this country that is extraordinary, and we have to do something about it. I disagree with President Obama when he says that we need to tax people who make $200,000 and up as individuals and give it to those who don't have it. The underlying assumption there is somehow the people who don't have the wealth don't have it because the people who have it somehow took it from them or got it in a way that disadvantaged the others. If you can imagine a ladder of success, that's like saying that we're going to pull the people at the top down a few rungs so we can help pull the people at the bottom up. I don't believe that America is about mediocrity in the middle. I believe all of us want to ascend that ladder. We don't increase income mobility by taking from those who have and giving to those

Congressman Eric Ivan Cantor

A member of Congress since 2001, Eric Cantor represents the Seventh District of Virginia, where he grew up. He serves as House majority leader. After practicing law in Richmond and working in real estate development, he earned a seat in the Virginia House of Delegates, where he served from 1992 to 2001.

who don't. Instead, we try to help with a hand up, through charitable efforts, training programs, and jobs.

This country has offered more opportunity to more people of different backgrounds than any other at any other time in history. We've not done it because the government has said, "Here's a job." We've done it because we've created an environment that unleashes the initiative and entrepreneurial nature of our people. My view is much more opportunity-driven than the president's.

I'm Jay Carney.

I am the White House press secretary to President Obama.

My previous career was in print journalism, mostly for *Time* magazine. In college, I decided to study Russian. That decision led to my being a Russian speaker when I graduated from college in 1987. I had done some journalism in college, and the combination of the two got me focused on wanting to go to the Soviet Union to be a reporter. In the late 1980s, the Soviet Union under Mikhail Gorbachev was a huge story. It was transformational, and I wanted to be a part of it. I ended up working there for *Time* for three years, from 1990 to 1993. It was an amazing period, and it gave me an opportunity as a young reporter to be part of something historical. Every day I went to work, especially in 1990 and 1991, I wondered, "What is going to happen today that has never happened before that I'll get to see?" It was thrilling.

Looking for a new adventure, I decided in 1993 to lobby my editors to send me to Washington. I was intrigued by the idea of covering Washington with a young, new, dynamic president, Bill Clinton, after twelve years of the other party's controlling the White House. My editors relented, and I came

James Carney
A former journalist, Jay Carney honed his skills reporting for *Time* from Moscow and, later, Washington, D.C., where he covered the Clinton White House. He worked as the magazine's Washington bureau chief from 2005 to 2008. After serving as Vice President Joe Biden's director of communications, he became President Barack Obama's second press secretary in 2011.

to Washington. I covered Clinton's first term; then Congress, with Newt Gingrich as speaker of the House through the impeachment of Bill Clinton; then the 2000 campaign, covering John McCain and George W. Bush; and then back to the White House, covering Bush in the first term of his presidency.

I have a good friend who was working for Joe Biden in the Senate in foreign policy, and the day after the 2008 election we had a conversation. He suggested that I join this great new enterprise. The idea of being part of the change was greatly appealing. I was offered a job as Joe Biden's communications director in the White House, and I did that for two years. Unexpectedly, the president then asked me to be his second press secretary, and here I am.

Covering the White House as I once did, and now engaging with the people who cover this president in this White House, are unique jobs within American journalism. Covering the president is in many ways less glamorous than it sounds. It's a lot of people chasing the same story. It's competitive. The White House is always interested in telling its story and explaining the president's policies to the best of our ability. Reporters are always looking for different angles into those stories and counternarratives or different ways to distinguish themselves from their colleagues and their coverage. I'm sympathetic to the reporters I work with now and the pressure they're under to do their jobs and to get it right in an intense news environment. The cycles are now so fast—hourly instead of daily or weekly.

When you're a reporter covering the White House, you're at the center of things. You're always working, whether it's a foreign policy issue or domestic policy or political. Issues almost always flow through the presidency and the White House, so you're never bored. Just so, the accelerated news cycle forces us to respond or get out ahead of things much more quickly than was the case when I was a young reporter. Under George W. Bush, whom I covered from 2001 to 2004, we

didn't have Twitter, and blogging was a new thing. The cycles have intensified since then. It means that something can catch fire and demand an immediate reaction. What we have to do in the communications part of the White House is not just to decide how we're going to respond or get out ahead of something, but also to make judgments very quickly about what matters and what doesn't, because there's a ton of information flowing, and a ton of reaction and commentary and news and false news because of all the input. We have to make judgments about what merits response and what really matters. That's a lot of what we spend our time doing.

The new media are ever changing. Blogging is almost a quaint practice now, because people now tweet so much. I have my Twitter feed up on my desktop, and it's also on my Blackberry and iPhone. It's a good way to check what's going on and what's getting the attention of the people who either cover policy and politics or comment on it. Blogging is now the second-level, more sophisticated analysis at greater length than 140 characters. Then there are the old forms, the two-minute pieces on the evening news or morning shows or longer newspaper stories, or then the real luxury: a magazine piece, the kind that I used to write.

Reporting is an isolated experience. It's your story. You report it. You write it. You deal with your editors and staff, but you own it, and it's you putting yourself out there. It's very much about you and your byline. Having had a terrific time in journalism for twenty-one years, one of the things that I have enjoyed so much coming into the administration and government is working on a team. We're all working together for something bigger than our own bylines. This has been particularly satisfying to me.

There is an adversarial nature to the relationship between the White House press corps and the administration, just because there's always a demand for more information than the administration can give. We are trying to get

our story through the filter of the media, and reporters who cover us are getting a lot of counterinformation on our story from other sources. I certainly am not immune to being frustrated, and even angry sometimes, at some of the coverage that we get. But mostly, I understand that the motivations aren't sinister. They're not out to get us. They may be approaching something either naively or obtusely, or they may just be plain wrong about something. But they're just trying to do their jobs. They don't always do it to our satisfaction, but they're trying to do their work.

I've been at the White House for three years now, and rarely does a day go by when I don't step back for a moment and marvel at how unique and rare the opportunity is, how fortunate I am. I'll serve at the president's pleasure for as long as he wants me. When that ends, I expect that I'll want to do something challenging and new, because there's nothing better than waking up scared every morning because you're not quite sure you can pull it off.

I'm Steve Case.

I'm the CEO and chairman of a company called Revolution, as well as chairman of the Case Foundation. All the dots in my life connect to entrepreneurship and innovation.

When I was ten years old, I started little businesses like selling greeting cards door to door and running lemonade stands. I thought it was fun and engaging. It's been fun for a half a century now.

I went to Williams College, a classic liberal arts school. It didn't offer business courses, which I think was good. In an increasingly complicated, fast-moving world, knowing a little bit about a

lot of subjects is helpful to analyze and connect ideas in new ways. Even when I was at college, I spent as much time starting businesses as I did studying, and some professors suggested that it was probably not the best possible use of my Williams experience. I'm sure they were right, but I was always drawn to the business side of things.

When I was a senior, I became captivated by the idea of what's now known as the Internet. I read a book by Alvin Toffler, *The Third Wave*. It talked about this notion of the electronic frontier, an electronic cottage mixed with an interactive TV, getting news in new kinds of ways. I just knew it was going to happen, but at the time, there were no companies doing that. When I graduated, I ended up working for Proctor & Gamble, a traditional consumer marketing company, for a couple of years, and Pepsi for about a year. They were great experiences. I learned a lot, but all the while, my mind was really focused on this new interactive medium and how to get in on the ground floor.

In 1983, I moved to the Washington, D.C., area. There was a little company in Tysons Corner that had a product called GameLine. Very few people had home computers at the time, but a lot of people had Atari video game machines. The idea was to plug a GameLine cartridge into your game machine and then plug it into a phone line. You could download games, but also send email, check stock quotes, and the like. I thought joining GameLine would be a great way to jump into the Internet world. Pretty quickly, I learned that entrepreneurship is risky. When the company was announced, it had enormous fanfare, but when it actually shipped its product, the Atari market had imploded, and the GameLine cartridge didn't perform well. I remember attending a board meeting, and one of the venture capitalists looked at the sales statistics for the holiday season and said, "You'd have thought they would shoplifted more than that."

That was pretty much the end of that company, but thankfully, I was in Northern Virginia, and there

were other folks to work with. So we went off in 1985 to start what became America Online. Out of the GameLine failure came success. That's often the story of entrepreneurship. Most businesses fail, yet most entrepreneurs who take the risk of starting a business are captivated by an idea, and they believe other people are going to be captivated by that idea. It becomes a mission. That's an important part of what drives innovation, creativity, entrepreneurship and our economy. Our role as economic leaders didn't happen by accident. It was the work of entrepreneurs taking risks to not just create companies but to create entirely new industries that have made the United States the world's most entrepreneurial nation. Entrepreneurship is a central part of America's story. What motivated us at AOL wasn't just a business. It was a mission. We wanted to get everybody online, and we believed everybody should get connected. Now they are, and people take it for granted, but it took a decade before we began to hit our stride. There were a lot of challenges in that first decade, but we stuck with it. We had the perseverance and the passion to see it to fruition. We wanted to create a medium. We wanted to change the world. We believed we should take the power away from the traditional interests—the television networks or the newspaper publishers were deciding what you were going to watch, deciding what you were going to read. We wanted to empower everybody and give them the tools to watch what they wanted when they wanted; read what they wanted when they wanted; write what they wanted when they wanted.

We were driven always by the notion of community. We believed that the soul of the medium was people interacting with each other. That's more commonly called social media now, but we used to call it community. For us, community was the killer app. We launched things like instant messaging and chat rooms because we believed that it was important to get people connected—not just to people they already knew but also to people they didn't yet know but would like to know because they had a shared interest.

It took us nine years from the time we started AOL to get one million subscribers. Nine years later, we had twenty-five million. By the late 1990s, AOL was the globally dominant Internet company. Half of all Internet traffic in the United States went through AOL at our peak, and the market value of the company in 2000 was about $150 billion. At that point, we knew it had a great run, and we were the leader in the first generation of the Internet, what some people call "narrowband," using a dial-up modem. But we weren't particularly well positioned for the next wave, which was broadband. That led to the merger with Time Warner, the leading broadband company.

"We were driven always by the notion of community. We believed that the soul of the medium was people interacting with each other. That's more commonly called social media now, but we used to call it community. For us, community was the killer app."

These days, part of my work focuses on the Case Foundation—our nonprofit organization , which brings together the most innovative people and ideas that seek to change the world for the better. The Foundation seeks to tap into the principles of leadership, innovation, collaboration, and entrepreneurship to develop new models and approaches for solving social challenges.

Most of my time, however, is spent as CEO of Revolution, our venture capital firm in Washington, D.C. We invest in and mentor entrepreneurs and startups that are seeking to change the world by empowering consumers. In the last few years, we've had the privilege of backing a number of

Stephen McConnell Case
One of the most successful entrepreneurs in history, Steve Case founded the Internet provider America Online (AOL). Following the company's merger with Time Warner, he went on to found Revolution, a company dedicated to fostering innovation, as well as the Case Foundation.

exciting young companies, such as ZipCar and LivingSocial, that are using technology to change the way people travel, trade, and socialize.

Finally, I serve on President Obama's Council and Jobs and Competitiveness and chair the Startup America Partnership, two efforts focused on creating a new wave of entrepreneurial activity across the country. The stakes are high to come together to improve the environment in the United States for entrepreneurs to start new companies, and growing existing firms. If you look at a macro level, new job creation depends on new companies forming, growing, and innovating. The rest of the world is rapidly improving its entrepreneurial ecosystems. To maintain our edge, we need to improve ours.

My name is Vint Cerf,

and I'm Google's chief Internet evangelist—an interesting title. I'm pretty much a free agent. A lot of the job is public relations, a lot of it policy, both domestic and international. Some of it's very technical. It's a rich palette from which to draw.

I was born at Yale Hospital during World War II. My family moved to Los Angeles in 1946, and I grew up in the San Fernando Valley. My interest in science and mathematics came pretty early on. I can remember reading a book called *The Boy Scientist* when I was about ten, and it was all about experiments that you could do. I remember getting a Gilbert chemistry set, which, back in those days, had chemicals in it that you couldn't

get today. You could build little volcanoes with powdered magnesium and sulfur and powdered aluminum—and even a thermite grenade. It was wonderful. I also loved word problems in math, because they were like little Agatha Christie novels. You have to take a narrative description of a problem and then create a symbolic representation that matches the narrative.

In high school, my best friend, Steve Crocker, was the president of the math club. Thanks to him, we got permission to go to UCLA to use their computers. After catching the computing bug there, I went to Stanford University, majoring in mathematics, and took every computer science course that I could. Then I went to work for IBM. After two years at IBM running a timesharing system, I went back to UCLA to study the fundamentals of architecture, the design of computers, especially the software or operating system. While I was at UCLA, I helped build what was called the Network Measurement Center for ARPA, the Advanced Research Projects Agency. I've been a network addict ever since.

Leonard Kleinrock, for whom I worked, had developed a bunch of theoretical models of how packet switching would work, and one question was, "If you built a network based on those ideas, would it actually perform the way the queueing model suggests?" I was off writing software to pull data out of the ARPANet to match up against the analytical models. One of the key architects of the ARPANet system was Bob Kahn, who designed the interface message processors (IMPS) that served as packet switches. Larry Roberts ran the ARPANet project from the Information Processing Techniques Office (IPTO) at ARPA and eventually became the director of that office. Steve Crocker assumed the responsibility for forming and running the informal Network Working Group and led the development of the first host-to-host protocol, called the network control program. Steve brought in colleagues from UCLA and a number of other universities and institutions that were conducting computer science research, sponsored by ARPA. The Network Working Group eventually

developed protocols for email, file transfer, and remote access to other timesharing machines.

In 1973, Bob Kahn came to my lab at Stanford and said, "We have a problem. We've got this ARPANet. It uses dedicated telephone circuits to connect the packet switches together. But if we're going to use computers in command and control, we're going to have to put computers on board aircraft, and we're going to have to put them on ships at sea. We're going to have to put them in fixed installations, and ground mobile vehicles, and we can't use wires. We can't connect them together with wires. That obviously doesn't work, so we need radio and satellite to do this." Bob's idea, which was really new at the time, was to build distinct and separate networks. Instead of putting all the media together into one big net with some satellite links and some radio links, he thought we should do a kind of open network architecture where you have a distinct packet radio network and a packet satellite net for ships at sea, aircraft, and the like.

We developed the transmission control protocol (TCP) to connect these networks. Then we separated out from this carefully constructed stream-based TCP something we call the Internet protocol (IP), which managed the flow of packets in the combined Internet. We ended up developing TCP/IP, which is still used today. We wanted a nonproprietary protocol that would have no barriers to adoption. We released it, openly, to anyone who wanted it, including the Russians. People ask how we got away with that. The answer is, we didn't ask anybody. We just did it.

In 1985, the National Science Foundation said, "Let's use TCP/IP to build a network to connect all the universities in the United States." So they built a National Science Foundation network (NSFNET) backbone, and then they got a brilliant idea to create intermediate-level regional networks to service the universities, and they connected the regional nets to the NSFNET backbone. Around that time, I started to think about how we could make this available to the public. I started

Vinton Gray Cerf
One of the inventors of the Internet, Vint Cerf now serves as Google's chief Internet evangelist. The role befits the visionary computer scientist who helped develop—and disseminate without patent—protocols that enabled computers to be linked together around the world through the use of all manner of digital communication technologies.

promoting the idea of commercial networking, building an economic engine around it, but at the time no one was allowed to run commercial traffic over the backbones of the government-sponsored backbones.

I went to what was called then the Federal Networking Council, an interagency group, to beg permission to connect a mail system that I had developed for MCI earlier to the Internet as an experiment. They gave me permission to do that, and by 1989 we had a commercial email system. Not too long thereafter, Rep. Rick Boucher introduced a bill to make it legal for the government backbones to carry commercial traffic, and Al Gore was helpful in getting the bill passed.

It was not easy to get the TCP/IP protocols to work, but we spent about five years developing them, and it made the Internet possible. Now, it's important to recognize that the public would not have been very interested in Internet services at all were it not for the invention of the World Wide Web. Tim Berners-Lee, working at CERN in Switzerland, built the first WWW node, a server and a browser, and released it in December 1991. Then Marc Andreessen and his colleagues invented what was called Mosaic, a graphical-style browser and server. This captured everybody's attention, because now the Internet wasn't just text—suddenly, we were getting magazine-like characteristics such as text, imagery, and color. People were learning how to write HTML code manually to create their own web pages. Webmasters were inventing themselves, basically, and learning from each other. This led to an avalanche of content flowing into the network, which led to the need for search engines like Alta Vista and eventually Google and Bing and so on.

In 1998, one of my engineers introduced me to people at the Jet Propulsion Laboratory, and we began looking at what it would take to build a rich networking environment for space exploration. We quickly discovered that TCP/IP was not going to work for communication between the planets. We had to design a new system that we called,

eventually, the bundle protocol, a member of the more general set of delay- and disruption-tolerant networking protocols. A primitive version of it is already on board the rovers and the orbiters on Mars, on the International Space Station, and on board the EPOXI spacecraft, which has visited two comets. The Defense Advanced Research Projects Agency has just released a grant to a consortium to look at the design of a spacecraft that could get to the nearest star in a hundred years. It's very exciting to be part of an activity that's looking that far ahead. Of course, I won't be around to see the result. But that's okay. It's fun knowing that you're in at the early stages of something that could be really amazing for the rest of humanity.

I'm Pete Chiarelli.

I'm the chief executive officer for One Mind for Research, an organization that is striving to become the American Heart Association for diseases of the brain. Before that, I was vice chief of staff of the US Army and served in the military for almost forty years.

I was a paperboy, and I was in the Army, and that's about it. I was an average kind of guy. I liked ROTC. I liked the whole concept of leadership, of being able to work with a group of individuals to a common goal. But it wasn't really until I went to graduate school that I realized how critical education is. I had the opportunity to get an advanced degree, and I blossomed. I earned a master's degree in public administration, then taught American government at West Point.

When I was told to take the First Calvary Division into Baghdad, I realized that this assignment wasn't just going to be about kinetic engagements. We were going to do a lot of nonkinetic things that soldiers were not trained to do in 2003 and 2004. Although we weren't allowed to call it nation building, the fact of the matter is that the US government gave $18.2 billion for the rebuilding of Iraq and basically turned the money over to those of us on the ground. We were expected to execute projects designed to do that rebuilding. That focus for this war went against everything that I had grown up believing as a Cold War soldier. There we had battle books, and we knew exactly where the forward edge of the battlefield was. It ran right through the Fulda Gap. We knew our positions. We knew where the good guys were, and we knew where the bad guys were. It was a linear kind of fight. I was told as an armored officer to stay out of big cities—don't get anywhere near one with those big contraptions we ride around in. Yet I was told to go to Baghdad with the entire First Calvary Division—the heaviest division in the Army when it comes to Abrams tanks, Bradley fighting vehicles, and artillery pieces—and place it in the heart of a city of 7.5 million people. It made absolutely no sense to do that, but that's the kind of fight we were in, so we had to adjust. And that's what we did.

The person who had Baghdad before me was Marty Dempsey, of the First Armored Division. We had a program in the Army that was started at the beginning of the war, and one that we keep on today, where the incoming commander spends time with the commander who currently owns that portion of ground and then goes home and trains his soldiers based on what he has learned before taking command of the sector. I went into Baghdad for about a week with Marty. I met all his brigade commanders. I'll never forget going to meet one at a power station in the southern portion of Baghdad. This man was a caricature of a soldier—think of somebody with hand grenades hanging off his body and a big wad of chewing tobacco in his mouth. He wore every bell and whistle that a soldier could have. He told me that the most

General Peter W. Chiarelli, USA, Ret.

A career military officer, Pete Chiarelli retired from the Army as vice chief of staff. As corps commander in Iraq, he focused on the demands of nation building. As CEO of One Mind for Research, he now advocates for advancing the science of brain disease, improving treatments and finding cures.

important thing that he had at his disposal at this time was a young West Point first lieutenant who was helping him get that power station up to 60 percent capacity. This steely-eyed killer infantryman had realized that the key to success in his sector was getting power to the Iraqi people.

"We should have realized after 9/11 that the creation of the Department of Homeland Security alone is not going to set us up to fight these new kinds of wars. We are still hamstrung by a government that has not reorganized itself in all the different ways it needs to in order to fight nonlinear fights, which require a mixture of kinetic and nonkinetic operations."

We realized we were going to be put in charge of running a big city. I went back to Killeen, Texas, called the mayor of Austin, and asked him if he would schedule a seminar for our folks on how you run a city. The head of the sanitation department gave us a talk on the importance of garbage pickup, for instance. We took those lessons to Baghdad, providing the people there with critical elements that made their lives better. Number one was the opportunity to be employed, to earn money, so they could take care of their families. They wanted electricity. They wanted potable water and sanitation. We also provided them a modicum of medical care, which was the recipe that quieted down even the most violent neighborhood.

The biggest lesson out of Iraq and Afghanistan hasn't been learned yet. After World War II, we reorganized the government to reinvent ourselves for a new threat, the Soviet Union. We realized it was a new kind of war, and we reorganized our whole national security structure to do that. We should have realized after 9/11 that the creation of the Department of Homeland Security alone is not going to set us up to fight these new kinds of wars. We are still hamstrung by a government that has not reorganized itself in all the different ways it needs to in order to fight nonlinear fights, which require a mixture of kinetic and nonkinetic operations. You're going to need organizations like USAID, which we dismantled when the Berlin Wall came down. There have been great strides made between the relationship between the military and nongovernmental organizations, but that relationship needs to be codified and our interagency process restructured.

The new fights are complicated by the use of technology. Everybody has the ability to pass information around, whatever the theater of operations is, at breathtaking speed. In Afghanistan today, you can use your BlackBerry as well as you can use your BlackBerry in Washington, D.C. In fact, there are probably places in Afghanistan where the coverage is better.

In 2008, I was the new vice chief of staff, the chief operating officer of the Army. With that job comes a mass of PowerPoint presentations that people shove in front of you. I inherited an entire medical system. I had more doctors than I had infantrymen; it was a totally different culture. Once they put a single slide in front of me listing the most seriously wounded in the Iraq and Afghanistan. By far the most prevalent wounds were traumatic brain injury and posttraumatic stress. I am almost embarrassed to say it today, but when I was a corps commander in Iraq, with 170,000 people under my command, if you had asked me to define posttraumatic stress and traumatic brain injury, I would have looked at you and said, "Here, let me get my doc up here to talk to you about that." I did not really know the difference. When I saw that slide, it was clear to

me that the most prevalent wounds coming out of these wars were ones that we don't know enough about, and that we cannot fix in the same way we can fix the mechanical injuries of war.

For a guy who drove around in seventy-two-ton tanks all his life, this detour into brain science is amazing. I have learned that because we don't know a heck of a lot, even a guy with no science background can catch up quickly. This isn't just about soldiers. It could be a traffic accident, it could be falling off a ladder. There's no Veterans Administration to provide follow-up care for nonveterans who are seen for brain injuries. I hope that I can be seen as a catalyst of educating us all about this issue, advancing the science, and getting people the help that they need.

I'm Aneesh Chopra,

the president's chief technology officer. My responsibility is to ensure that we have the right policies to grow the jobs and industries of the future and to change the way Washington works to achieve that goal.

I was born outside of Trenton, New Jersey. There is a bridge there that crosses from Pennsylvania to New Jersey with a sign that reads, "Trenton makes. The world takes." My dad had a job at one of the city's manufacturing operations. He had patents in today's air-conditioning systems. That company no longer exists—in fact, Trenton by and large no longer makes.

I got my first job out of college at Morgan Stanley, where I saw the capital markets at work. Then I

Aneesh Paul Chopra
Aneesh Chopra served as the first chief technology officer of the United States. Former secretary of technology for the Commonwealth of Virginia, he has used his background in finance and public policy to seek technical and political strategies to enhance the secure exchange of information to benefit consumers and encourage innovation.

went to the Kennedy School at Harvard to study the policy tools needed to harness the creativity and entrepreneurial spirit of the American economy and to put it toward some of the biggest challenges we face. I then spent nearly nine years at a firm called the Advisory Board Company researching and reporting on best practices to apply technology and innovation in the healthcare sector.

Then I became Virginia's fourth secretary of technology, a cabinet position that had been created by a Republican governor and carried through Democratic administrations to emphasize the importance of technology, data, and innovation to grow the economy and to change the way government operated. When President Obama committed to the American people to have a government that was smarter and more effective and would put the power of technology to work, I was honored to be named our nation's first chief technology officer.

I strongly believe that we can emphasize the role of government to bring about the introduction of new products and services that will both grow the economy and solve our nation's biggest challenges. We're using a number of policy tools. First and foremost, we are encouraging the deployment

of an open infrastructure, such as the president's wireless initiative, which doesn't cost taxpayers any new funds. It repurposes existing resources, frees up capacity for innovation, and will help us lead the world on mobile broadband in the decade to come.

Using the existing tools of government, we are opening up data to help facilitate productivity improvement. In some cases, we're measuring outcomes, such as in health care, publishing data on what works and what doesn't work in the Medicare experience.

We're also figuring out which students are getting jobs upon graduation, drawing on data from a select number of our higher-education institutions. The third is thinking about lowering barriers to entry. If you can bring the private sector together on agreeing on approaches to share data using open technical standards, you can reduce some of the friction. For example, we are working with the major healthcare information technology companies to agree on standards for safe, secure email. If you wanted to send your doctor a message, as long as I can authenticate you and authenticate me, I can encrypt the file in between. We have the technical capacity to do this, but we hadn't actually nudged the industry to move this product forward.

We are also thinking about innovation pipeline management. When the government invests in basic R&D and we want to take ideas to market, what are the methods by which we can do this to be best in class? Last, we are celebrating innovation and entrepreneurship. It's amazing what you can do if you simply challenge the industry to make a difference. We saw this most recently with our Apps for Heroes contest, in which we asked the online employment and training sector if it could do more to support the transition from military personnel to civilian life.

The birthplace of our democracy is Jamestown, a startup company of a kind. We have our roots in entrepreneurship and innovation, working together to advance the greater good. Liberating government

data, bringing people together to identify technical challenges that can be overcome if you simply get them focused on the issue, celebrating the results: These are some of the things we do. Specific policy tools that are uniquely in the hands of government can help bring about this sort of entrepreneurial ecosystem, solving this nation's challenges and opening up growth opportunities at the same time.

Here's a classic opportunity. Today's healthcare industry is mostly focused on volume of care. That is to say, if you're a doctor or a hospital, you get every financial incentive in the world to see more patients in limited time. That's why doctors have six-minute office visits, soon to be five and a half minutes, then less than five minutes. They have to squeeze in ever more patients to cover the costs of running a practice. If you pay everybody the same, but some interventions lead to better outcomes than others, you're missing an opportunity to reward value. In the American economy, you pay for results, but that's not how we regulate the healthcare system.

> "The birthplace of our democracy is Jamestown, a startup company of a kind. We have our roots in entrepreneurship and innovation, working together to advance the greater good."

The first and most important tool we're bringing to the table is to change the payment system to reward value over volume. The Affordable Care Act actually created a Medicare innovation center, empowering doctors to experiment with new payment models. If the actuary of the United States, who is famously independent, certifies that this payment innovation has led to an improvement in quality and a reduction in

cost, then Health and Human Services has the administrative authority to bring that payment model and scale it across the country without going back to Congress. Now we have a goal. We can aim at a value-based payment system, and then the rest of the pieces will fall into place.

If a doctor doubles his or her income while keeping you healthier and lowering overall healthcare costs by 5 percent, wouldn't there be a new market for innovative new technologies that allow doctors to reach and communicate with patients to data mine, to make sure that the right patients are getting the right indications or treatment paths at the right time?

Innovative companies are going to create those products. Those innovative companies are just now getting off the ground, because they didn't have a market before. If a doctor wanted to hold a video chat with a patient, it would be an unreimbursable expense. There's no incentive to communicate with patients using modern technology. In this new value-based model, a doctor might double the number of patients, using sophisticated outreach efforts to make sure that they're doing what they need to do to stay healthy.

To encourage this, we've created a billion-dollar healthcare innovation challenge to kick-start this ecosystem. When we see the results, you'll start to see new products and services with that seed capital to get going, and if they can demonstrate results, we have the regulatory authority to scale that reimbursement model across the country. We are literally creating the market conditions for innovative new products and services to bend the healthcare cost curve, and we are doing so powered by open government data.

I'm Steven Chu.
I'm the US Secretary of Energy.

I grew up in a family that laid the foundation of my values, and education meant a lot. The pinnacle of that was to be a professor at a great university. The high point of my career was when I started at Berkeley and became assistant professor of physics, and then going to Stanford after that. It was then I felt that I'd "arrived." I was going to devote myself to teaching, to research, and to understanding nature for the rest of my life.

There was tremendous pressure to excel. My older brother holds a PhD and MD. My younger brother has a PhD and a law degree, so getting the Nobel Prize really just leveled the playing field. I hadn't gone to an Ivy League school. I went to Rochester, a very good school. No one there had heard of my brilliant brother and cousins. I was in a place where I could fend for myself, where the courses I took were my choice. I flowered. In response to external pressures, I had to have an internal compass to make sure I was not just doing what other people expected me to do or where the prevailing winds were blowing. That internal compass really served me well. Life is not all hardcore scientific decisions. You have to decide what to do based on the knowledge, but also based on your values, your own compass, and then move forward. *Then* you fold in all the other external things. Of course, you can't be tone-deaf to all the other things, but it makes decision making a heck of a lot easier.

When I was hired at Berkeley, I had the option of starting immediately or taking a leave of absence. I decided to go to Bell Labs. Bell Labs was a great experience. My boss encouraged me not to get involved immediately, but to spend the next six months thinking and talking to others. At Bell Labs, I was encouraged to think bigger: "Don't be content with doing just good science. Think bigger

than that. You should be doing great science, and *only* thinking about doing great science."

When I became a professor, perhaps my best guidance to my graduate students and postdocs was exactly that concept: Don't be satisfied with what you think you can do. You can actually do much more than that. Letting them know they could do much more than they thought they could had a profound impact.

The work that I did for the Nobel Prize was to use light to cool down atoms in vapor. Cooling them down means that you take a random motion of atoms or molecules going this way, that way, and every way, and lower the velocities and extract their energy. We were able to use lasers to cool them down to very, very low temperatures on the absolute scale where temperature is a measure of energy.

It turned out to have a lot of applications, including make better atomic clocks. Why do we care about atomic clocks? Well, atomic clocks are the basis for the global positioning satellite system. Without atomic clocks, it just simply would not exist. Atomic clocks synchronize the movement of data around the world with computers. The most

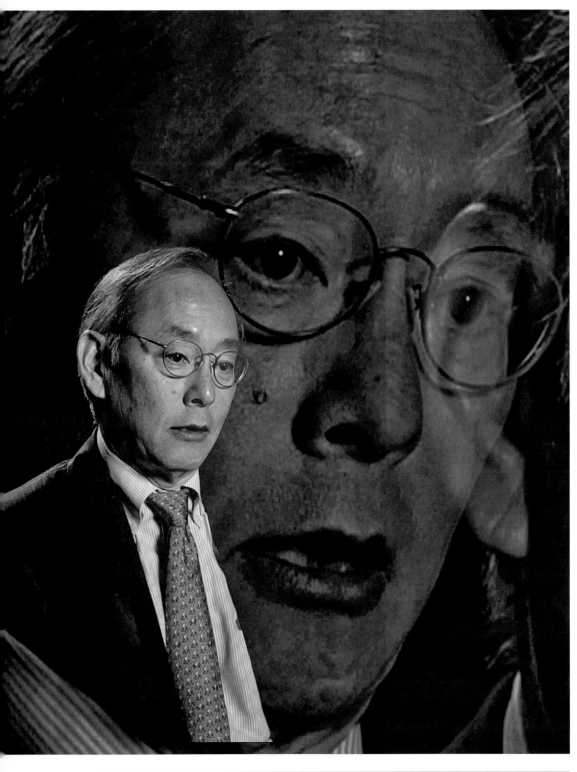

accurate scientific measurements in the world are based on atomic clocks. There were several Nobel Prizes for the improvement in atomic clocks, and another half a dozen for the application of very precise atomic clocks to make new discoveries. My Nobel Prize, in part, was developing the technology to make a better clock.

"You really can have your cake and eat it, too: clean, sustainable energy, economic competitiveness, and a sustainable world."

As soon as we were able to cool the atoms and control them, we did the obvious thing, which was to take a bunch of atoms, toss them up, and let go of them. They fly up, and then they fly down due to gravity. In the half a second to a second when they're in this trajectory, you can make an exquisitely accurate measurement.

We also found we can take lasers to split the atom quantum mechanically and make each atom take two paths. The wavelike properties of the atom would then interfere with itself. This method has become one of the most important ways we measure acceleration due to gravity and rotations. I wasn't thinking of this when I was trying to cool atoms, but it became obvious that this was the next experiment to do.

We now use satellites to do exquisite measurements of the changes in the acceleration of gravity that tell us that how fast the ice sheet in Greenland is melting. These types of measurements also help to track the major water tables in the world. They tell us all sorts of things, including how to find oil and minerals.

The first graduate student of mine to graduate, now a full professor at Stanford, has a contract

Secretary Steven Chu
Secretary of Energy Steven Chu, an atomic physicist and Nobel Prize laureate, is focused on climate change and the development of new clean and renewable energy sources to ensure that America remains competitive globally. This includes initiating specialized research programs, attracting highly accomplished scientists to the Department of Energy, and pursuing breakthrough energy technologies.

with the Navy to make an inertial guidance system for a Trident submarine. These applications started to spin out, one right after the other.

One of the most exciting applications of the optical trapping began at Bell Labs was due to Art Ashkin, who had dreamed for more than a decade of holding onto atoms with laser light. We used a single focused laser beam and laser cooling to hold onto atoms. As a proof of principle, Art trapped a micron-sized polystyrene sphere in water, which was the cooling mechanism. When I got to Stanford, I said, "Okay. We can hold on to atoms, and we can hold onto single cells and even organelles within a cell. Can we hold onto a single molecule, see what you are doing and manipulate it?"

This work helped open up a whole new field called single-molecule physics and opened a new window on biology. Holding onto DNA dragged me into this whole field of single polymer physics, because DNA is a long skinny molecule—a polymer. That was another application of lasers that no one ever foresaw. I suspect there will be a few more Nobel Prizes that come out of the methods that my colleagues and I have developed. The body of science that developed this technology, in 2012, has gone into many direct applications in biology, biomedical science, navigation and clocks, applications in condensed matter physics, and so on.

People will build on what I did. In terms of generations of students, I already have grandchildren, and I am about to have great-grandchildren. A third of them have become very distinguished scientists in their own right. Meanwhile, as secretary of energy, I have become interested in climate change. There are real risks. There are also incredible opportunities. Until recently, one couldn't say for certain whether clean energy or renewable energies would ever be cost-competitive with fossil fuels. Now, it's a matter of when, not if. You really can have your cake and eat it, too: clean, sustainable energy, economic competitiveness, and a sustainable world. It's going to be good for our country. It's going to be good

for the environment. It's going to be good for the world. For me, working on climate change is not just a job. It's a calling.

At the Department of Energy, we've started research programs with people who are so outstanding that it has become a badge of honor to work there, just as it was a badge of honor to have worked at Bell Labs. We're building a place where we can bring in extraordinary people and change the world.

I'm Wayne Clough,

secretary of the Smithsonian Institution.

I grew up in Douglas, Georgia, a small town in the Deep South, exploring swamps and forests, and creating games and contests while learning about nature. I also loved to read, which helped keep me out of trouble most of the time, and I had a builder gene in me, so that I was always the one who said, "Let's put a dam over this creek" or "Let's build a shack up in a tree." I was fortunate to have this free-form childhood because it helped an introverted kid grow up with an innate sense of curiosity and a desire to learn.

I studied civil engineering in college, majoring in geotechnical and geological engineering. I earned my doctorate at UC Berkeley and went on to teach at Duke and Stanford Universities. My consulting work and investigations into earthquake engineering enabled me to work in the design of large infrastructure projects like subways and water projects all over the world.

Eventually I became a provost at the University of Washington, and suddenly my responsibilities extended well beyond engineering to include music, political science, and medicine. As president of my undergraduate alma mater, Georgia Tech,

I prioritized creating a learning environment where students could participate in activities that broadened them as human beings. We even endowed two chairs for poetry and created a program called Poetry at Tech.

As an academic administrator, I exchanged the building of physical infrastructure for building institutions that last. At the Smithsonian I oversee a complex of museums and research centers that revolve around learning and discovery. We have a host of stakeholders, including all American taxpayers, donors who make generous gifts, and all those who care deeply about it, like its visitors—about thirty million a year in person and about one hundred million digitally.

Nothing is simple about the Smithsonian, which has activities in all fifty states and nearly a hundred countries. It includes art, history, culture and science museums and galleries, the National Zoo, and the Smithsonian Astrophysical Observatory. When I came in 2008, the Smithsonian was struggling to deal with lack of focus and persistent budget cuts. It was clear we had to break that mold in order to have a future—and this place must have a future. It's unique in the world and is a treasure of enormous proportions. We launched Smithsonian 2.0, a collaboration between outside and internal experts in the new area of social media and the web. My colleague and co-conspirator, Richard Kurin, and I saw not only a remarkable interest by the outside experts but also an outpouring of creative talent at the Smithsonian. That's when I knew it would work.

James Smithson gave us our mandate in his will: to increase and diffuse knowledge. It was the greatest act of philanthropy in history. He gave all of his estate to the American people because of his belief in our new democracy, but he never set foot in our country. All he asked was that the Smithsonian Institution be named after him, that it be in the nation's capital, and that it be an institution for the increase and diffusion of knowledge. We share that commitment.

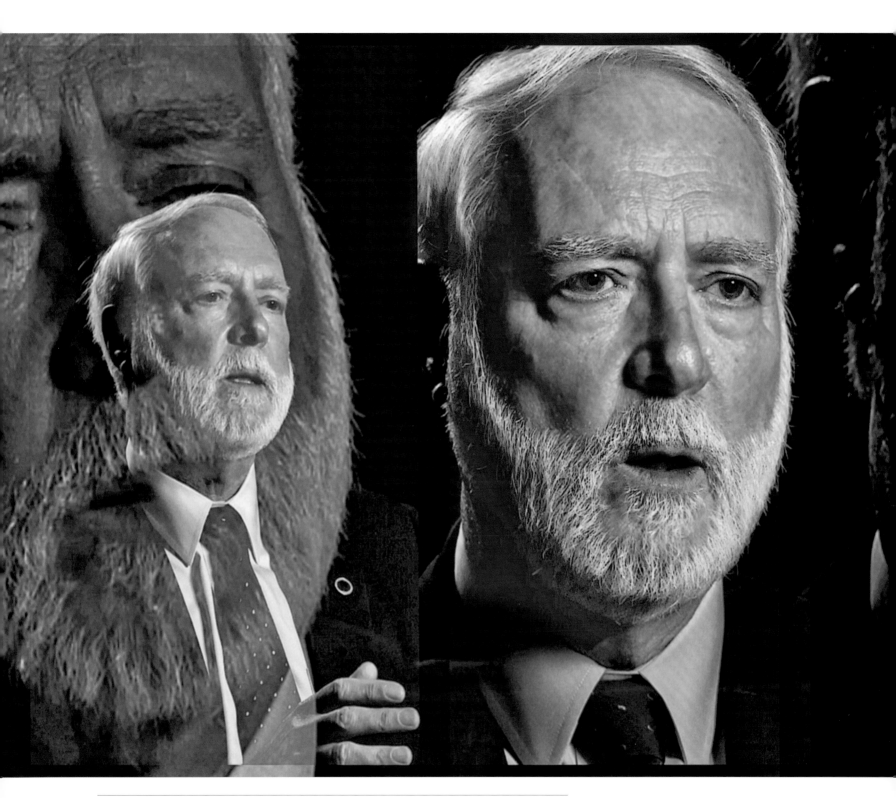

Secretary G. Wayne Clough
Wayne Clough is secretary of the Smithsonian Institution, leading it in an effort to make all that it offers in art, science, history, and culture more accessible to learners of all ages around the world. A civil engineer by training, he was president of the Georgia Institute of Technology for fourteen years.

Knowledge increases through discovery, the creation of new ideas. Knowledge diffuses through education and learning. We're enhancing that process with digital technology and social media, sharing that knowledge with people and allowing them in turn to interact with us. It's all about learning. We create the knowledge and help people learn. If we focus on those two things, we won't ever miss the mark.

People love to participate in what we do. They become part of the process, taking part in a thousand different ways through citizen science, using games in art, and sharing their stories with us. We get people involved in the design of civic parks, building the Encyclopedia of Life, and much more. It's a wonderful way to engage young people, enthusiasts and lifelong learners. People want to participate in learning how things work and making them better.

We have one of the largest, most diverse repositories of collections in the world, and every object that we have, every artifact, has a story behind it. These stories are teased out through research by our curators, researchers, and even the students who work with us as interns. Our facilities include a tropical research institution that works all over the world looking at the health of tropical forests and ecosystems; an astrophysical observatory with nine hundred people working in astrophysics; great art museums and galleries; history museums; an air and space museum; a zoo. How do you make any sense out of that? How do you convince people at the National Zoo that it would be a good idea to work in collaboration with the National Portrait Gallery when people at the two institutions have never met?

We're working to overcome that with a new kind of strategic plan, one that 1,500 people helped to create. It calls for us to cut across disciplines, and to reach new audiences. Our cross-disciplinary work is already producing exciting results. One such project is "African Cosmos." The principal investigator works in the National Museum of African Art, where she asked, "What are the indigenous peoples' views of the cosmos?" They knew a lot about it because they constantly observed the heavens and lived by what they saw. I was just in Machu Picchu, where every street, every window is aligned by astronomy. Because we have the Smithsonian Astrophysical Observatory, we can ask how does the indigenous view of the universe square with the recent discoveries that our astrophysicists are making about black holes and new planets? Artists and poets are great observers of life. The Cosmos project unites African art, the Smithsonian American Art Museum, the National Air and Space Museum, the Smithsonian Astrophysical Observatory, and the National Zoo. That's just one of many projects that have popped out of this process.

Another of our major projects recently has been a cultural recovery effort for Haiti. When the earthquake of 2010 occurred, what I heard as I walked around the Smithsonian was, "How can we help?" I knew as an earthquake engineer that many of their public buildings had crumbled, threatening their great works of art and other historic treasures. One of the things that we could do, with the work of our conservators and scientists, was to help rescue that heritage. To date, volunteers from the Smithsonian and other institutions have rescued 30,000 works of art and trained 150 Haitians in documenting and preserving them. As the institutional structure recovers in Haiti, the art can go back to the places where it came from. One of our citizen regents said to me recently, "Wayne, fifty years from now the people of Haiti will never remember we gave them $2 billion, but they'll remember that we saved their art."

With a little luck, the Smithsonian should be here five hundred years from now, a thousand years from now. Obviously the economic circumstances are challenging. But we have great opportunities, and if we succeed in taking them on, we will have created the Smithsonian of the future, building on its past but looking forward, an endeavor worthy of our best efforts.

My name is Francis Collins.

I'm the director of the National Institutes of Health, the world's largest supporter of biomedical research.

I grew up on a small farm in Virginia, immersed in the arts, humanities, theater, and music. But when I finally ended up in a public school after being homeschooled for the first six grades, I encountered a chemistry professor who captured my imagination about how science could be a great adventure into the unknown, a chance to learn interesting things about how nature works. I majored in chemistry in college and got a PhD in physical chemistry, doing quantum mechanics. I ignored the other sciences because I was so focused on chemistry, and realized only rather late that biology had fundamental principles, too. Biology was poised for an explosion of information and opportunity. So I changed direction and went to medical school. It seemed to be my calling to learn everything I could about human biology, including human medicine, and see where that took me.

I went all the way through medical school, did a residency in internal medicine so I'd have clinical skills, and then plunged back into the laboratory to learn molecular biology. That was a little intimidating, because my bench experience at that point had been theoretical, not practical. But it was the time when people were figuring out how to manipulate pieces of DNA, how to understand how genes get regulated, and how proteins sometimes get produced in the wrong way so that disease occurs.

In those days, there was no genome sequence you could go to on the Internet. If you were going to go chasing after the cause of a disease like Huntington's disease or cystic fibrosis, both of which my lab worked on, you had to do everything from scratch. Cystic fibrosis was perhaps the most visible project the lab worked on. Many thought it would not be possible in our lifetime to pinpoint the cause of cystic fibrosis in that amazing sea of information called the human genome, when you didn't know the nature of what you were looking for. But it was such an interesting problem, like a detective story where you know that if you keep at it eventually you'll get to the end and discover the answer. We found the cause of cystic fibrosis in 1989. It was proof that you could discover the cause of a human disease without knowing the normal function of the relevant gene; you could do what we started to call positional cloning, that is, cloning a gene for a disease by its position somewhere on a chromosome.

All that was arduous work, and I concluded that we ought to have a more systematic way if we were going to go beyond studying a few diseases. The thousands of rare diseases, and the common ones alike, all have hereditary contributions. If we were going to find them, we had to have better methods, better databases, and more powerful tools.

That's where the Human Genome Project came in. A few brave souls were beginning to talk about the idea of sequencing—that is, reading out the letters—of the entire three-billion-letter human genome. But many in the scientific community opposed the project. They thought it was technically unfeasible and that it might take too much money away from other things, which were going pretty well. After a good deal of controversy, the Genome Project got underway with considerable assistance from none other than James Watson, of the Watson and Crick team that won the Nobel Prize for discovering DNA's double helix structure. In fact, he became the first director of that effort at NIH. Then, a debate about gene patenting upset the apple cart, and Watson resigned. Suddenly, the Genome Project, which was just getting started, had no leader and was in disarray and under attack from many quarters as unrealistic.

I got a phone call asking, "Would you like to be considered as the next director of this enterprise?" I declined. My mother always told me, "Whatever you do, don't become a federal employee." But the calls persisted, and some months later I took the job. If it went well, this was going to be potentially the most significant scientific undertaking that humankind had ever mounted.

I benefited enormously from the chance to lean on some wise people already working at NIH. A few months after I arrived, Harold Varmus came on as the new director of the NIH. He was somebody I had great respect for, and he and I had the chance to think together about how to make this a successful enterprise. Because this project was so historic, there were a lot of very bright people who had not planned to spend their careers on this, either, but who just couldn't say no—a great advantage the led to an amazing team of scientific leaders.

It wasn't easy. We had many stubbed toes along the way. We had promised to deliver a finished sequence of the human genome in fifteen years, at a time when the technology to do it hadn't been invented. We knew that if we were going to finish the job, we had to sequence a thousand base pairs every second, seven days a week, for a couple of years. The scale of acceleration was breathtaking. It was the sort of thing that you could not have imagined happening in biology at all. But people kept at it. There was, I think, a sense that this was such an appealing kind of project that people would put down everything else and plunge in. And we did it—two years ahead of schedule.

Using tools and technologies generated by the Genome Project, we have learned about the precise molecular glitch in more than 4,500 highly heritable diseases, most of those in the last few years. For common diseases such as diabetes,

cancer, heart disease, high blood pressure, asthma, and mental illness, we have discovered more than a thousand variations in the human genome that contribute to risk. One of my greatest passions right now is to try to do something about that long translational pathway in going from an insight to a therapy. That will happen only by an effective partnership among all of the groups that have something to bring to the table: academics who are discovering an incredible amount of information about the causes of disease; other university researchers who are interested in technologies to translate that into something therapeutically useful; the government, with its ability to steer resources in promising directions; and pharmaceutical and biotech companies in the private sector, which have a long, deep skill set in terms of how to make a drug, get it through clinical trials, and get it approved.

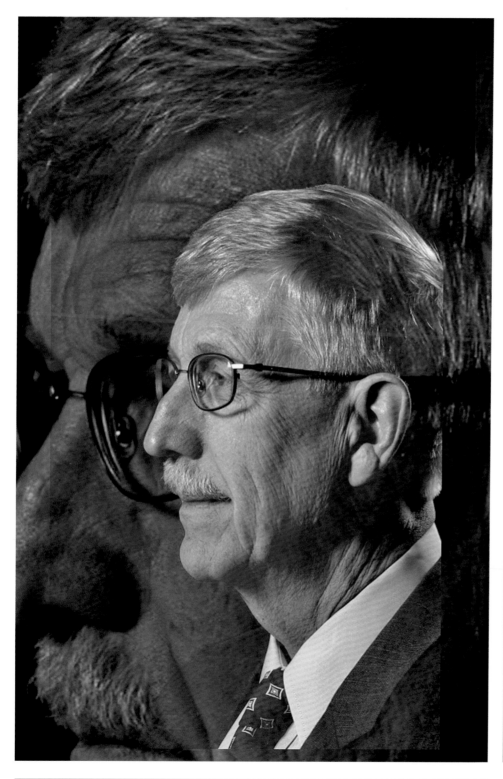

Francis S. Collins

Physician and geneticist Francis Collins, director of the National Institutes of Health, oversaw the sequencing of the human genome as director of the Human Genome Project (1993–2008). Dedicated to using research to combat disease, he helped identify the genetic causes of cystic fibrosis, neurofibromatosis, and Huntington's disease.

Genomics now drives so many of the exciting opportunities in science. We have a window into what's happening inside any living thing, and that is unprecedented. Take cancer, an area of particular promise right now, which comes about because of mistakes in DNA. Cancer is a disease of the genome. The precision-medicine approach to it is a big, innovative advance. In another five years, obtaining the complete sequence of a patient's cancer will become standard practice, guiding diagnostics, prognostics, and the choice of therapy. The pace of progress is breathtaking. The future is full of promise for preventing and curing disease. That's what research is all about.

I'm Tom Daschle.

I had the good fortune to serve in the US House of Representatives and to be one of the Democratic leaders of the US Senate.

I'm a South Dakotan originally. I worked for a candidate for the Senate from our state, James Abourezk. He was elected in 1972 and asked me to come to Washington with him. I worked as his foreign affairs and defense legislative assistant for a couple of years.

When he chose not to run for reelection, it opened up the House seat in the small district along the Minnesota border where I lived. I had no money and no name recognition. I just started knocking on doors. When I was elected in 1978, I was announced the winner by fourteen votes—which, we joke in South Dakota, is 60 percent. It took more than a year for me to be officially declared the winner. I was seated conditionally during the recount. That election made me realize the fragility of holding public office. I never take it for granted.

Thomas A. Daschle
Tom Daschle is a former member of the US House of Representatives and former Senator from South Dakota. While in Congress, he served as the Senate majority leader. To help stem the erosion of cooperation across political parties, he helped to establish the Bipartisan Policy Center in Washington.

I was fortunate to rise through the junior ranks on the House side to leadership. I worked hard, but I also had the good fortune to develop a relationship with a rising star in his own right, George Mitchell, who was the chair of the Congressional Campaign Committee the year I eventually ran for the Senate. He decided to run for leader. When he was elected, he asked me to be the first chair of the Policy Committee. That was my lucky break in many respects. It gave me responsibilities in the caucus, a lot of visibility, and the opportunity to advance through the ranks.

"We certainly haven't solved the problem of polarization in the country, but we've offered a venue for Republicans and Democrats and independents to come together and find solutions that we think make a lot of sense. We have a long way to go, but it's got to start somewhere."

In 1994, George Mitchell decided he didn't want to run for reelection, much like my former employer, Jim Abourezk. I decided to jump in and run for the leadership position and was elected by only one vote, which was seemingly part of my political experience. But whether the margin is fourteen votes in South Dakota or one vote in the Senate, that's all it takes.

The transformation in politics has been phenomenal since I came to Washington. First, I'd start with the media. When I came to Washington, there were three networks for all the news. Now there are blogs and Internet-related information sources. There are cable news networks. And there is much more hyperbolic political reporting than ever before. Second is the race for money, which puts greater and greater pressure on every member of Congress to make sure that he or she is adequately financed, and that race for money is a downward spiral when it comes to political comity.

A third factor is the jet airplane. And by that I mean the loss of shared purpose that came with the deregulation of the airline industry. Now it's uncommon for a new member to move his or her family to Washington; it's so easy to get on a plane and be back home in a matter of hours. As a result, there is very little socializing among members. Families don't know each other. There's just really no social network, like there used to be. In the old days, members of Congress used to carpool into work together, Republicans and Democrats. That's unheard of today. As a result, people are not in Washington nearly as much as they used to be. We used to lament that if we wanted to make sure that we had 100 percent attendance, we'd have to schedule the most important votes on Wednesday afternoon, because people came back from their states and districts on Tuesday and left on Thursday. That's not the way it should work. You can't run a country of 315 million people when all you get is one good legislative day a week.

We've also redistricted to a point that most of the districts are either safe Democratic or safe Republican, which means you become much more loyal to your base, your Republican base or your Democratic base, than to all the voters in the middle. You don't need them. As those bases become more polarized, you don't care about finding common ground. You want to make sure that you satisfy the people who elected you—and of the two elections, the primary and the general, the more important one is the primary.

All of those factors have played significant roles in the demise of comity and the political grounding that we have depended on for generations in America. But you can't turn back the clock. We're not going to get rid of the blogs. We're not going to get rid of the cable news networks. We're not

going to get rid of the airplane. At least in the short term, we're not going to be able to do anything about fundraising. All we can do is to make it easier under these circumstances for people on both sides to look for common solutions. We're not going to be able to replace the social environment that we had fifty years ago, but there are things we can do to bring people together, offer common solutions, and encourage that kind of environment.

In 2007, I was having dinner with George Mitchell, Bob Dole, and Howard Baker, and we talked about this disturbing polarization. We thought that maybe there was space, an opportunity, for a new organization dedicated to finding common ground on some of the bigger issues and encouraging people to work at bipartisanship. That was the birth of the Bipartisan Policy Center. It has been an even bigger success than we had hoped. We certainly haven't solved the problem of polarization in the country, but we've offered a venue for Republicans and Democrats and independents to come together and find solutions that we think make a lot of sense. We have a long way to go, but it's got to start somewhere.

One terribly divisive issue is health care. We have three huge problems. The first is access. About fifty million people have no health insurance in the United States—but that's just the beginning. We have somewhere between sixty million and seventy million who are chronically underinsured. Second, we spend more than any other country in the world on health care, in spite of the fact that not everybody has it. We now spend about $8,500 per person for health care in public and private funding, about 20 percent of our gross domestic product. It's going to go even higher in the years to come, and it's out of control. Third, we have some serious quality problems. The World Health Organization lists us as nineteenth in overall health-care quality, but many objective reports put us even lower than that. Our life expectancy has dropped precipitously. We were in the top ten in the 1980s. We're not even forty-fifth in life expectancy in 2011.

At its core, health care is one of the most important things that will determine the strength of our country. How healthy we are will affect how educated we become. In the end, it will affect the quality of life we lead. I'd like to keep spending my time to build a better health system in America.

I'm Marty Dempsey.

I'm the chairman of the Joint Chiefs of Staff.

I am the oldest son of two blue-collar workers. My dad worked for Esso, Standard Oil, in Bayonne, New Jersey. My mother stocked shelves in a department store. My grandmother owned the house in which we lived, and she was upstairs, widowed at a very young age, at about forty. As my parents went off to work every day, they would send me upstairs to grandma. She was an Irish immigrant, and she took it upon herself to make sure that I knew that I was an Irishman. She came over at sixteen with two suitcases and challenged America. I had a genuine sense that I could be whatever I wanted to be, if I could just figure out what that was.

I went to high school from 1966 to 1970. Those were really tough years in the Vietnam War. I applied to Annapolis, but I had to take my physical exam at West Point, the closest military installation. While I was there, they invited me to apply. On June 29, 1970, I got a telegram from them that said, "Congratulations, you got the appointment. Be here at 0800 on the first of July." When I got to West Point, I went to an upper-class cadet in a red sash and said, "I'm new cadet Dempsey, reporting." He said, "Dempsey, you probably had a great high school career, didn't you?" I said, "Yes, sir, pretty good." He said, "Well, you're not going to make it here." I thought, "Yes, I am," and they had me. West Point builds on that sense. You always have to be better than you are, not for yourself, but for your country.

After graduation, my first assignment was to an armored cavalry squadron in a little place about an hour north of Nuremberg, near Bayreuth. We spent most of the time on the Czechoslovakian border, where the Warsaw Pact was facing off against NATO. My job was to run my cavalry platoon up and down the border to keep an eye on them. I was coming to an army that had just finished a war, a second lieutenant without combat experience. The soldiers were disenfranchised, deflated, and angry. There were significant racial problems and drug problems. The leadership challenge was to take a group of young men—it was all men, then, of course—who were disenchanted with the military, and then, in my youthful enthusiasm, to convince them that it didn't have to be that way and that our mission was important.

After two tours, one in Germany and one at Fort Carson, Colorado, I looked for a way to get an advanced degree. I applied to both the history department and the English department at West Point. The English department took me, then sent me to Duke to get a master's degree. I took courses in art history, music, and literature and wrote my thesis on the Irish Renaissance, which ran from roughly 1890 to 1922. Then I went up and taught for three years at West Point.

You cannot go through a program of instruction related to literature and composition without becoming a better communicator. You become more precise in the choice of words, in the use of grammar, in punctuation. At that point in my life, where I had a certain amount of success, I almost had to reinvent myself. I had to challenge myself, and I had to see the possibility that I might actually fail, something I'd never done before, and then climb back out. It occurred to me that facing failure is a healthy thing on occasion. To be an adaptable leader, you have to keep challenging yourself, and that was one of those opportunities for me.

There has never been a West Point class that goes a full twenty-year career without experiencing combat. We were close. At seventeen years in, I served in the Gulf War. That's been called a

General Martin E. Dempsey, USA
Martin Dempsey is chairman of the Joint Chiefs of Staff. A thirty-year veteran of the US Army, he has proven himself in war and peace. He is dedicated to cultivating a joint US military force that thinks, communicates, and adapts in its service to the nation.

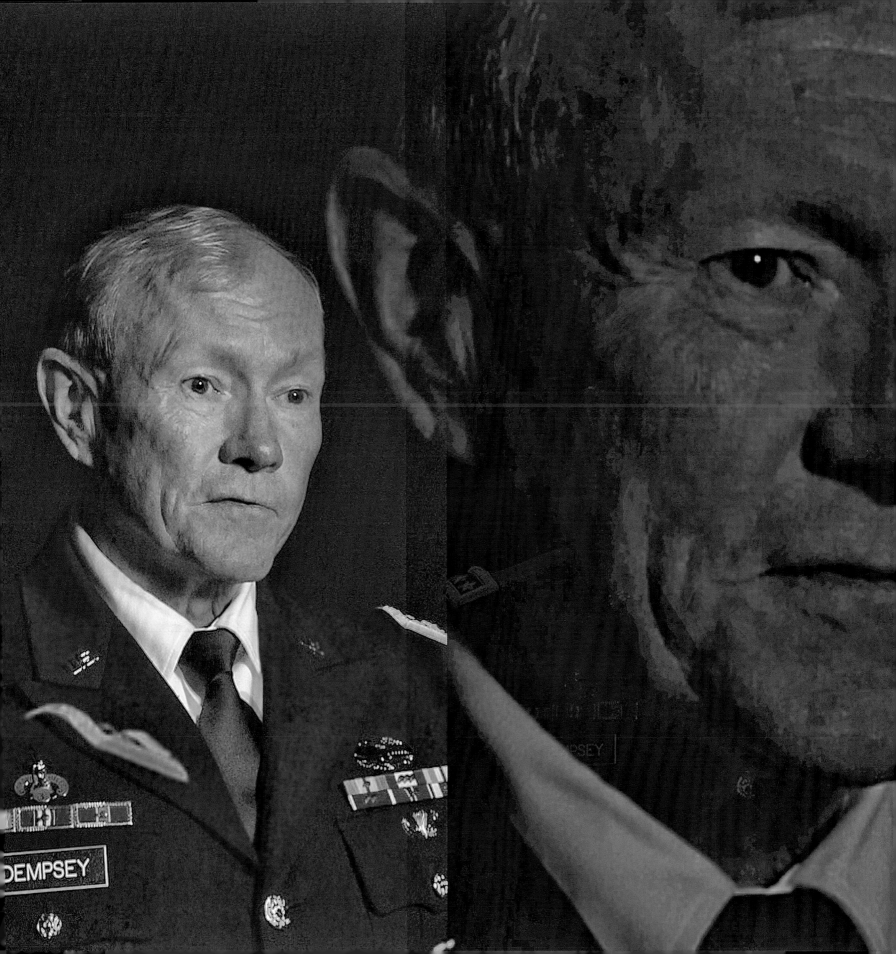

hundred-hour war, but looking back on it, it's easy to forget how nerve-wracking, uncertain, and fearful we all were. The calculation of the potential casualties, which turned out to be grossly exaggerated, ran into the tens of thousands, and there was the specter of chemical weapons. But the challenge was to take an army that had been fundamentally static for a decade and a half and then get it ready to do something that could have been life-threatening for tens of thousands of soldiers.

I had another experience in that part of the world when I served as program manager for the modernization of the Saudi National Guard, whose purpose is the protection of the regime and the state. I gained a deep appreciation for their commitment to Islam and the way they interact as families. I was ordered to take command of the First Armored Division in Baghdad in 2003. I went to pay my respects to Crown Prince Abdullah before I departed, and I said to him, "Your Royal Highness, I'm getting ready to go up to Baghdad. Do you have any advice for me?" He said, "Yes, be careful you don't alter the face of Islam." He wrote it down. I had no idea what he was talking about. I didn't realize the degree to which I had been exposed to the Sunni sect of Islam, with no contact of the Shia sect, in Saudi Arabia. When I got to Baghdad and began to understand the competition at best and conflict at worst between those sects of Islam, that was the moment when I began to develop a deeper appreciation of some of the issues that we face in that part of the world. I couldn't have come to that moment without the experience of Saudi Arabia.

I've stolen, unashamedly, a quotation from Jack Welsh, who ran GE: "I only make the decisions that only I can make." It's about prioritizing what you are going to deal with personally, and then trusting your subordinates to manage the rest. I tell them that I don't need a lot of information briefings. I need them to bring me the things that I need to know to make the handful of decisions that really do rise to my level. Make those decisions that only you can make, and then encourage your staff to understand

that they have your trust, and empower them to pass information to you on that basis.

Here is an example. In 2004, we were getting ready to leave Iraq. We were close, even at that point, to passing sovereignty to the Iraqi government. About a third of the division already redeployed to Germany. Then there came an uprising, and General Abizaid asked me to handle it. It became clear that I actually had to have the whole division back, so first of all, we had to stop everyone moving. One group was turned around at the airport and made its way back to Baghdad. On the way it was attacked, and one of the soldiers was killed. I will always remember asking him to stay, and I wonder what would have happened if we'd let him fly. I had to encourage everyone to take this on board, as a chance make a difference. They did, and we turned it around, and then we came home.

I'm Tom Donohue.

I'm the president and chief executive officer of the US Chamber of Commerce.

My mother's father was a Republican leader in Brooklyn and Nassau County in New York, and my father's father was a Tammany Hall Democrat sewer inspector, back when they were building the sewers. I have a unique perspective of people's views of the world from both sides, and I think it's one of the reasons that I can work with people from both parties. Both grandfathers, and my father, gave me the sense that it doesn't matter where you live, doesn't matter where you land, it matters what you do. I learned from them and from extended family that if you can, you must. If you can do the job, if you can help the person, if you can make a contribution, you must. You're only measured against what you do, not what you say.

I went to St. John's University in New York. It was a great experience. It took me five and a half years, because I had four jobs at the same time. I met my wife there and married her forty-nine years ago.

"The Chamber of Commerce represents the interests of three million businesses around the country. We have 300,000 direct members. We represent the one thing in this country that really works: a free enterprise system, free businesses investing their own capital to create wealth and jobs, which creates a huge freedom to innovate and to fail and get up and go and do it again, which you can't do in many other countries."

The first thing I did, going out of college, was to work as an executive in the Boy Scouts of America. I worked in the biggest Boy Scout camp in America and helped build it. I had 150 people working for me, and I was feeding 1,500 people three times a day in a very complex system. The Boy Scouts sent me to school, and I'm still doing things I learned there, all those years ago. I did pretty well at that, and then I decided to go to graduate school and get an MBA.

I had one great job after the other. I worked for a man who was born without legs. He made it possible for veterans, injured veterans, and people with less capacity to have good jobs and decent lives. Then I went into the university business

Thomas J. Donohue
Tom Donohue is president and chief executive officer of the US Chamber of Commerce. Previously, he served as deputy assistant postmaster general and president of the American Trucking Associations. He is dedicated to promoting economic growth in the private sector.

as a fundraiser. I was vice president of Fairfield University when, one day, I got a phone call from one of our board members, who said, "I'm going to become the postmaster general of the United States, and I want you to go to Washington with me and take a job in the postal service." That was six years that I should have paid them for. It was the greatest experience in education.

When it was about time to move on, a good friend introduced me to the president of the US Chamber of Commerce, and I ended up going to work there. I worked at the Chamber for eight years, then left and ran the American Trucking Association. Thirteen years later, I got a chance to go back to the Chamber. That was fourteen years ago.

The Chamber of Commerce represents the interests of three million businesses around the country. We have 300,000 direct members. We represent the one thing in this country that really works: a free enterprise system, free businesses investing their own capital to create wealth and jobs, which creates a huge freedom to innovate and to fail and get up and go and do it again, which you can't do in many other countries. Representing people in that extraordinary endeavor is one of the most exciting things I've ever done. I've been on university boards and corporate boards and every other kind of board, but this is a fundamental issue that will define the future of this country. The way we deal with enterprise and free capital markets is going to decide who we are and who we're going to be.

By free capital markets, I mean ones without so many regulations in place. People can't get access to the capital markets. We need a free trading system. Most of the people we want to sell something to in the world live somewhere else, and if you're not trading while everybody else is, you're going to be left along the side of the road. We need a massive effort to use private and public money to build the nation's infrastructure in a way that makes us mobile, that supports our supply chain, that gives us national security.

The last great industry was the dot-com industry and its extensions. The next great industry in this country will be energy. Ten years ago, fifteen years ago, we thought we were running out of gas and we were going to have to buy it all from somebody else. That's not the case. We know now that we've got more of it than almost anybody, and all we need to have is the will. We have the technology. We know how to do it in a clean way. We know how to use all different types of energy. If we have the will to take it out of the ground and to refine it and sell it here and abroad, we'll put millions of people to work. Not thousands, millions. That will take us away from the dependence on foreign oil. We'll clean the air and the water and the land as we've been doing, spending trillions of dollars over the years. We will create new products. We'll shrink the federal deficit, and we'll pay down the debt.

We're all over the question of protecting intellectual property. We're all over protecting labor and management in a system that doesn't distort relationships. We're all over being very engaged on the issue of environmental sensibility. But that doesn't mean you shut down the world and shut down the country. It means you use modern technology. It means you try to manufacture in a sensible way. You care about the water and the land, but that doesn't mean you prohibit everything and leave it to everybody else in the world to grow their economies.

We believe in a program of economic growth and development, and we believe in, and we protect, the right of business to be seen, to speak, to protest, to prosper, as does any other institution in our society. The real jobs in this country are created by the private sector, and government can't create enough jobs. Still, we're very active in the political process. We do not participate in presidential elections, but we're very active in state and judicial elections, and in elections for the Senate and House on a federal level. Politics comes before policy, because if you put the right people in the chair, then you have a better chance at getting a balanced, bipartisan sense of how to move ahead.

We have helped to protect a system that provided opportunity and extraordinary benefits to tens of hundreds of millions of Americans over a long period of time. But we've been too long without growth. We'll get it as soon as we put more people back to work, and as soon as we get the regulatory mess sorted out and people begin to spend their money. But show me a better place to live than the United States. There is none.

I'm Shaun Donovan.

I'm the secretary of the US Department of Housing and Urban Development.

My passion for housing and urban issues started when I was growing up in New York City. The 1970s was a pretty grim time, particularly in the South Bronx, which was the poster child for urban devastation. Recently I was in Buenos Aires and went to visit the toughest housing project there, which they call "Fort Apache," named after the nickname for the police precinct that sat in the center of the devastated South Bronx.

The civic bonds that hold a city together were fraying in the 1970s in New York. I remember the blackouts and being mugged walking to school. I remember the World Series in 1977, when Howard Cosell had the camera pan outside the stadium across the outfield to the neighborhoods around Yankee Stadium. Fires were burning everywhere. For landlords, the quick way to make money was to pay somebody to come in, strip out the plumbing, and then burn down a building and collect the insurance. There were thousands of fires every year, and there was Howard Cosell, with millions of people watching the World Series, saying, "Ladies and gentlemen, the Bronx is burning."

Two weeks later the HUD secretary and President Jimmy Carter visited the Bronx. President Carter compared Charlotte Street to Dresden after World War II. It was devastated.

That's where my passion and interest in urban issues comes from.

I took a class at the Kennedy School of Government with a professor named Bill Apgar. In the first three days of class we didn't talk about housing at all. We talked about race and class. I realized that yes, I was interested in housing, the bricks and mortar, and getting folks off the streets into a decent place to live—but there's so much more to housing. When you choose a home, you choose where your kids go to school. You choose public safety. You choose access to opportunity. Like so many of my classmates, I thought that if we really wanted to change the world, we would go work for nonprofits or foundations. When the Clinton administration nominated that same professor, Bill Apgar, as the federal housing commissioner at HUD and he asked

Secretary Shaun L. S. Donovan
A native of New York, Shaun Donovan is secretary of the US Department of Housing and Urban Development. Recognizing the widespread personal, social, and economic benefits of access to secure homes and neighborhoods, he has focused on rejuvenating American cities, addressing the problem of foreclosures, and alleviating homelessness.

me to work for him, I got a chance to try public service for the first time.

At my first meeting at HUD, there were ten lawyers talking about the budget. I'm pretty good with numbers, but it wasn't a math I understood in any way. I was ready to give up. But then I remembered something that Martin Luther King said: "The arc of the moral universe is long, but it bends toward justice." I realized that you have to be patient in government, that things can take a long time. You have to be, I often say, patiently relentless in getting things done, but the scale of what we can do in the public sector is unique.

"There are some people who say, 'We just need to let the housing market hit bottom.' I don't agree. A family's single biggest investment is its home. That investment is how most families send their kids to college, start a business. It's retirement savings, a decent life after you've stopped working. That's what a home means to most families in this country. And that keeps me up at night."

For too long we had a national housing policy that was all about home ownership, and we forgot about rental housing. We've got to worry not just about getting folks into homes as homeowners, but also whether they're actually going to be able to remain homeowners over time. And we've got to have a balanced housing policy that says that it's all right if somebody chooses to rent.

Also important is not just thinking about ownership versus rental, but also where that housing is. It's no accident that the communities most devastated by the housing crisis are in exurban areas an hour's drive from jobs, locations that don't have public transportation options. They're also in inner-city neighborhoods that are cut off from decent schools and jobs. We have to think about housing located in places that have transportation choices, that have access to opportunity. In the Obama administration, cities are coming back. People want to be in cities. They want to be in neighborhoods where they can walk down the street to go to dinner, to go a movie. They want to get on a bike and ride to school. The way cities are going to compete is to become great places to live. Creative folks, intellectual capital, are attracted to places where neighborhoods are vital.

One of our most successful initiatives is called the Neighborhood Stabilization Program. In the neighborhoods that are hardest hit, where you have a dozen houses sitting vacant on one block— and this might be in suburban Las Vegas, or in downtown Detroit, or in Cleveland, where houses are selling for less than a new car—you need more than just loans, more than just what the market alone can provide. The basic idea is to help local communities and governments, nonprofits, and for-profits buy up foreclosed homes, renovate them, and try to start to reverse the spiral of decline. This creates a lot of construction jobs, and the construction industry was desperately hard hit in the downturn. It also helps to lift everyone's property values. If I see that the house that was sitting vacant and boarded up is now occupied and looks different, it makes me think differently about my own house. There are ripple effects of individuals investing in communities, of private owners coming in and buying homes and renovating them. Where we've invested that money, vacancy rates go down. In about two-thirds of those neighborhoods we've seen the house prices start to rise relative to surrounding communities.

One of the actions that will make a huge difference is the historic $25 billion settlement between the Obama administration, a bipartisan group of forty-nine state attorneys general, and five of the largest banks. The settlement will not just hold the banks accountable for their wrongs in servicing mortgages, but it will also directly assist nearly two million homeowners and help our housing market recover.

When the president walked into the Oval Office, we were losing 750,000 jobs a month. Foreclosures were at record levels. We've made enormous progress since then. The number of people falling into foreclosure is down more than half from where we started, but we still have a significant way to go. There's a real family behind every one of those numbers, every one of those statistics. There are some people who say, "We just need to let the housing market hit bottom." I don't agree. A family's single biggest investment is its home. That investment is how most families send their kids to college, start a business. It's retirement savings, a decent life after you've stopped working. That's what a home means to most families in this country. And that keeps me up at night.

The other thing that keeps me up at night is homelessness. We have the opportunity to end homelessness in this country. Not manage it, not put a Band-Aid on it, but end it. We have the technology. We know how to do it. The average chronically homeless person costs taxpayers $40,000 a year. Not only can we save their lives by getting them into housing, but we can also save taxpayers money by doing so. And there's a growing bipartisan consensus on this issue.

We're making real progress. Last year the number of veterans sleeping in our streets dropped by 18 percent. But I have a photograph of a homeless child on a wall in my office to remind me every day that we're not done yet.

I'm Beth Dozoretz.

I'm the director of Art in Embassies, a program at the State Department that places art in all of our embassies around the world.

After working my way through college as a sale clerk, I worked as an assistant buyer for a clothing store. I was there for a year when the buyer was fired, and I was given the opportunity to do the job. The president of the company brought me into his office and said, "I have this job, and I could give it to you or not give it to you. How do you feel about it?" I said, "Give me the job and let me try. If I'm really good, give me a big raise, and if I'm not, you can fire me. I want the chance to prove myself." Accepting a challenge and being clear about what you want is something that has worked well for me. I've tried to teach this to my children: Be respectful but be clear and forthright about what you want, and then work really hard.

My next job was at Casual Corner. I was the first woman hired as an executive, and working in a male-dominated environment was a great lesson for me. A few years later, I moved to New York City and became president of an apparel manufacturing company. Because of my past experience, empowering women was a priority for me. I wanted them to know that they could have the best and most important jobs in the company.

I retired from the apparel industry at thirty-nine, when I met my husband. We married just a few months after that and I moved from New York City to Norfolk, Virginia, where I joined the healthcare company he founded. My husband was a bit of politics junkie, and before we met he had run for the Senate in 1988. I was not remotely interested in politics, but at the 1992 Democratic Convention, Senator Chuck Robb asked if I would help raise money for the women who were running for the Senate. That resonated with me. It was the Year of the Woman, a very exciting time that was filled with promise. It was a time that seemed to bring enormous potential for women to have a real voice in Washington.

I accepted Senator Robb's offer, and much to my surprise, I was good at it. To thank me, he arranged a meeting with Hillary Clinton at the home of Vernon and Ann Jordan. I had seen Mrs. Clinton at the convention and was thrilled at the opportunity to meet her. I have enormous admiration for Hillary and for President Clinton. I have great faith in them, and my work on their behalf was a turning point in my life.

Something else happened that made me understand the power of government and how essential it is to be involved. I participated in a conference call with Al Gore and Sherry Lansing, and several others. Sherry was advocating for an increase in the funding for cancer research. Al Gore used his influence to propose a significant increase in the budget for cancer research more than $800 million. He did so successfully, and I immediately understood the impact that good government can have.

I continued to work in fundraising at the DNC. I went from asking people for a thousand dollars to asking them for a hundred thousand. At first that sum was beyond my comprehension, but the men did it with ease, so I embraced the challenge of raising money at a level that was comparable to them. At that time, I was one of the few women who were raising money at that level. I tried to bring in as many women as I could, and I don't think the men were happy about having them as equals in the fundraising game. Now more and more women have become a force in the fundraising world. In fact, several of the top fundraisers are women—Penny Pritzker and Maureen White, for example.

I ended up becoming the first women finance chair of the Democratic National Committee. I was incredibly proud of helping the Democratic Party and President Clinton. Bill Clinton truly cares about the lives of all Americans, and his compassion is authentic. He cares as much about a homeless person as he does the most important CEO or head of state anywhere in the world. It is part of what makes him such a compelling leader.

Hillary Clinton is one of the greatest female leaders in history. Her work ethic is beyond compare, her intellect is extraordinary, and she, too, projects a real concern for humanity. She will do everything that is humanly possible to make the world a better place. It has been a great privilege for me to work for both of them. When you're around them, you somehow feel a part of their extended family.

Several years ago, I was honored to have Betty Friedan and Ellen Malcolm in my home. I had invited a group of women to talk about Emily's List—I was involved with the organization early on—and Betty said to me, "You know, you're a great convener. You have an ability to bring people together." In truth, bringing people together is what I enjoy most. I turned sixty this year, and at that age you start looking at how

Beth Dozoretz

A businesswoman and political activist, Beth Dozoretz recently completed a fellowship at Harvard focusing on international relations and innovation in education. She serves as director of Art in Embassies for the US Department of State, which uses art as a means to open communication and cultural connections between people.

you have lived your life, what you have left to do? What you regret? What you want to spend the rest of your time doing? I love people, and I derive great satisfaction from making connections. That also provides an opportunity to learn and have interesting experiences—which is the fountain of youth.

The curators at Art in Embassies are incredibly talented, and I have learned a great deal from them. I see my role as amplifying their work and letting people know about the great impact of our program. I am focused on the possibilities the visual arts can have on cultural diplomacy. Art is a universal language that can and should have an impact on the way America is viewed.

Recently, we met with the new ambassador to Jordan, and we talked about the Arab spring. Young people inspired that movement. We came up with the concept of doing an exhibition of young Jordanian, Iraqi, and American artists with the theme of seeing the future through the eyes of youth. The ambassador and his wife can take a visitor through the exhibition and explain that the theme is to understand Jordan through the eyes of its young people. It's our job in Art in Embassies to communicate this to other countries: "We respect you. We respect your culture. We respect your artists, and we have researched what is important to your country. It is our mission to have the exhibitions and collections communicate respect and understanding for their country."

This is a time when arts funding is in jeopardy. Many people think of art as decorative, but it is so much more. If used properly, it is a tool of diplomacy that can open doors, inspire conversation, and encourage connection, personal and cultural.

I'm Regina Dugan.

I'm the director of DARPA, the Defense Advanced Research Projects Agency. I call DARPA the nation's elite army of futuristic techno-geeks.

My early interests were in both art and the heavy disciplines of science and math, and I love the blending of those things. I like the beauty and simplicity of science and math. A few simple principles can be applied to solve a whole variety of puzzles. People misunderstand how creative scientists and engineers are. They're very much like artists, just in a different realm. Scientists and engineers imagine things that don't exist, and then they set about making those ideas come to reality.

In graduate school I was, for two years, the cochair for the organization for women at CalTech. In that capacity, I did a lot of public speaking, and I did some organizing. My family

used to say, "If there is a cause for justice, you can find Regina nearby." And so I found a path there, which was a lot about trying to participate in things bigger than self. That's a constant calling for me.

When I finished my PhD, I had a number of options: Go to academia, go to the private sector, or go to this outlier organization, IDA, which was a think tank in Washington. I dutifully completed my spreadsheet analysis and talked to all my advisors, who told me not to take that think tank job. But I found myself one Saturday morning lying in my bed looking at the ceiling and asking, "Which job would you get up and go to right now?" And that think tank job was the job I wanted. I felt intrigued by the mix of technical analysis and decision making.

People find their callings and their passions in various places. There is hardly a more noble, selfless group of men and women than in the United States military. I consider it an honor to be able to contribute. The problems of national security are very complicated, with lots of dimensionality to them. I like those kinds of complex problems.

It's not just about serving national security. It's also about the people we meet, the individual men and women who become the symbols of the greater whole. It's a very big organization, the military, but it's the personal connections with individuals that motivate me on a day-to-day basis.

A story I often tell is of walking into a college stadium near the anniversary of September 11 in 2009. There were thousands of people there and the energy was high. As I was taking my seat, I got a text message from a colonel who was in Afghanistan. The first part of the message said, "Dr. Dugan, life here is stranger than even Coppola might have imagined. We just unloaded a helicopter full of St. Louis Rams cheerleaders, and it was just moments after we finished loading the flag-draped coffins of the two Marines who died yesterday."

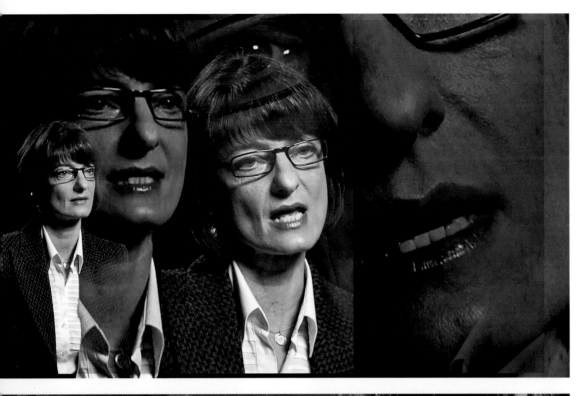
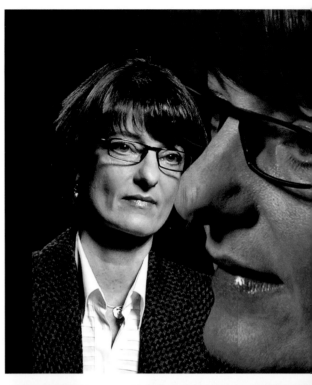

Regina E. Dugan

The first woman director of the Defense Advanced Research Projects Agency (DARPA), Regina Dugan has long emphasized creative responses to challenging problems. As a leader, she encourages others to aspire toward goals that seem just out of reach, arguing that great success only comes by accepting the possibility of failure.

He was clearly struggling with how surreal it felt. So, there I am, in this football stadium, and I'm having this moment with a colonel in Afghanistan. And it's as if I'm in a bubble myself. Just then, the announcer said, "I'd like for us to observe a few moments of silence in remembrance of all those who died on 9/11, and all those who are continuing to serve." And the whole stadium fell quiet. For me it felt as if everybody in that stadium was honoring those two fallen Marines.

Those are the stories that stick with you. Every day.

Part of the reason that DARPA has been so successful over half a century is that our work occurs at the powerful intersection between basic science and a driving application, the so-called Pasteur's quadrant. In Pasteur's quadrant, big technological breakthroughs are forced to yield results in applications that matter. And important applications create an intensity that drives breakthroughs in science. The difficulty and urgency of this intersection inspires greater genius, I believe.

Not long ago, someone said to me, "The reason DARPA is so successful is because you encourage your program managers to fail." I said, "I've never encouraged a program manager to fail. We encourage them to succeed, and to succeed really big." But if you want to have a very big success, then you need to be unafraid of failure. The fear of failure keeps people from reaching big. So, one of the things we say, even remind ourselves internally, is that you cannot lose your nerve for the big failure, because the nerve you need for the big success is exactly the same nerve. Until the moment you know which one it will be. Not before. It's the exact same nerve.

Most program managers come to the agency with a fire in their belly. Quintessential DARPA program managers see something that the world has not yet seen, and they see it with such clarity that they can't unsee it. They come to the agency to make it real. They want everyone to see what they see.

The people who come to DARPA are exceedingly gifted technically. These are best-in-class, world-class scientists and engineers. That, for us, is the beginning. Beyond that, you have to be able to articulate a vision, to call people to it, and then drive it. To execute a program well, you have to understand the black art of setting the bar. If you set the bar too low, then people feel insulted, and if you set it too high, then people think that you don't appreciate how hard the task is. Somewhere between is the right place to set the bar. It should always feel just out of reach, just beyond your grasp. And then, even if you go just underneath of it, you can really celebrate.

I am the first woman to sit as the director of DARPA. I feel honored. More so, I feel a tremendous sense of responsibility. I knew it was a big job when I took it. The agency has a big responsibility to national security and the warfighter. DARPA has been at the epicenter of a whole list of innovations: GPS, the Internet, materials science, unmanned aerial vehicles, and robotics. Many of these innovations have been important to the country. I don't think that's coincidental. After all, we serve this mini-society, which is the Department of Defense, and that mini-society has to be deployed anywhere in the world on a moment's notice. It has many of the same needs as the broader society, so when we develop big advances they have cascading implications for the rest of society.

And that's why so many of the DARPA innovations have made their way into the broader world. It may be our greatest accomplishment that so much of what exists in your life has its roots in the agency, and you don't even know it. Indeed, when people say they don't know DARPA, we often reply, "You may not know DARPA, but your life knows DARPA."

I'm Donna Edwards.

I represent Maryland's Fourth Congressional District in Congress.

I grew up in the military. My dad was in the Air Force for thirty years, and growing up in the service, going to many different schools, and living in every region of the country is what shaped me. My mom was the volunteer of the year for everything. I also volunteered in community service organizations as a child, and I've worked with nonprofit organizations throughout my professional career. Congress is just an extension of that.

My father served at a difficult time. We were in the midst of the Vietnam conflict, and we lived on installations where our neighbors were being deployed, where they didn't come home for a very long time—or at all. When I look at the military conflicts that we're engaged in now, our relationship with service members today is different from the one that I knew growing up. Vietnam itself actually created conflict at home, where many people in our communities did not value those in the service. I like the idea that we can disagree about policy matters but stand behind our service men and women.

I majored in English at Wake Forest University, and I thought that I would be a technical writer. I went to work for Lockheed and discovered that I had a lot more science in me than I knew. Eventually I became a systems engineer, working on the Space Lab project, a laboratory that was housed in the cargo bay of the space shuttle. Space Lab is now a museum piece, and now we've just retired the space shuttle as well, so it's been full circle. When the *Challenger* disaster happened, I thought, like many of my colleagues, that we would be up and running again after a short time. But the investigation went for a long time, which put off a lot of missions.

During that lull, I decided to go to law school. I thought I might be a public defender or prosecutor. I clerked on the Superior Court of the District of Columbia, which was an eye-opening experience that helped me discover the things I wanted to do and didn't want to do. I decided to do public policy work. I helped start an organization called National Network to End Domestic Violence, and we did the earliest work on the Violence Against Women Act.

I also started a group called the Center for a New Democracy with the idea that we could re-create democracy by changing the way that we finance campaigns. If you look at modern-day campaigns, you see a lot of money influencing the process, and we need ways to make sure that elected officials are accountable to the public. I've introduced a constitutional amendment for campaign finance reform, and I wouldn't have done that if I didn't think that we could make it happen. It's a slow process, though, and some people have said to me, "Well, you know, a constitutional amendment takes ratification by the states, it takes an overwhelming majority in the Congress, and it can take years." I have replied, "Well, we have a campaign finance system that's taken us years to mess up. I think we can spend a couple years to try to fix it."

> *"My politics centers on community building. I believe in Social Security and Medicare and the baseline safety net that was established generations before I came along."*

I don't think people are happy with the *Citizens United* decision, where the Supreme Court said that corporations can reach into their treasuries and spend money on campaigns. The public interprets that to mean that somebody else owns their elections, and the elections aren't owned

by the people. They want to change that. Now, the details, the nuances, of how we do that are complicated, but the public does understand the idea that we need to make the change to restore elections to the people.

I ran for Congress as kind of a grassroots candidate. I don't have personal wealth, so I had to organize people and money in order to run for Congress. I defeated a long-term incumbent to win my seat in Congress, something that's just not done very often because of the kind of system we have. I'd like to see a system where anybody who has good ideas and is of substance and has something to contribute can decide that he or she wants to be a member of Congress and go out and convince people of that. Money shouldn't get in the way of that decision.

There are 721,000 people in my congressional district. That's a lot of convincing. While I was going to work every day in Washington, going to work at nonprofit organizations, I was out in my community, down at the town hall, testifying, doing community work, meeting with my neighbors, and talking to our neighbors. Politics is just about expanding the circles. You start out with one circle that's close and then you widen that and widen it, and the next thing you know, you're in Congress. Of course, it's not nearly that easy. I knocked on a lot of doors, and I went to every community center and senior center, stood at Metro stops.

When I went around through my congressional district, I learned that people are mostly concerned about creating a better life for themselves and their children, making sure that they can get on public transportation that works so they can get to the soccer game, are able to participate in their children's schools and activities, and meet basic needs. My politics centers on community building. I believe in Social Security and Medicare and the baseline safety net that was established generations before I came along. I believe in going to work for a job that pays you enough to be able to take care of your families and send your children to college. I advocate for policies that do exactly that. I'd like to think that I'm in Congress to fight for people who

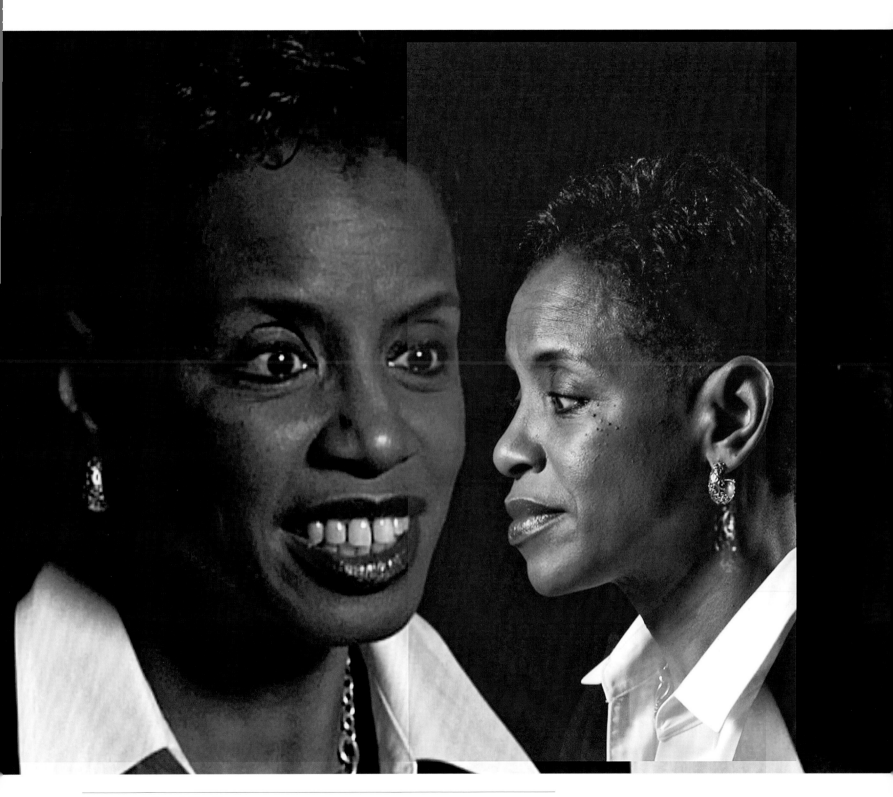

Congresswoman Donna F. Edwards

Trained as a systems engineer and lawyer, Donna Edwards, a Democrat and the first African American woman to represent Maryland in the US Congress, now serves on the Science, Space and Technology Committee. As a public advocate, she has fought domestic violence and is focused on campaign finance reform and improving education.

get up every day and work for a living. It's what I did before I came to Congress, too. I'm a single mom. I understand what it means to struggle. I want to make sure that we have policies in place that help people who want to do better, want to take care of themselves and their families, in a world where that's not easy.

I serve on the Science and Technology Committee in the Congress. I'm the ranking Democrat on the Innovation and Technology Subcommittee. From the years I spent with Lockheed and NASA, I know that we have to do a lot more to prepare future generations for the kind of jobs and opportunities that we want to see for this century. We're going to have a different kind of economy. We need to make sure that our schools are equipped in a way that allows our young people to thrive. Have we invested in the laboratories that we need in schools? Do we have educators who are prepared to teach the technologies that young people are going to need? Do our young people have the baseline skills to communicate ideas to innovate in the kind of way that we've known for centuries past? We can't wait to make those investments. We have to make them right now, and we're failing to make investments that will build for the future.

I came to Congress because I'm a doer. I want to get things done. I'm very solution-oriented. There's such tremendous need, but also tremendous opportunity.

I'm Anthony Fauci.

I'm the director of the National Institute of Allergy and Infectious Diseases at the National Institutes of Health.

I was born and raised in a working-class neighborhood in Brooklyn. I went to Regis High School in Manhattan, a Jesuit institution with high academic standards that leaned toward understanding humanities and the classics— Latin, Greek, philosophy, history. To the extent that a high school student could get involved in philosophy, I was taken by it. The spirit of the school was public service, and from an early age I knew that I wanted to do something that would have an effect on other people.

I got interested in science toward the latter part of my high school career and then went to another Jesuit school, College of the Holy Cross. I did very interesting coursework referred to as Bachelor of Arts, Greek Classics Pre-med, which means that I concentrated on the classics and philosophy but took enough science to get into medical school. I went to medical school at Cornell University College of Medicine in New York City and did all of my internship and residency postmedical graduate training in internal medicine at The New York Hospital–Cornell Medical Center.

During the time I was doing my training in school, the Vietnam War was on, and all of the doctors were drafted. We went into the Public Health Service, the Army, the Navy, or the Air Force. I asked for the Public Health Service because I wanted to study infectious disease. I was fortunate enough to be chosen.

I was at the National Institutes of Health (NIH) for ten years, studying diseases that interface between the body's immune system and infectious diseases. I studied a disease that we developed a cure for, a very unusual inflammatory disease of the blood vessels called vasculitis. I was in my late twenties, and I found myself in the unusual position of having achieved a degree of success in biomedical research at a young age. But I remember thinking that even though it was great to be in this situation, it was not fulfilling my desire to study infectious diseases and their impact on global health, because infectious disease is the second leading cause of death worldwide and the leading cause of death among people in the developing world.

In the summer of 1981, a document landed on my desk from the Centers for Disease Control and Prevention (CDC), reporting the first five cases of what ultimately turned out—even though we had no idea at the time—to be AIDS. There were five gay men from Los Angeles who presented with an unusual pneumonia, suggesting that their immune system had been destroyed. Since I was studying immunology and infectious diseases and the interface between the immune system and infectious diseases, it immediately struck my interest, but even so I said, "Well, maybe this is a fluke, and we won't hear any more about it." But a month later, in July 1981, a second publication appeared from the CDC, now reporting that twenty-six men, all gay, all otherwise previously well, had come down with devastating infections such as pneumocystis, as well as a very unusual cancer called Kaposi's sarcoma. These were men from San Francisco, New York City, and Los Angeles.

I had no idea what this brand-new disease was, but it acted like an infectious disease. I made a decision in the midsummer of 1981 to change the direction of my career and start to study it. My mentors thought I was crazy to leave a successful career to start studying a curiosity disease that was thought to affect only gay men. Fast-forward from then to the present, and AIDS has turned out to be one of the most devastating pandemics in the history of human civilization, ranking with smallpox, with the bubonic plague, with the pandemic of influenza of 1918.

From 1981 until we developed effective therapy for HIV, I watched all my patients die. The median survival period was six to eight months. Now, with the therapies that we have developed over the last several years, if someone in their twenties comes in with early-stage HIV/AIDS, we can put him or her on therapy and I can look that person straight in the eye and say, "I can mathematically predict that you will live an additional fifty years if you stick with your drugs and take care of yourself." That is extraordinary, from seeing all your patients die to seeing them essentially living normal lives.

We now have what is called an "implementation challenge." We have excellent treatments for HIV infection. We know how to prevent infection. There are a number of prevention modalities that we know work: Circumcision, interestingly, is a very important preventive modality for men acquiring infection, as is proper use of condoms. In the summer of 2011 we discovered that if you treat someone who is HIV-infected, you can bring the level of virus down below a detectable level and it will be extremely unlikely that the patient will transmit the infection to a sexual partner. For years there was a tension between whether we should put resources into prevention or into treatment. It was an unnecessary but real tension. Now we know that every time you treat someone you actually prevent that person from infecting someone else. So we already have the tools, if we implement them, to turn around the trajectory of the pandemic.

The good news is we have developed the tools. The challenge is to implement what we already know about treatment and about prevention and to get enough people voluntarily tested, linked to care, followed in care, and put on therapy. Then you are going to start to see a major shift in the trajectory of the pandemic. That is what everyone is talking about now in 2012: the implementation of tools that we have spent years developing through biomedical research.

We are still pushing for the development of a vaccine. That has been difficult, because the body does not make an immune response against HIV that is adequate to suppress it and eliminate it from the body. With the other historical microbial killers such as smallpox, polio, and measles, most people develop an immune response that protects them from reinfection. The challenge with a vaccine for HIV is to present to the body a component of the virus in a form that would induce a response that is better than what the response is from natural infection.

The next challenge is the question of a cure. Therapy is spectacularly effective in suppressing

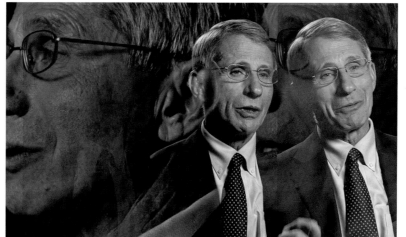
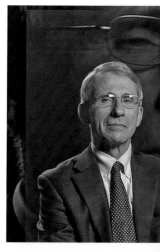
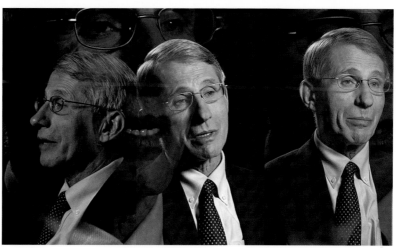

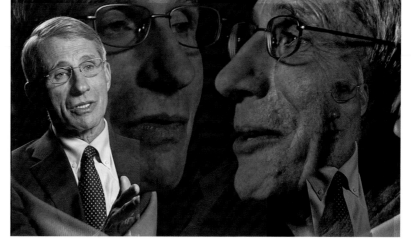
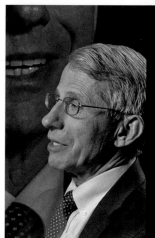

Anthony S. Fauci

Anthony Fauci is director of the National Institute of Allergy and Infectious Diseases at the National Institutes of Health. He specializes in the study of infectious diseases, was one of the first researchers to study HIV/AIDS, and has made pioneering contributions to the understanding, control, and treatment of HIV disease.

the replication of the virus, but it does not eradicate the virus. Probably the biggest obstacle is that the virus has the uncanny capability of inserting itself into the genome of a cell and lying there quietly. You can give somebody therapy and the virus will never reemerge, but when you stop it, the cells that are still alive and have virus in them will start to spit out that virus. We are trying to discover new molecules that can actually get into the cell and either eliminate the virus or strengthen the immune system enough that when we stop therapy, the immune system will be strong enough to keep the virus suppressed.

I am confident that we will get a vaccine that is at least moderately protective. But it is not going to be next year, and it is not going to be the year after. It will take several years.

I'm Michèle Flournoy.

I'm under secretary for policy at the Department of Defense.

I studied political theory and philosophy at Harvard, held internships and fellowships in Washington, then ended up back at Harvard as a research fellow at the Center for Science and International Affairs. A lot of the work I did was on preventing nuclear proliferation. At one level you need a very technical understanding about the materials that are necessary to build a weapon, but on the other hand you're dealing with international treaties and relations between countries and motivations of countries and why they're seeking these technologies in the first place.

After graduate school, I had gotten involved in nuclear arms control and nuclear nonproliferation, which seemed to be the number-one challenge of the day. But then I came into the Pentagon to work in the defense strategy office. There, strategy is everything. It's about America's role in the world.

It's about how we use the military as an instrument of policy. It was a much broader canvas, if you will.

"Our technical edge is one of our advantages. But the real strength of our military is the people. We have a professional, all-volunteer force and are able to recruit some of the best and brightest in the country. Today, we have the finest military in the world."

I then spent time at the National Defense University and at one of the bigger think tanks, the Center for Strategic and International Affairs. In early 2007, Kurt Campbell and I decided to found the Center for New American Security (CNAS). We felt that it was important to have a place that was focused on national security that could host a dialogue between people on the left and on the right, between Democrats and Republicans, between civilians and military, and between generations, because we were interested in recruiting and growing the next generation of people who are going to think about national security. CNAS is willing to go to the most difficult and contentious issues and have it out in a civil manner—have it out in a way that is not about ideology, but about trying to solve problems for the United States of America. Most Americans don't have a lot of experience with the military, and over time the risk is that it becomes a professional force that is separated from society. We also wanted to make sure that the military professionals who were executing our policy and the civilians who were either making it or being groomed to make it were in frequent conversation across people's careers. And indeed, we've had had a lot of senior military people

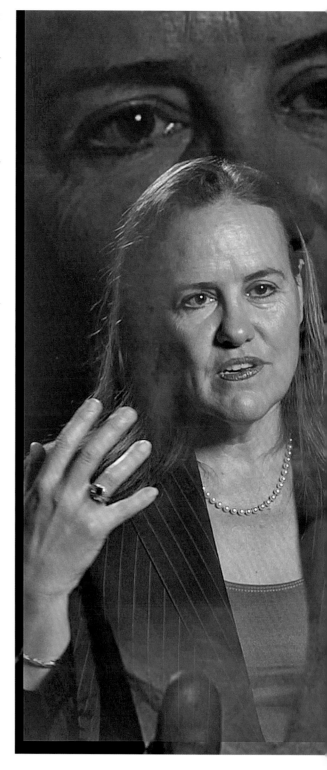

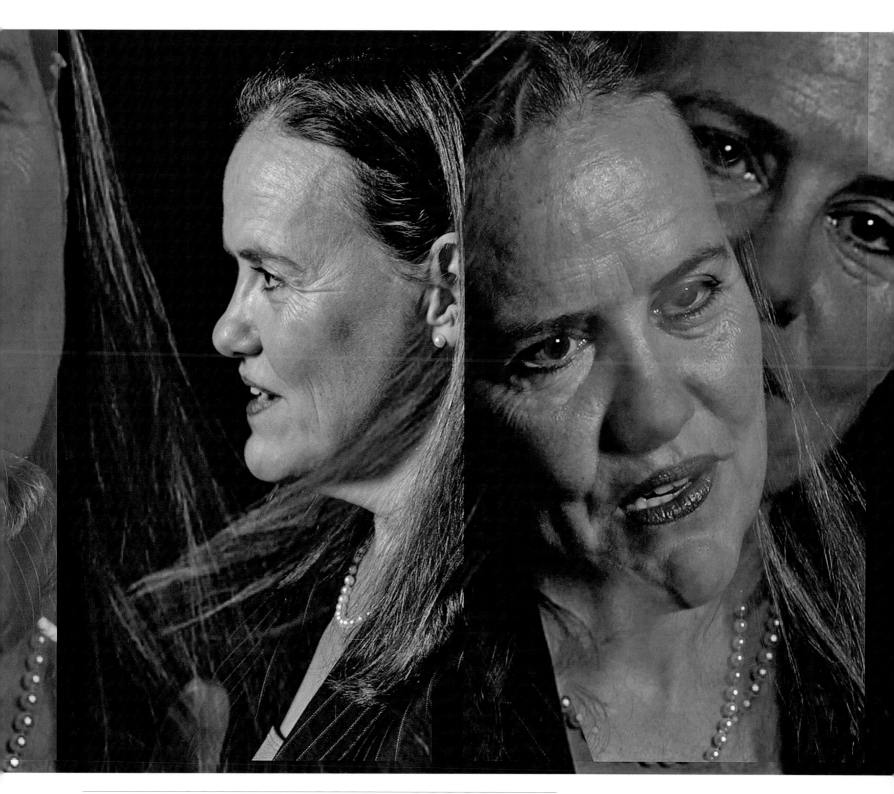

Michèle Angelique Flournoy

As under secretary of defense for policy from 2009 to 2012, Michèle Flournoy was the highest-ranking woman ever to serve at the Pentagon. In 2007, she cofounded the Center for New American Security (CNAS), dedicated to developing strong, pragmatic, and principled national security and defense policies.

wanting to come and engage as a vehicle for having more of a conversation with the broader policymaking community.

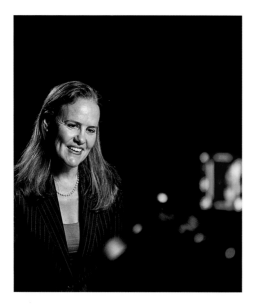

I took from that experience a couple of important things. One is that it's important to create an environment where debate can happen and dissent can be heard. If everybody just tells you what they think you want to hear, you're not going to make very good decisions. The second thing from my experience at CNAS was all about hiring people who were more expert than I was, smarter than I was, better than I was, and then empowering them to go off and do great things. I have tried to do that in government as well. My assistant secretaries know far more than I will ever know about their given subject areas. They are tremendously talented people. The trick in leadership is to empower them, give them guidance, and harness all of that talent and energy.

One of the things we've tried to do is create time and space to get away from the tyranny of the inbox to give people time to think strategically and long-term. To innovate well you have to experiment, and good experiments often fail. It's a process of learning. It's not about getting to the perfect product the first time. It's about trying

things, refining, failing, learning, trying again. That's a countercultural idea in an organization like the Department of Defense, where it's very hierarchical. It's all about the mission, and you obviously don't want to experiment and fail when people's lives are on the line. It's been interesting to try to create some space for innovation and experimentation in an environment where that's traditionally seen as a high-risk proposition.

In response to 9/11 and the scourge of terrorism, liberties were taken with regard to the rule of law. I think it was tactically expedient at the time, or so it seemed to some, but fundamentally it started us down a very bad path. If President Obama should get credit for anything, it is for turning around the ship of state to get us back onto a path where we are about abiding by the rule of law ourselves and promoting it everywhere else we can in the world. It is fundamental to who we are and our ability to have influence in the world.

One of the precepts in the counterinsurgency literature is that all insurgencies are local. We learned this in Vietnam, and again in Iraq. The first thing you have to do is understand what is fueling the insurgency: grievances, conditions, why people are taking up arms to get their needs met. Your strategy, even though there are some broad lessons learned and best practices for countering insurgency, has to be tailored to the local circumstances. More often than not, it's not just about security; it's about governance, dispute resolution, and addressing grievances. It's about the basic needs of populations in terms of services, economic prospects, and the like. We need a comprehensive approach that uses a lot of instruments other than just military forces to get to a resolution. Indeed, it's hard to find a problem out there, including counterterrorism, where you can just succeed using the military alone. Eric Olsen, the admiral who commanded Special Operations Command, says, "We can't kill our way to victory." We have to address the fundamental conditions that give rise to terrorism in the first place. We need a whole-government approach.

We're going to see rising countries using more asymmetric means to challenge us on the global commons in the maritime domain, in the air, in space, in cyberspace.

In the next ten years, our military is going to become somewhat smaller, but it's still going to be very flexible. It will be able to operate across the wide spectrum of operations from humanitarian assistance in the wake of the Japanese earthquake and tsunami and nuclear accident to dealing with sophisticated challenges to our ability to operate freely in the maritime and cyber and space environments to be able to deal with counterterrorism and stability operations in the middle. Our technical edge is one of our advantages. But the real strength of our military is the people. We have a professional, all-volunteer force and are able to recruit some of the best and brightest in the country. Today, we have the finest military in the world. At the end of this process after these budget cuts, I want us to be able to still say that we have the finest military in the world and that it can protect this country against whatever combination of threats we face.

I'm Barney Frank.

I am the representative in Congress of the Fourth District of Massachusetts.

My first clear recollection of wanting to engage in politics was in 1954. I was fourteen. A man named Emmitt Till had been in Mississippi visiting relatives, and had apparently either whistled at a white woman or looked at her inappropriately, according to the locals, so they murdered him. I remember reading that not only did the law enforcement people know who murdered him, but they also almost certainly were involved. I thought, "How can this be? This is America. How can the cops

kill a black person because they don't like the way he looked at a white woman?" I also remember running home from school to watch the Kefauver crime hearings and the Army-McCarthy hearings. All that got me interested in politics as well.

We lived in New Jersey, where local politics had such a bad reputation that when I went to Boston after college and was appointed to be the chief assistant to Mayor Kevin White in 1968, I told my mother, who said, "Oh, that's wonderful. I know you really want to do this, but let's not tell anybody around here." In the local context, becoming assistant to the mayor was almost a prelude to an indictment.

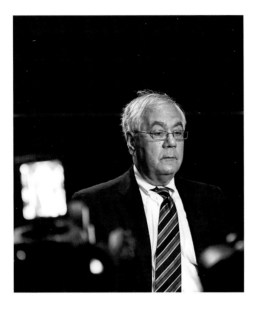

For me, frankly, being both Jewish and gay, it never occurred to me when I was young that elected office was a possibility. I went on to get a PhD and teach politics and government, and then I went to work as an aide to others at the start of the Kennedy administration in 1960. John Kennedy brought a lot of people from top-flight members of the academic world to work with him: John Kenneth Galbraith, McGeorge Bundy, Arthur Schlesinger, Carl Kagan. What evolved in my mind was that I could write about politics, study it, and teach it as an academic, and be involved in it by working for other people.

In 1967, Kevin White was running for mayor of Boston against Louise Day Hicks, a South Boston resident whose main political position was to resist the notion that there needed to be fair treatment for black people. Boston had been a city where blacks were really rather badly treated, relegated to a very inferior set of positions. I was in the ideal position to go help on White's campaign, because I didn't have a full-time job. I assumed that it was a one-month stint, and then I would go back to Harvard and write my thesis. But when Kevin White won, he asked me to stay on. I said, "No, I can't. I've got to go write my thesis. I'll come back later." But he convinced me to stay. He said, "Look, you're a big liberal. You want me to do all these things, and I agree. It's going to be tough, and you know what I'm up against. If you leave, don't complain if I'm not able to do some of the things you want. Some of you have to stay with me."

I left after three years and went back to Harvard to take up scholarship again. My attention span was too short to be an academic. In 1972, the moderate Republican state representative from the area of Boston where I'd been living announced he wasn't running again. The area was populated by yuppies, although we didn't call them that then. They were fairly cosmopolitan, and they were an unrepresentative sector of the Boston electorate, the only one where I could have won office—which I did. I served eight years as a state representative. During that time I was increasingly unhappy about being closeted. I told no one, literally no one, that I was gay. I had decided in 1974 that I would go to law school, leave the legislature after one more term, acknowledge being gay, have a law practice, and be a gay-rights activist with some credibility on the political side. I was methodically working through that, and then Pope John Paul II intervened. He did not want any priests in elected office, and he particularly didn't want Father Robert Drinan, a liberal Jesuit who represented the congressional district next to the one I lived in. So Father Drinan announced he was retiring, although he was sad about it, but he was a good priest who had taken vows of poverty, chastity, obedience. It never crossed his

mind to disobey. His whole adult life had been in the church. He stepped down, and I moved into his district, ran for the House, and won.

"I worked hard on a number of issues—immigration, affordable housing, civil rights, financial sector reform. I believe that the public sector is an important way for us to improve the quality of life."

I did go to law school, before that, in self-defense. I was a member of the state legislature, and the state legislatures in this country are where the laws are written. Congress writes some laws, but it also does resource allocation. The criminal laws, laws about marriage, laws about who can own property, liability for accidents—those are state laws. When I first went into the legislature, I would say, "Let's do this." And some lawyer would say, "Oh, you can't do that." I'd say, "Why can't you do it?" He would say, "Are you a lawyer?" I'd say, "No, I'm not." He would reply, "Well, you wouldn't understand." I went to law school to be able to deal with that, because I knew they were hiding behind the law. I went to law school both to be able to better defend my arguments against people who invoke the obtuseness of the law to block things, and also to have a profession after I retired from elected office.

In the 1980s, I started to figure out how I could come out and survive politically. Then I reached a point where I said, "Even if I can't survive politically, I can't live this way. This is not a healthy way to live with the emotional and physical repression on yourself." I finally decided that I had to just acknowledge being gay, because I was just spending too much emotional time and energy in being closeted. My colleagues in the House were

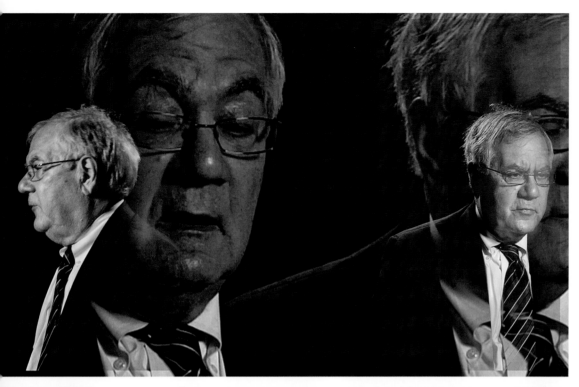

all fine with my announcement. Legislating is a very personal business. I was under less tension, less strain, and I got some political credit for being honest.

I'm a good legislator, better at it than I am at other things. I worked hard on a number of issues—immigration, affordable housing, civil rights, financial sector reform. I believe that the public sector is an important way for us to improve the quality of life. We have a society in which there is a private sector under a free market system that's very good at producing goods and services, and I'm a supporter of it. We need to do things that improve the quality of our lives, but in a positive sense in avoiding bad stuff, and the private sector won't do it. The public sector has to do it. That can only come from a government that has adequate resources and is functional. The private sector gives us the wherewithal to do it, but absent a well-run public sector, except for a handful of very rich people, people are not going to live very good lives.

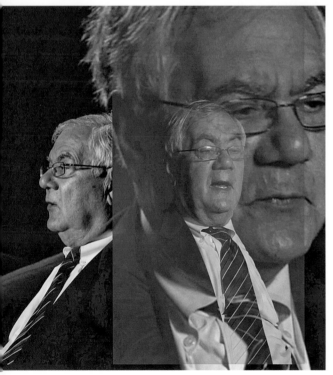

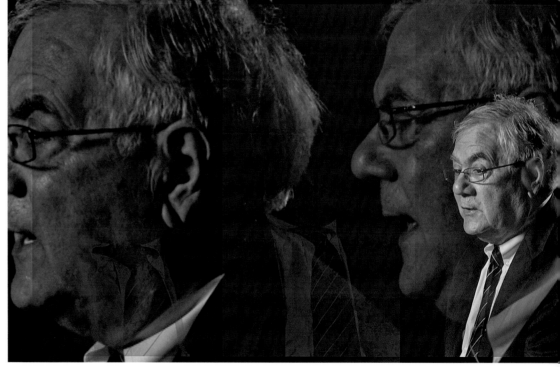

Congressman Barney Frank
Barney Frank has been a Democratic member of the US House of Representatives from Massachusetts for more than thirty years. As a gay politician, he has played a pioneering social role in Congress, while as a legislator he has focused on immigration, affordable housing, civil rights, financial reform, and reducing military spending.

I'm Julius Genachowski.

I'm the chairman of the Federal Communications Commission.

I grew up with a very strong appreciation of this country. My parents were victimized by the Holocaust. My father's family, close family members, were killed in Auschwitz. The United States ultimately opened its doors to my parents, though, and my father was able to create a life here. He went to MIT and had a great career. Only in the United States could Holocaust survivors come and have a chance to build a life and send their kids to schools, and to good schools at that.

All that became one of the topics of conversation with Barack Obama as I got to know him in law school. We come from very different backgrounds. His is well known. Mine is very different. But one of the things that we both appreciated was that only in America could people from his background and my background get to a place like Harvard Law School and be on the *Harvard Law Review*—and, in his case, be elected president of the *Harvard Law Review*. That success helped spur a recognition that giving something back through public service is important.

I started off college thinking I would go to medical school, taking the math and science courses that would lead to that path. But I discovered my college newspaper, the *Columbia Spectator*, and then enrolled in history, political science, and literature classes. I was better at math and science, but I really liked the other subjects. I switched my major to history, gave up on the idea of medical school, and later applied to law school.

I didn't want to go directly to law school, though, so I decided to move to Washington and try to

find a job. I thought about journalism, but I'd also gotten interested in public policy issues in college. I got a job with Chuck Schumer, who was then a young congressman. I liked the work, and I applied for a second deferment from Harvard Law School. Then I lucked into a job with the Iran-Contra Committee—Ollie North, the American hostages in Iran, trading arms, supplying weapons to the Contras in Nicaragua. I ended up in the middle of all that. I needed top-secret clearance for the job. That required a third deferment, which Harvard didn't grant.

Later I reapplied, and fortunately, I got in. I did well at law school and got a clerkship with Abner Mikva, who was chief judge on the District of Columbia Circuit Court of Appeals. I got the seat that was vacant because Obama turned it down. Then I clerked for Justice Brennan and Justice Souter at the Supreme Court.

Some people were surprised when I went to work for the FCC, when most Supreme Court clerks were going off to law firms or teaching at law schools—or, if they were going into government, they were going to the Justice Department, or maybe the White House. But I had an interest in communications technology. I had stumbled on the Internet during these years. By chance, I had worked on a couple of cases at the Supreme Court and the District of Columbia Circuit that involved communications technology and the FCC. The communications technology world was just dawning. I knew enough to say to myself, "This world is about to explode, and it's the kind of explosion you want to be near, because it's going to be very interesting."

I was at the FCC as a young staffer from 1994 to 1997, and it was a terrific experience. It was the first time the FCC struggled with digital communications technologies, the first auctions of spectrum for wireless. It was the time of the Telecommunications Act of 1996 and its implementation.

Then I worked for a company in television, film, and ultimately the Internet. Eventually, I moved back to Washington and worked with a technology-oriented private equity firm. During this whole period, I had stayed in touch with Barack Obama and was energized about his candidacy. I helped on his campaign. He was always extremely interested in the opportunities of technology. He asked me, after he won, to serve as chairman of the Federal Communications Commission. Of course, there was only one answer.

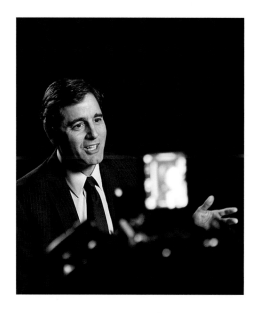

One of the challenges in government is that it's natural to focus on today's issues and to solve for yesterday's problems. There's nothing wrong with that; it's important to learn from the past. But whether you're in government or at a company, the real question is, "What should you be doing now to meet your objectives in several years or more?" Particularly in an area like communications technology that presents so many opportunities for the economy, looking backward isn't enough. But as important as it is to be thinking about the future, as we do our jobs at the FCC, if we assume we know the future, we're going to make mistakes. So the challenge is: How do you put together an agenda, a set of initiatives that are future-oriented, while simultaneously realizing that there's

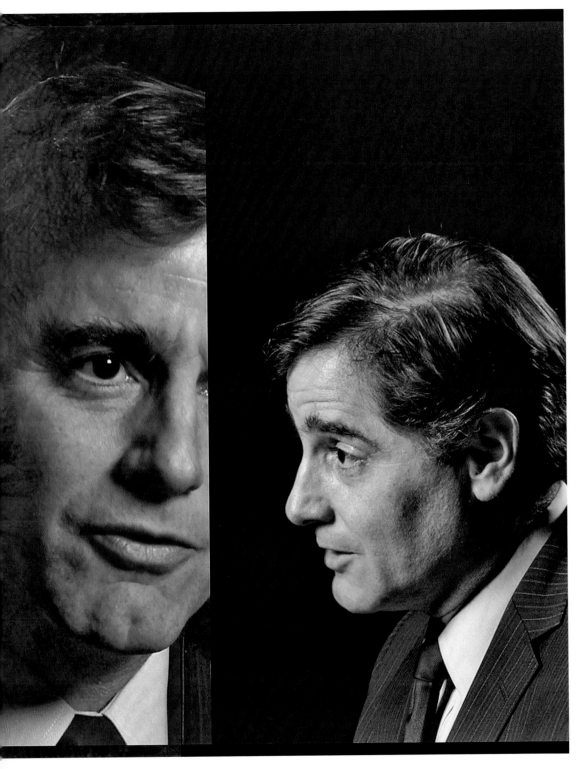

so much uncertainty about the future? That's informed the agenda we've build at the FCC: What are the things that we can do now that increase the chances for ongoing innovation, ongoing dynamism around communications technology, whether it's the Internet, mobile internet, or cloud computing? What are the things that we can do to increase the chances that this new world will make an ever-increasing contribution to our economy, to job creation, to improving education, health care, and public safety?

That's how we've organized our work. We think about what our goals are and the obstacles to those goals from the world as it is. What can we focus on, either to remove obstacles or incentivize innovation and investment so that we can unleash these opportunities in the United States?

Public-private partnerships are very important, along with smart policymaking. It's appropriate for government to set goals, identify challenges, and have in mind outcomes that are good for the country, such as universal broadband deployment and adoption. The next question becomes: What's the fastest, most efficient way to get from here to there in a way that maximizes the benefits and minimizes the cost? People in government should look at the full arsenal of tools. Public-private partnerships are one of them. Setting goals for industry, challenging it, putting in place new initiatives that can make a difference—that's part of how I see our role.

One of the first things I did when I took over was to oversee the development of a national broadband plan. Three years later, we've implemented much of it, and it's already paying dividends. It's not practical to think that government alone can solve the problems, particularly given the amount of money needed to narrow the gap between what broadband costs and what many people can afford. So the cable industry has committed to offering a new low-cost broadband rate for families with kids on school-lunch programs, and BestBuy's Geek Squad is being deployed to help teach people how to use

Julius Genachowski
Chairman of the Federal Communications Commission Julius Genachowski has focused the agency on unleashing the opportunities of broadband—pursuing policies to promote investment and job creation, drive innovation, foster competition, and empower consumers. He spent more than a decade working in the technology and media industries as an executive, investor, and board member.

the Internet. This is beginning to make a difference in communities around the country. If we increase broadband adoption, we increase the size of the online market, and that's a good thing for the American economy.

New technologies create new opportunities. New technologies also create new challenges. It's been true of every technology in the past, and it will be true of every technology in the future. The people and the companies and the countries that seize the opportunities of new technology by tackling the challenges will be the ones that win.

I'm David Gergen,

and I'm officially part of the over-the-hill gang here in Washington. I teach at the Kennedy School at Harvard. I'm a professor of practice, and I run the Center for Public Leadership there. I am also a senior political analyst with CNN. I wear many different hats, but those are probably the most relevant.

When I first came to Washington in the late 1960s, I was in a Navy uniform. The World War II generation was governing when I first arrived, men and women—mostly men—who had been young officers in the war. When they came out of the war, they became the civic generation; Tom Brokaw has described them as the "greatest generation." There was a spirit about the city that I found, especially in retrospect, to be very appealing, and that was all thanks to the people

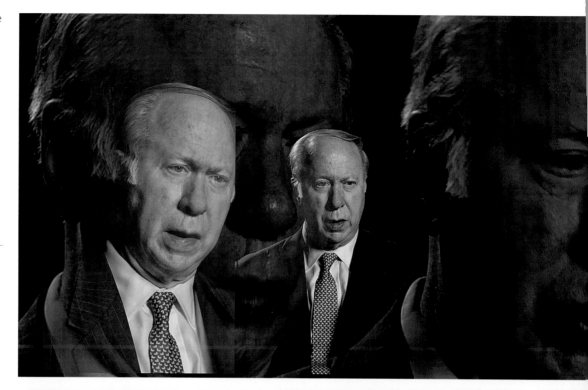

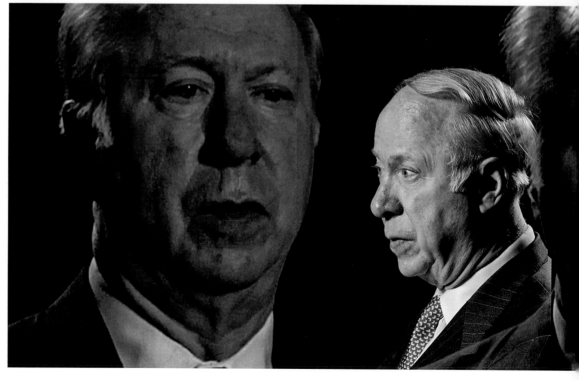

David Richmond Gergen
David Gergen directs the Center for Public Leadership at the Harvard Kennedy School. Over the course of his career, he served under four presidents: Richard Nixon, Gerald Ford, Ronald Reagan, and Bill Clinton. He has also worked as a journalist, including roles at *U.S. News and World Report* and CNN.

of the World War II generation who had come to Washington. We had seven presidents in a row, from Kennedy through Bush senior, who had been in uniform during that conflict. There was a sense then that people were strong Republicans or strong Democrats, but first and foremost, they were strong Americans. They put the country's interest first.

That generation wasn't perfect. It gave us Vietnam. It gave us Watergate. It gave us many things that fell short, but when those people left the stage, America was not only at peace but also the most powerful nation since the days of Ancient Rome, economically, politically, militarily, and culturally.

That moment was very short-lived, and since then we've been pitched into a very different period, which is much more anxious, much more uncertain. Frankly, today's governing class is not as effective as the World War II generation was. My generation is now running things, and we leave a lot to be desired. We're far more polarized, more partisan. People no longer think of themselves as Americans first and foremost. They think of themselves first and foremost as identified by their cause or their group.

In political Washington, the sense of community has almost disappeared. When I first got here, most members of Congress brought their families with them. Their kids went to the same schools. They worshipped in the same churches or synagogues, and they often had dinner together. A lot of those customs are regarded as antique now. People come here for very brief periods. They go home to raise money, because you've got to raise so much money to run a campaign. They don't get to know each other. Their luncheons are often with their caucus, not people on the other side, and they go to the caucus in order to figure out how to beat the brains out of the other side.

If you talk to members of Congress today, many of them will also tell you that the media are contributing to this partisanship. The media gravitate toward voices of rancor, of extremism,

of people who throw things at each other verbally. They make more interesting copy. If you're running a media organization, you're searching for people's time, you're searching for their eyeballs. And what do you do to bring them in? How do you attract them? Many have decided to appeal to emotions and ideological biases. Food fights have become very popular, and that also has contributed to a decline of the discourse.

"America is resilient. We self-correct. But we're living in a world that's moving at an accelerated pace, and we're slow at adapting. In area after area, we're being overtaken."

It's possible to become extremely pessimistic, but I look up and see that there's a new generation coming. New members of Congress who are coming in—in the Senate, for example, Mark Warner on the Democratic side or Rob Portman on the Republican side—give me considerable hope that a lot of these folks up here are sick and tired of the politics being played, and they want to see a new day. Behind them are the people I have a chance to teach, in their twenties and thirties. They're impressive, and I'm hopeful. I think they could be the next greatest generation. Many are men and women also newly out of uniform who want to change America.

Change is hard. You don't make fundamental changes in the country or the conditions of our citizenry by proposing some bill, getting a big headline, having a week of publicity, and then having attention turn to the next issue. Headlines don't make progress. Hard work makes progress, and it takes years before you get significant breakthroughs. You've got to convince the public of something new. You've got to build a coalition.

Then you've got to get through the arcane labyrinth of Congress. Special interests will shoot at you. Machiavelli said a long time ago that change is one of the hardest things to do, because those would benefit from it are fearful of change, and there are many who have a vested interest against change and will resist it.

America is resilient. We self-correct. But we're living in a world that's moving at an accelerated pace, and we're slow at adapting. In area after area, we're being overtaken. Let's take K–12 education, which is fundamental to this country's future. At the beginning of the twentieth century, we were the number-one nation in the world in terms of education, and in every generation, children tended to go to school two years longer than their parents. We stayed ahead until the 1970s, but then we began to stall out, while other nations that saw our past progress began to bear down on us. By now, any number of these countries have passed us by. We're scrambling to get back to being competitive, but there's so much resistance and so little goodwill.

When I worked for Ronald Reagan, I and many others thought that the only way you could govern this country was for the president to seize the microphone and bring the bully pulpit back to the White House. We were aggressive about that, and some of that trend involved what's now called "spin." The trend line since then has been to more and more spin, more and more artificiality in the conversation, more and more efforts to convince people of things that aren't true. That has undermined public confidence in government and leadership.

It's important to have beliefs and judgments, but it's also important to have an open mind about different perspectives, about alternative ways of seeing reality, and, indeed, of appreciating things that you might not understand but that might make you change your mind. In politics, people are becoming more and more close-minded. They're not open to alternative views. They're not open even to listening or reading.

When I got here, politics was very contentious. People went after each other hammer and tongs. But that's what the founders intended. They understood that it was going to be a contentious system. What the founders also believed was that in contentious politics, eventually you would work it out—you would compromise, find common ground, and move forward. Now we can't find common ground at all.

I have a lot of sympathy for people working in the Obama administration and the Bush administration that preceded it. It has become a lot more difficult to govern, and the culture of this town has changed in the time I've been here—and not for the better. But let's be clear: Even as we accept that we face a rocky road over the next few years, we remain a resilient, innovative, free people. I believe the long-term future of the country remains very hopeful.

I'm Scott Gould.

I'm the deputy secretary of the US Department of Veterans Affairs.

I joined the Navy as a midshipman at Cornell University and accepted a four-year scholarship. I studied philosophy. My dad had been a naval officer, and there was a lot of push toward the military community and military service. My mom was a schoolteacher, the female version of Mr. Chips. At age eighty-three, she is still teaching twice a week.

I said goodbye to Mom and Dad in the hangar of Barton Hall up at Cornell University, and I realized as a Marine gunny stared me in the face that life was going to be different. I grew up in that four-year period, advancing both in terms of responsibility as a student and getting out during

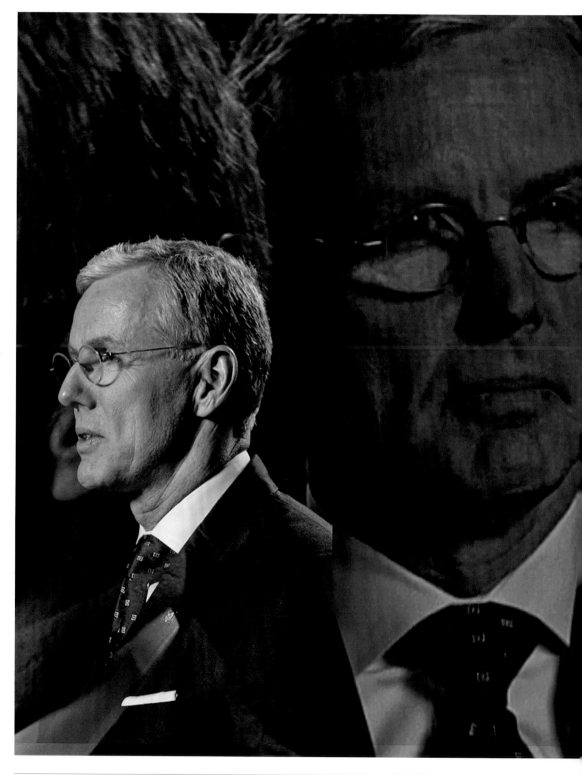

W. Scott Gould

Scott Gould is deputy secretary in the US Department of Veteran Affairs. He honed his leadership skills in the Navy, at IBM, and in the federal departments of treasury and commerce. He is focused on developing a service-based culture to improve access to health care, education, and jobs for returning soldiers of all generations.

the summers in the fleet, traveling the world. The day I graduated, unlike some of my classmates, I knew what I was going to do next—go to sea.

"The key leadership lessons I learned in the Navy are these: Take care of your people. Listen. Commit to building the culture and making your contribution. Organizations are full of moments that involve three acts: keeping the good, letting go of the things that are no longer relevant or that haven't proved enduring, and then embracing the new things."

My first experience was being lowered from a helicopter onto my ship, which came in and out of my field of vision as I twirled at the end of a steel cable. We touched down on the deck, and my life began as a leader and manager of thirty people in a gunnery division. I met my new chief. He was all of thirty-six, starting to gray. I thought it an amazing thing that someone could be that old. He said, "Mr. Gould, we've got a problem," and he took me down into the aftermagazine. It was filled with cases of Coca-Cola. He said, "Sir, we will not be able to get to more than sixty or seventy rounds of five-inch ammunition if we don't find a way to get the Coca-Cola out of here." I realized that there had been a moment when the Navy got the balance wrong between caring for these young sailors, who were halfway around the world in 110-degree weather, and our need to be able to fight.

So one of my first tests as a leader, at age twenty-one, was to work my way through the

chain of command. My department head told me, "No, the Coke is staying." I had to say, "No, by the standards I learned in gunnery school, that can't be so, and I'm prepared to go to the XO." As soon as I got to the executive officer, he was enormously supportive. It turned out the captain did not even know that the Coca-Cola was in the aftermagazine. A simple and early trial of leadership introduced me to the Navy and one of the great things about it, which is that large organizations, when they're run well, have a self-correcting capability. They ultimately get it right. And so did we, in our little corner of the world, floating around in the Persian Gulf. We were there during the Iranian hostage rescue attempt, an environment where we were thinking very seriously about the Iranians, their weapons systems, and the evident animus in the Persian Gulf to our presence. This was not hypothetical; it was real.

Individuals have homeostatic capabilities that bring them back to health, to centeredness. In the same way, large organizations, good ones, have strong cultures that bring people back to principles of service and commitment to values. In times of crisis and stress, those are the things that come forward, because in a crisis, you rarely have the knowledge of all the external factors, but you do know what you're bringing to it: your purpose, the reason you're there, commitments that you have to each other, the principles that you want to abide by. Values play a key role. They help organizations respond to change.

The key leadership lessons I learned in the Navy are these: Take care of your people. Listen. Commit to building the culture and making your contribution. Organizations are full of moments that involve three acts: keeping the good, letting go of the things that are no longer relevant or that haven't proved enduring, and then embracing the new things. You're constantly moving in a balance, trying to hold on to that strong center, departing from the things that don't make sense anymore, and embracing the change.

My next assignment put me in the second-largest Naval Reserve Officer Training Core unit in the country, at the University of Rochester. My primary duty was to care for 120 freshmen college students, midshipmen fourth class. I taught weapons systems, engineering, and leadership. I counseled them individually on their progress, both in the classroom and on the field. Because I was a member of the faculty, I could take any course in the university for free. I decided that business school was the next place that I wanted to go to learn more about leadership and the managerial and analytical skills that are required. I completed my business degree, then walked across campus and asked the dean of the school of education if I could pursue a doctorate in education along similar lines, studying administration, finance, management, and leadership in large organizations. That was the beginning of a kind of cross-sectoral pattern in my own career, moving from the military to business, nongovernmental organizations, and finally government.

Here at the VA, we invest money and time in our people. A lot of folks in organizations come up with ideas but think, "If I just tell my boss, then I'm done." I want to create an environment where you can tell your boss just about anything, and

when you do, you are accepting responsibility to do something about that idea. Peter Levin's work here is an example. He came up with the simple idea that patients might like to own and keep their data for their health records. He solved that problem from a technology standpoint and brought it to me one day. We started with a wild hypothesis that maybe 20,000 people would like to use this technology. Today, 800,000 do. Twenty million people in America have access to it. Fifty of the major healthcare firms, associated companies, and technology firms in America use a version of it. Like that experience, simple ideas can be encouraged, and the ownership is still with the individual. That's the ideal situation, because then you can have five or ten ideas going at once.

We are the largest direct healthcare provider in the United States, second only to the National Health Service in Britain. We have 316,000 employees in three principal lines of business. The first is health care. The second is benefits payments. We pay about $60 billion in benefits payments a year, insurance and loan guarantees, funding for educational loans and scholarship programs like the new GI bill. The third is the National Cemetery Administration, which manages 131,000 cemeteries across the United States.

I hope that the next family who wheels up to a veteran facility with a loved one who's hurt and needs help gets world-class service, second to none, that the treatment team are advocates, that they are respectful, that the environment is the best it can be. One of the heartbreaking aspects of this work is that you've got to go. So when my time comes, I hope that the next generation of leaders whom Secretary Shinseki and I and our leadership team have invested in, trained, and developed is ready to step forward.

I'm Lanny Griffith.

I'm the chief executive officer of the BGR Group, a lobbying firm here in Washington. We've been here in business a little over twenty years. I came here in 1989 after I'd finished with the Bush campaign for president, and I went to work in the White House in intergovernmental affairs. I was later assistant secretary of education.

Our family wasn't particularly political, but we had a family friend who ran for governor back in 1963. He actually ran as a Republican in Mississippi, which was unheard of then. I got interested in the campaign, and from there one thing led to another. When I was in college and law school, I was active in politics. I was the state chairman of the College Republicans, and Karl Rove ran for national chairman. Through him, I met Lee Atwater. We became a cadre of Roger Wicker, who's a US senator now. Lee ended up being the campaign manager in 1988 for George Herbert Walker Bush, and then Karl was a campaign strategist for George W. Bush. It all got started at the Lake of the Ozarks College Republican convention back in 1973.

My first paid job in politics was as executive director of the Mississippi Republican Party. Then Lee hired me after George H. W. Bush asked him to run his campaign. We decided that I'd be in charge of the South and that I would do Super Tuesday, which was a new creation at that point. After we

won, Lee asked me to work on the transition. So I came up here right after the election and stayed through January, when they asked me to work in the White House. I became involved in education, something I had an interest in but didn't know that much about. In our first year, 1989, we held the first National Education Summit, which I conceived and executed while I was at the White House. I met Lamar Alexander, Tommy Thompson, and others who were pioneers in driving improvements in education. I spent a good bit of time in the policy area, working and organizing governors in support of what we were doing, then served in the Department of Education.

I then went to BGR. Ed Rogers, who had worked in the Reagan White House as well as the Bush White House, had joined Haley Barbour, forming Barbour and Rogers. I came in 1993. We called it Griffith and Rogers, because Haley had left to go be the chairman of the Republican National Committee. In 1997, when he came back from the RNC, we started calling it Barbour Griffith and Rogers.

It was a rough time. We had just lost the Senate, and then we lost the White House for the first time after twelve years in 1992. We had eighteen Republican governors, and that was about it.

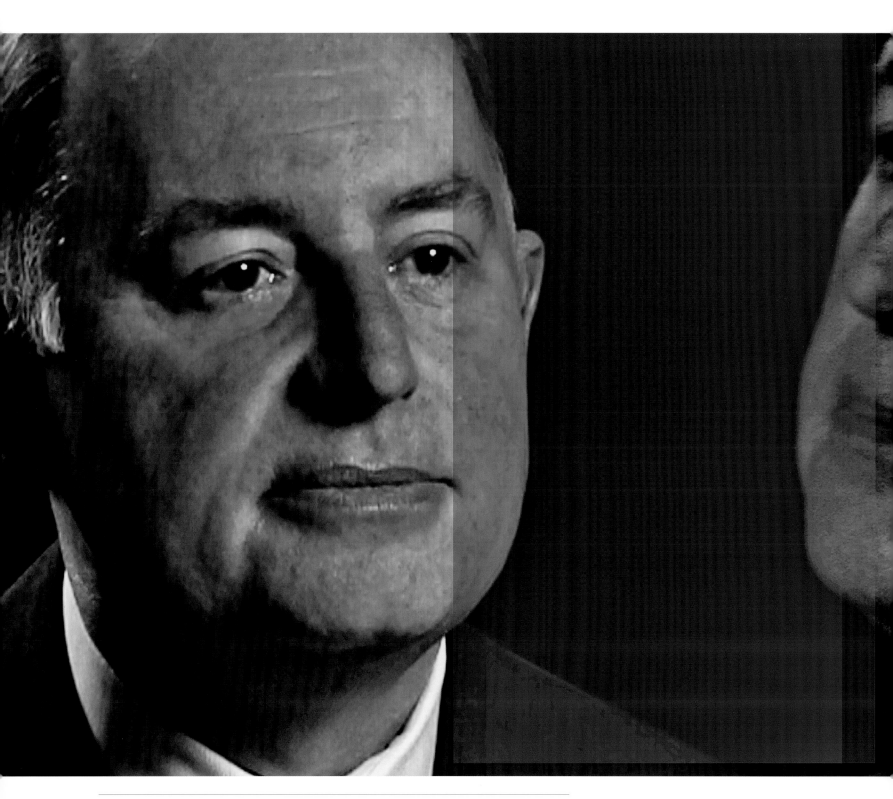

Lanny Griffith
Republican lobbyist Lanny Griffith is chief executive officer of the BGR Group. After campaigning on behalf of George H. W. Bush, he served in his administration as assistant secretary of education. He played an important role in the return of Republicans to political control in the mid-1990s.

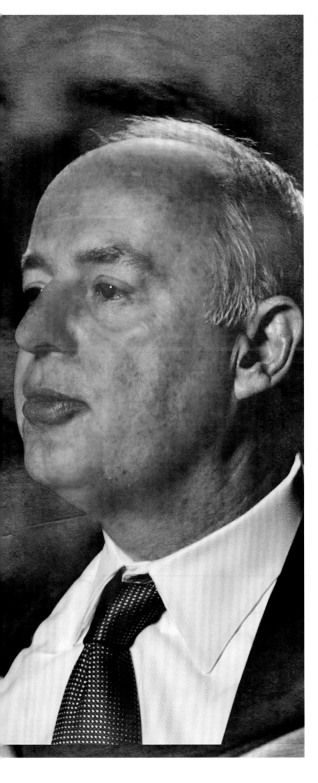

So we had very little influence and power. In 1994, though, with Haley Barbour as chairman of the RNC, we won the House for the first time in forty years and took back the Senate. And that kind of started a whole new paradigm in terms of Washington and how we operate. One thing that came with the victory was the idea of term limits, which the Republicans ran on. It broke up these fiefdoms where you had people who built a lifetime of work by lobbying a single member who was chairman of Ways and Means for twenty or thirty years. We were pioneers in driving the notion that lobbying is a serious business about serious clients who have serious opportunities or problems. We thought in terms of how to organize, then of knowing enough about the policy so that you can actually talk about it in meaningful ways and drive policy changes.

If our assignment is to stop something from happening, in Washington, that's a whole lot easier to do then getting something accomplished. There are very few laws that are introduced that actually ever get to the president for his signature. When we know a client doesn't like something that is in legislation or proposed, then our job is to either change it or get it out or defeated. In the House, the deck is stacked in favor of people trying to stop things, just because there are so many ways to do that. James Madison may not have been able to envision exactly where we are, but I'm often struck by how much we've ended up with a government that is exactly what he wanted. These were people who had won a hard fight for freedom over eight and a half years against the British Empire, and what they feared most was tyranny and a strong government. They deliberately made this process difficult for power to concentrate in any one place and made it difficult for things to get done. Oftentimes when we talk about gridlock and things not working in Washington, the truth is that Madison is sitting there looking at Alexander Hamilton and saying, "I guess we did a pretty good job, didn't we?"

Things change in Washington. We try not to base our work too much on any individual or any group of individuals, because it is a dynamic place. Some win; others lose. Republicans come and go, and the Democrats are going to have their day as well. You really need to be looking around the corner to see what will happen next.

People talk about our profession, and sometimes they're unkind. Our president seems to have a particular thing against lobbyists. But it's important that the American people have the right to come to the seat of their government and petition the government for redress of their grievances, and lobbying is born out of that.

The lobbying business is no different from any other. How we communicate and what you know, how people get their information, how you get things done, how you deliver your message—all that has changed in recent years. There's been an enormous revolution since the time when I was first at the White House. I did have a computer there, but it was just the desktop for a mainframe computer somewhere else. We didn't really have PCs at that time. We had email, but it was a pretty rough version of what we have now. But now the town runs on Blackberries and cell phones; now we have iPads and Twitter. That has been remarkable, and the toughest tasks for me in terms of trying to run a successful business that is always relevant lie in understanding and trying to keep up, trying to stay ahead so that we can have the impact we need and make the kinds of changes we need to—not so much in terms of our strategy as such, but in terms of how we carry out a strategy. The political change hasn't been all that difficult, but this technology revolution is a challenge for all of us, regardless of what business we're in.

I'm Ned Holland.

I'm the assistant secretary for administration at the Department of Health and Human Services. The secretary has a nice way of describing my job. She says, "Look, Ned, everyone else around here gets to think big thoughts. Your job is to keep the trains running on time."

I am a political appointee, of course, but my job on a day-to-day basis has virtually nothing to do with politics. My job is to help run a $900 billion organization. I have about 3,800 people who work for me, and we provide all kinds of services around the department. Whenever you have a place that big, you need information technology, HR, security, and real estate—all those sorts of administrative things—and that's what I do.

I was fourteen when I went away to seminary. It was a wonderful place to get an education, with a very traditional, disciplined classical curriculum. I stayed there until I was a sophomore in college, until I concluded that being a priest probably wasn't what I was going to do with my life. I left, and I thought about alternatives ranging from being an engineer, as my father was, to studying law. I chose to be a lawyer. I went on and finished a liberal arts education and then went off to law school. I can't claim a great plan. It was just what happened.

My maternal grandfather was an active public servant in Illinois. And my dad used to tell us how lucky we all were. We weren't wealthy by any stretch, but we were solidly middle-class. He used to say that you have to find a place where you can make a contribution.

I first worked as a labor lawyer. I'm a management labor lawyer, which is a little odd for a Democrat. I got interested in labor and employment law when I was in law school, and I looked for firms that worked in that area. I joined one in Kansas City. In those days, lawyers, unlike today, didn't leave law firms. You went and you stayed your whole life, until you retired or died. But in 1979, a young partner who was one of our stars decided to leave. The head of the firm wasn't happy about that. He didn't want this guy to take all his clients with him. He said to me, "Ned, aren't you on a hospital board?" When I said yes, he said, "Fine, you handle the hospital clients." I didn't have any idea what that was going to mean, but I did, and we kept most of our hospital clients. That's how I got into health care.

In time, I became the chairman of the Hospital Association. I was its general counsel. I was deeply involved as a healthcare provider. But then, in 1992, a friend of mine seduced me out of the practice of law to go work for him at a big company, one of three Fortune 500 companies for which I worked. All of a sudden, I was a large healthcare purchaser. When I was working in Overland Park, Kansas, for Sprint, I was buying $500 million worth of healthcare insurance a year.

So I've seen it from all sides: I was a provider, then a purchaser, and now a regulator. I've had a front-row seat—maybe closer than front row.

There are some measures by which we don't do very well, but I've seen all the angles. I've seen states that have to buy insurance. I've seen companies that have to buy healthcare coverage. I've seen doctors who have to figure out how to provide it. I've seen hospital boards that have to figure out how to operate a hospital. Every one of those enterprises has some piece of the multitrillion-dollar activity we call health care in this country. It's 17 percent of the gross domestic product. You can hardly avoid it. If you were born without midwife or hospital care, in the barn someplace, and then managed to die in an accident and be dead on arrival, then maybe you wouldn't engage the healthcare system, but, absent that, you're going to be there sooner or later. Everybody needs it. If you're in the individual market and you have to get health care, you need an insurance company, because they're the ones that can accept, take, and spread the risk.

Given the fact that the Supreme Court will soon rule on the president's healthcare reform law, the healthcare industry is apprehensive. There are people who want the Supreme Court to strike down the law. There are people who want the Court to sustain it. There are people who want to do part of it and not other parts of it. We've got all sorts of constituencies: insurance companies, hospitals, doctors, and patients. All of them are trying to figure out what to do. If I have a twenty-four-year-old who has some chronic disease, and the law is struck down and I no longer can make sure my kid stays on my plan until he or she is twenty-six, I'll be worried about that. Hospitals are worried about how we're going to pay their bills, and doctors are worried about how they're going to get paid. Apprehension is the right state for the system today.

Beyond that, no matter what happens, I think most people of good faith would tell you that we cannot sustain the current system without significant adjustments. We spend a greater percentage of our gross domestic product and more per person on health care than any other country in the history of the world. And yet, on a public health basis, our results are in the thirtieth percentile compared with other countries. We have fifty million people without ready access to health care. That's not acceptable. We've got to fix that, whether it's through the Affordable Care Act that's now pending before the Supreme Court or some other vehicle. Even with all the great technology we have, we're ill organized, and we pay too much. Without change, the cost curve is going to keep going up and up, and calculating that makes calculus look like child's play. There are 160 million

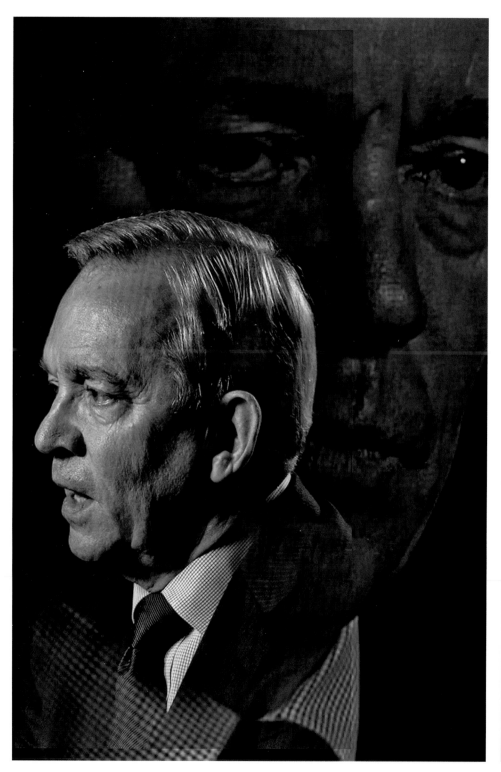

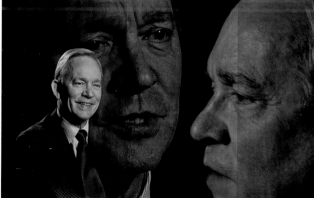
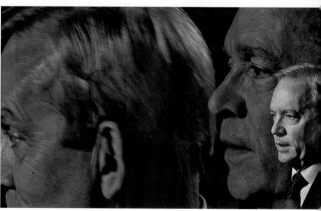

E. J. Holland Jr.

Ned Holland is assistant secretary for administration in the US Department of Health and Human Services. A labor lawyer by training and with a background in both hospitals and business leadership, he is dedicated to creating an effective healthcare delivery system in the United States.

people in this country who have perfectly fine health care provided through their employers. We need them to see what's going on in the rest of the system, notwithstanding the fact that they're well cared for. They might have a family doctor who does an excellent job of keeping them healthy, but we need them to understand that there's another part of the system that, in the end, is going to swallow them up if we're not careful.

I'm Lisa P. Jackson.

I'm the administrator of the US Environmental Protection Agency.

I was born in Philadelphia. I was adopted at about a month old by my parents, who came up to Philadelphia looking for a little boy in a Catholic orphanage and then came home with a boy and a girl. They took me to New Orleans. My dad was a postman. One of his routes was in the French Quarter, and I remember, as a little girl, walking through the French Quarter with him. A letter carrier serves the public in a personal, one-on-one way, and I once told him that I wanted to be one, too. He said, "No, you don't." He wanted better for his kids. My office now is in the headquarters of the Postmaster General. Every morning, to get to my office, I have to cross the great seal of the US Postal Service, and every day I think about my dad.

Both my parents were African Americans growing up in the segregated South. As a little girl, I remember not understanding why it was important not to stop much on the road between New Orleans and Orlando on vacations. My mother and father had lived through a time when you didn't stop while driving through Mississippi or Alabama or the panhandle of Florida, even to use the bathroom.

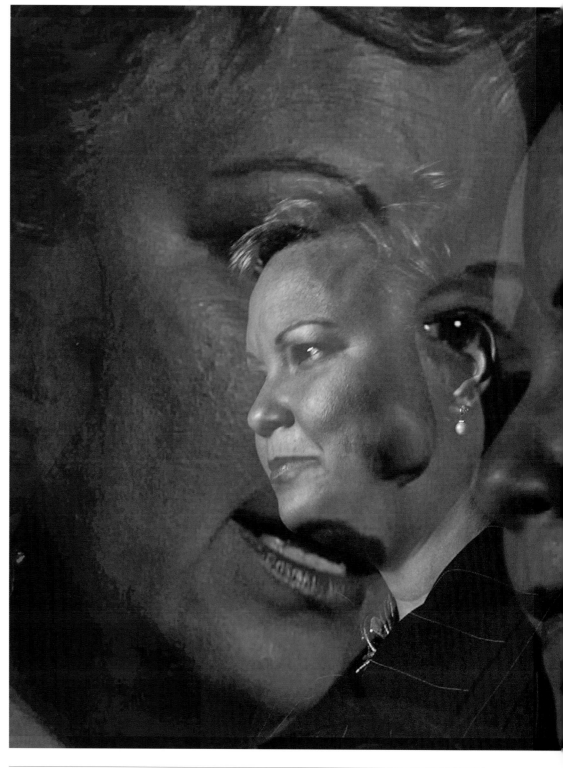

Administrator Lisa P. Jackson
Administrator of the US Environmental Protection Agency, Lisa Jackson is a chemical engineer focused on protecting Americans' health, safeguarding the environment, and ushering in a green economy. As the first African American to serve as EPA administrator, she has made it a priority to ensure environmental justice for all Americans.

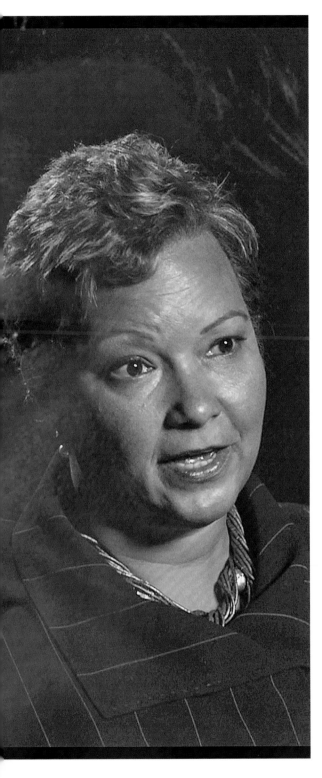

I was very good in school, a straight-A student. I was a geek. I had a female pediatrician, which I think was probably rare then, but it never occurred to me that doctors weren't women, that scientists weren't women. I went to an all-girls Catholic high school, so I didn't face the pressure of being a girl interested in science because everyone around me who was in my science class was female. I attended a summer engineering seminar at Tulane, where all the attendees got a free programmable calculator that we could never have afforded otherwise, and I went to college to study engineering. I considered medical school after finishing my degree, but then I became aware of Love Canal and other hazardous-waste sites that were in the news at the time. I remember thinking that if an engineer makes all this industrial waste that pollutes our water and our air, it's going take an engineer to figure out how to clean it up. From that day on, I was in the environmental field.

When I was in college and high school, we were just starting to see stories about what was in the Mississippi River, which is the drinking-water source for everyone in New Orleans. By the time the water got to New Orleans, it had drained farmlands and industrial facilities, and was badly contaminated. There was a notion that the river was a kind of cancer alley. A lot of people came to the environmental movement because they were privileged enough to afford to go to the most exquisite natural wonder parts of this country. I didn't have that experience. I grew up in a city, and so my first calling toward the environment was on the health side. What happens to children who inhale pollution? What happens to mothers if they eat fish that's contaminated with mercury? The protection of those exquisite places and the protection of a city street are intertwined.

EPA was formed in 1970, when I was eight years old. The Cuyahoga River was burning. Lake Erie was declared dead. We now talk about China's environmental problems, but you couldn't see the sun in Pittsburgh at noon back then. It's interesting now to think about what motivates our call to environmental issues, because thanks to EPA the

air is less smoggy, our rivers are not on fire, and it's very rare, if ever, that you see a pipe with green gunk coming out. Even so, we haven't turned the corner on some of the issues of our time. Part of the concern about climate change, for instance, is that it's not something you can see that inspires the same level of urgency as a river on fire, but it is as important and as urgent as any challenge we face.

"I hope that we have been building the next generation of environmentalists, one that is more diverse, and that the next generation sees in us a public service agency that listens more than it speaks, an agency that always protects their health and the environment in which they live."

When I finished graduate school, I worked at a small nonprofit. If you really wanted to make a career in the environmental field, you really had to spend some time at EPA, though. It was the gold standard. It still is in terms of research and the people we hire. It's very scientific. The environment has a reputation of being about granola and Birkenstocks, but environmental protection is about as technical a field as there is. Think about what we're doing: dealing with climate change, making cars more fuel-efficient but still safe. It's material science, it's physics, it's math, it's chemistry, it's everything I liked as a student.

As a woman, too, I wanted to have a work/life balance, and public service never required me to make that choice. In fact, I got my first big promotion not long after my second son was born. The glass ceiling wasn't apparent within

the work I was doing at the agency. EPA has a history of women leaders, and our staff is almost 50 percent women.

I worked for a while in New Jersey, a state with a strong environmental ethic, and served as the cabinet member for the environment when John Corzine was elected. I was about to become his chief of staff when the president-elect called and asked me to help with his transition, and that turned into this challenge. It was unexpected, and I didn't know the ways of Washington—I had worked in Washington for years, but I didn't know the political side. We looked at good models. We looked at Bill Ruckelshaus, the first EPA administrator, a Republican, who issued the famous "Fishbowl Memo," which said, "We have to do our work as if we're in a fishbowl." The scientific integrity and legal processes can't be shaded, must be transparent, and must be done with incredible integrity, because the integrity of the agency is its hallmark. We did our own version of the Fishbowl Memo, which went out right after I was sworn in and confirmed the message that we're back on the job for the American people. In the memo, we talked about, first, the importance of addressing climate change. Then we looked at clean air issues in general. When I took over there had been a series of court decisions that had gone against the prior administration. We had all kinds of court cases that had been litigated, so we had a huge backlog of work. We talked about communities, about contamination that can hold back a whole community's growth. We talked about toxic chemicals. I am proud that, early on, the president embraced the idea of calling for a new Toxic Chemicals Law. We haven't seen it happen in this Congress, but it's not for lack of trying, and it's not for lack of need.

Under my tenure, we have used the Clean Air Act to start to bring down carbon pollution, and we did it in a way that was open and inclusive. I hope that we have been building the next generation of environmentalists, one that is more diverse, and that the next generation sees in us a public service agency that listens more than it speaks,

an agency that always protects their health and the environment in which they live.

I'm Vernon E. Jordan Jr.

I live here in Washington, D.C. I work four days a week in New York as an investment banker, and one day a week here in Washington as senior counsel in my law firm.

My mother was the CEO of our household. She was the president of every PTA at any school that I ever attended, starting in the first grade. When my youngest brother and I went to separate schools, she was president of both PTAs. That gave me some notion about responsibility and leadership.

We lived in the first public housing project for black people in this country, University Homes, dedicated in 1937 by President Franklin Delano Roosevelt. It was right across the street from the Atlanta University Center complex. I grew up looking at Spelman College, Clark College, and Morehouse College. I was awed by the buildings, by the students, by the professors as they went to and fro on the campus. I can remember seeing James P. Brawley, the president of Clark College, and the president of Morehouse, Benjamin Elijah Mays, a legendary figure in black higher education and in education generally in this country.

Very early in my career, Mays called my office and said he had a problem. Getting a call from Benjamin Elijah Mays was like getting a call from God. He said, "I have a problem. I'm expected to be in Buffalo to speak to the NAACP Freedom Fund Dinner, and I can't do it. I want you to go in my stead." I said, "Dr. Mays, number one, you never heard me speak. Number two, I didn't go

to Morehouse. Number three, you don't know much about me." He said, "Well, I know more about you than you think I do, and I have heard you speak." And then he told me something I've never forgotten. He said, "Son, whenever you get up to speak, always do your best, because you never know who's listening."

It was a given in my youth that I was going to college. My heart was set on Dartmouth. I got a call from the president of the Atlanta Dartmouth Alumni Association inviting me down to his office at one of the big banks in Atlanta, and I got dressed up and went to see him. He said that ten boys from Atlanta had applied to Dartmouth in 1952. Then he said, "You are the only colored. You have the best record. We will support your candidacy for admission because we want you to get a good education, come back to Atlanta, and be a Booker T. Washington for your people." I said, "I can't do that. I'm a W. E. B. Du Bois man." I'm not sure he understood what that meant, but he didn't like it. I think I got into a Dartmouth, but I went to DePauw. I was the only black in my class.

One summer my mother got me a job as a chauffeur for Robert F. Maddox. He was the ultimate representative of southern gentility, a banker who sat on the platform when Booker T. Washington gave his Atlanta Exposition address, in which he said we can be as separate as fingers on the hand. In the afternoon, I would read in his library while he napped. One afternoon he couldn't sleep, and he walked into the library room with a bottle of Southern Comfort. He came and stood over me and said, "What are you doing in my library?" And I said him, "I am reading, Mr. Maddox." And Mr. Maddox said, "I have never had a nigger work for me who could read." I said, "But I can because I'm colleged." "Where do you go to school?" I said, "DePauw University in Greencastle, Indiana." "White children go to that school?" "Yes sir." "White girls go to that school?" "Yes sir." And then he asked a question that defined the dark side of the Southern Everest: "Well, are you going to be a teacher or a preacher?" In his mind, if you were a learned and educated black you only had

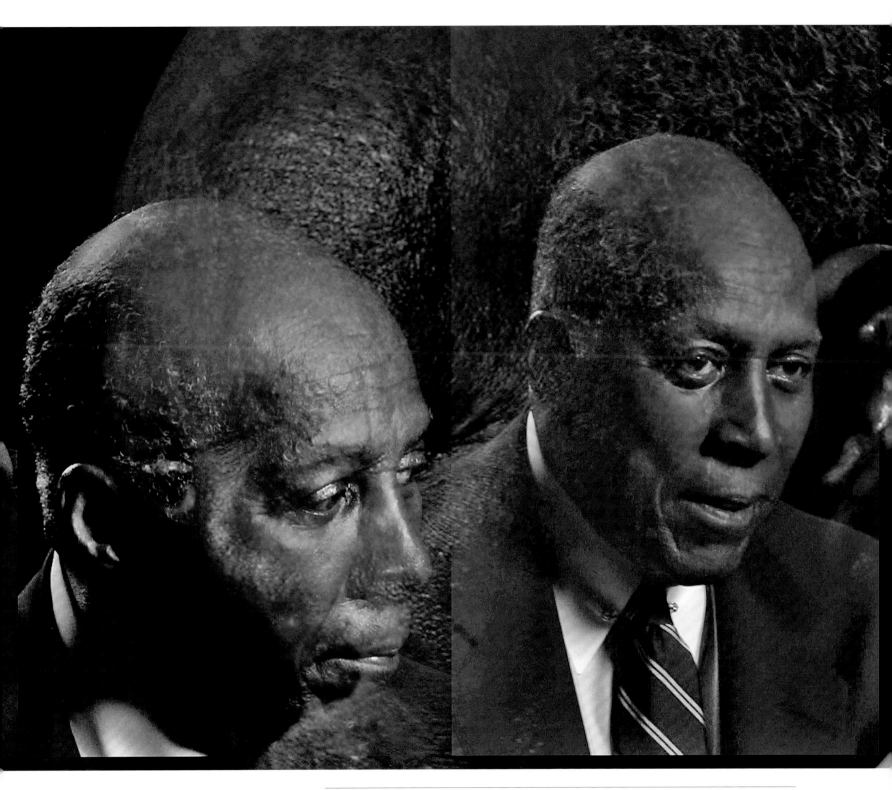

Vernon E. Jordan Jr.

A civil rights leader and lawyer, Vernon Jordan has distinguished himself as a political advisor. As president of the National Urban League (1971–81), he survived an assassination attempt in 1980. His publications include his memoirs, *Vernon Can Read!* and collected speeches, *Make It Plain: Standing Up and Speaking Out*.

two options: to teach or preach. I said, "No, Mr. Maddox, I'm going to be a lawyer." "Niggers aren't supposed to be lawyers," he said. I said, "I'm going to be a lawyer."

He thought for a minute, and he just said, "Well, read, then, just read." That night I was serving dinner to him and his family, and Mr. Maddox said, "I have an announcement to make. Vernon can read. He goes to school with white girls." And then he sat back for a minute and said thoughtfully, "I know it's coming, I know it's coming, but I'm so glad that I won't be here when it does come."

I went to law school and became a lawyer. In 1964, Wiley A. Branton, the lawyer for the Little Rock Nine, was recruited by Leslie W. Dunbar to lead the Voter Education Project to do research on low voter registration and political participation by blacks in the South and to conduct programs of voter registration and citizenship education in local communities. I was Branton's assistant. In 1965 he went to New York to head up a new program for the civil rights movement, and I was asked to succeed him with the Voter Education Project. We increased voter registration rolls by two million-plus people in the South.

I moved to New York in 1970 to head the United Negro College Fund. Then I went on to the Urban League. But I wanted to test my skills in the other world. I wanted to pierce the corporate whale, and I did. So I went to work in finance while staying involved in politics.

I was on President Clinton's transition team, but I didn't stay in the administration. I liked what I was doing in the private sector. I supported very enthusiastically Barack Obama's bid for the US Senate. Then, some years later, he came for supper, and it was clear what he had on his mind—and it wasn't the next senatorial race. I said to him, "So running for the presidency, it's on your mind. I think that for everything there is a season, and I don't think this is your season." I was obviously wrong about that, but that's just what I felt. I also said to him, "If in fact you decide to run for

the presidency, I would not be with you; I would be with my friend Hillary, because I'm too old to trade friendship for race. The Clintons have been longtime friends of mine, and I'm going to be with them. But if you beat her in the primaries, I'll help you in the January election."

He beat her, and I put my efforts toward helping elect Barack Obama president. Election night was an incredibly emotional moment. When the networks announced that Barack Hussein Obama was the president-elect of the United States, tears ran down my cheeks like water running down the rivers of Babylon, and it dawned on me as I cried that my tears were not just my tears: They were the tears of my parents and my grandparents, the tears of all those black people who lifted that cotton and toted that bale, and I thought about what my mother said every day: "This is the day the Lord has made; let us rejoice and be glad in it."

I'm Michael Kaiser.

I'm the president of the John F. Kennedy Center for the Performing Arts.

My grandfather was a violinist in the New York Philharmonic Orchestra. He tried to teach me the violin. I was dreadful, but I got to go to concerts. And then I started singing, and my passion for singing drove me into the arts. Unfortunately, I was a terrible singer, too. After going to college and a career in business, I was invited to join the board of the Washington National Opera. I loved being a board member, but I kept trying to make decisions that were really up to the staff. I realized one day that I wanted to be on the staff, not on the board. So I sold my business to my business partner and looked for a job in the arts.

"We are no longer a manufacturing economy. We are a creative economy. Business leaders will tell you that they need a workforce that can think, problem solve, be creative. What better way than the arts to start exercising those muscles in children?"

My first job in the arts was running a ballet company in Kansas City. I knew nothing—but I was the fifth CEO of this organization in five years, and my predecessors hadn't had any training to do their work either. It was pretty clear, coming from a business community where everyone had an MBA and all this training, how little was done in training arts leaders, how little was codified. That's why I do so much writing. Fifty years ago there wasn't a field called arts management; people fell into running an arts organization, but they didn't start out with that as a goal.

My career has been mostly about helping financially troubled arts organizations. I have learned to take an organization that's sick and make it healthy—and there is a very fine line in the arts between sickness and health. When arts organizations get scared about money, one of the first things they tend to do is to cut back on either the quality or the quantity of their art, the assumption being that if we save money we will be okay. The problem is, when you do less, donors, volunteers, and ticket buyers tend to look elsewhere, particularly in a time of recession when they have less money to spend. They gravitate toward the organizations that are more interesting and more daring. The worst thing you can do as an arts organization facing financial challenge is to do less interesting, less special, less surprising art.

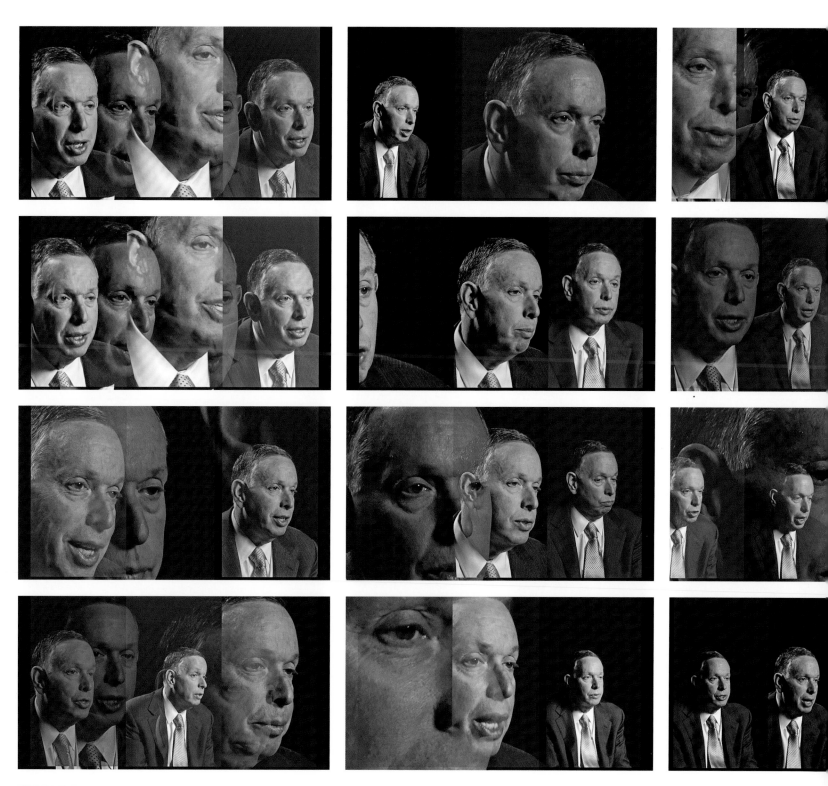

Michael M. Kaiser

President of the John F. Kennedy Center for the Performing Arts, Michael Kaiser has built a career rehabilitating troubled performing arts organizations. He shares his lessons through such programs as Arts in Crisis and publications that include *The Art of the Turn Around: Creating and Maintaining Healthy Arts Organizations*.

I think we have made a mistake in arts education in our country. Traditionally, we encourage those children who can do the arts well. And so if you audition for the course in school and you sing well, they take you. If they don't, they say, well, why don't you try playing the flute, and if you don't like the flute, why don't you try drawing, and if you don't draw then play sports. I have had a wonderful career in the dance world not being able to dance a step. When I was at American Ballet Theater I created a program where I took the entire ninth grade of the Frederick Douglass Academy in Harlem and allowed the children to select one of four areas. One group made a dance and danced in it. One group learned how to design and build the sets and costumes. One group learned how to be the crew and the lighting designers. I taught the fourth group how to do the budgeting, marketing, and fundraising. The entire ninth grade created a ballet—and now every child will tell you that he or she loves ballet. Not all of them can dance, but they all found their own entry point into the arts.

I believe that as a national cultural center we have an obligation to educate people about other people. The arts are a wonderful tool to educate them about other people because you start to see what they care about, what they value, what their fears are. In the last few years we have done major festivals of China, India, and the Arab world. We brought in a multidenominational children's choir from Syria, and no one could watch these children sing without affecting the way he or she thinks about Syria and the Syrian people. Now that so much is going on in Syria, I think those of us who were lucky enough to see those performances will view what's going on politically now in a different context, because we know so much more about the people than we did before. We only read about politics—we don't read about people.

We are no longer a manufacturing economy. We are a creative economy. Business leaders will tell you that they need a workforce that can think, problem solve, be creative. What better way than the arts to start exercising those muscles

in children? The children who were involved in our arts education program scored between 5 percent and 19 percent better on their math and reading test scores. Children who participate in the arts think more clearly and do better in other subjects. Those who say we have to worry about our children's basic skills and think the arts are a luxury or an extra do not understand what really creates a child who learns well. But in this economy, school systems are cutting arts education even more than before. It's a very scary time.

Corporations, too, are under increasing pressure to show that they can return profits, and so they have become increasingly cost-conscious. All of this has forced corporations to care much more about arts sponsorship as a part of a marketing profile and marketing strategy. We compete in this way with sports events. For many smaller organizations, corporate sponsorship just isn't a reality anymore, because corporations are looking for wide exposure, so they tend to associate with the biggest arts organizations. We have seen a dramatic shift away from corporate support, particularly for small and midsized arts organizations. You have to now be part of their marketing plan, understand their strategy, and show how you can support that strategy. It used to be that we would write a proposal saying, "We're a wonderful arts organization, you've heard of us, give us some money." Now we have to say, "We know you are trying to reach this particular segment of the market, we reach that segment, let me give you a creative idea for how we can address that segment on your behalf." It's a whole new approach to fundraising.

Many people who are interested in the arts stop their arts participation when they hit puberty. Between the ages of fifteen and forty-five, roughly, a lot of people are not active arts participants, because they don't have a lot of discretionary time or money. When they get older, if they enjoyed them as a child, they tend to come back to arts participation. But we now have generations of young people who aren't getting arts in the schools, and so we are concerned that

twenty years from now we won't have those fifty-year-olds coming into the arts because they never enjoyed them as children. That's why I spend so much time worrying about arts education for children—because I fear what's going to happen long after I am running an arts organization.

I'm David Keene.

I'm the president of the National Rifle Association.

I'm involved in a lot of other organizations as well. I'm on the board of the American Conservative Union, which I chaired for some twenty-seven years; serve as well on the board of the Center for the National Interest, which used to be the Nixon Center here in Washington; and am very active in the Constitution Project and an organization called Right on Crime, a criminal-reform group.

If you look back at the history of the modern American conservative movement, I guess in some ways I'm typical. I come from a Democratic family. My father was the president of the Labor Council in Rockford, Illinois, for ten years, and he spent most of his life as a labor union organizer. My mother was president of the Women's Auxiliary of the United Autoworkers nationally. My first political activity was passing out literature in the snows of Wisconsin for John Kennedy in the primary of 1960.

By 1964 I was campaigning for Barry Goldwater. What happened was that I was coming of age in reading; I was very issue-oriented. My conversion came about as a result of Friedrich von Hayek, but not as a result of *The Road to Serfdom*, his best-known book. Instead, when I was in high school the library ordered a copy of another one of his books called *The Constitution of Liberty*. It was the most influential early book that I'd read. What resonated with me were von Hayek's ideas on the

David A. Keene
President of the National Rifle Association, David Keene is a leading member of the conservative movement in the United States. Dedicated to limiting federal authority, he served as chairman of the American Conservative Union and has been active in the Conservative Political Action Conference.

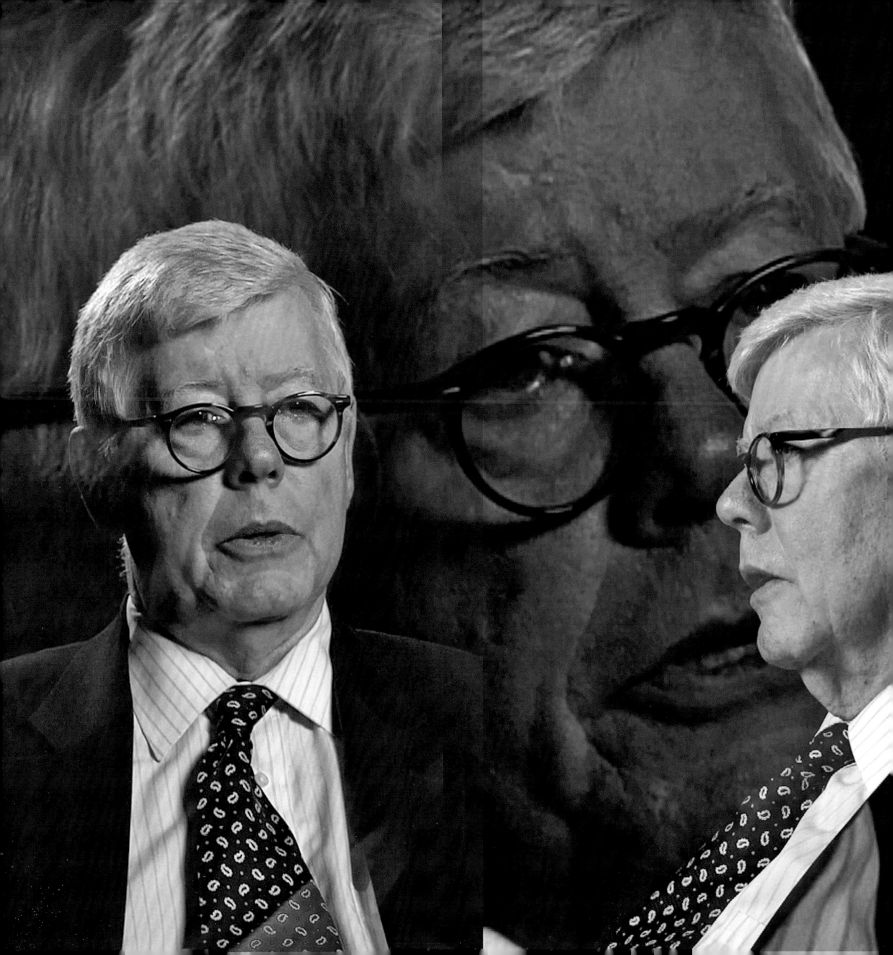

limits on what government can do, the danger to individual liberty as a result of government growth and government action. *Road to Serfdom* famously converted Ronald Reagan and Margaret Thatcher to conservatism. *The Constitution of Liberty* was a more detailed book dealing more with theory than did *Road to Serfdom*, and after reading it I began to look at things differently.

In those days, if you retired as a labor union organizer you opened a tavern, which is what my father did, and we moved to a small town in Wisconsin. I began to see some of the things that were going on. A famous Supreme Court case began there, in which the Wisconsin state government had decided that Amish children were in violation of the Compulsory Education Act. The state government sent police in to chase these kids down and handcuff them in the cornfields, all of which was on the television at the time. I went to the original trial. The Amish eventually went to the Supreme Court and won. But the government in those days was beginning to feel its oats, if you will. You saw a government in this country that was beginning to think that it had the right and the obligation and the duty to run every aspect of people's lives. What I saw then was a government that was morphing into the one we have today.

If I were to describe my emerging philosophy in philosophical or historic terms, it would be quasi-libertarian and Jeffersonian. If somebody thinks something ought to be done by the national government, I suggest that it should be done by the states, and if they suggest it ought to be done by the states, I ask what's wrong with the cities and the counties. If you say that it ought to be imposed there, I ask what's wrong with voluntary associations. I think those are questions that Jefferson would have asked.

The interesting thing about the conservative movement, both when I started and now, is its consistent factionalism. Successful political movements are coalitions of people who agree on a lot of things and disagree on other things. Conservatives have been famously fractious.

The early movement was basically anticommunist. Frank Meier, my early mentor, was perhaps the highest-ranking communist ever to defect to the United States. We had Whitaker Chambers and other former communists who said that the final battle was going to be between communists and former communists. Then you had the free-market people, the von Hayek school, the libertarian school, the limited government people. And then you had traditional conservatives, values conservatives, social conservatives. From the very beginning, those three groups were fighting with each other. The signal contribution of Frank Meier was the development of something called "fusionism," in which he argued that these various groups had much more in common than they had to fight about, and that they ought to form a cohesive coalition that could have political impact. That was what the modern movement became.

I have been very involved with the development of something called the Conservative Political Action Conference, which has been going on for thirty-odd years now in Washington. We draw eleven thousand to twelve thousand people a year. When they began in the early 1970s, we drew a hundred people. Over the years we have asked some of the same questions in a straw poll. The press

always pays attention to which politicians we like, but we conduct the poll to find out which parts of this coalition are growing or dominant. We've discovered over the years that the coalition is very stable. Most conservatives are primarily limited government, free-economy people. Then there are smaller groups of national-defense conservatives and social conservatives. They work together, but the thread that runs through everything is hostility to big government and belief in individual freedom and free markets. Successful coalitions have to reach out and bring in as many people as possible who have common values, rather than seek people who agree on everything.

I am now president of a group that's part of the broad conservative coalition in America but focuses on one area, the Second Amendment. We judge everything on the basis of that. At the same time, we recognize that we're part of something much bigger. The NRA is probably the largest, longest-lived, and most effective single-issue advocacy organization in the history of the United States. It was formed after the Civil War. Two of our first presidents were Ulysses S. Grant and Phil Sheridan. That's something that we don't really advertise in our recruitment in, say, South Carolina.

Before 1968 the National Rifle Association had never endorsed a candidate for any office, had never spent a nickel on lobbying, had never contributed to any campaign. The NRA was a service organization that taught gun safety, ran competitions, and put together the Olympic shooting teams. Life members of the NRA included everybody from Teddy Roosevelt to Hubert Humphrey. It wasn't until Lyndon Johnson forced through the Gun Control Act of 1968 that things began to change. But even today the NRA spends most of its effort, resources, and time on nonpolitical activities. About 12 percent of our budget goes into advocacy and politics and the like. The rest of it goes to all of the traditional functions that we serve. We provide millions of dollars in grants to college and high school shooting teams. We have something like 75,000 licensed safety and firearms instructors around the country.

If you were there in 1968, and if you had asked if in 2012 the American people would have Second Amendment rights and be able to exercise them, the people of Johnson's time wouldn't have believed it possible. The NRA has enjoyed tremendous success. But all of those strides in Second Amendment freedoms can be reversed quickly in a second term by this administration.

I'm Gil Kerlikowske.

I'm the director of the Office of National Drug Control Policy for the White House.

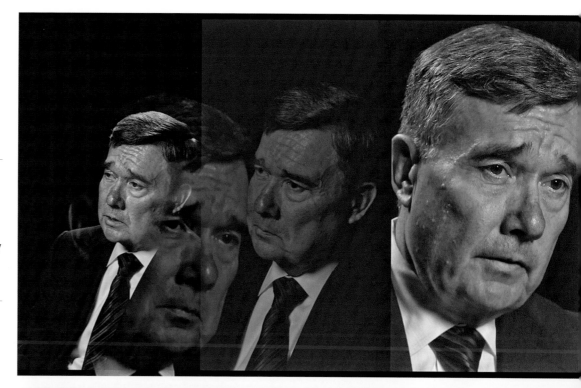

I was a product of the Kennedy years, with the commitment to service of the time. My mom was secretary to a judge in Florida, and after school, I would go down to the courthouse, meet police officers, and hear their stories. My mother knew the sheriff, who gave me a job, and so as a high school student, I ended up fingerprinting prisoners on Saturday and Sunday mornings, processing crime scenes, attending autopsies, things that OSHA would never allow today. It has been my career for many decades now.

When Ronald Reagan was the president and Ed Meese was the attorney general, I held a visiting fellowship at the Department of Justice. For the entire year, I traveled the country and got a chance to meet many people who were involved in different levels of new thinking about policing and criminal justice. I went back to Florida after my year and told my police chief about all my new ideas, and he said, "Well, if you're so smart, go out and try them." I went on to become a police chief myself, and I have had a chance to try them.

Police chiefs, sheriffs, and prosecutors around the country have recognized that we need to deal with the drug problem in a much more holistic way. It's a

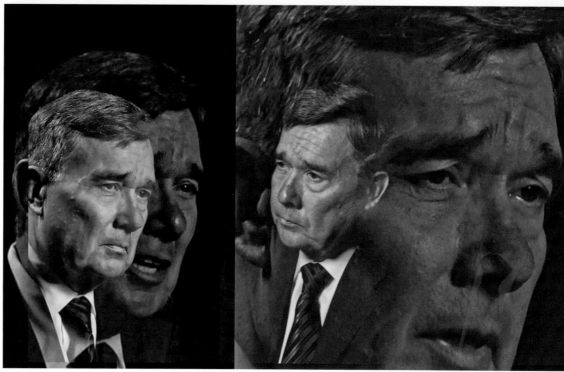

R. Gil Kerlikowske

Gil Kerlikowske is director of the Office of National Drug Control Policy for the White House. He has focused on a holistic approach to combating drug use, such as advocating treatment and prevention programs and innovative criminal justice reforms that break the cycle of drug use, crime, and incarceration.

public health problem; it's an educational problem; it's also a criminal justice problem. Unfortunately, for a long time, many elected officials made this a third rail, because if you came out with such ideas, they would think of you as either soft on crime or soft on drugs. Over the last few years, though, two things have occurred. One, my colleagues are much more forceful in saying, "It's not just about the Police Department." Two, we've been going through a terrible economy. Elected officials want to find ways that are not as expensive—and incarceration is unbelievably expensive—to deal with low-level drug offenders while keeping communities safe. This confluence has been helpful in moving drug policy to a different level.

"We have to recognize that giving people education, economic opportunity, better health care, and so forth can all work to improve the quality of life and make sure that in that prevention mode young people are getting the right message about what the future is."

Now, for a police chief to profess treatment and prevention as the primary emphases of drug policy is a little bit like Nixon going to China. We are unexpected messengers, and we're able to deliver that message without much fear of being categorized as soft on drugs or soft on crime.

When it came to the technical aspects of prevention, to understanding medicine and public health research around drug policy, the amount of information and the number of briefings I had to attend and absorb overwhelmed me. But then

I realized that a lot of other groups were trying to find a smart way to deal with our drug problem. What they haven't done very well is to talk to each other. We have the law enforcement community, busy with one part of the drug problem; we have the prevention community, working very hard to keep young people away from drugs; and we have the treatment community trying to figure out how to get addicted people back into society. When things are tough, we fight over resources; we tend to circle the wagons and shoot inward.

The President's National Drug Control Strategy, which we produce, has really worked well for us. It has the authority to tell every federal agency how to deal with the drug problem. But more important, because it's based on research and science—and the president specifically directed that I get as much input from people across the country as possible—the drug control policy also has the power to influence states, counties, and cities as they develop their own drug policies. We thought it was an innovative approach to ask people around the country for their opinion and not just let a lot of really smart people inside the Beltway develop a strategy and then send it out.

We've made great strides in reducing tobacco use, particularly among youth in this country. We've made great strides in reducing alcohol-impaired driving. Clearly we haven't done as well in the drug area. It's not just about illicit drugs such as marijuana, cocaine, and heroin; it's also about prescription drugs. As the police chief of Seattle, I was concerned about what hurt people in the city: car crashes, robberies, gunshots, muggings, and so on. I was surprised to learn that more people die from overdoses of prescription drugs than die from gunshot wounds in this country.

We have to recognize that giving people education, economic opportunity, better health care, and so forth can all work to improve the quality of life and make sure that in that prevention mode young people are getting the right message about what the future is. Particularly with young drug offenders, we need to get them out of the

system as quickly as possible so they don't have the stigma of an arrest record. People should not be punished forever as a result of low-level drug offenses. We need to be smart about this—not soft, but smart. We can't arrest our way out of this situation. In the long run, figuring out smarter, more holistic ways of dealing with the drug problem will help everybody.

One innovation that interests me is the drug court. Drug courts started a little over twenty years ago. A forward-thinking judge, along with a state attorney in Miami by the name of Janet Reno, said, "Why don't we take the judges off the bench, maybe without the robes and quite that level of stature, and let's hook them up with drug treatment professionals, with probation and parole officers, with the police department." When that offender comes forward, instead of the judge sitting on high and saying, "Fifty days" or "One year," he or she will say, "For the next two years, we are all going to be engaged with you as a drug offender. We're going to test you and hold you accountable. It's not going to be easy, but we're going to do everything we can to help you if you wish to change your lifestyle." I'm on the road every week, and often I'll turn on the television and hear about people protesting government, saying, "Government is too big. Government doesn't listen. Government wastes my money." I'd love to tell those people, "If you want to see government that actually listens, is effective, and makes a difference for not a lot of money, go to a drug court graduation."

We don't have a single, simple answer. In my first interview on this job with the *Wall Street Journal*, I said, "We need to stop calling this a war on drugs." The reporter said, "Well, then, what bumper sticker are you going to use?" I answered, "I don't have a bumper sticker answer to what really is a very difficult and complex problem, but my bet is that the American public is ready for a level of complex discussion about it." If I'm wrong, I'll be out of a job. But so far, I'm still working.

I'm Ray LaHood.

I'm the secretary of the US Department of Transportation.

I grew up in Peoria, Illinois. My father worked very hard as a restaurateur. I went to Catholic grade school and Catholic high school. Caterpillar is the dominant company in Peoria. I think about 80 percent of my high school graduating class went to work at an apprenticeship program at Caterpillar, but I went on to community college for two years and then to Bradley University in Peoria. I studied to be a teacher and taught school for six years.

Teaching junior high school students about the Constitution sparked my interest in politics. I left teaching and worked for two congressmen. After seventeen years as a congressional staffer, I ran for Congress myself. I had the good fortune of being elected from a twenty-county district in central Illinois and served in the House for fourteen years. When I was elected in 1994, I knew every member of the House on both sides of the aisle, because I'd been in meetings with them and got to know them during my time as a staffer. I came to the job of congressman pretty much knowing what needed to be done, whether it was back in the district or in Washington.

I really wanted to make sure that the district that I represented was well taken care of, that people's problems were dealt with, that big issues in the district—particularly concerning transportation and aviation—could really be solved. I became what I called the mayor of my district, making sure that potholes were filled, making sure that we had good airports, making sure that people were getting good government services while casting my votes representing 600,000 people from central and west-central Illinois. The job is two-pronged: being there as the vote or the voice of the people, but also as the leader in the community to get people together to solve community problems. It takes a lot of time to be a good representative in Congress. A lot of the time is spent here in Washington debating issues, voting on legislation, and dealing with the federal bureaucracy, and then back home, making sure that you're attentive to local needs and paying attention to the politics of your district, too.

One of the big issues of the time was the Contract with America, a movement led by Newt Gingrich, a congressman from Georgia who was also obviously running to be speaker of the House. I had come to know Newt over a long period of time, listened to a lot of his lectures and pontifications about issues of the day, and I really thought that the Contract with America was the kind of gimmick that my constituents didn't need. I really objected to tax cuts during a period when we were running high deficits. I thought we should address the deficit issue instead. Ultimately, we did. During the fourteen years I was in Congress, five were years when we balanced the budget, which was important for Washington to do. I thought that passing tax cuts would only reduce our ability to address a very important issue.

> *"If America is going to make progress in transportation, the next generation of transportation is not our highways. The next generation of transportation is high-speed rail."*

In my last couple of years in Congress, I got to know a young senator from Illinois named Barack Obama. I bumped into him on the House floor one day, after I had announced my retirement. He said, "If this thing works out for me, I may be looking for some Republicans." After the election, I met with him in Chicago, and a few days later, he offered me this job. I thought it was a great privilege and opportunity to serve in what I believe is one of the most historic administrations in our county.

Within thirty days of being sworn in, President Obama signed an executive order that the Department of Transportation and the Environmental Protection Agency should work together to raise gasoline standards. We've done that. In two and a half years, we have developed a program in which, in 2012, cars and light trucks will get 26 miles per gallon; in 2016, 36 miles per gallon; and by 2025, 55.4 miles per gallon. The most significant part of this is that we worked with the auto companies. They wanted certainty in knowing what kind of cars they should build to meet the standards. On the day that the president announced that goal of 54.5 miles per gallon by 2025, all of the auto manufacturers were there, every CEO, foreign and domestic. They now have that certainty. It's a win for the automobile manufacturers, for the American people, and for the environment.

We have built out America with a state-of-the-art interstate system. But people want alternative forms of transportation other than automobiles.

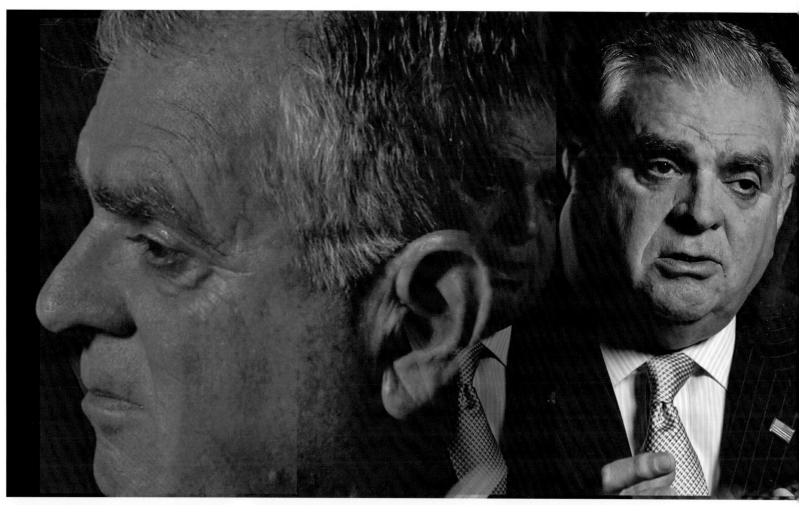

Secretary Raymond H. LaHood
As a former Republican member of the US House of Representatives, Ray LaHood was a firm advocate for bipartisan cooperation, refusing to sign Newt Gingrich's Contract with America. In 2009, he joined the Obama administration as secretary of transportation. He has focused on improving gasoline standards and repairing roads and other infrastructure.

In the Northeast corridor, Amtrak now is running trains that are almost completely full on every train route. If you go to Europe or Asia, where they have the best trains in the world, you come back here saying, "In America, why don't we have this?" Well, it's because we haven't made the investment. President Obama, through his budget, has now begun to do so, but we need partners in the states to really implement it. If America is going to make progress in transportation, the next generation of transportation is not our highways. The next generation of transportation is high-speed rail. The president has a vision of connecting 80 percent of America with high-speed rail over the next twenty-five years. It will be costly. Some of the money will have to come from Washington. Some will have to come from the states. And some will be private investment.

Making sure that every form of transportation is safe is our number-one priority. Thousands of people every day board airplanes, board trains, get in their cars, and almost none of those people think about safety. That's our job at DOT. We don't take safety for granted.

Right now, America is one big pothole. There's no question about it. Our roads and our bridges are in very bad shape. That's why we're pushing Congress hard to pass the a multiyear transportation bill that will allow us to engage with the states to fix up roads, repair bridges, improve runways at airports, and promote the kinds of communities that people want with the amenities they want. America has always been about doing big things. The Hoover Dam is an example. People with vision who came before us did big things. That's what we need to do again, and it takes comprehensive vision.

I'm Rocco Landesman.

I'm the chairman of the National Endowment for the Arts. I hold the arts portfolio in the federal government.

The National Endowment for the Arts essentially is an arts funding organization. We give government funds appropriated by Congress to arts organizations across the country. I grew up in the theater. My dad and his brothers had a cabaret theater called the Crystal Palace in St. Louis. It was a very avant-garde, adventuresome place, the incubator for what we now know as Second City, which morphed from a group called the Compass Players. Elaine May, Mike Nichols, Severn Darden, Del Close, and a lot of other early improv actors were in that group; May and Nichols lived in our house, in our ratskeller. I grew up watching them and other events at the Crystal Palace. The Smothers Brothers played there, and Barbara Streisand opened for them very early in her career. Lenny Bruce played there. So I got to see a lot of things growing up that most kids wouldn't see.

I went to the Yale School of Drama after college and earned a doctorate in dramatic literature and criticism. I was invited to be on the faculty and taught for four years. Then I went into New York, running a hedge fund and racing horses. One day, my then-wife and I decided to produce a Broadway show out of the blue. I had always loved Roger Miller. I thought he was the greatest songwriting genius that America ever produced. We had the idea that he could write a Broadway show. I had a notion that country music, which tells stories and is all about the lyrics, wasn't that far from Broadway songwriting. *Huckleberry Finn* was my favorite book, and we felt that Roger had the voice, could enter the vernacular of Mark Twain and write a Broadway score.

In a sense, my whole career has come from one perception. Roger really didn't know what we were talking about. Not only had he never written a Broadway show, he had never even seen one. But Mary Miller, his wife, was intrigued by what we were talking about, and we began a conversation that led years later to my first show, *Big River*. We went on to do two other big shows, Stephen Sondheim's *Into the Woods* and *The Secret Garden*, and I ended up working on Broadway for more than twenty years.

Theater is the most collaborative of the art forms. If you're a producer, you're essentially presiding over a collaboration. You pick the creative team, the writer, the composer, the lyricist, the designers. All of the elements of a show are put together by the producer, and they all have to collaborate. The producer is the fulcrum for all of that collaboration.

Running a federal agency is not that different. My job is to raise the level of the arts in the national discussion—to have the arts be at the table in domestic policy where they hadn't been before. Our budget is limited, so I had to find ways that were going to raise our profile. Part of it is bringing resources into the field, bringing support.

Rocco Landesman
Chairman of the National Endowment for the Arts Rocco Landesman's career has been a hybrid of commercial and artistic endeavors. At the NEA, he has sought to increase collaboration among the arts and other government agencies. He is interested in the intersection of the arts and the "real world."

Our budget is only about $155 million. We're the largest national arts funder in the country, but in the scheme of the federal government, we're probably one of the very smallest agencies. My good friend Kathleen Sebelius, who has eleven agencies in health and human services, likes to tease me that in the smallest of her agencies, our entire budget would be a rounding error. Their budget is $800 billion.

Somewhere in there is some discretionary money for the arts. Indeed, when we start to look at it, we see points of intersection between the arts and early childhood and childhood development, mental health, geriatrics. The arts have a role all across the lifespan, and there are intersections with the Department of Health and Human Services. There are intersections with the Department of Housing and Urban Development, the Department of Transportation, the Department of Education, the Department of Agriculture. These agencies have significant discretionary funding available that can be applied to the arts. My job has been to find out where those points of intersection are, develop alliances, and then to go to the private sector and find resources and funding in the foundations, with corporations, with individuals who can work alongside the NEA. In short, my mission, as I see it, is to enlist cooperation across the federal government and across the private sector to bring more resources into the field of the arts. There has to be collaboration and cooperation so that the money is spent strategically and effectively. It just makes sense.

Our narrative has to do with the role of the arts in neighborhood revitalization, urban renewal, and economic development. It lies at the intersection between the arts and the real world. That's a narrative that I think has real traction in Congress, in the administration, and with private funders all across the board. When you bring art and artists into a town, into a city, into a place, it changes that place. It changes the perception of it by others who are outside and by people who live there. It makes it a more engaging place to be

a part of. People want to be around vitality and a feeling that there's something going on that matters, and artists make that happen. When you have them in a place, it makes that place feel much more vibrant, much more vital, and it changes that community.

Where you have art and an arts presence, there is much more civic engagement in that community. People who are involved in the arts are much likely to vote, more likely to join other organizations. That it's a real force for civic cohesion in a community, a powerful force for that. Second, art makes a big difference in child welfare. Where there is art, where there is an art presence, you have notably lower levels of juvenile delinquency and truancy. Kids who are engaged in art in their schools tend to stay in school longer. And third, art is a poverty fighter. When you have an arts cluster, an arts district, it drives economies and attract people. Those are powerful tools to make a community more cohesive, a better and more attractive place to live.

The arts are who we are. I don't think you can have a discussion about the quality of life without talking about the arts. They're a big part of our identity. It's what we remember from just about every culture through history. There's not much you can tell me about commerce in ancient Rome and Greece and the Middle Ages, but you can tell me about their art, because there's a record of it still and people care about that. It's an expression of our identity, our aspirations, our personalities.

Art is as important to us as eating, breathing, sleeping, shelter, and health care. When you talk about a fully engaged human being, you're also talking about an aesthetic element, a sense of the quality of your life. Art is central to that.

I'm Jim Leach.

I'm the chairman of the National Endowment for the Humanities.

The Midwest, where I grew up, is more international than many in the country assume. My wife and I have a phrase, "coastal parochialism," that we apply to people from the coasts who register surprise that Midwesterners are interested in anything beyond our region. My parents, for instance, were extremely well read and traveled extensively. Indeed, my father like so many citizen-soldiers of his generation traveled by foot across Europe at the behest of the US government. He waded ashore at Omaha Beach and helped lead a regiment from Normandy through the Bulge to the Elbe when the war in Europe finally ended.

When I was in junior high school, an English teacher gave as a class assignment the writing of a paper on what I want to do in life. Befuddled, I asked my parents at dinner, "What should I write about?" My father said, "Well, why don't you check out a book at the library on the Foreign Service?" I asked, "What's that?" And he replied: "Diplomacy—the State Department." So the next day after school I went to the library, found the two books it had on the subject, checked them out, and wrote the assigned paper.

From that point on, I geared my studies to preparation to enter the Foreign Service, which I eventually did in 1968. In the 1960s, when I went to college, there were two significant powers in the world, the United States and the Soviet Union. The Soviet Union appeared to be the greatest threat to America and American values. Hence, I decided to study the Russian language, Soviet foreign policy and economics. As a student at Princeton, Johns Hopkins, and the

James A. Leach
After serving in Congress from 1976 to 2006, Jim Leach taught at Princeton and Harvard and now serves as chairman of the National Endowment for the Humanities. Heading an institution that advances perspectives in history, literature, and philosophy, he has launched a variety of programs designed to bridge cultural differences.

London School of Economics and later as a young Foreign Service officer, I was fortunate to have exceptional mentors. My principal model was a distinguished scholar-diplomat named George F. Kennan. He coined the term "containment" as a policy prescription, and it became the broad blueprint that eight administrations followed. The policy was absolutely correct: America and our allies should do everything in our power to thwart Soviet expansionism and, at the same time, carefully engage Russia on the assumption that the people were courageous but the government was totalitarian. Making the distinction between a populous deserving of respect and a government that must be stood up to was critically important.

All Foreign Service officers of any rank are technically presidential appointments. It was with surprise and disappointment that one day I felt compelled to resign in protest of a government action. On a particular Saturday in October of 1973, in the middle of the Watergate investigation, the president of the United States chose to fire the special prosecutor, which entailed first firing the attorney general and the deputy attorney general. In my view, the president put himself above the law and I thus felt I could no longer serve in his administration.

Richard Nixon, in effect, propelled me to go home. The next year, 1974, was a catastrophic one for the Republican Party. One day, the Republican chairman of my home county came to me and said, "Jim, we have no candidate for Congress. Would you consider running? We think you have a chance." In reality, the party was looking for a lamb. Nevertheless, I agreed to run and received a nomination that I did not deserve, having never participated in politics at any level in my state. But I had a sense for national issues and how Washington operated, so I began the process of learning how to campaign.

In announcing my candidacy, I made a personal pledge based on an aspect of Watergate that nobody really focused on: the excess money that President Nixon controlled and apparently felt had

the right to use with impunity because it had been secretly raised. The pledge was never to accept political action committee money or out-of-state contributions. I went to small towns and farms, knocked on a lot of doors, spoke to all the local clubs and ran a race that was never likely to prevail. In the end, it didn't, but it proved to be surprisingly competitive and in the following election I was able to prevail.

Governance has many aspects, one of which is to set priorities. Research is very important for society, but in my congressional years I became concerned that funding priorities had become skewed. The term "research" had come to connote laboratories rather than libraries. I am adamantly for scientific research. But we had started to cut back on research in humanities disciplines and the National Endowment for the Humanities was on the block for possible elimination. I believed this would have been a grave mistake. If you take almost any political issue, particularly international, politics is on the surface. What's below the surface is culture. It is important for Americans to understand what the culture of a given country or region is. It matters how people mesh religion and history with lifestyle. In my view, we needed to do far more as a country to learn about others, and so with a colleague I founded a congressional caucus on the humanities and became an advocate for an overlooked aspect of public policy.

While I was in Congress, I also founded the Republican Mainstream Committee to reflect moderate attitudes in my party. A great friend and leading conservative spokesman, Jack Kemp, said, "Jim! You can't use the word 'mainstream.' I'm mainstream." I responded: "Jack! In that case you can't use the word 'conservative.' I'm conservative." Conservatism was once symbolized by two people, Robert Taft and Barry Goldwater. Goldwater was a classic individual rights conservative. He was pro-choice and pro-gay rights. Today's social conservatism is much different.

The higher you get in politics, the more ideological things have become. American politics have

also become increasingly oligarchic, although, intriguingly, the oligarchs aren't those in the Senate or the House of Representatives. They are the outside power brokers who distribute egregious amounts of money with implicit IOUs in the political process. I have always considered myself a moderate, but on one issue, I am absolutely radical. I believe we need campaign reform of a truly significant dimension. My preference is a system where a candidate matches small contributions with public funds up to a given level, with public funds not kicking in until the candidate has raised a minimum amount. The key is that anyone elected should only be indebted to constituents rather than those who use special interest money to influence their vote. Our founders were concerned that every element of society be represented in legislative chambers. Right now, we have one overwhelmingly underrepresented group in Congress: the center-left and the center-right.

At the National Endowment for the Humanities, I have tried to put an emphasis on bridging cultures through programs that cause us to have greater understanding of ourselves and others and how we relate to each other. In discussing civility and civil discourse, one has to begin with great care because some people think the subject is namby-pamby. It's not. Civility is the heart of civilization. Argumentation is, of course, a social good, and without argumentation, there is a tendency to dogmatism, and potentially in politics to tyranny. The goal should be to expand rather than restrict argumentation, but if two sides don't listen to each other, argumentation itself withers.

Civility does not mean manners. It means establishing that one individual is concerned about another. Particularly when the differences are the largest, the greatest effort should be made to understand. The person with the greatest disagreement should always have a chance to be heard. To me, that's what democracy is all about.

I'm Theodore Leonsis.

That's my real first name, but I've been called Ted forever. And my real last name is Leotsokos. My father came through Ellis Island as a child, and they couldn't pronounce the name, and somehow it became Leonsis. I'm an entrepreneur, starting companies, investing in companies, and mentoring young entrepreneurs. I own sports teams: the Washington Capitals, Washington Wizards, and Washington Mystics. I also own the Verizon Center. I'm a philanthropist. I make films. I write books.

As I've gotten older, I sleep less and less. I think that's the only way that I've been able to do all the processing I do in the nonlinear way I do it.

When I was a student at Georgetown University, I was overwhelmed. Everyone was smarter than me and more educated than me and had mothers and fathers who had careers, whereas my mom and dad had jobs. I was the first one in my family to go to college. I was reading Earnest Hemingway's *Old Man and the Sea*, mostly because it was a short book. I read paragraphs like, "It was a good day. The sun was hot." I enjoyed the book and decided to read some more Hemingway. The next

book I read was *Across the River and into the Trees*, and it wasn't at all like *Old Man and the Sea*. I read some more of his books and wondered why *The Old Man and the Sea* was so different from his other work. I mentioned all this to my mentor at Georgetown University, a Jesuit priest and the most influential person in my life, Father Joseph Durkin. He said, "Well, that's an interesting thought. Maybe Hemingway wrote the book earlier in his career and brought it out of the drawer and freshened it up." And I said, "That's what I think happened. But why, and how can we prove it?" And Father Durkin said, "Let's use a computer."

Back then—this was 1976—my vision of a computer was Hal, from the movie *2001: A Space Odyssey*. There was just one computer on the campus of Georgetown University, an IBM 360 mainframe that ran payroll. We recruited a linguistics major and worked on developing a program through which we could do comparative, algorithmic analysis of Hemingway's work, using *Old Man and the Sea* as a control and looking at variables like the number of words in a sentence. I typed in the first five thousand words or so from all his books. We then asked the computer, "When was this book written?" It was probably the first dynamic, organic mash-up in which a computer was used to prove an idea in the liberal arts. It was mesmerizing. I've just read Walter Isaacson's biography of Steve Jobs—I knew Steve and worked with him closely—and there was a line that said Apple was so successful because it was a place where technology and the liberal arts came together.

When I graduated from college, I used my thesis on Hemingway to get my first job, which was with a computer company called Wang Laboratories. Wang was really the first populist computer company. It wasn't a mainframe company for data scientists or the government. It used technology to take the tedium out of typing. I was there at the birth of populist computing, a forebear to personal computing—and my first entrepreneurial endeavor. In 1979, I went to a computer fair

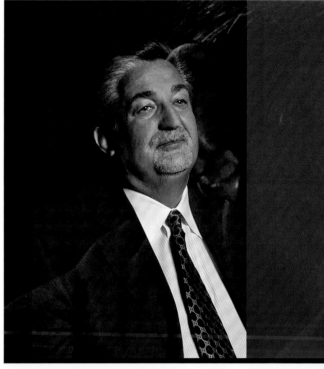

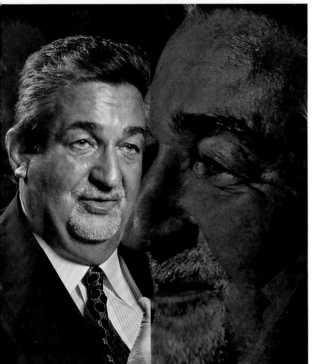

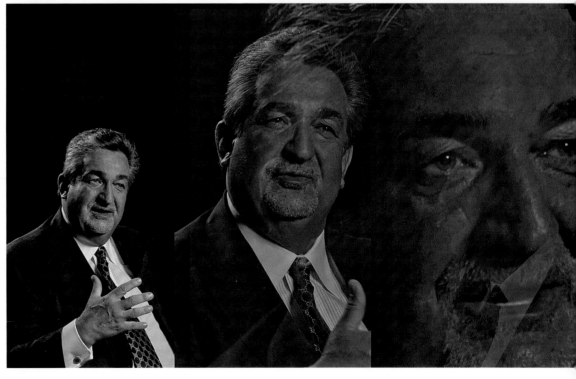

Theodore John Leonsis

A gifted entrepreneur, Ted Leonsis has played a pioneering role in opening up the Internet to the American public by recognizing the interface between technology, entertainment, and communication. He is the founder of Monumental Sports & Entertainment, which owns the Washington Capitals, Washington Wizards, Washington Mystics, and Verizon Center.

in California and bought an Apple II computer. I bought the manual from a guy who had written it, photocopied it, and was selling it for five dollars. He had copies in plastic bags, like a drug dealer.

> *"Nothing brings a city closer together than a winning sports team, a team the community is proud of."*

Around that time I went to a grocery store. As I was waiting in line, I saw a *TV Guide*. On the cover there was a slogan that said, "The number-one best-selling magazine in America." I couldn't believe it. I bought it and took it home. While I was cooking dinner, I opened the magazine. The front of the magazine was interviews with directors and television stars. The back of the magazine was a directory, what programs played on what networks at what time. I then turned on my Apple II. It had the CP/M operating system, Visicalc, which was the first spreadsheet, and something called PFS, which was a little database. I got a whack on the side of the head. I looked at this computer, and I said, "This looks like a television. It's got this screen." I had an idea that these two things, television and computers, were going to come together.

I quit my job in 1980 and started my first company. It was called List, the Leonsis Index to Software Technology. It was like *TV Guide*, with a database of all of the software for the various platforms. The front of the book had interviews with Bill Gates and Mitch Kapor, whose Lotus 1-2-3 had just launched, and articles on how people were using software and what was happening in the industry. The back of the book was a directory. I raised a million dollars in venture capital, and it was a huge success out of the gate.

I went on to work at AOL, the online company. I had this populist notion that if you could make really complicated things accessible at a low price, and take the complexity out of it, you would really be doing the world a service. There was something magical about getting people connected to computers. Back to that vision of computer and television, we would deliver entertainment online. Mail and messaging would be delivered online. Frankly, almost anything that you could do offline could be done faster, better, more efficiently, maybe even with more enjoyment in this new world. When I joined the company, we had fewer than a million members. At our peak, we had about thirty-six million paying households—one out of every three in the country. During the 1990s, AOL was the best-performing stock across the board, more than Microsoft, more than Google. It was quite a ride.

I wrote a book called *The Business of Happiness*, and in it I talk about my old view that if you were successful, you could be happy. I've since come to believe that if you're happy, you can be successful. After I sold my first company and made a lot of money, I got on a plane that nearly crashed, and I thought I was going to die. I didn't. I made a list of 101 things to do before I die. I wanted to have an idea of how to live the second part of my life. On the list there were a lot of items involving sports— buy a sports team, win a championship. Then I was offered the opportunity to buy the teams in my hometown. The Washington Capitals are now in the playoffs, our fifth year in a row. Nothing brings a city closer together than a winning sports team, a team the community is proud of.

I'm in the business of making lifelong memories. The social responsibility of the positive bonding memories between fathers and sons and mothers and daughters and friends and communities is enormous. I view what I do with stewarding and owning the teams as being a second mayor of the city, a much richer, higher calling than just wins and losses or ratings points or the number of tickets that you sell.

I'm Peter Levin.

I'm the chief technology officer in the US Department of Veterans Affairs.

My interest in technology began in elementary school and has continued throughout my professional career. My first serious exposure and activities were in amateur radio. I got my first amateur license when I was twelve. Even today, I find it astonishing that that I can speak into a microphone, into a device on my desk, and somehow, magically, be connected to someone I anywhere in the world. Remember, this was before cell phones; wireless and radio were once a big deal.

I enjoyed math and science, and I've always had a deep interest in public policy: anything having to do with democracy, freedom, civil liberty, and the basic tenets of our diverse society. I have been looking for the connections between those two threads my whole life, because I think that science, technology, and education offer our best tools to promote health and welfare, create jobs, relieve suffering, and weave together the threads of our culture.

I was born in 1961 and raised in a German Jewish household by people who had survived the Holocaust. There was always a transcendent interest in what was going on outside of the house. I remember watching Martin Luther King on television, and that frame—a family of Holocaust survivors watching the profound social changes taking place in the United States— permanently fused in me those two interests, science and public policy, in a way that has defined my personal and professional identity ever since. I have been lucky to bring those things together under the same umbrella, in the same place at the same time, in the job I have today.

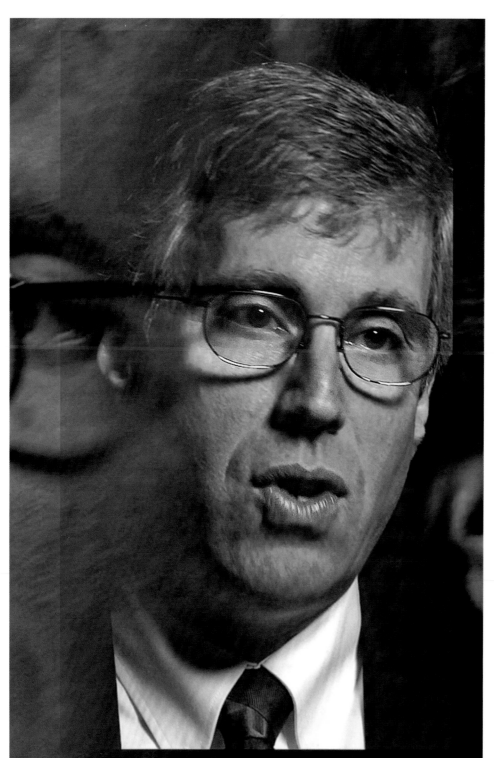
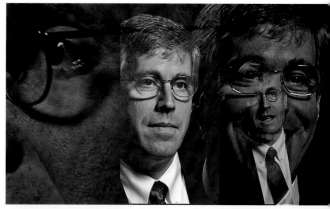
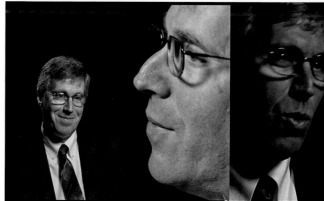
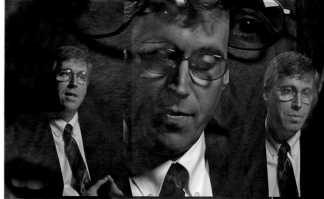

Peter Lawrence Levin

Trained as an engineer, Peter Levin is chief technology officer at the US Department of Veterans Affairs. He has dedicated his efforts to innovations in gathering, storing, and accessing information, and has actively engaged new technologies, such as social media, to revolutionize these processes within the agency.

I've worked in the three great magisteria of our society. I spent about half of my career as an engineering professor. I worked about a decade in the private sector, started a software company, sat on boards, served as an advisor. Now I'm in public service, working as part of the Obama administration.

My appointment to the VA was a great and wonderful surprise. I had never worn a uniform, had never worked in a hospital or for a health insurance company. It is an enormous intellectual challenge, and one that I cherish deeply. I think that the administration made a bet that I could take my experience and my expertise—semiconductor design and systems engineering, program management and large enterprise systems—and apply structure and rigor to an altogether new area. Fortunately, it seems to have worked.

All of us—red team, blue team, no team—care about our health. It's not a political issue, just like caring for veterans is not a political issue in our country. We're noticing now, especially as the demographic gets older, and as all kinds information becomes more liberated and accessible, that we don't have easy, convenient, secure access to our personal health data. In an era of reliable computing and cheap solid-state memory, we're still trying to remember what doctors we've seen, what medicines we take, what procedures we've had. And even if we remember where the records are or who may have them, they're probably not digitized and therefore are extremely difficult to access.

There are two gigantic forces that led us to a solution we call Blue Button. One of them was congestion and inefficiency, the utter uselessness of having Everest-like static standards, none of which were being observed, and none of which were in any way effective. The other was the absolute dearth of information, the fact that we had such sparse and incomplete information— electronic, digital, or otherwise—about our own personal health histories.

We can now pass information safely, privately, and securely from one institution to another, from a doctor to a hospital, from a laboratory to a nurse. We can do this and at the same time make that transaction visible to the patient. People actually want to know everything—every immunization, every appointment, every allergy, not just for themselves but for their partners and their kids as well. We can make this possible. The promotion of personal responsibility has been a transformative part of my experience inside the VA and inside the administration.

"I think that science, technology, and education offer our best tools to promote health and welfare, create jobs, relieve suffering, and weave together the threads of our culture."

We are building on this success in a methodical, transparent, and structured way. Of course, for many people it is a massive culture change. The technology was not the hard part; there were the people who wanted to but didn't believe that they could, and there are the people who know what's possible but for whatever narrow reason didn't want to see that change. In my experience there were actually relatively few bureaucratic obstructionists, but they're sadly well placed. It takes work, persistence, authentic collaboration, and terrific secretarial leadership, but you can break down the obstacles. There's truth in the old saw that the biggest critics can become the staunchest zealots. In many cases, all we had to do was ask.

The empowerment that we've been able to bring is part of the culture of the administration, but also reflective of the culture of the leadership inside the VA. For example, we've run innovation competitions

to draw people out, get them involved, learn what they had to teach us. The first had to do with something that I think many people would find mundane unless they have a service-connected disability or injury: We have an enormous problem with the claims backlog. Literally 99 percent of us have never served, never worn a uniform, don't participate in the military establishment. The 1 percent, the three million or so that are affiliated with the armed services, stand in harm's way, and sometimes that harm occurs. I think it would be abhorrent to anybody who thought about it at all carefully to say, "So you have sacrificed a limb. You have a disability. You have a mental health issue that you acquired because of where you served, what you saw, what you did on our behalf honorably, and we're going to put you in a hospital now and make you wait until we get around to fixing it." That simply is not what this country is about. And so, as mundane and ordinary as it might seem to process a claim, it's something that I feel passionate about. It's not the claim I care about. It's the individual behind the claim for whom I feel personally responsible.

We are also looking closely at how government can take better advantage of social media. The first benefit is the dialogue that we have with our institutions, the dialogue that we have with each other, the dialogue that we can have with strangers in this new medium. Social media can influence health care by making information accessible to people: what you should be eating and drinking, where you can receive services for chronic care management, who other people are who have similar issues, and the like.

Veterans are not necessarily the most quiet and passive constituency. But nobody would have expected us to be the most friended agency on Facebook. Hundreds of thousands of people are receiving our messages twice a day. We think this is a template for accessible, open government. What we're basically saying is: This is your government. You pay for it. You have voted for it. Some people participate more, some people less, but it belongs to all of us. Society benefits

when more people are engaged and welcome the dialogue with government. We want create a space where it can occur transparently and collaboratively, with a minimum of bureaucracy and with maximum benefit. Health data is an interesting place to start, but it is just a start.

I'm Judith Lichtman.

For thirty years, I was the head and president of the Women's Legal Defense Fund, which, after 1998, was called the National Partnership for Women and Families. I stepped down as president in 2004. I then became a senior advisor to the organization, taking on specific responsibilities.

I work on issues that I care about with extraordinary, committed people, knowing that the vision and ongoing mission of the organization are in safe hands. It doesn't get much better than that.

I was the child of politically liberal Jewish parents in New York. They were very clear about social and economic justice, clear that you were put on this earth to make it a better place. They expected much of my sister and me. They expected that we would be educated. Unlike their peers, they didn't think they were raising two girls to get married and have children, although they certainly wanted those things. We were expected to be contributing members to society and to be economically independent.

Judith L. Lichtman

The former president of the National Partnership for Women and Families, Judith Lichtman has spent her career advocating for women. Now senior advisor to the organization, she works to promote fairness in the workplace, access to quality affordable health care, and policies that help women and men meet the dual demands of work and family.

I went to the University of Wisconsin as a junior, transferring from what was then a small school on Long Island, Hofstra College. My major was American history, and my minor was political science. Shirley Abrahamson was teaching an undergraduate course in constitutional law. She is now, and has been for many years, the chief judge of the Wisconsin Supreme Court. I was hoping to earn a PhD in American political theory, but she advised, "That is not an activist enough degree for you. You should think about law school." That was way beyond anything I had ever considered, and my supportive parents were so worried about that decision that they made me take education courses between graduating from college in June 1962 and starting law school in the fall, so that if the law-school option didn't really work, at least I would have a teaching vocation to fall back on.

"When I look at the world and the educational opportunities that have opened for young women at every level, I am in awe of the change, of the true revolution."

I never thought that I would go into corporate law or be an in-house counsel. I never thought I would join a big law firm. I got that degree so that I could be a better civil rights advocate. It turned out to be a good decision or my part. When I graduated from law school, the 1964 Civil Rights Act had just passed. In my self-centered way, I was positive that this law was an employment opportunity for me. What better job for me with these brand-new skills than to work in Washington enforcing these new civil rights provisions? I was fortunate enough to get as my first job working for what is now the Office of Civil Rights and later the Office of the General Counsel in the Department of Health, Education, and Welfare, which has since morphed into the Department of Health and Human Services and the Department of Education. HEW was in charge of enforcing a very important provision of the Civil Rights Act. We call it Title VI. It holds that if you receive federal financial assistance or funding, you cannot discriminate on the base of race, color, or national origin. In the Johnson administration, school districts were beginning to receive very significant federal dollars for the first time. As a condition for continuing to receive the federal money, they had to commit to desegregating their schools, among other things. And I was part of a vanguard, really, of a bunch of young lawyers who traveled all over the South telling school superintendents what they had to do to comply with this new law.

I met my husband here in Washington. He was a volunteer lawyer with a wonderful group called the Lawyers' Committee for Civil Rights under Law. We married in December 1967 and moved to Mississippi. I taught at a historically black college, then called Jackson State College, now Jackson State University. We were both civil rights legal activists. We were certainly mindful of the dangers, but on an everyday basis, I didn't feel under threat.

I was planning to spend my life working on the evils of race discrimination, but Judge Gladys Kessler, then the president of a new organization, founded in 1971, called the Women's Legal Defense Fund approached me about whether I would be interested in being its first executive director. She approached me several times, and several times I told her that I wasn't interested. She explained to me that what was happening to women of color in this country was something worth addressing, and that to the extent that I was interested in race discrimination, taking a very serious look at what was happening to poor African American and Hispanic women was an important interest of the mission of the Women's Legal Defense Fund.

I didn't know very much about sex discrimination. When I took the job in July 1974, *Roe v. Wade* had only recently been decided. Ruth Ginsburg had begun bringing the first Supreme Court cases challenging gender bias, both in the law and in the Constitution, and having a fair amount of success. An extraordinary amount was happening in the mid-1970s to address sex discrimination. I had a lot to learn.

We have come a far way, but we have far to go. An important Supreme Court decision held in the mid-1960s that married couples could legally purchase contraception. It was a landmark decision because it really addressed the right of privacy and women making the most personal of decisions about when and under what circumstances to become pregnant. Here we are in the twenty-first century talking about contraception. For all the years that we have been defending abortion rights, we have said to major political leaders and to young women alike, about our opposition, "They're really after contraception. This is not just a fight about abortion. This is really, in a very fundamental way, the most personal of decisions." Young women cannot imagine that contraception might not legally be available. What's important about contraception, and abortion rights as well, is the straight and direct line between a woman's choosing to use contraception and the economic choices of that family. Without being able to control your reproductive rights, your ability to be an economic contributor to the family is significantly diminished.

When I look at the world and the educational opportunities that have opened for young women at every level, I am in awe of the change, of the true revolution. I'm also sometimes heartsick by some of the conversations we continue to have. But when I look at that my eight-year-old granddaughter playing on her soccer team, I'm impressed that the thought that she doesn't have a place on that field never occurs to her. If young girls do not participate in sports, they have very few opportunities to figure out how you lose, pick yourself up, and do the best you can immediately, because you have another practice, another scrimmage, another game tomorrow. These young girls' experiences are our futures.

I'm Jane Lubchenco.

I'm a marine biologist and environmental scientist by training. For most of my academic and professional life, I've taught and done research. I am now the administrator of NOAA, the National Oceanic and Atmospheric Administration, and under secretary of commerce for oceans and the atmosphere.

My five younger sisters and I grew up in Denver. I was very fortunate to grow up in a family that embraced giving children opportunities, giving them lots of chances to find themselves and encouraging them in whatever they wanted to do. I'm very fortunate to be married to a wonderful man who has enlightened ideas about partnership and is supportive. My father was also enlightened, and he treated us the way he would have treated sons. I grew up before Title IX was passed, but my mom and dad appreciated that sports were important for girls as well as boys. Learning how to push yourself, how to pick yourself up when you didn't do well, how to keep going, as well as the value of teamwork and the rough and tumble of team sports, I think, were certainly good preparation for my life today in Washington.

Between my junior and senior year in college, I had the opportunity to spend a summer at Woods Hole, Massachusetts, taking a course in invertebrate zoology—sea stars, barnacles, crabs, squid, all the life forms in oceans that don't have backbones were the subject of the course. That summer was glorious. I discovered a world that I didn't know existed, and I couldn't get enough of it. The second half of the summer required me to do a research project. That was my first real experience with hands-on science, designing an experiment and figuring out what my hypotheses were, how to test them, how to analyze data, and how to make conclusions. Based on that experience, I decided to go to graduate school in marine biology. That set me on my path.

Mentors have been important to me throughout my career. A high school biology teacher and college biology teacher helped me and gave me opportunities. During the summer that I spent at Woods Hole, one of the professors really took me under his wing and gave me the opportunity to do that research project. In graduate school, the faculty members were not only superb scientists but also wonderful human beings and great supporters.

I entered graduate school interested primarily in marine physiology, how animals work. I was exposed to a broader set of ideas at the University of Washington, where I began my graduate career, looking at relationships between and among animals, how they interact with one another and their physical environment, and how those interactions determine how many and what kinds you see in any particular place and in what physical configuration. Rocky seashores turned out to be a model ecosystem for understanding the dynamics of the plants and animals and microbes in a particular place. There are clear gradients from high on the shore to low on the shore. Things high on the shore are exposed to air for much longer when the tide is out than are things lower on the shore. There are gradients, too, from super-wave-protected to wave-exposed. Those two gradients set up stark physical differences, not unlike what you would see going up a mountainside, where there are different life zones. Those physical gradients set up the conditions for different species' doing better in one place than another.

Rocky seashores have a distinct advantage in that you can do experiments in them, too. You can transplant something from high on the shore to low, or low to high. It's a lot easier to do that with barnacles and mussels than it is with a tree or a squirrel. If you transplant an organism, it actually can grow faster lower on the shore, which is a better physical habitat. But, it many cases, that organism is outmatched by something that's a better competitor for space, or it will be eaten by a predator that lives only where the physical conditions are more benign, as opposed to the harsh conditions up high. Being able to differentiate correlation from causation was a powerful new advance that experiments allow to happen. That led to many new breakthroughs in understanding the basic processes that determine how many plants or animals, how many different species live not only on rocky shores but also lots of other places all around the world. It was a good model system to use to get basic information that applies for mountains, valleys, forests, coral reefs, and kelp forests alike. So many different types of ecosystems, we now know, are affected by many of the same interactions between the physical conditions and the biological conditions, such as competitors or predators, that determine these patterns.

"The evidence is overwhelming that climate change is taking place, and the consequences are likely to be challenging for much of our society. It's imperative that we take this seriously and act to reduce greenhouse gas emissions as fast as we can."

I taught at Harvard before I moved to Oregon State University. My husband and I moved in part due to the opportunity OSU created for us for separate half-time but tenure-track positions, an arrangement that enabled us to juggle careers and family life. We launched into doing research in Oregon, as well as in Panama, comparing rocky seashore communities in different parts of the world. We began to see changes in many of these systems, mirrored by experiences of our colleagues elsewhere, where things were different now from where they had been ten or twenty years ago. We began trying to track changes through time and understand what the causes of those changes might be. That was well before people were really thinking about impacts of climate change. We were beginning to see some of those dynamics in these systems, as well as other influences of people, indirectly, on the patterns you see on seashores. The work we were doing was pushing the boundaries of knowledge and giving us new insights into basic patterns. I could see connections between that information and decisions that were being made by managers or policymakers that were not taking into account some of the basic information that we and other scientists were uncovering about human impacts on the natural world. I began to understand that scientists have an obligation not only to teach their students and to discover new things about the world,

Jane Lubchenco
Scientist Jane Lubchenco is under secretary of commerce for oceans and atmosphere and the first female administrator of the National Oceanic and Atmospheric Administration. At NOAA, she has sought to create a bridge between scientific research and the public to encourage the development of informed policy.

but also to share that information more broadly with laypeople. Far too often, scientists have been unable to provide credible, understandable, and relevant information to policymakers. That's not always an easy thing to do, but it's something that I have been working toward and encouraging other scientists to work toward for some time.

The evidence is overwhelming that climate change is taking place, and the consequences are likely to be challenging for much of our society. It's imperative that we take this seriously and act to reduce greenhouse gas emissions as fast as we can. Parallel to reducing emissions, we need to prepare to adapt to the climate change that is already happening and that is going to continue for some time. We're seeing more extreme precipitation events, more intense storms, more heat waves, and more drought. Climate change is also affecting the distribution of many species.

Although we don't know everything we'd like to know about climate change, there is strong consensus within the scientific community that the climate is changing and that human activities such as burning of fossil fuels are largely responsible. There are viable options for more sustainable futures. Communicating them is one of our biggest challenges.

I'm Mohamed Magid.

I'm the imam of the All Dulles Area Muslim Society, a mosque in Northern Virginia. I am also the president of Islamic Society of North America, known as ISNA.

I came to the United States from Sudan with my father, who was seeking medical treatment, and I came to know the United States through the care and the passion the American medical doctors gave to their patients. One doctor was Muslim, and one was Jewish. That was the first time I had seen interfaith work in action. I had never met a Jewish person before. My father connected with him very well, and that created a new reality for me.

After that, I just started exploring this beautiful multicultural, multiethnic, multifaith community and society. For a while, I worked in Washington in another mosque. Then I took some time to train people in intercultural business practices—how you can do business with people of other cultures, deal with intercultural marriages, and those sorts of things. In late 1997, I started working with the All Dulles Area Muslim Society. It was a very small community at the time, about two hundred families. Now, it's five thousand families with six branches throughout Northern Virginia.

My calling to be an imam came after I volunteered for a program to help drought victims in Darfur in 1982 or '83. It really changed my life, and it became my call to help people in social service and in religious teaching about compassion and caring about others. I will never forget that as we were helping the families who suffered from the drought, there was a woman who had a baby in her hand. She was the first person to arrive, and we offered her food. She looked so exhausted. When I came to her and said, "Help is here," she looked at me and said, "You're late. The baby in my hands has died."

I don't think she was trying to be mean to me, but she expressing her feeling at the time, and that transformed me. I said, "I should never be late again in helping people." That call has driven me ever since. I don't have to be a person who has a lot of numbers in his bank account, but I want to leave a legacy of helping people. My calling now centers on doing interfaith and intercultural work, and helping women in the issue of domestic violence. Whenever I hear that somebody is hurt, I respond to that, or try my best to do so.

We live in a world today in which religion has become the focus and the core of discussion. Interfaith work is very important to me because I want to see how people utilize their faith and their belief system in advancing the human project—that is, helping humankind. It is very important, I think, that in order to work with people of other faiths we must know where they come from. I have studied a lot about Judaism and Christianity for this reason. I spent two days just last week sitting with Jewish scholars discussing Islamic law and Jewish law and comparing how similar we are. We talked about how to bring people into the beautiful faiths of Islam and Judaism and help them navigate their way through the modern, multicultural society with the help of religious society.

After the horrible tragedy of 9/11 hit this beautiful nation, my world changed again. We've become the focus. Who are the Muslims? What does Islam stand for? People are asking those kinds of questions. Now the interfaith message has become more than understanding one another; it also addresses the issue of violent extremism. I am very worried about people hijacking my religion. I lose sleep over this. And I am very concerned about people in cyberspace trying to

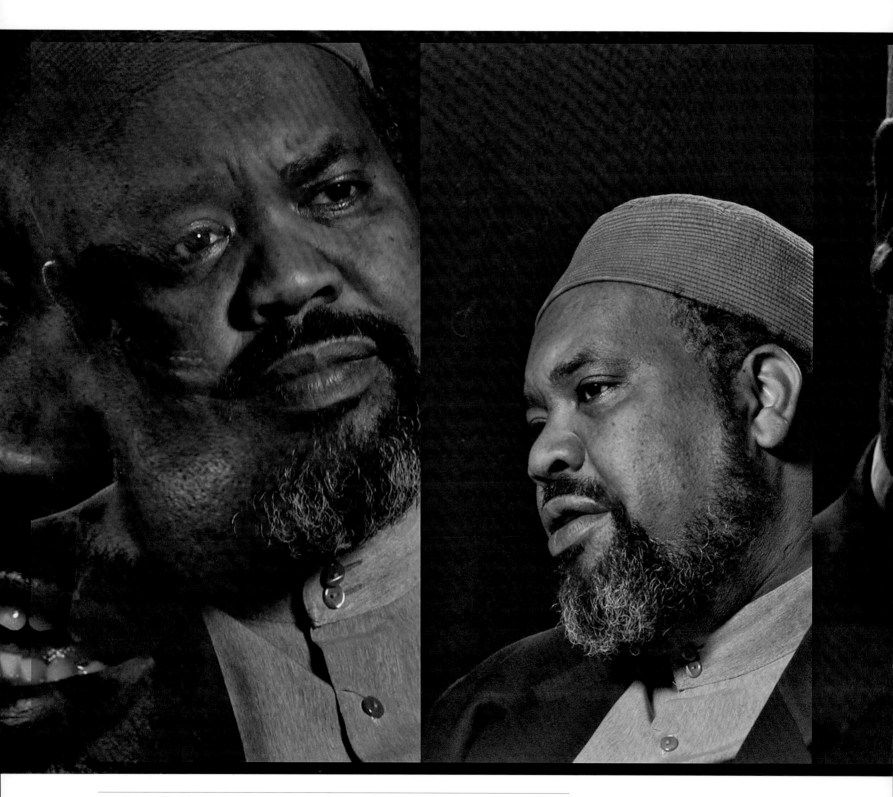

Imam Mohamed Magid

Imam Mohamed Magid is president of the Islamic Society of North America and imam of the All Dulles Area Muslim Society. As a religious leader, he has stressed the importance of public service and interfaith collaboration in addressing the challenges faced by Muslim Americans in the wake of September 11.

target young Muslims. I have become very alert to the distorted message of violent extremism preached on the Internet.

Violent extremism is a cult. It is not a religion. Islam is a beautiful religion that is centuries old. Muslims have worked with the Jewish community and Christian community through the years and decades in building a peaceful environment. You saw see this during the Holocaust, when Muslims in North Africa opened the door to the Jewish community. The violent extremists don't represent me. They don't represent Islam. They don't represent any Muslims. They are representing an ideology of hate, which is not Islam.

"We live in a world today in which religion has become the focus and the core of discussion. Interfaith work is very important to me because I want to see how people utilize their faith and their belief system in advancing the human project—that is, helping humankind."

But we in the interfaith communist must now ask, "How can we have a positive message, reinforce peace, tolerance, understanding, and harmony, rather than identify ourself with who we are not?" We like to define ourself by who we are, instead of saying, "We don't accept violent extremists. We don't do this. We don't do that." We have to shift the conversation. We have to make a conversation of substance that deals with peace building and with building a just society, and that by itself will filter out those violent extremists.

For Muslim Americans, the issue of identity has become very important. Some people think that no Muslim will be loyal to this country, that there is a conflict between Muslim identity and American identity. I would like to have those people come to our mosque and see the Girl Scout and Boy Scout programs, where young people have an American flag on the shoulder and pray in the prayer line. We work in soup kitchens, adopt highways, donate blood. Muslim Americans are contributing every day to this great nation in many ways.

I always address the issue of identity in my sermons. I say that we as Americans who believe in the Constitution of the United States as the law of the land, who believe in dedicating and devoting ourselves to protecting our neighbors and ourselves, who believe in the message of mercy, tolerance, and understanding, we're here to build harmony, and we're here to stand against anyone who wants to divide the country, whether that person be Muslim or from another faith.

The tension between being American and being Muslim is not from Muslims themselves. It's what being projected on them from the larger community. They have to answer for any event that has taken place anywhere in the world. And as the election of 2012 comes soon, Islam again will be in the focus. Some people will try to make political statements by using Muslims as a football. They need to concentrate on fixing the economy, providing jobs, not taking a shot at the Muslim community. The Sharia issue—who said we want to put Sharia in America? It is a solution to a problem that does not exist.

They are becoming an industry, creating fear, these people. But I am very optimistic that we shall overcome them, because my Jewish friends—my rabbis, I call them—and my pastors say to me, "We're with you."

I'm Marcia McNutt.

I'm the director of the US Geological Survey.

I have always been a scientist. As a young child, I liked to solve puzzles. But I never saw myself in a lab coat with test tubes. I always saw myself as doing science outside, so it was perhaps no surprise that when I got to college and took my first geology class, I thought, "This is incredibly cool." Going out, scrambling up and down mountains, and learning about science firsthand from first principles—it was the ultimate hands-on job, where you could get down and dirty and figure out how Earth really worked.

I went on to graduate school and geophysics, and ultimately I became a faculty member at MIT. After I had been there for fifteen years, the offer came to lead a small oceanographic institution in Monterey, California. David Packard had founded the Monterey Bay Aquarium Research Institute, or MBARI, ten years earlier. His goal for the institution was that it become a NASA for the oceans, a breeding ground for new technologies and new ways of exploring the deep sea.

I spent twelve years at MBARI. I loved every minute of it and thought I'd be there forever. But then the offer came to lead the US Geological Survey. I had actually worked for the USGS very early in my career, and I knew of its reputation for high-quality science. During the years that I worked at the USGS right after graduate school, I was part of a program to study what sort of precursors might be reliable indications of earthquakes, trying to look at the basics of how rocks deform under stress. We were hoping that that fundamental understanding would someday lead to a breakthrough in understanding of the entire earthquake process.

Marcia K. McNutt
Director of the US Geological Survey Marcia McNutt, an experienced geophysicist and administrator, has weathered both natural and manmade geological challenges, including earthquakes and the BP oil spill of 2010. As a scientist, she helps inform good policy to protect people and the environment, as well as sustainable use of our natural resources.

We have made a lot of progress on this problem. Although we still can't exactly predict earthquakes, we have made great inroads in what we call earthquake forecasting, with a better understanding of which faults are likely to be more dangerous than other faults, and therefore which areas should be priorities for, say, retrofitting schools and hospitals, and which areas should be zoned for better building codes because they are more likely to sustain larger earthquakes than others. After all, that's really what it's all about. Earthquakes don't kill people; buildings kill people.

The USGS takes its direction back from its Organic Act, which was written in the mid-1800s. We are actually one of the oldest of the federal agencies. That Organic Act is very broad, and it instructs us to do science in support of the natural-resource needs of the United States. We have maintained our mission focus to keep abreast of the needs of the nation for more than 150 years as it has moved from an undiscovered continent that needed mapping in order to move west and develop its lands to a nation that is concerned about sustaining limited resources and maintaining clean water, minerals, energy, and healthy ecosystems, one that is concerned about how climate change could affect those resources.

We are perhaps best known for our program in natural hazards. Our earthquake scientists, for example, have worked very hard to understand for each known fault system in the United States what the strong ground motion to be expected from the earthquake is. There is a maximum magnitude that would be expected from a fault based on the length of the fault and how deep it goes. We can predict the magnitude for that fault, but then how much shaking occurs around it depends on a lot of other factors, such as soil type. For example, we found that in the Virginia earthquake of August 2011, the felt area from that earthquake was ten times larger than what it would have been had that earthquake happened in California. That's because the rocks in California absorb the energy more locally. They don't transmit it as far.

All that information has to be taken into account when you draw maps of strong ground motion. Then we work with engineers to transfer that information into earthquake-safe design. Communities take those designs and turn them into building codes. And then over time, as the building stock turns over, old buildings get torn down, new buildings go up, and communities become more resilient.

One thing that surprised me in Virginia was how few people even knew they were in an earthquake. The first rule in earthquake safety is that you need to know you're in an earthquake, because the first thing you need to do when you're in an earthquake is duck and cover. You have to get under something that's safe. Instead, what so many people on the East Coast did was to revert to the one emergency drill that they knew, the fire drill. They filed out of the building, which was the worst thing to do. Facades were falling off buildings. Towers were falling off the National Cathedral, and people were moving outdoors right into harm's way. Out on the West Coast, we have the Great Shakeout, an earthquake drill that we've held for a number of years. Eight million people participate in it. We started having such exercises in the central United States, and millions of people have been signing up for them. We're going to start having them on the East Coast, so that people there understand what to do in an earthquake now that they've experienced one.

We also worked on the BP oil spill in the Gulf of Mexico. It was an all-hands-on-deck emergency. We had our coastal zone ecologists out there on the front line trying to protect the wetlands and the ecosystem on the Gulf Coast. We had our water quality people out there worrying about the effect on the Gulf and the Mississippi River. We had our sediment people out there looking at whether sand berms were going to be effective or do more harm than good.

I personally went to BP headquarters in Houston and spent nearly four months there working with the BP scientists and engineers on well control, on

how to stop the flow of oil. When I first arrived in Houston it was overwhelming, because there had been nothing like it before. We were trying to pull in everything that we knew from *Exxon Valdez* and from the Santa Barbara oil spill. There were many lessons learned that were useful for the response on the shoreline, but really nothing of that was relevant for killing the well. I went back to my experiences at MBARI of using robots a mile deep and understanding the limitations of those robots, what they could and couldn't do, to try to figure out intervention methods that had a hope of succeeding.

Circumstances such as the Gulf oil spill have helped to raise the visibility of the USGS. After years of lackluster budgets and a sense that other agencies in the administration don't necessarily appreciate them, for once our workers are seeing a lot of their science getting put into action. I can't tell them enough how much their work is appreciated. They're finally getting the message that their work is important, it's timely, and it's making a difference.

I'm Ellen Miller.

I'm the cofounder and executive director of the Sunlight Foundation and of two other nonprofits here in Washington, the Center for Responsive Politics and Public Campaign.

When I first came to Washington, in 1964, I worked for Ralph Nader. I started as a lowly research assistant, but I learned a lot about Washington and how decisions were made. Then I had an opportunity to go up to the Hill to investigate FBI abuses under J. Edgar Hoover's reign. I spent

a number of years in the Senate working for Abraham Ribicoff on the Governmental Affairs Committee. That introduced me to the world of government—how it works and why it works the way it does. In 1980 I moved on, with all the other Democrats who lost the majority. I tried my hand at work in the private sector and found that I didn't really enjoy that, so I accepted an invitation in early 1984 to become the founding director of the Center for Responsive Politics. It was founded by two well-respected former members of Congress, Senator Hugh Scott, Republican from Pennsylvania, and Senator Frank Church, Democrat from Idaho. The mission of this organization was to figure out what was wrong with Congress and contribute to solutions. At CRP we undertook a number of early studies about Congress as an institution, and the first of one of which that really struck was looking at the issue of so-called "soft money," unregulated political money. People were trying to fix the post-Watergate campaign finance system that had been enacted ten years earlier, but they didn't have a really good view of what was wrong with it. CRP decided that we would delve in deep into that system, and we made a name for ourselves creating huge databases, making data accessible, and training reporters how to use it. Over sixteen years we built a strong and valuable institution. No one has followed the money the way CRP has over the years.

But I was itching to change the system. With other colleagues, I founded Public Campaign. By this time it was 1996, and most people in this country understood that this issue of money and politics was not just a political action committee problem, it was also a problem of soft money and "bundlers" who could marshal hundreds of thousands of dollars for their favorite candidate. At Public Campaign we told that story over and over again in extreme detail and pointed out the connections between the money, who gets elected, and what they do after Election Day. We also coordinated grassroots organizing efforts to demonstrate the viability of a full public-financing system from a policy perspective.

In the fall of 2005 I was introduced to Washington businessman named Mike Klein, who asked me, "What can we do in this day and age to enhance the public's awareness of the corruption that is rampant in Congress?" Remember that this was in era of Bob Ney and Jack Abramoff (who is back on the scene today in the guise of a reformer), the era of Tom DeLay and so many others who were caught in the web of special-interest influence.

As Mike and I talked with journalists and others who are thinking about the role of journalism, we heard over and over again that if data were more accessible online and if we had more access to it so that we could develop tools and literally connect the dots by mashing data, it would be easier to write the stories and inform public opinion faster, better, and more completely. We had one meeting that sealed the deal with our now senior consultants, Micah Sifry and Andrew Rasiej, to talk about how technology was changing the nature of civic dialogue and engagement with government information.

In April 2006, the Sunlight Foundation was born online with hardly a piece of paper behind it. (Mike generously provided the initial seed funding.) The main focus has always been digitization of data, building tools and websites to enhance citizens' and journalists' access to that data and to make meaningful connections. One of our major activities has also been to change public policy around the accessibility of government data. Initially we focused just on Congress, then expanded to include executive branch, state, and global transparency issues.

At the heart of our work has always been the influence industry—what their campaign contributions buy and what they get in return and the distorting impact they have as a result. The issues of the influence of big money in politics, and the lack of transparency about it, were really exacerbated by the Supreme Court decision that allowed corporations essentially to spend unlimited money. This money is not coming from the 99.9 percent. They are not represented in this arms

race around the money, and the horror is that the inequality has fundamentally, truly corrupted the democratic process. The money determines who runs for office, who wins, and what those donors get from government.

Sunlight's approach, which we think of as fundamental platform, is that we must have real-time transparency of these translations. Campaign finance reports, lobbying reports, government grants and contracts, positions on Federal Advisory Committees and the like are filed well after the fact. Mike Klein likes to say it's like watching the video of a bank robbery. Sunlight is demanding real-time, digital reporting of influence data and what donors are getting in return. Online citizens and journalists then can watch the flow of money and actually say, "Wow, look at all the money that the supercommittee members are getting from the finance, insurance, and real estate interests. Isn't that going to have an effect on the decisions that they are making?" The answer to that is yes—but we cannot see that real-time reporting, because they report on a quarterly basis.

Members of Congress are reluctant to give us that information, because information is power, and we want the power of information in the hands of citizens.

Public information belongs in the hands of the public, not locked up in a government file cabinet. Public information should be defined today as being online. As the public becomes more accustomed to ordering a book online at 2:00 a.m. or making a plane reservation at 6:00 a.m., they also looking for information about government and its politicians 24/7. The culture is changing in fundamental ways around the ability of technology to allow citizens to engage with their elected officials. Government—not an institution that moves quickly—is really absorbing the fact that this information is going to have to be online. It's a bit like a genie that's been let out of the bottle. I think it will be and I hope it will be impossible for it to be put back.

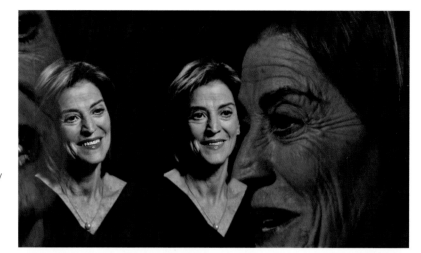
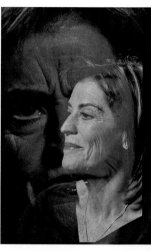
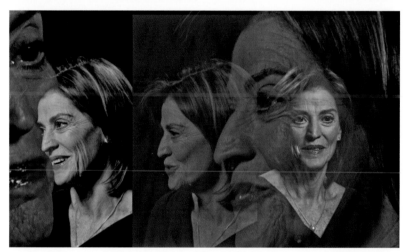

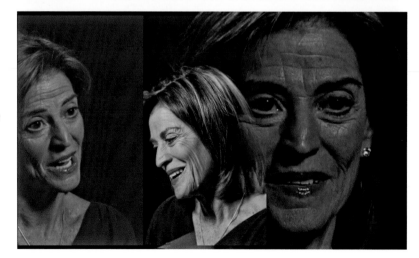

Ellen S. Miller
An advocate for transparency in government, Ellen Miller has established numerous organizations to promote democratic access to information. Recognizing the power of new technology and social media, she recently cofounded the Sunlight Foundation, dedicated to using the Internet to improve the public's ability to hold elected officials accountable.

It's not just access to legislators, it's not just legislation, it's not just rules and regulations, but it's all of that. Technology has allowed us to paint a larger narrative of what happens in Washington, how the powerful influence the system. The technology is a game changer because it allows more people to access the information, to help create the information, to hold their politicians accountable for what they learn.

The more sunlight we can shine on government, the less things will happen in the dark. Corruption thrives in those dark, dank basements of government. In the final analysis, it will be the use of technology in innovative and exciting ways that really breaks through the barriers so that our politicians actually listen to us.

I'm George Miller.

I'm a member of Congress from the San Francisco Bay Area of California.

I grew up in a political family. My father was a state senator in Sacramento, and he was very powerful and progressive. We lived in a rural area, if you can imagine that in San Francisco today. He would sometimes stop at the bus stop in the morning when I was sitting there and say, "What are you doing in school today?" I would say, "Nothing." He'd say, "Get in the car and let's go to Sacramento. Don't tell your mother." I'd travel around with him and watch him work and watch people coming to him asking for help. People would come to our house, needing something. The Italian fishermen were losing their boats because people said that they were killing all of the fish, when it turned out to be the refineries were killing all the fish. They were losing their livelihoods. What were they going to do? People would sit in our living room and work on water, a big issue in our part of California. I just

started thinking about leverage, and I saw that my father had it, leverage, usually on behalf of poor people, on behalf of minorities. I thought, "I want some of that leverage." And here I am.

I went on to college and law school. While I was in law school, my father died. I ran for state senate. I was twenty-three. I won the primary but lost the general election. When I came back, I worked as staff in the state legislature for George Moscone, who later became the mayor of San Francisco and was assassinated. I was participating. I was writing legislation. I was preparing testimony. And now I could see what was going on. I met with other staff people and legislators, and I started to see how politics played out. In my early years, my father told me, "If you run, just remember, they don't have anything you want. You just do what you think is right." I didn't know what he was talking about then, but I figured it out in my years in Congress.

I learned from Moscone how to structure a battle. You may have the votes, but still it's a struggle, particularly if you're on the minority side. If you understand what you're getting into and the merits of the case, then you can suffer some body blows. I started to see how he was going to frame his arguments when he went to committee, when he went to the floor, when he gave a speech, when he traveled in the state. I also saw that his stance was anchored to a value that he was holding. His opposition to the death penalty is an example. When I ran for Congress, I ran against the war and for national health care. Forty years later, I'm still working on getting those two things done.

This congress is the toughest environment I've ever worked in. I've been out here plowing these fields day in and day out on behalf of children, mainly poor minority children or their families, or children with disabilities, and it's what I do every day. I made a decision, and my values dictate that I think children with disabilities ought to have access to a quality education. I think poor children ought to have access to a quality education. I have a great office with a wall of documents

and photographs. We say it is devoted to lost causes, and we say, "If you want to get into a fight, bring your lunch, because we're not going to go away." We're really very proud of what we've been able to accomplish, and I mean "we" in the very large sense of other people in Congress—staff, experts, families, constituents.

We're the people's house, we like to say. They have a big stake in what's going on. If we don't step up to engage in oversight, to engage in the investigations, to check whether or not this is really essentially right or wrong, who will? We know that people are getting gamed every day in the financial world. People are exposed to dangers in their workplace. People are exposed to pollution in their environment because someone's gaming the system or not doing what they should be doing. It has real cost to people in so many ways. Your child might have cerebral palsy. If you can't get that child help early on, early interventions, if schools can't figure out how to make the best effort, that child's got a lot of trouble coming down the tracks. He or she is about to get sentenced to a very different life, because the education system isn't working. We have to pound away at it, and good oversight can provide the basis for decent laws. That's what we should be about.

"We're the people's house, we like to say. They have a big stake in what's going on. If we don't step up to engage in oversight, to engage in the investigations, to check whether or not this is really essentially right or wrong, who will?"

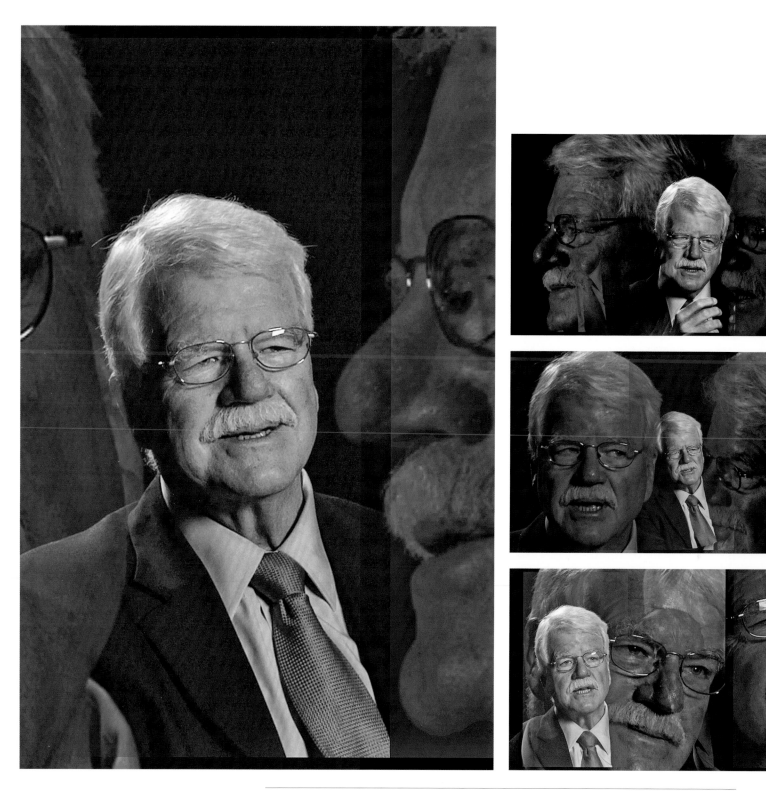

Congressman George Miller III

A longtime member of the US House of Representatives from the San Francisco Bay Area of California, George Miller has built a career dedicated to serving those in need. He has focused in particular on issues of education, the environment, and the workplace and on ensuring services that support the creation of opportunity for all Americans.

The federal government, at its best, is a facilitator, an enabler, and a cop on the beat. We have to keep renewing that cycle. We have to provide some of the foundations of an education, because obviously an educated population is important for democracy, and it's important for an economy. We need the idea of social security, the guarantee that we will keep you out of poverty if everything else goes wrong in your life. We look at healthcare legislation as being entrepreneurial. Some people think that it's the heavy hand of the government, but the assurance that you will never be without health care, or, more important, the means to pay for it, is critical. These are basic social foundations that enable the country to move, to create. They are the foundations of prosperity. This insurance allows a small businessperson to take a gamble. It allows for discovery. That's the dynamics of America. We can battle over the size of that government. At the end of the day, if you don't have any money, the government's going to pay for your health care for whatever reason. It's important that people know that they have coverage all the time.

The government shouldn't be in the way. But it should allow and maximize the ability of people to move within society and the economic system. That might be by building the interstate highway system, or passing the national Elementary Secondary Education Act, or helping people pay for college, or funding the National Science Foundation and the National Institutes of Health. Those are things that allow people the liberty to move across the society. If you're trapped by sickness, if you're trapped by dirty water, if you're trapped by dangerous neighborhoods, you have no such liberty.

Thirty percent of the students who graduate from high school in California are taking remedial English and remedial mathematics. That's a problem for the economy. It's also a troubling trend for a democracy for a number of reasons. We're trying to maintain a huge, diverse democracy. I say to young people in school, "The more education you have, the fewer people in the world can tell you 'No.' The more skills you have, the fewer people can tell you 'No.'" We've got to allow people to achieve. Everything else flows from that.

I'm George Mitchell.

I'm a former US senator. I left the Senate in 1995 and joined a law firm in Washington, which through a series of subsequent mergers became the firm of DLA Piper. I am the chairman. I served in that role for the first five years of the firm's existence, then reentered government as President Obama's special envoy for Middle East peace. I served in that position for about two and a half years and then returned to the firm. I now am based in New York.

My father's parents were born in Ireland. They immigrated to the United States, and my father was born in Boston in 1900. He never knew his parents. His mother died shortly after his birth, and his father couldn't care for their several children, so my father was raised in an orphanage in Boston. An elderly couple from Maine adopted him, and he grew up in the small town of Waterville, where his parents had a small store. There he met my mother, who was born in Lebanon in 1902. In 1920, when she was eighteen, she immigrated to the United States.

My father had a hard life. He worked in the woods in Maine. Many of the loggers were French-Canadian from Quebec, so he became fluent in French. Because my mother did not know English, my father also learned to speak Arabic fluently. So here was this young man who had no education but could speak three languages. Later he worked as a janitor, while my mother worked the night shift at a textile mill. My parents' principal goal was to see that their children received the education that they never had. All five of us graduated from college, and some of us went on to get graduate degrees.

My entry into public service was pure chance. I worked my way through college. I went to Bowdoin College in Brunswick, Maine, and joined the Army Reserve Officer Training Corps. After college I worked in Berlin in military intelligence. When I got out, I went to law school on the GI Bill. I worked for four years while going to law school as an insurance adjuster in Washington for the Travelers Insurance Company. My goal was to return to Maine to practice law, but I had no contacts there. One day I received a letter from someone in the US Department of Justice offering me a job as a lawyer. I accepted and worked as a trial lawyer in the antitrust division.

After about two years in the Justice Department, I received a telephone call from the administrative assistant to Senator Edmund Muskie of Maine. He said that Senator Muskie had a vacancy on his staff and wanted to hire someone from the state. I told Senator Muskie I would take the job on the condition that he understood that I was not interested in politics and that my goal was to return to Maine to practice law. I said that I would do my best for him, but I would commit only to work until the next election. This was in 1962, and he was up for reelection in 1964.

I stayed with Senator Muskie for nearly three years, then joined a law firm in Portland, Maine. By then I'd gotten interested in politics. So shortly after I went back, I became the chairman of the Maine Democratic Party. One thing led to another, and when President Carter appointed Senator

George J. Mitchell
A leader in law, business, and politics, George Mitchell, a widely respected former US senator from Maine, served as majority leader of the Senate, as special envoy for Northern Ireland under President Clinton, and as special envoy for Middle East peace under President Obama.

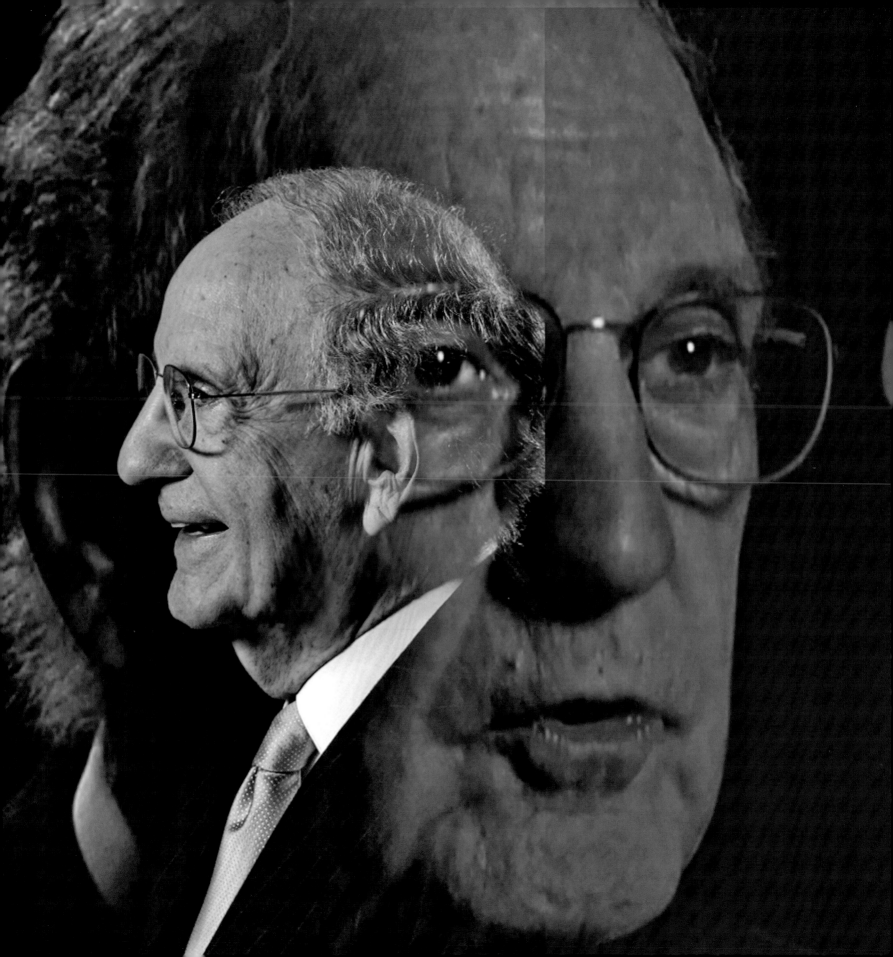

Muskie to be secretary of state, the governor of Maine appointed me to complete Senator Muskie's term. I later won election and went on to serve nearly fifteen years in the Senate, including six as the majority leader.

"Peace in the Middle East is of central importance to the entire world. An Israeli-Palestinian resolution of the conflict would be so valuable because it would permit countries that are now at odds with each other, the Arab countries, and Israel to look together toward their principal threat, which is Iran and its influence in the region."

I am the author of three so-called Mitchell Reports. In 2001, I made one as chairman of an international commission on violence in the Middle East. What became known as the second intifada, or Palestinian uprising, occurred or began in late September of 2000. Violence escalated very quickly, and a lot of people were killed. The leaders of the region and of the United States and other interested nations met in a summit in Egypt the following month to search for ways to deal with the situation. One of the suggestions on which they agreed was to create an international commission to look into what happened and prepare a report in a manner that would enable the parties to get back to talks. The parties agreed to ask me to serve as chairman of that international commission, which I did. My report was accepted by the government of Israel, the Palestinian Authority, the United States, and the

European Union—but then nothing happened. It joined many other studies on the dusty shelves of history, but it gave me a good insight into the problem.

When President Obama asked me in 2009 to return to the Middle East as his special envoy, my experience proved to be very helpful. Peace in the Middle East is of central importance to the entire world. An Israeli-Palestinian resolution of the conflict would be so valuable because it would permit countries that are now at odds with each other, the Arab countries, and Israel to look together toward their principal threat, which is Iran and its influence in the region. Right now, they're so divided that they can't present a common front to the real opposition. Iran is a threat to the region, but also to the world. There are now nine countries with nuclear weapons. Iran is trying hard to make that number ten. Iran with a nuclear weapon could cause the disintegration of the antiproliferation regime. We could end up in a world in which many nations have nuclear weapons. Imagine the threat then—not just because of conflicts between them, but also because of leakage to terrorists and other nongovernmental organizations. It's a serious problem.

An earlier Mitchell Report concerned Northern Ireland. The British and Irish governments asked me to serve in a variety of positions to try to end the conflict between Catholics and Protestants in Northern Ireland. There was a major issue in what, in their terms, was the decommissioning of paramilitary arms. There was a lot of conflict. There were paramilitary organizations on both sides. The best known in this country is the IRA, the Irish Republican Army. On the Protestant or Unionist side, there were several militia organizations. The British government had demanded disarmament prior to talks, but the paramilitaries wouldn't agree to that. The Mitchell Report formed the basis for the parties coming into talks, which the British and Irish governments asked me to chair. That negotiation lasted two years, and ultimately we were able to get a peace agreement, which, I'm pleased to say, has held to this day.

The third Mitchell Report involved the use of performance-enhancing substances in major league baseball. In the spring of 2006, the commissioner of baseball, Bud Selig, called and asked me if I would conduct an investigation and prepare that report. It took me about a year and a half. I released the report in December of 2007, and it got a lot of publicity. With the report on the conflict of Northern Ireland, we printed about three hundred copies, and we had a bunch left over. With the report on the conflict in the Middle East in the year 2001, we printed two hundred copies, and I don't think we distributed all of them. But when I did the baseball report, several million were downloaded. To this day, there isn't a week that goes by when I don't get someone writing me and asking me for a signed copy.

I'm Cecilia Muñoz.

I am the domestic policy advisor to President Barack Obama.

My parents came to the United States from Bolivia in 1950, as newlyweds. My father had studied here, as had my grandfather, both at the University of Michigan. My parents stayed here and became citizens. I was born in Detroit, but I've always understood myself as part of the immigrant experience. There has never been a time when that wasn't part of my consciousness.

We traveled to Bolivia when I was about six years old. It was my first experience seeing real poverty. It was the first time that I remember understanding that my life could be very different from my cousins' lives by virtue of the accident that I happened to be born in Detroit and they were born in Bolivia. It's a story that's replayed over and over and over again in this country, and as a country it is what makes us special.

There is a tradition of service in my family. I always understood that what I wanted to do with my life had to do with other people, and I feel incredibly lucky that I managed to find a path where that works. I never thought in a million years that I would end up at the White House, though.

"We are stuck in a terrible logjam on immigration reform right now. Six years ago, the US Senate passed a bipartisan comprehensive immigration reform. We had twenty-three Republican votes on that bill. The following year, the bottom fell out of the debate, and we have yet to recover."

I took my degree in Latin American studies and English. I did an undergraduate thesis comparing William Faulkner and Gabriel García Márquez, because I understood regional literature from my country and from Latin America to be comparable. It's the same thing as being an immigrant. You can be connected to more than one place at the same time. I got a lot of encouragement to study what I loved. The assumption was that if you study what you love and you learn how to think, you'll find your way; you don't have to worry exactly about where it's going to lead you. I've done pretty well so far. I was lucky to have that experience, and lucky to have parents and siblings and teachers who made that possible, and who gave me the space to just explore. I still reap the benefits of that, and I'm enjoying watching my children arrive at that place.

I'm a Roman Catholic, and it meant a lot to me to find a job with the Archdiocese of Chicago after

graduate school. I believe deeply in the social teachings of my church, and I was proud of so much of what I saw there. I also got a chance to see how decisions were made and to see how hierarchy works. I learned a tremendous amount, and I was part of an enterprise that provided a vital service to a lot of people. I helped form an immigrants' rights coalition that still exists in Chicago, and I learned a lot about the power of having multiple voices from different sectors come together and raise issues about the needs of particular communities. I learned the power of finding collaborative ways to work and discovered my voice as an advocate. I ended up running the legalization program for the archdiocese after the 1986 immigration reform law passed, and we served five thousand people in the course of a year.

There is a continuum of ways to make a difference. Direct service and community organizing are on one part of the continuum, and we need great people doing those things. Advocacy, public policy, and work in government are on another part of the continuum. We need great people doing those things, too. The key is finding out where your voice is strongest, where you belong, because that's where you'll be successful, where you'll make the biggest contribution to people. I learned that I'm an advocate, and that's where I belong on the continuum. That path led me into the civil rights movement, and now, into government.

When it was time for me to leave the archdiocese, I came to Washington. It was at a time when the National Council of La Raza was growing as an organization and developing a middle-management structure, and so I started as the immigration policy person at NCLR. I worked there for twenty years. I ended up running the entire public policy operation. Our job was really about explaining to official Washington who we as Latinos were. We were working from the very first census data reflecting the Latino community, because the 1980 census was the first one that asked questions about our educational status, economic status, and the like. We were doing sort of Latinos 101, explaining to the Reagan, Bush,

and Clinton administrations and to Congress who we are and our views on policy. We made the case that if we're going to move forward as a country, everybody has to move forward. You have to be deliberate about the folks who are falling behind in order to be successful.

I came in at a really fascinating time, as it turns out, in our community's history and in the country's history. I will always be proud of having played a little role at the moment when Latinos went from being invisible to being visible as a community, which happened around the 2000 census, when Hispanic Americans became the largest minority in the country. Suddenly, other Americans figured out that we were here, and they had a lot of questions about us. Our job was to communicate the answers to their questions, and chart a way forward for everybody.

Of course, we didn't just arrive here. It's our country, too. We see ourselves as agents of change. We're part of what's going to make this country a better place, what's going to catapult us into the future. It's a very positive, affirmative, optimistic vision, not just for the Latino community but for what it means to the country, that we are who we are, and that we're here, and that we

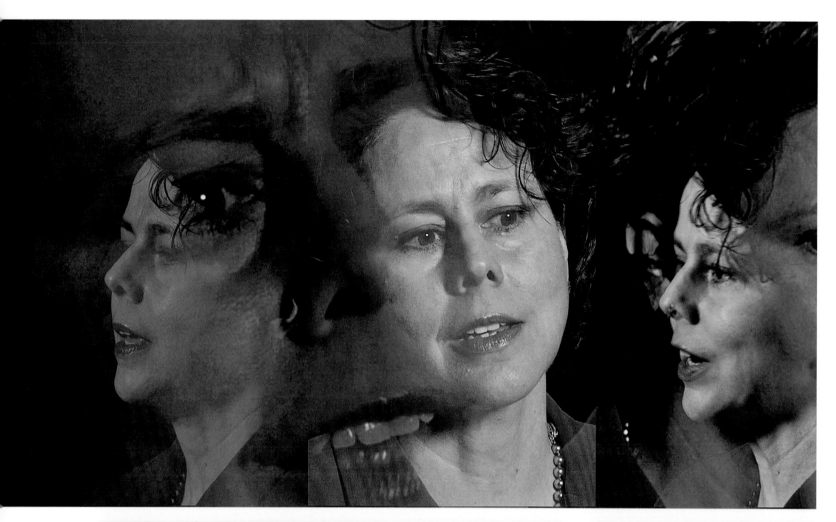

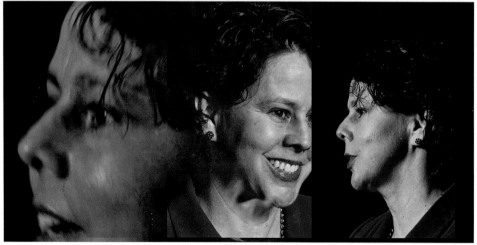

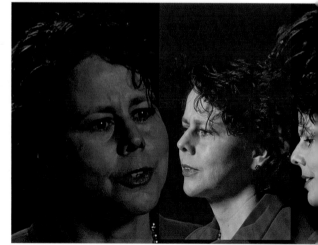

Cecilia Muñoz

Cecilia Muñoz, assistant to the president and director of the White House Domestic Policy Council, has served as an advocate for the Latino community for more than twenty-five years. She has worked at the forefront of immigration, civil rights, and other policy issues, receiving a MacArthur fellowship in recognition of her work.

arrived at this place understanding that we have a role to play in making sure everybody moves forward together, and that's how the country moves forward. That has defined my work, and it certainly informs what I do at the White House.

We are stuck in a terrible logjam on immigration reform right now. Six years ago, the US Senate passed a bipartisan comprehensive immigration reform. We had twenty-three Republican votes on that bill. The following year, the bottom fell out of the debate, and we have yet to recover. In 2012, we have no Republicans willing to even have a conversation with the president about immigration reform. Some of the same Republicans who voted for immigration reform six years ago are still there in the Senate, but they won't enter in the conversation with us. Our job is to break the logjam and create the space for the partners that we need so that we can get this done, because it's an economic imperative. It's not just something that we need to do to honor our history as a nation of immigrants, and a nation of laws, it's what we need to do to move our country forward economically. President Obama has a huge sense of urgency about this. But we don't have a single partner on the other side of the aisle, and without a few, we can't get it done.

I was born in the 1960s. We've seen incredible transformations in our understanding of discrimination and our ability to push back on it. We're not done yet, but it is not a small matter that I was born at a time of segregation, and before my fiftieth birthday, I was serving with the first African American president of the United States. As the president likes to say, we are so capable of becoming a more perfect union. That's the essence of who we are.

I'm Janet Napolitano.

I'm secretary of the Department of Homeland Security.

I grew up in Albuquerque, New Mexico, and attended public school all the way through high school. One of my first political memories was watching the Watergate hearings on television. I was enthralled by the people on the House and Senate committees, and I began to pay attention, read and watch the news.

When I graduated from college at Santa Clara, in California, I knew I wanted to do something in public policy, but I wasn't sure whether to go for a law degree, a graduate degree in economics, or something else. Peter Domenici, from New Mexico, was then on the Senate Budget Committee. He offered me a position with the Republican staff of the committee. I started as an intern, but soon thereafter one of the staffers had to leave, and they put me in a paid position. I worked on the windfall profit tax bill and the Chrysler bailout bill. There was no better place to see all of government and politics than in those big budgetary and financial decisions.

I decided to go to law school. After graduating from the University of Virginia, I moved to Phoenix. I didn't know anyone in Arizona, but I was trying to decide whether to move back to New Mexico or to the Bay Area, where I'd worked during law school. I decided to postpone the decision for a year, and in the meantime I got a clerkship with Mary Schroeder, a Ninth Circuit judge whose offices were in Phoenix. I piled everything I owned into my little Honda hatchback and drove across the country. I soon decided that Phoenix was a good compromise between California and New Mexico, so I stayed and joined a law firm. I was

an associate, then a partner. I was a commercial litigator and did a lot of appellate work, arguing in courts all over the United States.

At some point I decided that I was either going to be in private practice for forty years or that I would make the leap into public service. I knew that I wanted to eventually find some opportunity there. Even when I was in private practice, I saved all my money, because I knew that if I wanted to go into public service I'd probably need a little nest egg to work from.

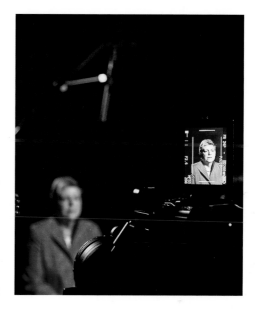

After Bill Clinton was elected president, the administration was looking for women to take some of the positions that traditionally had gone to males. One of those positions was the US attorney for Arizona. I didn't really have experience in criminal law, since I'd been a commercial lawyer, but it sounded like a great opportunity and a great learning experience. I was nominated and confirmed. I had a little bit of time between when I was named and when I actually took office. I was studying and reading, but that's not the same thing as actually running the shop. You've got the grand juries, you're approving warrants, looking at how to handle plea bargains, and doing all of the other things that go into criminal law and the effective

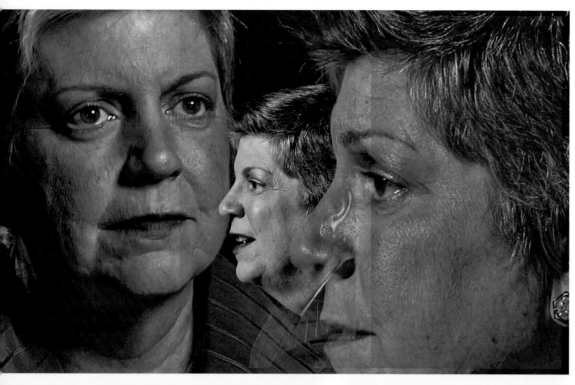

operation of a big district. We had a lot of border-related crime, and there's lots of Indian country in Arizona—and every felony in Indian country is prosecuted by the US attorney. I had homicides, I had rapes, I had aggravated assaults. It was the time of a lot of savings-and-loan fraud cases. So I had a little bit of everything.

After a little more than four years as US attorney, I campaigned for and was elected to the post of attorney general for Arizona. I served for a term, and then the governorship came open. I ran for governor and was elected. That first gubernatorial campaign was a real challenge. In a Republican state, you have to persuade people to cross over and vote for a Democrat. Following the election, I had to write a budget, appoint a cabinet, and just wait for the first crisis and the first mistake—because you're going to make a mistake, life being what it is. Part of the test of being a political leader is not whether you make a mistake, but whether you recover from it.

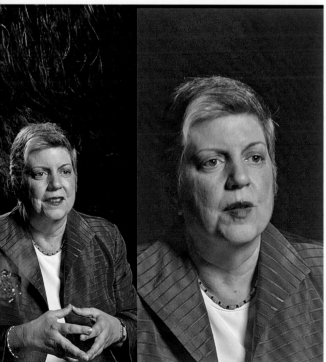

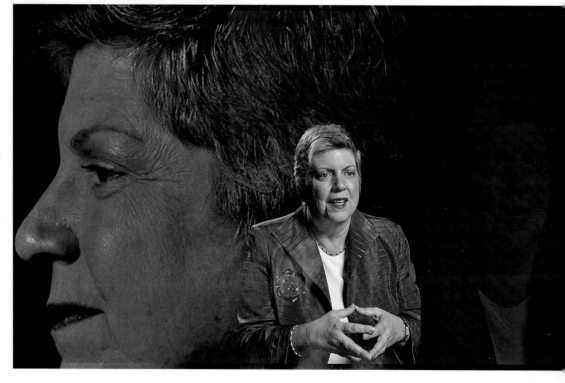

Secretary Janet Napolitano
A former governor of Arizona, Janet Napolitano was the first woman to win reelection to that post. As secretary of the US Department of Homeland Security, she strives to balance the need to protect Americans from terrorism, virtual and real, and to respond to such threats while respecting personal privacy.

The state had a deficit. We had to pass a new budget immediately to cure that. I had Republican leadership in both houses. Persuading them that we could work together and work through a new budget was another big challenge. I identified early childhood education as an area to work on, as well as investment in the scientific enterprise in Arizona, particularly our universities. Then came prison reform and making sure we ran our places of incarceration according to high standards. Those issues were the big ones that I worked on for my six years as the governor.

I had been an early supporter of President Obama, and I knew that they would be looking for people to fill the cabinet after he was elected president. It was interesting, though, how I got the call. It wasn't the Sunday after the election, but the Sunday after that. I play tennis on Sunday mornings. I came home from playing tennis and the answering light was beeping on my phone. The message was, "Hey, Janet, it's Barack. Give me a call." I wrote down the number, then hit the erase button. Then I thought, "Oh man, I just erased the president-elect of the United States. That's so wrong."

We had a good conversation, and I asked for a few days to think about it because I would have to leave the governorship. That would mean turning the governorship over to a Republican under the rules in Arizona. It would mean a lot of dislocation—not just for me, but also for the staff and everyone else, and not least for the people of the state who'd voted for me. But I believed then and I believe now that when the president calls and says, "I need your help. I need you to do this job," you should answer, "Yes, absolutely."

I run the third-largest department of the federal government. It represents the largest reorganization of the federal government since the creation of the Department of Defense. I have responsibilities for counterterrorism. We were formed after the terrorist attacks of 9/11. I have responsibilities for all border security, land, air, and sea. I have responsibilities for immigration enforcement. I have responsibilities

for cybersecurity and securing the civilian side of cyberspace. I have responsibilities for disaster response. Those are the five fundamental functions of our department.

The terrorism threat is real. Terrorism didn't start with Osama bin Laden, and it didn't end with his death. We have al-Qaeda and all its offshoots to deal with. There are other terrorist groups representing different ideologies. We have our own domestic groups as well. When we think about an existential threat in the United States, we still have to be concerned with terrorism. But we have to balance this with privacy and other concerns. How do you make sure you accommodate privacy? How do you make sure you're not racially profiling? How do you make decisions that are based on intelligence and causal factors, and not just on stereotypes? It's a constant challenge.

I want Americans to know that we wake up in the morning thinking about what we need to do to make sure the country is safe, and we go to bed at night wondering whether we've done enough.

I'm Tom Nides.

I'm the deputy secretary of state, working for Hillary Clinton. I joined the State Department in January 2011 after spending the previous decade in the financial service industry on Wall Street.

I grew up in Minnesota. In high school, I got Vice President Walter Mondale to be our commencement speaker. Introducing him started my career in public service.

I was an intern for Mondale for two months at the White House, when he was vice president under Jimmy Carter. The other intern was none other than Amy Klobuchar, who is now a senator from Minnesota. Amy claims that she did all of the work. I'm not exactly sure that's true. But we spent the summer of 1980 in the White House, and then I went back to college, graduated from the University of Minnesota in 1983, and went to work on Walter Mondale's presidential campaign. That began my time in politics.

After the campaign was over, Mondale picked up the phone and called Tony Coelho, who was then chairman of the Democratic Congressional Campaign Committee, and I went to work for him as his PAC director, the fundraiser for the campaign committee. For good or for bad, Tony Coelho was the godfather of political fundraising. He did such a good job that he became the next majority whip, the third-ranking member of Congress. I went with him to the Capitol, and I spent the next seven years working there.

Then Tony Coelho decided to resign from Congress in the middle of his term. Tom Foley, who was then Speaker of the House, asked if I would come work for him. I did, until 1992, when Bill Clinton won the presidency, and I went to work for Mickey Kantor, who was the US trade representative, as his chief of staff.

Tom Foley was a gentleman's gentleman. He let his staff have an enormous amount of authority. I hope I didn't take advantage of that. But, as we all know, what goes up comes down. I was well aware that the opportunity to be Mr. Big is very fleeting: You'd better take advantage of it, but also make sure you understand that this is not about you. For those of us who have been lucky enough to serve in the public sector, just as in the private sector, you're going to see the same people on the way up as you're going to see on the way down, and you'd better remember that.

I've been very fortunate. But I find myself in situations all the time where I have to decide: Do I

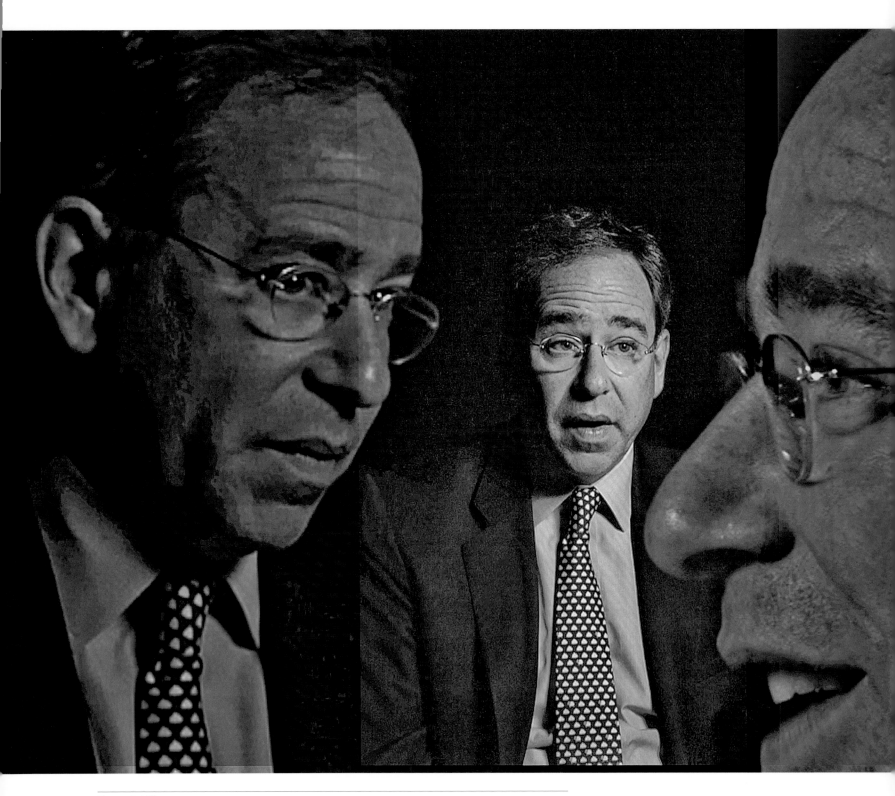

Thomas R. Nides

Tom Nides is deputy secretary for management and resources at the US Department of State. He has held significant positions in the public and private sectors, including assistant to the majority whip, executive assistant to the speaker of the House of Representatives, and chief operating officer of Morgan Stanley.

want to return that phone call? Do I want to help that person look for a job? Do I want to be a jerk, or do I want to be considerate? I constantly remind myself that I was in the same position as that person was a few years ago, and I might be back in that position again some day. I was brought up to understand that you should serve, you should do well, but you should also remember that there are a lot of people who aren't as lucky as you are. As someone who's been lucky both in politics and in business, I well understand that we're all flying very close to the sun and we can get burned any day.

In any event, in 1998 I joined Fannie Mae. I worked for Jim Johnson, who was the chairman of the Mondale campaign in 1984. I worked on the Partnership Initiative, which we used to build partnerships with local communities around the country around homeownership. You know, everyone now talks about how bad Fannie Mae and Freddie Mac are, blaming the financial crisis on them. But let's be clear. Homeownership stabilizes neighborhoods. It reduces crime. It's a great way to save money. Fannie Mae was at the forefront of all that. I was proud of my service there, and I worked at Fannie Mae for two and a half years before leaving to go for my first stint on Wall Street.

I went to Morgan Stanley. I stayed there for fourteen months. Morgan Stanley was going through its own upheaval, and it was merged with a company called Dean Witter at the time. So I resigned and went back to Fannie Mae, where I ran human resources, corporate services, and a variety of other functions. I was at Fannie Mae for another two years until I left again for Credit Suisse First Boston.

In 2000, I took a leave of absence and ran Joe Lieberman's vice-presidential campaign with Al Gore. I was heavily involved in the whole issue in Florida. The Florida ballot initiative and the hanging chads and all the nonsense that we went through in 2000 taught us that elections have consequences. Supreme Courts do matter. Governors do matter. In 2008, John Kerry could have won that election if he had won Ohio. He didn't lose Ohio by very

many votes. All these elections are very close now. There's no question about it. This country is completely and evenly divided. One state, one precinct, can change the direction of the country. How would the country have been different if Al Gore had won in 2000, and not George Walker Bush? Would have we been in Iraq? Would we have made the same decisions on tax cuts?

Every vote does count. There's nothing I hate worse than a bunch of clackers who sit around and complain about politics, complain about politicians, complain about participating, people who say, "My vote doesn't matter. It doesn't count." Now, in my new job, I travel around the world, to places like Afghanistan and Iraq and Pakistan, and I see what our soldiers are doing defending the rights of people to vote, and I say, you'd better get out there and participate. You have no right, in my view, to complain unless you get involved. I don't care if you're a right-wing Republican or a wacky liberal or wherever you are in between—it's irrelevant to me. You need to be educated. You need to be smart. You need to get in the game.

The Constitution was set up so that people like me couldn't just come in and make wholesale changes. I think I'm a pretty good guy. But who knows? Some people might think I'm a complete jerk, and I accept that. I'm under no illusions. I'm just one person filling a job for a period of time. I'm lucky to be here. It's an honor for me to work at the State Department, because of all the jobs I've had, it's by far been the best thing I've ever done. It's good to be in the game.

I'm Grover Norquist.

I run Americans for Tax Reform, a national taxpayer group. I've done that for twenty-five years. I have a series of other project lines as well. I serve on the boards of directors of the National Rifle Association; the Parental Rights Organization, which works on school choice and parental rights in education; and the Nixon Center, which is committed to a realist foreign policy effort as opposed to running empires. I also run the Wednesday meeting of the Center Right Coalition in Washington, D.C.

I was political early. In 1968, when Nixon was running for president, I was twelve years old. I worked on his campaign, taking the train into Boston from the suburbs. I was for Nixon as opposed to Rockefeller. I was largely an anticommunist conservative concerned about the nature of the Soviet Union and the expansion of the Soviet empire. From that began an interest in liberty questions in general and how best to defend liberty in the United States.

In 1974, I went to Harvard as an undergraduate, focusing on economics. I was reasonably free-market going in, but I became more so over the course of my college years through studying microeconomics, which is how economics works—prices and costs and demand curves and so on. I also took pre-med courses in chemistry and a lot of mathematics, but I focused on economics and politics. I worked at the Harvard *Crimson*, a left-of-center student newspaper. I wrote some articles, but I mostly worked on the business side there. I was also active with the Harvard Libertarian Association and the College Republicans.

I graduated with an economics degree, came down to Washington, and became associate director and then executive director of the National Taxpayers Union. This was two years before Ronald Reagan was first elected president. Then I went to Harvard Business School for two years. I returned to Washington, worked with the College Republicans and Americans for the Reagan Agenda, and then was the chief speechwriter for the US Chamber of Commerce. Then the Reagan people set up Americans for Tax Reform and asked me to run it. They incorporated it, put it all together, gave me a board of directors, and handed it to me. That's the group I've run every since.

Ronald Reagan was focused on liberty. He took national security seriously, but he focused on freedom domestically. Taxes are important in that because they are the central meeting point between the state and individuals. If taxes are going up, liberty is declining. If taxes are growing, the state is growing.

What you want is a government that protects liberty and your property. When governments grow beyond that, as throughout history they have tended to, they become abusive of liberty. If you want a competent government doing those things that make people free, you want it to keep from growing.

There are some legitimate functions of the government. National defense is one of them. Critics of the freedom movement say, "Oh, you're against government." That's like saying cancer doctors are against cells. Cancer doctors like cells; what they object to are cells that are reproducing so quickly that they threaten to kill the person who thought they were his friends. Governments also can grow and become too abusive, in taking both people's resources and their lives and freedom. You want a limited government doing a limited number of things; otherwise, the government should leave you alone. You're free to run your life as you see fit. You're allowed to make stupid mistakes. You're allowed to have the wrong religion. You're allowed to spend Saturday lying around instead of doing something else. That's your business, not the government's.

I would like to see the government act in a way that people are confident that it will continue to act properly. We should never have faith, however, that even the best-run government will continue to do so. The whole point of the Constitution is that you can't trust these guys. The men who wrote the Constitution said, "Don't trust us—don't trust the government to run your life for you. Keep an eye on it."

The Taxpayer Protection Pledge is a simple statement that a congressman, a senator, a state legislator or governor or president, a candidate for office or an incumbent, signs and by doing so says, "I promise the voters of my state and the American people that I will vote against and oppose all efforts to raise net taxes." It's very simple. There are two witnesses. The statement is dated and put up on the web; copies are made and handed out. The pledge is the same wording in all fifty states, all 435 congressional districts, all 7,400 state legislative districts around the country.

The pledge has made it possible since 1986 for a candidate for office to credibly commit to voters that he or she won't raise your taxes. People run for office saying, "I'd rather not raise taxes. I really don't want to raise taxes. Raising taxes now is not a good idea." Such people have not promised not to raise taxes. They have just told you how pained they will be when they raise your taxes. There are many politicians who say, "I won't raise your taxes,

but I won't sign the pledge." Those people all raise taxes. People who put it in writing who almost never break it.

Now, we did have George Herbert Walker Bush, who signed the pledge running for president in 1988. He then said, "Read my lips. No new taxes." He had been seventeen points down to Michael Dukakis, but that won him the election. Two years later, he raised taxes. He had a very successful presidency. He managed the collapse of the Soviet Union without a lot of blood on the floor. He pushed Iraq out of Kuwait and didn't get stuck occupying the place for a decade. He had a very successful presidency, except that he raised taxes. And then he lost to a nobody out of Arkansas. Why? Because he raised taxes.

"What you want is a government that protects liberty and your property. When governments grow beyond that, as throughout history they have tended to, they become abusive of liberty. If you want a competent government doing those things that make people free, you want it to keep from growing."

The Taxpayer Protection Pledge is the commitment to reform government and have it cost less. You can't get to reform if taxes are on the table and available to the politicians. Tax reform is fine. If you want to raise one tax, cut another one. If you want to create a new tax, get rid of an old one. Tax reform is fine as long as it's not a Trojan horse for a tax increase.

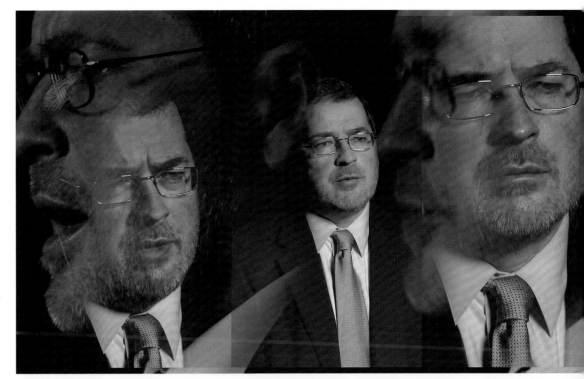

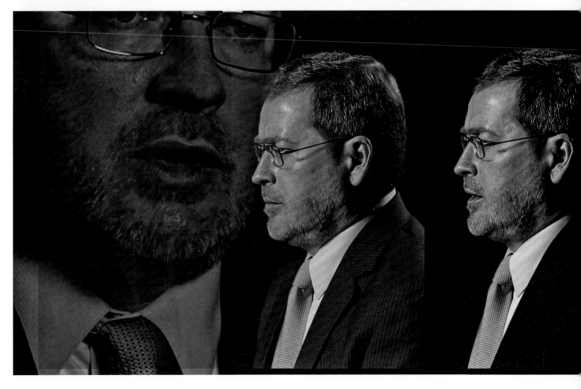

Grover G. Norquist
President of Americans for Tax Reform, Grover Norquist is an influential voice among conservatives and a frequent commentator on conservative television and radio programs. Dedicated to limiting federal authority, he opposes any rise in taxes, and encourages conservative candidates to commit to a pledge not to raise taxes.

I want to work with Americans for Tax Reform to where we reform government so that it costs less and is more effective. It's all about getting more control and more freedom into individuals' hands, maximizing liberty here and, by example, maximizing liberty internationally—not by showing up with troops and telling everybody in Zaire to behave, but by doing it right here so that the people in Zaire say, "I'd rather do it that way than our way."

I'm Sandra Day O'Connor.

I served twenty-five years as the first female justice on the US Supreme Court.

I grew up on a cattle ranch in Arizona and New Mexico. My grandfather started the ranch in 1880 on land that was acquired by the United States in the Gadsden Purchase. After he died, my father took it over. He was nineteen years old and had no intention of spending his life there; he was going to go off to college to do I don't know what, but instead, he was packed off to keep the ranch going until the estate was settled. It took fifteen years before that happened, which involved litigation that went all the way to the US Supreme Court.

I lived with my grandparents in El Paso, Texas, and went through grade school and high school there. I did well. The only place I applied to college was to Stanford University, which was very unrealistic. But it was 1946, at the tail end of World War II. Many young men of college age had gone in the service, and most of the colleges and universities were short of students at that time. Stanford accepted me.

In my third year, I took a class about the law from the most inspiring professor I ever had. Because of him I decided to apply to law school, and, to my amazement, I was accepted.

I finished law school, and I didn't know what I would do. I was young and poorly informed about opportunities for women. In the meantime, I had met John O'Connor. He was a year behind me in law school. We got engaged and were married at my parents' Lazy B Ranch. I had to work, because John still had to finish law school. I tried to get a job. Not a single firm would give me an interview. They said, "No, we can't talk to you. We don't hire women." I was shocked.

I heard through the grapevine that the county attorney in San Mateo, California, had once had a woman lawyer on the staff. I made an appointment to see him. He said, "Oh, Ms. Day, you have a fine résumé here. The problem is, I'm not funded right now to hire another deputy, and I don't have an empty office to put another deputy in."

So I went back to the Lazy B, and I wrote him a long letter telling him all the things I could do if he hired me. I said, "I'm willing to work for you for nothing until such time as you can get funds to pay me. I know you don't have an empty office, but I met your secretary, who's very nice. There is room in her office to put a second desk if she wouldn't object."

That was my first job as a lawyer. No pay, and my desk was in the secretary's office. But I loved my work. It was fabulous. Then after about four months the county attorney was appointed to be the county judge. His deputy took his job, and that opened up a room and a salary. So it all worked out, but it was a hard way to get a job.

John was drafted into the Army. We lived in Germany for several years. Afterward, he interviewed with a law firm in Phoenix, Arizona, and they offered him a position. One of my classmates in law school had married and settled in Phoenix—a man named Bill Rehnquist.

Justice Sandra Day O'Connor
The first female US Supreme Court justice, Sandra Day O'Connor joined the court in 1981. Her appointment followed a career in public service in Arizona. Since retiring, she has dedicated herself to creating a Web-based program, iCivics.org, to teach children about American government. She received the Presidential Medal of Freedom in 2009.

Living up on the hill nearest us was a man named Barry Goldwater, and there were other notables in the area.

We settled in and made good friends. I became a precinct committeeman for the Republican Party, and John became the chairman of the Young Republicans in the Phoenix area. I tried to get a job in Phoenix as a lawyer, but none of the law firms would hire a woman lawyer. I met a young man who came from the East Coast, and he didn't have any contacts in Arizona, so we decided to open a little office. We did whatever legal work came in: a divorce or child custody issue, a collection issue, a minor accident, whatever the dispute was. We both took criminal defense appointments, and that helped pay the rent.

"The American public as a whole is not well educated on the role of judges or on the role of the US Supreme Court. I think there is a lack of understanding and appreciation of our system and how issues are resolved."

After I'd been there two or three years, there was a vacancy in the Arizona State Senate from my legislative district. My little law practice wasn't doing all that much, and I thought I could keep that going and do the state senator's job because it was not full-time. So I became a state senator, and eventually I became the majority leader, the first time in the United States that a woman had held a leadership position in a state legislature.

Ronald Reagan ran for president. He was a captivating candidate. He said that if he were elected president and had a chance, he would like to put a qualified woman on the US Supreme Court. He was elected, and he hadn't been there

more than four or five months when Justice Potter Stewart announced his retirement from the Supreme Court. It wasn't too long after that that I got a phone call. I had become a judge in Arizona, and I'd ended up on the Court of Appeals in Arizona. Ronald Reagan was on the phone, and he said, "Sandra, I'd like to announce your nomination for the Supreme Court tomorrow. Is that okay with you?"

Frankly, my heart sank. I didn't really want the job. I liked my life in Arizona. I talked to John about it, and he said, "Of course you have to do it." I said, "Yes, but you'll have to give up your position in the firm. We'll have to move to Washington." He said, "That's fine, you have to do it." And that's what happened. We moved to Washington, and I was sworn in as the 102nd justice to serve on the Supreme Court—and the first female.

At the Supreme Court we had to review all the petitions and decide which cases to take. All the cases the court took were ones in which there was a division of opinion in the courts below and good arguments could be made on either side. Every one of the cases was a challenge.

The American public as a whole is not well educated on the role of judges or on the role of the US Supreme Court. I think there is a lack of understanding and appreciation of our system and how issues are resolved. That is one reason why, after retiring, I helped start a website, www.iCivics.org, to try to teach young people about our system. Today half of the states no longer make civics and government classes a requirement in school. Our young people know very little about how our government works. I hope that my website will help close the gap in civics education. It is entertaining and effective. It is also free for students and teachers.

I am happy to have been a part of developing it. Teaching young people about how our government works so that they can be good citizens is critically important.

I'm Ray Odierno.

I'm the thirty-eighth chief of staff of the US Army.

I grew up in northern New Jersey, in an Italian American family. My father and mother stressed the importance of family, set high ethical standards, and emphasized education as the foundation for success. My father and two uncles were in World War II, and their selfless service to our country was very appealing to me.

When I was in high school, I played baseball, football, and basketball. I had nine letters in high school sports and was on the state championship football team. I was drafted by major league baseball. However, I decided to attend West Point as a football recruit. From an early age, I was drawn to sports because of the camaraderie, and I liked being an individual who was able to operate within a team.

I entered West Point in 1972, at the height of the Vietnam War. Not a lot of people wanted to be in the military and were worried about the draft. But something about West Point drew me to it—it was what the institution stood for, and the people who had gone before me. It was both physically and mentally challenging, which also appealed to me. West Point just fit.

I began Operation Desert Storm as a field artillery battalion executive officer, responsible for the deployment, maintenance, and readiness of the unit. Later, I was promoted and was responsible for advising the division commander on employing fires. In this job, I was able to watch how a senior leader went about making decisions—how the commander got the necessary information to make the right decisions. As I've become more senior as a leader, I've learned that it's about how you manage information in order to make the right decision at the right time.

As a division commander, a corps commander, and a theater commander, I learned that the real challenge is that with large staffs, and as our information technology grows, we're gathering more and more information. What's the critical information? How do you share that critical information, and how do you collate it in such a way that you can make the right decision? As a leader, you have to work out those questions. You can't have somebody else do it for you. To me, this is one of the most critical things you do as a leader.

But leadership isn't just collecting information, sitting in a building with your staff. It's about leading from the front. You've got to be out there. You've got to be able to see it, smell it, and sense it. You've got to understand what's happening on the ground in different areas. That allows you to make informed decisions at the right time.

"My responsibility is to ensure that we are ready for the missions we'll be asked to do, and that we continue to modernize our force in such a way that we'll be able to meet our commitments today and into the future."

In Operation Iraqi Freedom, I commanded the division that captured Saddam Hussein. At the beginning, if you remember, we had baseball cards with pictures of the top fifty-five war criminals in the Hussein government. We picked up quite a few of those individuals, but none of them had any connection to Saddam Hussein. We learned, in the summer of 2003, that a more personal network made up of family members and close associates were protecting him. We worked very closely with the special operations forces, sharing information

General Raymond T. Odierno, USA

Over nearly forty years of military service, General Raymond Odierno has commanded units at every echelon, from platoon to theater, with duty in Germany, Albania, Kuwait, and Iraq. As the chief of staff of the US Army, General Odierno is responsible for staffing, training, and equipping a force ready to win the nation's conflicts.

and intelligence in order to go after these difficult targets successfully. After four or five months, we knew we were very close. Lots of people asked me, "Where do you think Saddam Hussein is?" Other people said, "I think he's dead," or "I think he's in Syria." I'd tell them, "Nope. He's right here. We will find him in the next few months." Finally, we got actionable information about the location of Saddam Hussein, and we picked him up. Finding him was essential for Iraq to move forward.

I was reassigned to the Pentagon not long afterward. In the beginning, it was a little frustrating. I wanted to be directly involved in shaping operationally what we would do in our current conflicts. But it was probably the best thing that ever happened to me, because I got to spend so much time with what I consider to be two incredibly intelligent and strategic leaders, Colin Powell and Condoleezza Rice. I traveled around the world with Condoleezza Rice. I got to meet presidents, prime ministers, and kings. In many cases, I got to meet the chiefs of defense. I think we ended up going on eighty or so different trips, to almost every country around the world. It helped me tremendously, and still does today, in understanding the importance of a civil-military relationship as we attempt to solve complex problems.

I returned to Iraq as a corps commander. A week after I took over, Robert Gates became the secretary of defense. On his second day on the job, he came to Iraq with the chairman of the Joint Chiefs of Staff, and they asked me my opinion about what to do. I told them, "I think we need to have more troops here. That's the only way we can turn this thing around." Leading up to this deployment, I had concluded there was a security gap. The Iraqi government was fragile. It was not yet able to provide what the people needed: security, jobs, and basic needs. The insurgents were trying to fill that gap. We needed to get there first to buy time for the Iraqi government to develop itself.

A week or so later, we got the word that the president of the United States was going to support the surge. Many people believed it would not work. The headlines back then called it a failed strategy. This was the toughest time in my Army career. I believed in what we were doing, but I also knew it was going to initially cause more casualties. Additionally, I had to extend units from twelve to fifteen month deployments, which is significant for soldiers with multiple combat tours. I spent the next thirty days out talking with leaders, soldiers, and Iraqis leading the change and articulating a vision for the future. That is what leaders do. In the end, we succeeded because our great men and women in uniform persevered.

Leading these incredible young men and women is rewarding. I tell my soldiers that if you are not passionate about what you are doing, you're in the wrong business. You have to be selfless, dedicated, set high standards, and be willing to make tough decisions. And if you don't enjoy your work, you don't get what it means to be a leader. You have to be willing to learn everyday because lives depend on it. You have to uphold the moral and ethical tone of our country. You have to be firm but fair.

As the chief of staff, I'm responsible for training, equipping, and manning the US Army—1.1 million soldiers, 275,000 civilians, and 1.4 million family members. My responsibility is to ensure that we

are ready for the missions we'll be asked to do, and that we continue to modernize our force in such a way that we'll be able to meet our commitments today and into the future. It's a big job, and it's an incredibly satisfying one.

I'm Farah Pandith.

I'm the special representative to Muslim communities at the State Department.

I was born in northern India and came to Massachusetts as a baby. I was raised by a single mom, a physician who was very focused on the importance of serving the community around her. When I think about the issues surrounding the subject of equality and the importance of giving respect to differences among races, religions, heritages, and so forth, it is through her teaching that I became the person I am. The experience of how my mother spoke about her patients is one example. She worked for a county hospital. Usually, at that time, immigrants like her entered private practice and made a lot of money. I remember asking my mom, "Why are you working for the government? Why are you working for the county hospital?" My mother said, "Everybody deserves dignity, Farah, and everybody deserves the best quality care that they can get. Somebody has to treat these patients, and I am honored to do so."

Her brother was a thoracic surgeon in Boston, and he would say, "When I operate, a Jewish heart and a Muslim heart and a Christian heart are exactly the same." Together they provided a respectful ethos that was very much embedded in the way in which I grew up. My uncle got us involved in the Islamic Center of New England at the time so that we could learn about our religion. They balanced being a proud American and being a proud Muslim.

There was no contradiction between the two. I learned from them.

In the spring of 1989, I was a junior in college and had just been elected student body president of Smith College. All year long some really horrible events had been taking place: a cross-burning on the front lawn at Amherst, racial incidents at Yale. At Smith, in the spring of 1989, someone left a threatening note on the door of a woman of color.

"By connecting and building networks, highlighting different voices, showing different faces, we are beginning to change the narrative."

Because of that incident, at the traditional opening convocation before the whole student body that fall, I gave a speech about diversity and mutual respect. The First Lady of the United States, Barbara Bush, was in attendance. I gave the speech, and the next day the White House called to say that the First Lady really liked the speech and wondered if she could have a copy. I faxed it to her. When I look at the trajectory of my life, it began there, because Barbara Bush started quoting me. She quoted me all through my senior year. And we started to correspond, I a senior in college and she the First Lady. I would write her a note, and she would handwrite a letter back. My first job out of college was serving in the Bush administration in the early 1990s as a political appointee. I was a junior staffer at the US Agency for International Development.

On 9/11 I was working in Boston in the private sector. I was vice president of international business for a company. My office was on the forty-first floor, overlooking the Bay and Logan Airport. I remember looking out on that perfect sunny day as we were getting news of what was

taking place, talking about the fact that people had stepped onto a plane from Logan. And I remember feeling dread inside, thinking about who was responsible for this and what was going to happen, certainly in the days following when the name of Islam was being used. I remember having a very personal reaction—and I still do—that some crazy man in a cave in Afghanistan was defining my country and my religion.

I reentered government in 2003 because of my reaction to what happened on 9/11. I was a political appointee to the US Agency for International Development, which is where I had worked in the first Bush administration. Later I went to the State Department. Twenty years after my first job in government, I was part of the team that briefed Hillary Clinton, the new secretary of state. I briefed her on Muslims in Western Europe. She was immediately interested in the trajectory of this generation of young Muslims in the West and how we could make a difference, the themes that I am dealing with right now. There are 44 million Muslims there, and they certainly are not the same: A Turkish German Muslim is having a very different experience from someone of Arab descent, who is not having the same experience as an Iranian.

We have to be sophisticated about how we think about things. When I think about the youthquake that is taking place on the planet right now, we are moving in ways that we didn't even expect to move. Everybody is focusing on what's happening in the Middle East, but I can have a very engaged conversation with you about Mauritania or Tajikistan or Indonesia, whose young people also want to be heard. They have something to say. And their ideas matter. We have got to make sure that we are engaging with them because we will miss this moment in time if we don't.

There are several things that we have done in my office to make sure that we are listening. One is to make ourselves absolutely accessible. So I am on Facebook, I am on Twitter, I am tweeting and reading the tweets that come in, sharing stories in real time. In many ways we are talent scouting

with technology; we are seeing really great people around the world and connecting them to each other so they can create their own networks. It's not government speaking to government about what's taking place; it's people speaking to people. The community-to-community approach makes a difference, and that an average person can interface with a senior US government official is pretty mind-blowing.

I am focused on young people under the age of thirty, a generation of change makers who are connected in new ways. We are building networks of change makers around the world. Some of the frames that are being built go back, of course, to 9/11, where there is this concept of an "us" and a "them." President Obama has said, "There is no us and no them—there is just us."

By connecting and building networks, highlighting different voices, showing different faces, we are beginning to change the narrative. We cannot forget that there are ideologies that preach violence and extremism, that prey upon vulnerable communities in different parts of the world. I see this everywhere; whether I am in the Maldives, in The Hague, in Central Asia, or in Africa, young people say to me, "We have to do more to push

Farah Anwar Pandith

Born in India and raised in the United States, Farah Pandith is the first special representative to Muslim communities in the US Department of State. Galvanized by the events of September 11, she has focused on developing new models of engagement between the West and Islamic society.

back against this extremist narrative. This isn't going to happen, this isn't the world we want to live in."

Ten years after 9/11, more and more initiatives come directly from Muslims themselves who say, "Don't use the name of Islam. Don't bring this ideology in here." We have to do more to amplify those voices. We have to do more to give opportunities for these young people to be connected to each other so that they are the voices that are heard, not al-Qaeda and others who are preaching that there is an "us" and a "them."

I'm Nancy Pelosi.

I'm the Democratic leader of the House of Representatives. I had the honor of serving as the first woman Speaker of the House of Representatives. My biggest honor politically, though, is to represent the people of San Francisco in the Congress of the United States.

When I was born, my father was a member of the House of Representatives from Baltimore, Maryland. When I was in first grade, he became the mayor of Baltimore, and when I went away to college, he was still the mayor. I grew up respecting public service as a noble calling of being attuned to the needs of people in the community. My mother was not an elected official, but she was a public servant in a volunteer sense. She was all about fairness and opportunity. This was a long time ago, so politics was not defined by where you stood on the environment or a woman's right to choose and all the rest. It was largely about

Congresswoman Nancy Pelosi
Elected to Congress in 1976 from California's Eighth District, Nancy Pelosi became the first female speaker of the House of Representatives in 2007. She now serves as the Democratic leader of the House. As a congressional leader, Pelosi has worked for campaign finance reform and to establish public-private partnerships.

fairness in our economy and giving everybody a fair shot. That's what drives me. People ask, "How do you have the energy to continue to do what you do?" I reply, "It's the one in five children in America who live in poverty." I pray for them morning and night and work for them during the day. That principle was driven into us: We all had responsibility to lift people up.

In 1976, I was a library commissioner in San Francisco. I was a friend of Leo McCarthy, who was the speaker of the assembly in California. Our governor, Jerry Brown, wanted to run for president. My family was involved in his campaign in Maryland, where he won. How on earth could he have won Maryland against Jimmy Carter when Jimmy Carter was on the rise to become our nominee? When we went back to California a couple of days after the victory, Jerry Brown said to a huge, roaring crowd, "Nancy Pelosi was the architect of my victory in Maryland." I soon became involved in the California Democratic Party, first as a member of the state central committee, later as the chairperson. My children were in school all day, and I could do that. Just a few years later, our congresswoman became ill, and she called me in and said, "You have to run for my seat." I didn't think that would be possible. She insisted that I run. She passed away just a few weeks later, and I kept my promise to her and ran. That was my path to Congress.

The most exciting part of serving in Congress is that you're learning constantly. One minute it's the environment, another minute it's health care, and another it's education, international peace, disarmament, you name it. Said Sala Burton, the former congresswoman, "You're going to love the issues. You like the politics because you like the issues. You've worked on the politics. Now enjoy the issues." I didn't realize that the intellectual stimulation would be so overwhelming and so fabulous, and that's what I love about it.

When I came, there were very few women, perhaps twenty, in Congress. There was that challenge, but by and large, it was hospitable in

terms of opportunity, with so many issues to work on. When we lost in 1994, I thought, "You know what? I know how to win elections. If I had a bigger role, I could turn this around." People supported me. I had a broad base of support around the county. We couldn't wait for lightning to strike. We had to go out there with a plan to get it done. We did, and I became speaker.

You have to have vision. You have to know what's going on. You have to have a plan to get it done. And you have to attract people to it. That's about leadership provision, knowledge and judgment, plan and the ability to attract people to it. When George W. Bush was president and he was going to privatize Social Security, we decided that we would fight it, since preserving social security was a central core value of the Democrats. We stayed disciplined, and we won.

To be the speaker of the House is a very big deal. It's the third highest office in the land, after the president and vice president. One thing the speaker needs to take leadership of is ethics reform, so that Congress operates at the highest ethical standard. It was my view at that time that the previous control of the House had created a culture of cronyism, incompetence, and corruption. People in government were being indicted all over from one week to the next. We tried to drain the swamp. Right now, to restore the public trust, I think it is important to reduce the role of money in campaigns and in elections. You have a recent Supreme Court decision, *Citizens United v. Federal Election Commission*, that in my view seriously undermines what our founders had in mind: that the voices of the people and the votes of the many would determine the outcome of elections, not the bankrolls of a few. The Supreme Court turned that ideal upside down. I promise you this: If you reduce the role of money in campaigns, if you stop the voter suppression accompanying that, and if you elevate civility in the campaigns, you'll have more women, more young people, and more minorities elected to public office, and that would be a very wholesome thing.

We Democrats believe that there has to be a public-private partnership for advancing our county, whether it's the economy or the education of our children or the protection of our nation. If you don't believe in government, it's hard to find common ground. It isn't important about who wins elections. It's important how we sustain the values of America, how we sustain the American dream.

The American dream is the most enduring theme of America from the beginning of our country. Our founders did something nobody on the face of the earth had ever done. They declared their independence. They went to war and won. They wrote documents about opportunity, about freedom. And they were so confident about what they were doing that they put it on the great seal of the United States: *Novus Ordo Seclorum*, "a new order for the ages." Their optimism and their hope sprang from the principle that every generation would take responsibility to make the future better for the next—the American dream. People flock to our shores to seek it from all over the world, and they make America more American because they reinforce the American dream. In the last twenty years or so, some people have been insecure about whether the American dream is alive and well. We want to remove all doubt in anyone's mind. It is alive, it is well, and it is well rooted.

It's always been that the next generation could have more opportunities economically and the rest. It's as fundamental as our republic. I like to recall a letter of John Adams to Abigail Adams, in which he said, "I must study war and politics so that our children can study medicine and architecture and law so that their children have the freedom to study music and art and poetry and the rest." Adams wrote of ever-expanding opportunities for the next generation to have the liberty to do more. Because of the bad economy and other problems that we have now, that optimism needs to be reignited. And that's what we, as Democrats, do.

I'm John Podesta.

I'm the chair of the Center for American Progress, which is a Washington-based think tank that works on progressive policy and tries to communicate with the American public about what a progressive government could do to improve their lives. I've been involved in politics for most of my life and somehow haven't gotten cynical in all that time.

My dad was a factory worker. My mom was always really interested in politics. There was a famous columnist in Chicago who had his own talk show before talk shows were so crazy. His name was Irv Kupcinet. My mother always used to watch Kup's show and got very interested in politics, even though my family wasn't at all engaged in the political world—but politics in Chicago is in the DNA. It's a place that eats and breathes politics. My brother, Tony, was a little bit more engaged in the political world. He went to the University of Illinois in Chicago when it first opened and was involved in student government and Democratic politics.

The Vietnam War got me engaged in political work, and to some extent, that's what got Tony engaged as well. He went to New Hampshire and worked for Eugene McCarthy. A little later, I left college and joined the national staff of the McCarthy campaign. It was an interesting experience to travel the country and work in

John David Podesta

Chair of the Center for American Progress, John Podesta served as chief of staff in the Clinton White House and oversaw the transition between the Bush and Obama administrations. He now provides research and policy advice concerning issues of particular interest to Democrats, including health care, the economy, and education.

primary after primary when the country wasn't quite so homogenized—when Nebraska was really different from Illinois and Oregon was really out there in a very different culture, a very different place. America's place in the world was reshifting and refocusing. The fights we're having with conservatives today were born then.

I first met Bill Clinton in 1970. He was a law student at Yale, working for a candidate named Joe Duffy. My brother was the campaign manager. Then we went to work for the McGovern campaign in the next election. After that, both my brother and I went to law school at Georgetown. After I finished, I worked as a trial lawyer for the Justice Department. I found it to be a lonely existence. I longed for the policy and politics world. It was just more exciting, more fun. I ultimately got up to the Hill, working first for a senator from Iowa named John Culver and then for Pat Leahy, who now chairs the Senate Judiciary Committee.

I was on the Hill for nine years as counsel, and then Tony and I decided to start a firm. He was the original president of People for the American Way, another public-interest advocacy organization. Through my experience on Capitol Hill, I had become an expert in technology and copyright and working in those industries and areas. We built a business oriented toward communications, doing some lobbying, mostly in the high-tech world. I left it when I went to work for President Clinton. Tony has continued to build and expand it, and it's now one of the top lobbying firms in Washington. He has a broader group of clients than we had then, some of whom I approve of, some of whom I don't. He's been an effective advocate for their interests.

I ended up developing a subspecialty in the dark arts of opposition research and debate preparation, trying to figure out what the other guy was thinking—to understand the personality, the drive, the campaign of the other side. I did that for Clinton. I worked on the debates when he went up against George H. W. Bush and H. Ross Perot. The most memorable scene of all was during the one debate that allowed questions, when President

Bush looked at his watch, as if he couldn't be bothered to talk to the people in the audience.

Clinton's people asked me to interview for a position in the administration, and a few days before the inauguration I was offered the job of staff secretary. I had no idea what the job entailed. The staff secretary manages all of the paper flow to and from the president. It's less important because of the electronic systems they now have, but at the time, almost everything the president saw and did happened on paper. In any event, I called a man who had held that job for President Bush, who is the general counsel of AT&T now. He spent a couple hours with me telling me what I was supposed to be doing. It's a fine part of the American government that even having beaten an incumbent president, the successor gets full support in the transition from one party to the other.

I was one of the few people who, on the day of the inauguration, actually had something to do, because the first thing the president does after he gives his inaugural address is to sign executive orders and proclamations, which I had to manage. We were nominating people, running up to the Hill with lists of names. They were confirmed almost instantly, and then they had to be appointed. There's a formal process to do that, and I was running paper back and forth to the president while everybody else was partying.

It was raucous in the beginning. Clinton wanted to get a lot done. The first year of the Clinton White House was noted for being chaotic in its energy. I think that's a little overstated. We actually got a lot done that first year, including passing a massive budget bill, which planted the seeds for Clinton's long-term success, particularly on the economy. We passed NAFTA and the Brady bill. It was exciting to be part of all that. Clinton presented a progressive vision and was able to accomplish a lot for the American people. That's why they stuck with him through impeachment. He focused on the challenges of building the middle class, making people's lives better, and making government work

to support that. He was an idea-based politician. It was really a tremendous experience to work for him, to be his chief of staff, and to see what could be accomplished across a very broad range of issues.

I started the Center for American Progress in 2003. We were very much in the wilderness then. The first decision we made was to take on George W. Bush on national security. This was at a time where Democrats were cowering after 9/11. Nobody was really pushing back on the Iraq decision with any real vigor. We began with our national security program, then built out a program on health care, education, and core issues around the economy, which proved to be particularly valuable in the 2008 presidential campaign. We helped shape the debate and provided both information and policy prescriptions to all the Democratic campaigns.

President Obama has been very productive in putting the building blocks in place for success for the American economy. His accomplishments are being challenged in the political campaign as we speak. We'll see whether the Supreme Court upholds the decisions that Congress and the president made, but it was a fight worth fighting.

If the Court does uphold it and the president is reelected, I think people will look back at this as a watershed moment, particularly for providing people a basic guarantee of health care, which they deserve.

I'm Stephen Porter.

By training and profession, I'm a commercial lawyer. First I was a CPA, and I hated it, so I had to find something else. Now I work in the arts.

I grew up in Wisconsin when Joe McCarthy was a senator. There were a lot of things to dislike in Wisconsin politics then, and yet it was a progressive bastion. I went to a great high school that had all sorts of opportunities. It's hard to imagine that the schools have become what they have become, given the time when I grew up.

Although it never was a part of my plan, I went to the University of Wisconsin. That was the in-state school. Tuition was $90.00 a semester. I went to undergraduate school there, and then I practiced accounting for a while, then went back to law school. It certainly wasn't part of my plan to go to Washington. I probably assumed back then that when I was finished at law school, I'd go back and practice law in Milwaukee. But when I was done, my interest in government matters had grown. I'd done a little speechwriting for the governor and been involved in gubernatorial campaigns. I did a bit of work for Gaylord Nelson, who was governor and then senator; his successor as governor, John Reynolds, who later became a judge; and then Bronson La Follette, who was the attorney general.

I just drifted toward political matters, and when I sent out my résumé to law firms around the country, the very first response I got was from a Washington firm to be a tax lawyer. I can't say that I was all that thrilled about being a tax lawyer, but that's what I was trained to do, so I accepted a job with the firm. It then had forty-three lawyers; now it probably has 2,500 lawyers. I'm not with them any longer. Then I went to work in commercial law. Interestingly, I was drawn to Washington because I liked the idea of it, and yet, when I got here, I worked in commercial law. In this town, there's no industry, so it was real estate matters—real estate and real estate finance. It frustrates me that I spent such a large part of my working career working on matters that involved how ten rich guys disposed of an asset and another ten rich guys bought the asset.

Washington doesn't have home rule. It has a very limited self-government. I've been involved in the law and never been elected to office, but I've worked with council members and been involved in civic organizations that appear before the council. I was twice chairman of the District of Columbia Chamber of Commerce. And my wife and I became interested in the arts. The Kennedy Center wasn't yet built, but we had DAR Constitution Hall, and Wolf Trap, and the National Theater, which had touring Broadway plays. Washington now has numerous venues: the Shakespeare Theatre, and the reopened Fords Theatre, the National Theater, and the Kennedy Center with its three separate venues; many of the colleges have large theater venues. We capture a fair amount of touring companies, from rock stars to Broadway plays to concerts to classical concerts. We became involved in that.

Both of us got involved in the Washington Performing Arts Society. My wife's tastes run broader than mine. I like symphony orchestras, the more classical the better, the more bombastic the better. If I arrive at the Kennedy Center, open the program, and see that the composer is still alive, I view it as a very bad sign.

I also got involved with the National Endowment for the Arts. The NEA is a federal government program to support the arts. I got interested in it because I could both contribute something and have some involvement in government policy. We were just going through a time when the NEA was under siege, for all the wrong reasons. You had people who didn't like the Mapplethorpe exhibit and the debasing of a portrait of Christ, and the NEA took the heat for that.

President George W. Bush did something very intelligent to save the arts. He appointed a poet named Dana Gioia, who was a great administrator, and who had great political skills, and Gioia cultivated every congressional district in the country to make sure they got something out of the NEA. He made it plain that governments have always supported the arts. He also did something substantive, which was to remove the government from electing the performers, instead granting money to the presenting organizations and letting them make the choice. If they make the wrong choice and the local press excoriates them, well, then they made a mistake, and perhaps they won't get a grant next time.

"The NEA is a federal government program to support the arts. I got interested in it because I could both contribute something and have some involvement in government policy. We were just going through a time when the NEA was under siege, for all the wrong reasons."

That said, I am concerned about the possibility of political correctness creeping into the arts. One of the programs that had been suggested for

Stephen W. Porter

A commercial lawyer by training, Stephen Porter has twice served as chairman of the Washington, D.C., Chamber of Commerce. He has also provided substantial support to the development of the performing arts in Washington and is a longtime member of the board of the National Endowment for the Arts.

approval was a fairly large grant for the NEA—and we don't have the world's biggest budget. This was a six-figure gift to support Islamic art in America. I don't usually mince words. I found it offensive, not because there's anything offensive about Islamic art, but because it ought to take its place alongside every other kind of art. It's inconceivable to me that we would back art that had gotten the imprimatur of the Catholic Church or that would have been to the liking of a rabbinical board. This was clearly an attempt to curry favor with the Islamic community, and it underscored one of the political realities I can't stand—the notion of appeasement—because you get nothing out of it and it has nothing to do with the arts. We discussed it and sent it back with the direction to the staff to come back with something different. They came back with the Silk Road Project, which was meant to spotlight art in various capitals of countries—almost all of them Islamic. We got our backs up and said, "You didn't hear us. This is the same thing dressed up in a different uniform, and we're opposed to it." It was the only project in my four years there to be killed. The art might have been magnificent, but it wasn't chosen for that reason, in my judgment.

Right after the current president was sworn into office, before they even appointed the new chairman, a young guy was sent over to be the White House's liaison to the arts community. He apparently convened a conference call of arts presenters around the United States, and he either implied or directly said that their ability to get grants in this administration would be dependent upon their support for the president's health program and environmental program. The trustees demanded that he be fired. I don't think he got fired, but he quietly left a few weeks later. Even though the NEA is an executive agency and the president is the head of the executive branch, that kind of direct involvement just didn't pass the smell test. I've tried to make the arts a neutral thing.

I'm Martha Raddatz.

I'm the senior foreign affairs correspondent for ABC News. I cover foreign policy, and I travel a lot to the places that I cover.

I was one of those kids who struggled. I didn't really know what I wanted to do, didn't know what the opportunities were. I kind of fell into this work at a television station, when I was still in college. I wasn't inspired at all by college—which I hate to tell young people—so I started working at the television station, at first doing just menial tasks. That led into photography and then to being a reporter. I loved the disciplined curiosity of reporting. The curiosity is not fearlessness, but it's that you're interested in the kinds of things that are sometimes on the edge or more dangerous. I remember early on getting sent out on a fire, and I got closer and closer and closer with my camera, and a firefighter said, "You are way too close to this. It's dangerous." I remember thinking, "But this is the really interesting part, getting closer and closer." I sometimes think of that moment, and I think there must be something wrong with me. It's not like I need danger. It's not like I need adrenaline. But I need to see those people who do that kind of job. That's the only real window into their work for the rest of the country.

I have covered the military for a long time. When I first started coming to the Pentagon in the early 1990s, it was like listening to a foreign language. A couple of months into it, I thought, "I am never going to memorize all these acronyms," and I'd ask, "What does Humvee stand for?" A soldier would usually reply, "I don't really know." I always tell people when you go into an acronym-filled world or the world of diplomatic speak that you just have

to step back, since it's not really your job to be one of them. When I talk to military people, I say, "Don't think of us as the press. Think of us as the public." We are there to help other people understand.

There are very few foreign affairs correspondents who travel overseas but are based here. In Washington, I can both hear policymakers talk and see what's happening on the ground. I was probably the only White House correspondent who was regularly traveling to Iraq during the war there, and once, after I'd just gotten back, I asked President Bush if he felt that Iraq was turning into a civil war. He looked at me and said, "It's hard for me to tell, living in this big, beautiful White House. You've been there. I haven't." I thought, "Well, that's quite a moment."

During the early period of the war, the press was criticized for not knowing more and not saying, "Wait, wait, there are no weapons of mass destruction." As the war progressed, we were getting all kinds of pronouncements from people in positions of power that the war was going well. They criticized the media for looking for bad news. Well, the truth is, the war wasn't going well. The public figured that out, and then the strategy was changed. President Bush even said in an interview

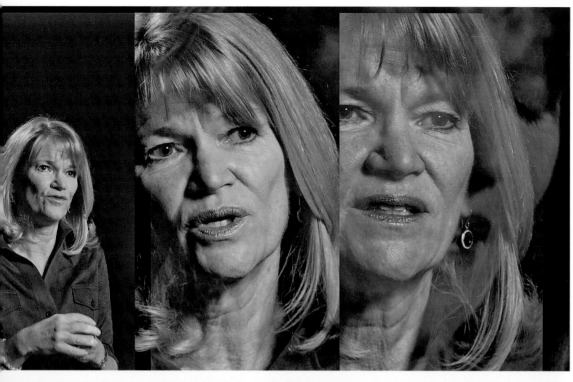

Martha Raddatz

Martha Raddatz is senior foreign affairs correspondent for ABC News. She has played a central role covering the wars in Iraq and Afghanistan while addressing the presentation of those conflicts by the White House and the Pentagon. Her book *The Long Road Home*, about the war in Iraq, became a best-seller.

with me, "Yes, I knew it wasn't going well, but I wanted to keep the morale of the troops up." I thought to myself, "I think they knew it wasn't going so well, too." The American public finally realized the truth, and if the press played a role in that, that's a role to be proud of.

> *"The administration really doesn't want us to talk about Afghanistan that much. They don't want it to be a central factor. My job is to find some way to tell a story so that people will remember that we are there. This is a huge cost in blood and treasure."*

Covering the White House is a unique position to be in, and in retrospect, I'm glad I did it. But I'm way more of an independent operator, and while the White House press corps is a fantastic group of people, I bristled under the routine of doing the same thing and traveling together and being given the same story. I felt a bit confined. It was not a natural fit for me. I would rather be out in the field.

I was covering the beginning of the war in Iraq from the State Department and from the Pentagon. It was several months before I actually went over there. When I first flew in on a C-17, a big cargo plane, it was stunning to me that I saw no huge amounts of damage and that life was going on in the streets. It seemed so lively and normal. But a lot of bad things were lurking that we didn't see.

Driving around, I noticed things. I especially remember sunsets and the light, flying with a full moon or a sliver of a moon out the side of the helicopter. At the end of the day, after seeing bad things and hearing bullets fly, to look at the moon or to watch the sunrise in the morning—those are among my deepest memories of Iraq. They make me realize that people there want the same things. They're under the same moon, the same sun.

In many ways, Afghanistan is harder to cover than Iraq. It's remote, rural, poor. Not only that, but people are also tired of war and war reporting. The challenge is to make people care about what's going on there. I rack my brain all the time to figure out how to do something different. In Iraq, I could go out in a convoy every day and be on the air every night and talk about what was happening in great detail. The administration really doesn't want us to talk about Afghanistan that much. They don't want it to be a central factor. My job is to find some way to tell a story so that people will remember that we are there. This is a huge cost in blood and treasure. They need to continue to ask whether America should be there, and if we stay there, what it is that we want to accomplish. Those are questions for which the American public deserves answers.

In the beginning of my trips to Iraq, I had a harder time coming back to the States, because it was so shocking and to be in the middle of a war zone with men and women doing things that were extraordinary and then coming back home and hearing people complain because they couldn't get a restaurant reservation. For a while, it irritated me. But we do what we do. We all live our lives. I try to urge people to pay attention to the news, obviously. I try to urge people to pay attention particularly to the wars that this nation is involved in. My son is twenty, and for half his life, we've been at war. It becomes routine—too routine. I think people tune it out.

Now it's not so hard for me to go back and forth. It's my routine. It's what I do. I have that flight to Afghanistan down. It's a strange kind of normal, but it works for me. I go back and forth pretty easily, and sadly, most of the military does, too.

I'm Addison Barry Rand.

I'm the chief executive officer of AARP, though I think of myself as AARP's chief servant.

I was born and raised in Washington, D.C., which was then a segregated city. It really didn't become desegregated until I was in the fifth grade. My mother had a master's degree, as did my grandmother. My father went to Howard University. They focused on education and achievement, on how to contribute. My mom and my dad and my grandfather, who was a Methodist minister, made sure that I understood that my responsibility was to give back and to constantly think of others. The 1960s was a time driven by Martin Luther King. We were always talking about inclusion: civil rights, rights for women, rights for the aged, rights for the poor. I believed in that, because I had experienced all sides of it. It made me understand that part of my mission in life was to be able to help transform society. I decided that no matter what I did, no matter what profession I chose, I had an obligation to continue to push for inclusion.

I had an advantage growing up in Washington during the 1960s. That advantage was Howard University. It produced some of the great lawyers, doctors, architects, and businesspeople of the city. Other than my parents, my role models growing up were the doctors and lawyers who were my father's fraternity brothers. There was never an issue about how good you could be or how good you wanted to be. I had a tremendous amount of confidence that I could be whatever I wanted to be, and that was because of Howard University. Martin Luther King also became a role model because he fought for things that he couldn't see achieved in his lifetime, but that didn't deter him.

There is a Brazilian saying that is apropos: "When we dream alone it is only a dream. When we dream together it is no longer a dream, but the beginning of a new reality." King proved that to be true. He was my hero, and I wanted to help continue his movement.

I decided that I wanted to be in a corporate environment. Washington didn't have many large corporations. It was government-dominated, consultant-dominated, education-dominated. My father wanted me to be a doctor, but I felt that my skills were in sales and marketing. Everyone thought I was crazy, because there were very few minorities in corporate America at that time. I went to Xerox with two objectives. One was to be the best that I could be. My philosophy was that the only way you could have power in any organization was to be seen as a performer, and therefore, I had to focus on excellence. I wanted to do that because I wanted to have influence, and the influence was to help change the environment.

My second objective was to bring people with me. I even told my bosses at Xerox that that was what I was going to do. And we did it. Some were under duress, but as long as you were performing, no one wanted to cut a good performer. We would bring people in and have training sessions over at various friends' houses. If someone was in trouble, we used to go into that person's sales territory to help them look for new prospects and close sales, so no one was ever in a failing category.

One of the things that I'm known for, which I appreciate, is that I helped make Xerox the most diverse major corporation in the United States. I wanted to prove that the more diverse you were, that you could strengthen any organization, and that was my goal. We did it, and we won several important industry awards for it. We were fortunate to have David Kearns as president of Xerox at the time. David was a real Renaissance man who went on to become CEO and chairman. Without his support, we wouldn't have been able to achieve all that.

Addison Barry Rand

A highly successful business executive at both Xerox and Avis, Addison Barry Rand is the CEO of AARP, a membership organization of more than 38 million people of age fifty and older. Recognized as a champion of inclusiveness and diversity, he also serves as chairman of the Board of Trustees at Howard University.

I spent more than thirty years at Xerox. I'd gone as far as I was going to go. Then I became the CEO at Avis. We sold it, and I did private equity and had a company that we sold to IBM. I was on corporate boards. I had gone through a period where I was selling a company that was owned in Ireland and another on the West Coast, and I was on three or four boards at the time. I was averaging two or three hours of sleep a night, so I decided that I needed to rest. I rested for a bit, and then I thought, "Okay, what else am I going to do? It's time to get involved again." A friend said that AARP seemed to fit my worldview. I really didn't know much about it, quite frankly. I started reading about it, and what got me excited was that when I looked at the mission, the mission was about helping people get and achieve the American dream.

AARP has roughly 38 million members. We are nonpartisan, evenly split among Democrats, Republicans and Independents. We have three parts to our mission: affordable health care for all, financial security for all, and helping people live their best lives as they age. When I came to the job, we were really entering what I call the transformational period, where America had to figure out how to deal with the aging population and the size of the aging population. We had millions of people who didn't have health care. Millions of people had lost their financial stability. I thought this was to be a great opportunity to continue my own calling.

Right now, our members' big concern is how we ever get to the American Dream. There will be more people over the ages of fifty and sixty than there will be people under the age of fifteen. What does that mean for America. What does that mean for them? We talk about helping people live their best. They are living longer. The baby boomers are looking around and asking, "What do I do next? What's my purpose? How do I take advantage of these incremental years that everybody's telling me I'm supposed to have?" Our challenge is to take this growing population and help them do what they want to do, which is to find purpose, to find how they're going to live their lives, to

let them understand what this means to their kids and grandkids.

At the same time, a lot of people are scared of what the future holds. We try to make sure that people have hope and they understand that their voices can be heard. They expect us to represent them, and we expect them to use their voices also. We will do both. We believe in self-determination, helping people understand what they can do.

AARP is focused on how we can help and what we will do to help. In the next couple of years, there are going to be some really big challenges. AARP must be there. People count on AARP, and we'll make sure that we deliver.

I'm Jack Reed.

I'm a US Senator from Rhode Island.

I grew up in Cranston, Rhode Island, with parents who provided a sense of both security and opportunity, had great aspirations for their children, and worked hard to make sure that those aspirations could become realities. My dad was a school custodian. My mother did not have the chance to go to college, but she made sure that all of her children did. That sense of learning and of working hard was always there, unspoken. You just had to watch my parents, and you understood.

I was ten when John F. Kennedy ran for the presidency. He was hugely popular in Rhode Island. His life seemed to exemplify the idea of service, not just in the military, but also in the public sphere. The whole atmosphere was one that made public service something that was not an option, but something in which you had to participate in some way.

Cranston was a great community to grow up in. I played peewee football. I rode my bike to see my friends. I walked every place. We had only one car, and my mother didn't drive, and Dad was working. All the families seemed to be the same way. Most of the fathers were veterans of World War II, and they were very quiet about their service. They understood how important it was, but they didn't dramatize it. As a youngster, I got fascinated with history, particularly the history of World War II, and that fascination led me to West Point, the other place that shaped what I do and try to do at my best moments.

When I was a senior at West Point, the policy was that the top 5 percent of the class could elect to go to graduate school immediately. I chose that option and went to the Kennedy School at Harvard University. I learned some extraordinarily important lessons. I got into the public policy program, which had some of the great minds of the time. The greatest lesson I learned is that I was not the smartest guy in the room. The second lesson was that intellectual ability is important, but so is temperament. Intelligence helps, but you also have to have the patience and the interest and the ability to focus, to communicate with people, to work with them on a practical and pragmatic basis. That's as important as any intellectual gift.

I had great academic preparation at West Point, and then the Kennedy School. But I learned a lot about how the world works by leading paratroopers. I commanded a paratroop platoon, and then a company. I appreciated the fact that you depend on other people to do their jobs, that you have to delegate effectively. You don't necessarily have to be liked, but you have to be respected. Respect flows from knowing your job as well as you can and working as hard as you can.

I commanded a company, and then I taught at West Point. I was approaching the ten-year mark in my military career, which is usually the point at which you decide to stay in for twenty years and retirement, or you get out. I thought that if I wasn't going to be an Army officer, I might

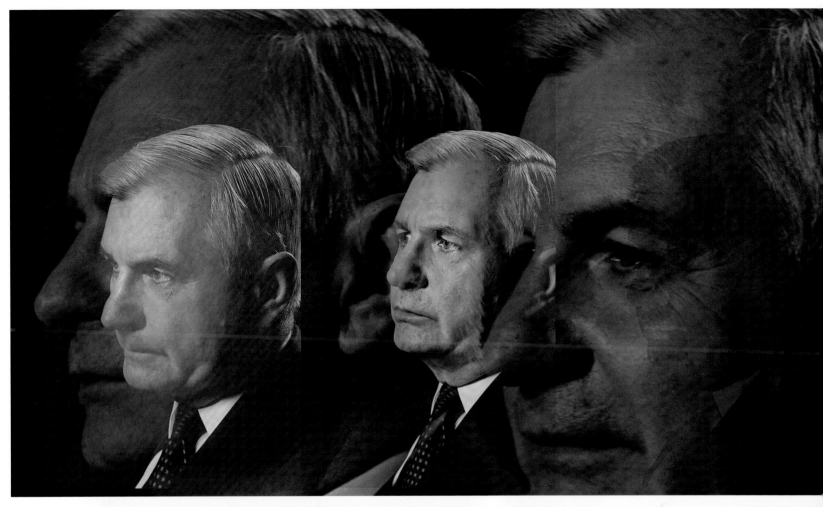

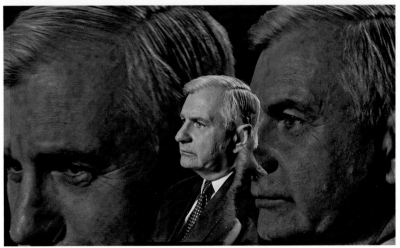

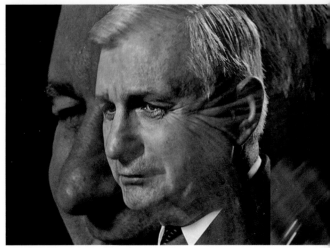

Senator John Francis Reed

A Democratic senator from Rhode Island since 1996, Jack Reed previously served as a member of the House of Representatives. A veteran of the Vietnam War, he voted against going to war in Iraq. He is committed to fostering bipartisan collaboration and using American strength to make contributions that go beyond military force.

work in law and public life. It was all very vague. Searching for options, I took the LSATs and got into Harvard. I resigned my commission and went to law school there. I was with talented, bright people learning, again, that it's not so much getting the right answer as it is asking the right question.

I came down here to Washington for a time and worked at a firm. But I had a hankering to get involved in politics, and that meant going home. I went to work for an excellent law firm in Providence, and then quickly got elected to the state senate. In 1990, I threw my hat in the ring for Congress, went through a complicated primary, and won.

When I first got down here, I got on the Education Committee in the House. I was also on the Judiciary Committee, but my principal thrust was education. That was in recognition of the huge role that my colleague at the time, Senator Claiborne Pell, played. He was the preeminent education legislator of his generation, and he created the Pell grants, the National Endowment for the Arts, and the National Endowment for Humanities. We were involved in a lot of issues with respect to education and libraries. I was in the House at the time when President Clinton was beginning, with Secretary of Education Dick Riley, to talk about reforming the system to try to provide a different model of elementary and secondary education, and we were active in those deliberations. My last term in the House, I was also selected to serve on the Intelligence Committee and began, for the first time, to have some formal role in foreign policy issues.

When Senator Pell decided not to seek reelection in 1996, I decided to run for his seat. It was a contested campaign, as races for open seats always are, but we worked hard and won. It was a strong year for Democrats. I continued my service on the Education Committee. We worked hard on reforming elementary and secondary education, for libraries and museums, trying to sustain what Senator Pell had started. Later, I was asked to serve on the Armed Services Committee

and began to work on foreign policy issues through the military and Department of Defense. I served on the Banking Committee, with a focus on affordable housing, an area that still needs tremendous support.

I voted against the war in Iraq. Having thought about it a very long time and listened to much testimony from administration officials and others, I considered it a strategic miscalculation. It took away from our efforts in Afghanistan at a time when the atmosphere there was much more promising for stability than it is today. We're paying today for six years of inattention in Afghanistan. That was one part of it. The other part was I simply did not believe that the best way to deal with the threat of Saddam Hussein was a military invasion of the country. The evidence for weapons of mass destruction was shaky. It turned out to be nonexistent when we got there. The notion of preventive or preemptive war is a very dangerous one, too. War has huge costs, in terms of lives, of dollars, and of the prestige of the United States. The administration failed, in my view, to make the case for an imminent danger. My opposition certainly takes away nothing from the valor of the soldiers and the sailors and the marines who fought there. They were magnificent. Thank God for them. But I think they deserved better policy and better guidance.

A great West Pointer, President Eisenhower, had a sense that America had to stand for something other than military force. Thus, we had programs such as Food for Peace. He wanted to represent the face of America as one of cooperation, collaboration, helping people in their own way to develop their countries. That was a time of greater unity. That bipartisanship has dissipated. How do we regain it? President Obama has certainly tried to set the right tone in holding that most approaches to problems have to be multilateral.

I'm Cokie Roberts.

I'm a political commentator for ABC News and for NPR, and I'm an author.

My real name is Mary Martha Corinne Morrison Claiborne Boggs Roberts. It's your basic southern Catholic name. My brother Tommy couldn't pronounce Corinne when I came home from the hospital a mere sixty-eight years ago, and it's been Cokie ever since.

I was born into a political family. My father ran for Congress the first time before I was born and served for a term and then was defeated and came back in 1947, when I had just turned three. I grew up in this city and was very much part of it. My parents felt very strongly that if they were going to have any kind of family life, the children had to be involved in their political life. We were at the Capitol all the time. We were on the campaign trail in Louisiana all the time. We knew a great deal about Washington and government and the workings of government. We were very blessed to have wonderful people in our lives, first and foremost of course our parents, but we also considered people who were around the house, among them Sam Rayburn, Hubert Humphrey, and Lyndon Johnson, to be our uncles. They came for dinner all the time, particularly the men whose families weren't here, the men who were "bachelors" in Washington.

Sam Rayburn was an actual bachelor, and he had no children. He spent a tremendous amount of time at our house. In fact, he presided over the burial of my chicken. My brother bought it for ten cents the day after Easter. I christened the chicken Charlie. My grandmother made him a roost, and I really liked that chicken a lot. And then one day the dog ate the chicken. We were having a

burial, and my brother kept humming the *Dragnet* theme: Dum, da-dum dum. It was very irritating because he was supposed to be singing a hymn. I ran in the house and jumped into Mr. Sam's lap and said, "Tommy is singing *Dragnet* at Charlie Chicken's funeral." Mr. Sam came out and said the appropriate Baptist prayers.

My mother's family had been in public service forever. Her maiden name is Claiborne. The first governor of Louisiana was William Claiborne. The Claibornes arrived in this country in Jamestown, and there's never been a generation that has not been in public office. When she met my father in college, my mother was the women's editor of the newspaper, and he was the editor. She saw in him someone who was out of her family tradition, even though his family was very different. But he was an up-and-coming young man, and she probably saw that he would be someone who would serve, and that that would give her the opportunity to serve as well.

My mother was the campaign chair for most of my father's elections. Part of the reason for that was that she was very good at it. But another part was that in Louisiana at the time there was no Republican Party, which is kind of amusing to think about now. There were factions inside the Democratic Party. Often all the factions actually supported my father, because they divided on statewide issues rather than national ones. To find a campaign chair who was not from one faction that would alienate another faction was very difficult. So my mother was the chair. She was very good at it. In fact, when she started running herself, it was very frustrating to her because she never found as good a campaign manager as she was.

I'm the only member of my original nuclear family not to run for Congress. I became a journalist, married a journalist, and left town. We came back to Washington after my husband and I had been married for eleven years. We had lived in New York and Los Angeles, and then in Athens, Greece. I came back and went to work for NPR, wanting

Cokie Roberts

Political commentator for NPR and for ABC News, Cokie Roberts grew up in a political family. With two parents in the US Congress—her father rising to House majority leader and her mother serving for nine terms—political analysis comes naturally to the journalist and author.

to cover anything but Congress and politics. I had children who were seven and nine at the time, and I wanted to cover education and lifestyle and things like that. And I did, kind of. But then the Panama Canal treaties were being debated, and NPR was covering them live. My colleague Linda Wertheimer had to do the live coverage. They needed somebody to do the news stories. I went up to the Hill to work with her and basically never left.

"In my work here as a journalist, I try to communicate the basics: What is going on and why. But I also try to communicate that there is, in this mess, a certain majesty that we should celebrate."

It was very peculiar, because I didn't want people to think that I was somehow advantaged by the fact that I had parents in Congress. But in truth, I was. I knew more about the institution than anybody did, and I knew more than I knew that I knew. I could explain things that nobody else even had a clue about, because I had heard about them my whole life. I knew that the best sources were not necessarily the members themselves, but the guy who sat on the door, in the parlance of Congress. The doorkeeper would sometimes know a great deal more than anybody else, particularly about schedules. Committee clerks would sometimes tell me things that they wouldn't tell other people because I had grown up with them.

Of course, most of the time when you're reporting on a beat like Congress or politics, what you need to cover and illuminate is as plain as the nose on your face. There's a big tax bill on the floor of the House, and that's what you're doing. During the times when there's not a big story, the individual reporter

has a role to play, which is one of the reasons why diversity in a newsroom is so important. I wanted people to understand the institution of Congress itself. Normally Congress is covered in opposition to the president or as an institution when there's some scandal. I wanted people to understand that this was the first branch of government in the Constitution, and that its role is essential. I think the founders had the right idea.

I am biased toward the institutions of government. That's not true for a lot of my colleagues. They think that members of Congress are either a bunch of crooks or at the very least just in it for political gain and do not have any sense of the public service that it entails. I don't think that way.

The political climate on the Hill is bad. It's not the worst it's ever been in our history; they're not shooting each other, for which the metal detectors are helpful. But it is far more partisan than it was when I was growing up. I had the incredible honor of being asked by Betty Ford to be a eulogist at her funeral, which was terrifying except that she had told me exactly what she wanted me to say. That made it easier. She wanted me to talk about how when President Ford was minority leader of Congress and my father was majority leader, they were good friends. They could go at each other on the floor of the House and then sit down to dinner together and be cordial and friendly. That is gone. That is definitely gone.

In my work here as a journalist, I try to communicate the basics: What is going on and why. But I also try to communicate that there is, in this mess, a certain majesty that we should celebrate.

I'm Alec Ross.

I'm Hillary Clinton's senior advisor for innovation at the State Department.

In West Virginia, where I grew up in the 1970s and '80s, the deindustrialization and loss of the manufacturing base was taking place at a wildly fast pace. Coming out of a part of the country that was suffering greatly, I decided early in my life that my focus, professionally, would be on social change.

As an adult, I became a teacher in inner-city, drug- and violence-riddled Baltimore. I started teaching in 1994, the same year that the first Internet browser appeared. Technology had not yet saturated America's youth, but I could clearly see that there was a remarkable affinity with technology among young people. It didn't matter how much money was in your wallet or how much melanin was in your skin. As rural communities like the one that I grew up in West Virginia and urban communities like the one that I taught in became devastated as the economy changed, I thought that technology and technology skills could be a way of helping people from historically poor or working class communities accelerate into the economic mainstream, into a knowledge-based economy.

I was drawn to the State Department for two reasons. First, I thought that we really needed to create an innovation agenda for America's foreign policy. The need and opportunity to bring them together, I thought, were profound. This led me to the State Department. The second thing, frankly, was Hillary Clinton. On day one she came to the job as a global stateswoman. I thought that to serve in the Obama administration while working directly for someone with enormous standing and

Alec Ross
As senior advisor for innovation to Secretary of State Hillary Clinton, Alec Ross is working to find ways harness the power of technology, and particularly social media, as a diplomatic tool. A cofounder of One Economy in 2000, he has long been interested in innovative uses of new technology to bridge economic, social, and power divides.

capability was the single greatest opportunity that I could have to serve.

"If you want to remain relevant, if you want to remain—to be blunt—powerful, you had better understand your networked citizenry. If somebody had met only with government ministers, generals, or CEOs in Tunisia or Egypt, he or she would have had no clue that there was about to be a successful revolution there. We see this not just in the Middle East, but also in the developed world."

As Hillary Clinton has said, our information networks are like nuclear power: They can power a city, or destroy it. We have to make sure that, regardless of what community you grow up in, in America, you are being educated in the skills that will propel you into the jobs of the future. This isn't all science, technology, engineering, and mathematics. That's a piece of it, but there are very specific skills that are rooted in leadership, in management, in the arts, that can allow people to compete and succeed in tomorrow's economy. We've got to make sure people have those skills. Because I've got news for you: India, China, Singapore, Malaysia, Brazil, Turkey, a great many other nations are taking serious steps to make sure that their fifteen-year-olds are going to be twenty-five-year-olds with good jobs.

Being digital changes the nature of the interactions between a member of a community and that community. It forces transactions to take place more immediately and closely. It demands transparency and accountability between the governing and the governed. It has played a very interesting and disruptive role in communities all across the United States. And if I've learned one thing in the past three years in government, it's that power dynamics are shifting. People talk a lot about the supposed transfer of power from West to East, from North to South, from established powers to rising powers. True or not, that is of far less significance than the transfer of power from hierarchies to citizens and networks of citizens. There's a transfer of power from the nation-state, from governments and large institutions, to citizens and networks of citizens. As power devolves to the individual, individuals, therefore, can do far more on their own or with a small cadre than was possible when I left college nearly twenty years ago.

As power has gone from central authorities to the proverbial edge of the network, it has changed. It has diminished the traditional role and authority of government. The very concept of leadership is changing in the face of the hypertransparency that comes from a networked world. When John F. Kennedy was president in the early 1960s, he didn't have to contend with 24/7 cable television. He didn't have to contend with the complete lack of privacy and scrutiny that comes from the eyes that are on you, inevitably, in the digital world. So one of the things that I think is interesting is that we see fewer iconic figures. It's more difficult to be a leader today, in the traditional sense, than it was twenty or thirty years ago, because every flaw, every hiccup in your life, is recorded, amplified, shared a thousand times over. So the notion of the flawless leader, the iconic leader, is diminishing. Leadership becomes less rooted in a charismatic individual organizing and inspiring the masses from on high.

The twenty-first century is a lousy time to be a control freak. There was a time when people

consumed information from a very small number of media forms—the newspaper they read in the morning, the news broadcast they watched at night. Today, people are getting content from dozens, if not hundreds, of sources of information. This produces a loss of control. And a loss of control comes from network effects. As more people go online, it becomes increasingly hard to control what they do or say. So one of the things that established powers, whether it's a big old company or a government, have to contend with is the inevitable loss of control that comes from living in a truly networked society.

But nobody gives up power willingly. People who lose power and control do so grudgingly. I tell people, whether it's a foreign minister, an ambassador, or a CEO, not to fight the loss of control; instead, seek to understand it. And if suddenly you have a great many more stakeholders than you used to have, figure out how to connect and engage with those stakeholders in new and productive ways.

Think about this from the standpoint of an ambassador. Typically, what an ambassador does is engage in a very formal way with an interlocutor, or with his or her cohort, from another country.

The ambassador meets with a government minister, meets with a CEO. In the twenty-first century, you can't just meet with that government minister or that CEO. You've got to figure out how to connect and engage with the networked citizenry. Part of that means stripping some of the elitism out of your job description, and that's not necessarily something that everybody likes.

If you want to remain relevant, if you want to remain—to be blunt—powerful, you had better understand your networked citizenry. If somebody had met only with government ministers, generals, or CEOs in Tunisia or Egypt, he or she would have had no clue that there was about to be a successful revolution there. We see this not just in the Middle East, but also in the developed world. We see citizens newly empowered with tools to demand that they are heard, and to demand change.

My name is Peter Rouse.

I'm counselor to the president of the United States.

I've worked in Congress or the White House for the past forty years. My career has been that of a generalist, not a specialist, somebody who deals in policy, management and politics, and I've been extremely fortunate in the opportunities that I've been provided. I had no master plan; it just evolved.

I started off as legislative director and then chief of staff for a congressman from Iowa, Berkley Bedell. Then I worked for the lieutenant governor of Alaska, then for Dick Durbin for two years in the House, and then Tom Daschle in the Senate for nineteen years. Then I worked for Barack Obama in both the Senate and the White House. My goal

has always been to make their operations run as effectively as possible so that the principal can be the best public servant he can be.

There are three elements you need to have a successful operation. Clearly, you have to have a superior principal, and I've had that in Dick Durbin, Tom Daschle, and Barack Obama. Second, you have to have smart, hardworking staff people who understand policy and can figure out strategies to get things done. Third, you have to have an organization that is greater than the sum of its parts. That's what I have tried to build, and I hope I've been reasonably successful.

I met Barack Obama because the Senate Democratic leader is responsible for overseeing the Democratic Senate Campaign Committee. There was a race in Illinois in 2004. It was an open seat, and Obama was running along with five or six other people. I said to Daschle, "There's this guy out here who's really impressive. His name is Barack Obama. Durbin's really high on him. I just don't see how he's going to make it, though. You know, he's African American, and he doesn't have a lot of money." Obama was a lot stronger than people thought, and he won the primary.

He still faced what appeared to be a tough general election race. At the 2004 convention, I gave a fundraising pitch at a DSCC candidates' event for the former governor of Alaska. The next person up was Obama. I was getting off the stage, and he said, "Good job." Then he got up and gave his fundraising pitch, and it was terrific. I told him after his convention performance that I had been fortunate to speak before him and was never going to speak after him.

In late September, he was in D.C. for a fundraiser, and we met. He said, "You know, I don't want to jinx myself and I won't get ahead of myself, but it looks pretty good. Can you give me some advice as to how I should approach the leadership and set up my office should I get elected?"

The election came. Daschle lost. Obama won, and he called me again, and after an hour he said, "Would you be interested in being my chief of staff?" I said that I had to close up Daschle's office and just didn't think I could do it. He said, "Why don't you think about it, and let's talk again in a couple of weeks."

"There are three elements you need to have a successful operation. Clearly, you have to have a superior principal, and I've had that in Dick Durbin, Tom Daschle, and Barack Obama. Second, you have to have smart, hardworking staff people who understand policy and can figure out strategies to get things done. Third, you have to have an organization that is greater than the sum of its parts."

I finally took the job when Obama gave me a recruitment pitch. It was an interesting one. He said, "First of all, I know what I know, and I know what I don't know." He said, "I can give a good speech." I said, "Yes, you can." And he said, "I know policy. I know retail politics. I don't know anything about coming into the Senate, getting established. I'm coming in as the only African American, with some notoriety as a result of the convention speech. I know people, a lot of my colleagues, Democratic colleagues in particular, are going to be suspicious about whether I'm going to try to do a good job and learn the ropes, or whether I'm going to grandstand. I want to get ahead,

Peter M. Rouse
Peter Rouse serves as counselor to President Obama, advising on matters of policy, organization, and strategic planning.
He served as chief of staff to Senator Obama, as cochair of the Obama presidential transition team, and, in 2010, as
White House chief of staff.

but I don't want to ruffle feathers, and I want to deserve it as I get ahead. I need somebody who can help me develop the strategy."

I was thinking about leaving the Hill. I did not plan to go to work for any other politician. As it turns out, the two Democrats who were elected that year were Barack Obama and Ken Salazar, and Salazar also offered me the job as his chief of staff, and he continues to grouse good-naturedly about why I picked Obama over him.

Obama made the correct assumption that he should not promise jobs to people until he had a chief of staff who could oversee the construction of his operation. The first thing I said was that before you start hiring people you need to lay out your structure: How many people are you going to put in your policy shop, how many in constituent services, how many in communications, how many in the state, and how many in field offices. The answer to all that is dictated by what you want to accomplish, and how you want to proceed. You have a budget, so you have to figure out what you can spend in these areas.

Then I said that the second thing you need to do, before you even start talking to people, is to put bullet points underneath each job identifying what each person's responsibilities are going to be. Before you say, "I want to hire someone," you need to know what each job entails and if that person fits in one of them.

In most cases, Obama talked to two or three candidates for each job, and then we decided as a group whom to hire. For one post, he wanted to hire someone with more than twenty-five years of experience in the Foreign Service, but at the last minute, I was able to convince Mark Lippert, a staffer on the Foreign Affairs Appropriation Subcommittee, to apply. Senator Obama really liked this Foreign Service person, and I said, "Well, four years from now, when you've been on the Foreign Affairs Committee for a couple of years, you'll have an additional slot, and she'd be perfect. But right now our strategic plan is for you to prove you're

dedicated to being an effective senator for Illinois. It's to make sure the leadership understands you're willing to help them with their priorities, and then we're going to start laying out some vision on issues separate from the standard fare."

A month later, Mark was still on the Appropriations Committee—we had hired him, but he still wasn't on our staff yet—and he worked wonders on the appropriations bill. Senator Obama was sitting in his legislative director's office, and I came in and said, "By the way, I just heard that Mark was able to get $50 million in your name in the appropriations bill. I wonder whose idea it was to hire him instead of the Foreign Service officer?" He said, "As I recall, it was mine." And I said, "That's how I recall it, too." And we all laughed.

When he first ran for the White House, President Obama told me, "In the unlikely event we're successful, you know, you should keep in mind that only 15–20 percent of what a president does is initiated. The rest is reaction." That has become prophetic, as it turns out. But even at the beginning he knew this was an uphill battle and a long-shot race, and then it became a perfect storm.

I'm Karl Rove.

I'm a columnist for the *Wall Street Journal* and an analyst for Fox News. I give speeches and do a little bit of consulting, and I spend a lot of time helping a group called American Crossroads.

I have always liked politics and being in the fray. When I was seventeen, I volunteered for Senator Wallace F. Bennett of Utah. The campaign manager

gave me my first assignment in politics. When I was at the White House forty-odd years later, I got to call him and say, "The president of the United States would like you to serve as ambassador to Belgium."

Between my freshman and sophomore years in college, I was offered a job on a campaign in Illinois, which was quite an experience for a kid from the West. Then I was offered a job in Washington as executive director of the Campus Republicans. And then the chairman of the Republican National Committee, George H. W. Bush, offered me a job as his special assistant. Within three years, I found myself in Texas, which was one of the best things to ever happen to me. It was a case of being in the right place at the right time. Texas was overwhelmingly Democratic but on the verge of big changes, and by being there I had a chance to have experiences that I wouldn't have had if I had stayed in Washington.

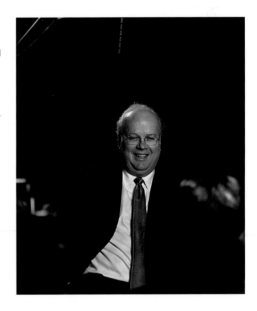

I was deputy chief of staff for the first Republican governor in over a century. He wanted me to run his reelection, but I said, "I'd like to start my own political business, and I'd like you to be my first client." He signed on, and I started my own business. I was a general consultant for a lot of campaigns—seventy-five campaigns for

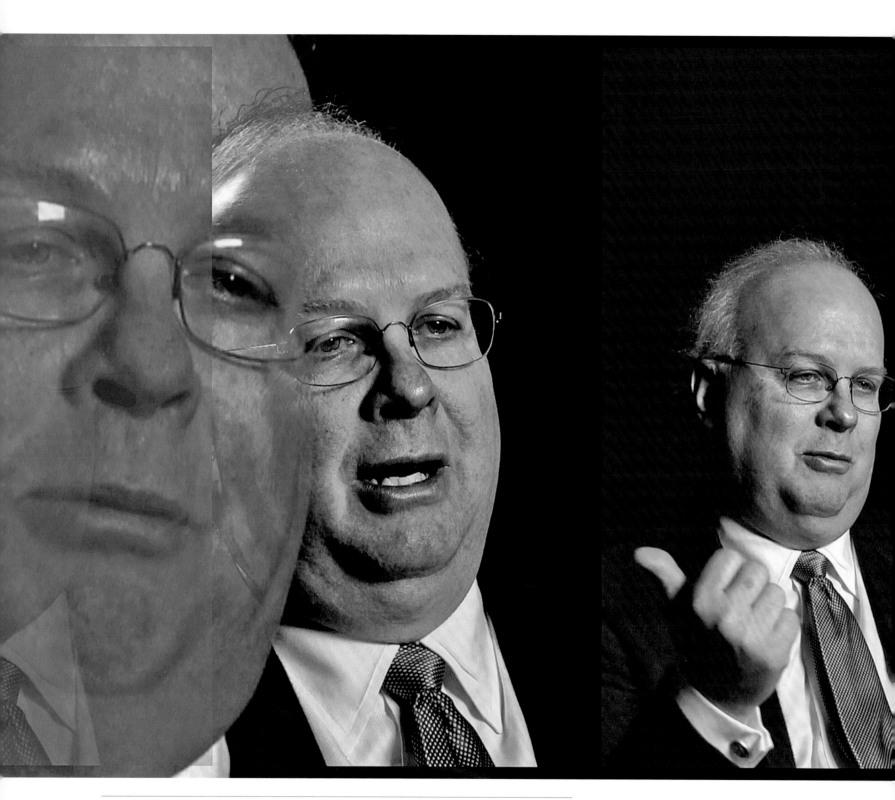

Karl Christian Rove

Republican political consultant Karl Rove served as deputy chief of staff and senior advisor to President George W. Bush and was with him during the events of September 11. He continues to be an influential Republican strategist in addition to working as a Fox New contributor and columnist for the *Wall Street Journal*.

governor, senator, and congressman in twenty-four states, and hundreds of campaigns in Texas. I was able to help a lot of people, and as they moved up the food chain I got to move with them.

I met George W. Bush the day before Thanksgiving of 1973. George H. W. Bush's chief of staff came in and said, "The chairman is going to be down at the White House, I've got a meeting up on Capitol Hill, and W. is coming down from Harvard Business School for the holiday. He'll call when he gets to Union Station. Meet him in the lobby and give him the keys to the family car." On the day before Thanksgiving, in walks this guy wearing his Air National Guard flight jacket, cowboy boots and Levis with the characteristic round marker in the back, showing where he kept his chaw of tobacco, and exuding more charisma than anybody should. I gave him the keys to the family car—a purple Gremlin with Levi Strauss interior. It was about the ugliest automobile you've ever seen. Despite that inauspicious start, we've been friends a long time.

The defeat of the senior Bush in 1992 made it possible for George W. Bush and his brother Jeb to run for governor in their respective states, Texas and Florida. Of the two, it looked like Jeb would have a better shot. Texas Governor Ann Richards was an enormously powerful and very popular incumbent. But George W. approached the campaign absolutely the right way. He said, "I'm not going to attack her. I'm going to talk about what I want to do. I think she's failed to take on the big challenges, so I'm going to talk about what I want to do and pound away at it, and at the end of the day, give people a choice between somebody with a fun personality and an exciting stage presence but who hasn't achieved anything as governor and doesn't have a compelling vision versus a guy who is earnest and wants to do four things: Reform our schools so every child is educated, reform our juvenile justice system so we no longer warehouse so many of our young people who've made a mistake, reform our welfare system to end dependency on government, and reform our justice system so Texas is not plagued by junk

lawsuits that discourage the creation of jobs and enterprise." He defeated Governor Richards by a landslide.

The thing that causes most campaigns to lose is that voters don't really have a good sense of what you want to do because you don't have a good sense of what you want to do. A compelling, authentic vision is the most important thing in a campaign. George W. Bush had that vision when he ran for president. The election was a long shot. The country was at peace and apparent prosperity, though there were already some strains. But he was the compassionate conservative who was going to reform education, tackle entitlements, and cut taxes. Concrete vision mattered.

"As we approached the White House in Marine One, the Pentagon came into view, and we flew through the plume of smoke that was streaming out of it. The president broke the silence, pointing out the window and saying very quietly, "Take a look. You're looking at the face of war in the twenty-first century."

The narrow victory in Florida—a lot of people were never reconciled to it. When *Meet the Press* interviewed the Democratic leader of the House in January 2001, Tim Russert asked him twice, "Do you think Bush is the legitimately elected president of the United States?" He refused to answer the question. That refusal was the sign of an animosity that persisted for years. Iraq only made it worse. It's still there today.

Still, the president led well in a time of crisis. We were in Florida when the 9/11 attacks occurred. My assistant called me and said, "A plane has flown into the World Trade Center. We don't know if it's jet or prop, commercial or private." I went over and told the president, and he got an odd look on his face and said, "Find out more." Shortly thereafter, the president went into a classroom of fourth and fifth graders and began a reading demonstration, because the school was emphasizing the kind of reading programs embodied in No Child Left Behind.

Then the second plane flew into the World Trade Center. Andy Card went in a minute later and whispered in the president's ear that a second plane had flown in. The president had to make a decision: Should he stand up in the middle of this reading demonstration and run out of the room with television cameras watching him, or just wait until the exercise concluded in a few minutes?

Shortly after the president came into the staff hold, the head of the Secret Service detail said, "Mr. President, we need to move you to Air Force One and get you airborne as quickly as possible." While we were en route, the president got word of the attack on the Pentagon. I was in the limo and could only hear one side of the conversation, but I knew it was bad, because he said, "Is Rumsfeld alive?"

We began to fly toward Washington. Almost immediately there was disagreement. The Secret Service, the Pentagon, Cheney, the people in the Emergency Operations Center did not want the president to return to Washington. They said, "We can't guarantee the airspace over Washington, Mr. President." The president said, "I'm coming back." There was argument back and forth throughout the afternoon, but finally, after a couple of detours, we headed back to Washington. As we approached the White House in Marine One, the Pentagon came into view, and we flew through the plume of smoke that was streaming out of it. The president broke the silence, pointing out the window and saying very quietly, "Take a look. You're looking at the face of war in the twenty-first century."

I'm Mera Rubell.

With my husband and children, I oversee a nonprofit foundation and museum, the Rubell Family Collection in Miami, which exhibits an art collection that we started fifty years ago and continue to build with more energy than ever. To support that foundation, we've had many jobs. At present we run hotels, one of which is in Washington, D.C., the Capitol Skyline in Southwest, which we bought fifteen years ago. We're currently developing another museum campus in Southwest Washington in an abandoned junior high school.

In a way, it was long-distance trains that set me on my path. I remember thinking as a young girl about the rhythm of trains going to places that were unknown to me. The train journey is still fundamental to my identity. Dislocation becomes your location, and you also learn to trust people. If you are open to people who don't think like you, look like you, act like you, it's very exciting. That's where the art comes in, because art, in some way, is about trusting a broad spectrum of ideas, of people, of concepts and not being judgmental. An openness and understanding of the other, whoever that other is, leads to real changes in our society.

Mera Rubell

An art collector and philanthropist, Mera Rubell is cofounder of the Rubell Family Collection, based in Miami. She advocates for the arts as a means to encourage tolerance and creativity, as well as to provide tangible economic and social benefits to communities where it is cultivated.

In my immediate family there was always the dream of America. Some surviving relatives went from Europe to Canada and Australia after World War II, but my father was determined to go to America. We were in a displaced persons' camp in Germany after the war. We were separated for a time, and I ended up in an orphanage for a short period, where I had to take care of my sister. But if we look at the broad picture, I think everybody is displaced in the world. There are moments in history where people have to look at their options and move from the comfort of what they know into the unknown. It's quite arrogant to think that you own a place or a way of life, when things are constantly changing. The more open you are to change, in general, the better your chances of survival.

Artists are very much in touch with these ideas, the idea of understanding specifically what "the other" means. Art can communicate with something so deeply personal that you might say, "I can't believe that someone would let me in here." An artist's work allows you to enter a place where you can explore secrets and hurts. It's a place to explore desires that we don't always articulate, or pain and suffering. It's an openness that creates a beautiful conversation that brings people together. It's not just about finding a painting to match the couch.

Sometimes people don't understand how integrated art is to the economics and vitality of a place. Artists are constantly bringing fresh ideas to the world. Miami is a case in point. It was perceived as a city of just fun and games, the beach, suntans, and nightclubs. Finally, Miami has achieved the distinction of being a cultural destination, and the economic and quality-of-life impact has been tremendous.

My husband and I were married in 1964. He had graduated from Cornell and was studying for his actuarial exams. I was still at Brooklyn College. We met in the college library. We sat across the table from each other for three months and a day, and then he invited me to go out for a vanilla egg cream. We left the library, and his first words were, "Will you marry me?" Across the library

table we experienced each other. By the time he finally spoke to me we had real feelings for each other. We had this whole interaction that was nonverbal. I tell this story because I think it gives a real insight into our art collecting, in which intuition—and the willingness to act on it—has played a tremendous role.

Don changed careers and went on to go to medical school, while I started teaching. My first job was with Head Start. Our art collecting started when we lived in Chelsea in 1964. We had very little money, but we came across the most incredible universe of artists working in storefronts on our walks. We'd see the work of talented artists and even with the little money we had, we were able to say to them, "Okay, we'll create this relationship if you can accept a payment plan." A payment of $5.00 per week made to five different artists allowed us to acquire original works of art. It was a long time before we considered what we were building to be a collection, and slowly came to understand the responsibility of caring for thousands of objects.

My husband has a collecting gene. When he was younger, he collected baseball cards and stamps. I was not born with that gene. As a refugee, I instinctively understood that the lighter the package you take with you, the faster you can run. It was a leap of faith to create a collection, as it requires you to believe you're going to be in one place for a long time. Slowly, my trust in America allowed me to have the faith necessary to create the extensive collection we have today.

I derive real pleasure from the way the Rubell Family Collection, for the last eighteen years, has reached children throughout the Miami Dade School System. Thousands of children come through our collection and their interaction with the art helps them to begin to understand their own uniqueness, talents, and possibilities.

My daughter is an artist. Our son inherited the collecting gene from my husband. Caring for the objects in our collection became a

family responsibility. In time, we came to realize that it was a great privilege to participate in the conversation of contemporary art as a collector and then jointly commit to sharing it with the public.

We travel constantly, and many call us American cultural ambassadors. A few months ago, for example, we traveled to see forty studios across China and to collect some of the most interesting new works we saw. Our collection is becoming more and more global. You don't know where the talent is and where the story of contemporary art is going to be told. Our mission is to help preserve that story.

I'm Stephanie Schriock.

I'm the president of Emily's List, an organization committed to electing pro-choice Democratic women candidates.

I grew up in Butte, Montana. My parents said, "You can do anything you want to do, you can be anything you want to be." I took that to heart. Our town was historically a political center for so many of our great movements, particularly the union movement. Growing up in that environment, with parents who said you could do anything, drove me into Democratic politics. People matter, and that's an idea that my mom gave me. People really do matter, and how you treat them means who you are. My father, right behind her, was there, too. And then I just wanted to do everything. I think I was one of those Type A personalities who decided, "Oh, what else can I do today?"

One day, Nancy Keenan, then the superintendent of public instruction for the state of Montana, came to my high school. Today she is the president

of NARAL Pro Choice America, and we work together all the time. She had won an election statewide in Montana, and I thought that was spectacular, because we still weren't seeing very many women rising to that level. She spoke. I can't tell you exactly what she spoke on, other than public service and the need to get involved in the community, but that was it. I thought, "There we go. I want to follow in Nancy Keenan's footsteps." It was important for me to see that kind of role model, someone who had taken that risk, run for office, and made a difference.

When I left Butte and went to school in Minnesota, I got involved instantly in the college Democrats. In my first paid campaign, I worked for Mary Rieder, who was running for Congress in southeast Minnesota. I called her up, per a tip of former state senator whom I knew from the university, and said, "I can be your scheduler." She said, "What I really need is a finance director." I replied, "Well, sure, I can try to do that." And so she had someone who came in and trained me, and that's how I became a fundraiser in Democratic politics.

Late in August of that election year, Emily's List came on board and endorsed Mary. We'd worked hard for that endorsement, and it meant so much for us. I remember, as the finance director, when Emily's List did the very first mailing to its membership to support Mary, asking members to give checks directly to her. And the checks started coming in. They came in from everywhere, from towns that I had never even heard of. The power for me of those checks meant that there was a woman sitting in Orlando who thought, "You know, we need more women in Congress. I'm going to send you a hundred dollars because I believe in you." You could feel it in that check. And I realized the power of women when they organize together in a movement. I'm still in awe of that first day the checks came in.

Mary Rieder didn't have a website in 1996. By 2002, when I became Howard Dean's finance director, it was unheard of not to have a campaign website. We still didn't quite know what to do

with it. We'd put information on it, hoping that people would come. We added a "donate" button in the hope that someone might actually hit it once in a while. I said, "You know, this is what we're going to do. We're going to put up all these sails. We're going to put up a website, and we'll do some direct mail sales, and we're going to hire some staff, and I swear this wind is going to come, and it's going to catch us, and we're going to fly." We waited for a while, but people found us. All of a sudden, the growth was so fast and so exponential that we realized this was larger than one man running to be president of the United States. It was a way for people to connect with each other and feel as if they were part of something so much larger than they've ever been part of before. That's how politics should be.

"When I look at the work we're doing at Emily's List, much of it has to do with the Republican war on women. I think lots of Americans believe that once we have a truly representative democracy, where 52 percent of the people in Congress are women, when that day comes—and it will come—the policies that we will have for our nation are going to be more community-based, more family-focused, and more forward-looking."

After my Howard Dean experience, I wanted to try something else. I went into campaign management. I became Al Franken's campaign

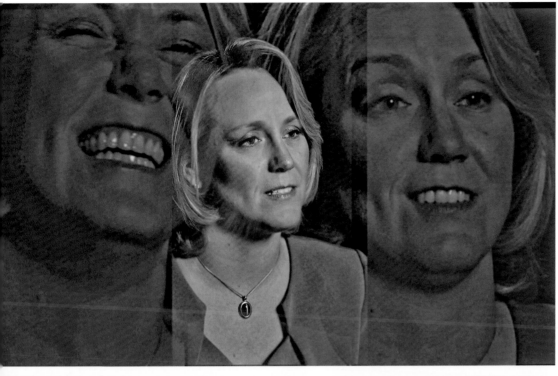

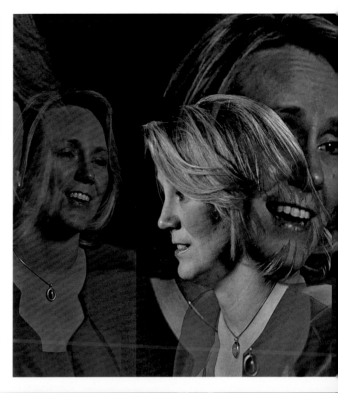

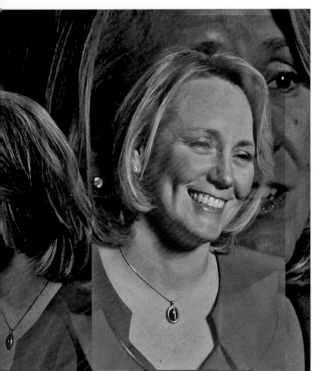

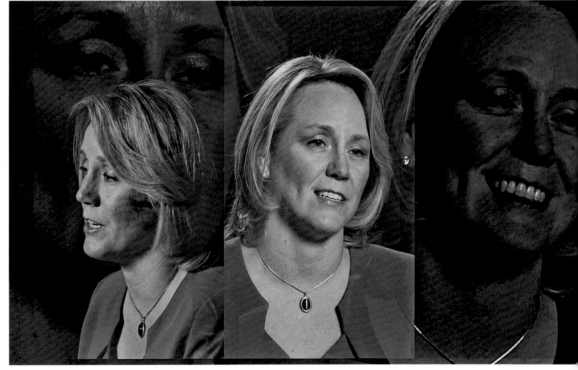

Stephanie Schriock

The president of Emily's List, an organization dedicated to electing pro-choice Democratic female candidates, Stephanie Schriock has based her approach to political advocacy on the recognition that many small contributions can have tremendous collective impact. She is dedicated to preserving rights and privileges that women have fought for in recent decades.

manager. He had great staff on board already, and all we had to do was to take that staff and motivate them to be even better. That's what I love to do. I love watching anybody who works for me grow and strive and accomplish great things, because I really believe in the power of individual people to do great things, and that's exactly what that campaign was about. People rose to the occasion. They came on board, they stopped everything they were doing, they came in from other states to say, "We want to win this. Al needs to be the next senator." It was really an incredible moment. I think everybody involved feels that was a moment in time that brought us together and elected a great man.

Emily's List is now twenty-seven years old. I came in on its twenty-fifth anniversary. It was the brainchild of the brilliant and strategic Ellen Malcolm, who founded it and ran it for twenty-five years. What's so brilliant about Emily's List is its basic foundation, the basic philosophy, something that I've been talking about through this whole conversation. When individuals come together and do their little pieces, but jointly, you can make great things happen. That's precisely what Emily's List is. If you talk about what Howard Dean did online, what Barack Obama did to take that model and explode it, it started when Emily's List figured out how to do the exact same thing, but through the post office. It's all the same process. Ellen opened up this whole concept of supporting candidates across the country whom you believe are going to make a difference, regardless of where you live. That's changed our entire political system, and I think for the better.

Right now, in 2012, we've got sisters in our country, fellow Americans, who do not have the same rights that we do because of where they live. That's not the country I grew up in. I don't believe that is the American way. When I look at the work we're doing at Emily's List, much of it has to do with the Republican war on women. I think lots of Americans believe that once we have a truly representative democracy, where 52 percent of the people in Congress are women, when that

day comes—and it will come—the policies that we will have for our nation are going to be more community-based, more family-focused, and more forward-looking. That's why I'm so excited and committed to being at Emily's List right now. You can either tip forward and make gains and make great change and provide more opportunity for people, or you can tip backward, roll back the clock, and lose the rights and freedoms that our mothers and grandmothers fought for. I do not want to tip backward.

I'm Larry Schuette.

I'm the director of innovation for the US Navy. My job is to promote science and technology in the Navy and the Marine Corps.

My father was an inventor and an engineer. I grew up with engineering and science at the dinner table. My two brothers and a sister and I are all engineers. We all went to Catholic University here in Washington, D.C. That was not a coincidence. My father went there, and my grandmother and her sister helped start one of the schools there.

When I got out of college, I worked at the Naval Research Laboratory doing underwater acoustics during the Cold War, conducting antisubmarine-warfare research. Then I moved onto computer modeling and electronic warfare. I was invited to go over to the Pentagon, moving out of the science realm and into the policy world. I was used to a very orderly, linear kind of rational thinking, and now I was in an area where there is no good decision: Everything is being stressed or strained by something other than an equation.

I ended up at the Office of Naval Research as director of innovation principally because I had a science background as well as a policy background and an understanding of how things actually work in government. I've loved my work and the ability to go to the field to be with warfighters to understand what the folks on the ships and the submarines were actually doing and then provide them that next big piece of technology that would make a difference in what they did. I've been on airplanes, submarines, ships. If it belongs to the Navy or the Marine Corps, I've been on it and probably have a piece of technology on board.

For instance, we've put solid-state lighting on board ships and submarines. We've long recognized that buying fluorescent bulbs and replacing them, having sailors involved in stocking light bulbs, moving light bulbs, installing light bulbs, and disposing of light bulbs is crazy. We're moving to solid-state lighting because the commanders recognize that the economic savings and the manpower savings are too much to ignore. For every problem there is a moment. No one had really thought about taking solid-state lighting and putting it on a ship before. Why would we do that? The answer is that there's no better environment for it, but we were paying more for electricity and had to haul light bulbs around.

We spend our time building the case, if you will, and finding the right people to talk with. It's opportunity-driven innovation. I look for the clever application of technology in a new way. I look at technology and then ConOps, or concepts of operations. The military goes out and does its thing, while we consider how new technology will change or improve what they do. Innovation often ends up being about small things. It's the subtle changes that make a big difference, that make the return on investment. Everybody agrees on them when you're done.

The people who are truly innovative look everywhere and talk to anybody and take ideas from anywhere. We think that the old school inventors spent all their time in the lab, not talking

to anybody. Well, they didn't. A chemist reads chemistry journals and talks to other chemists. An innovator talks not only to those chemists, but also to the consumers of that chemistry and imagines, say, that if we had a new coating to put on this submarine or ship or airplane, we could prevent corrosion. The innovator crosses all the boundaries and all the domains. Innovation occurs at those seams and intersections between all the different areas—the scientist, the warfighter, the company that's going to build the product. The innovator understands enough about all those areas to grab an opportunity and take it.

Much of what we do is classified, and so it's hard to talk about. But let's take the case of paint coatings. Paint. Who, you think, who cares about paint? The Navy buys a lot of paint, and it's put to work in a horrible salt-water environment. Steel does not like that. Aluminum hates it. Normally we would go in and paint the ballast tanks with an epoxy paint every three years. You have to go in and remove all the rust and recoat it. It's a lot of money and it's a lot of effort, and we have a lot of ships. Some scientists looked at the problem from an electrochemistry perspective— pure geek. They came up with a new paint, and nobody wanted it because it was too expensive. They went back and reformulated it to make it less expensive. Nobody wanted it because it took too long to put in the ballast tanks. So they came back and said, "Okay. We now have a paint that's faster to install than what you're currently using, and it's about same price as what you're currently using." The Navy said, "We'll think about it." The scientists persisted, and now, almost ten years later, they have a paint that lasts not three years but fifteen years. It's a commercial product made by Sherwin-Williams. They licensed that product and the process for making the paint. The big paint companies provide the thousands on thousands of gallons that we use every year, but to do reach that point required people with PhDs in chemistry who could work with warfighters.

When you're working with the Navy's administrators, you've got to understand

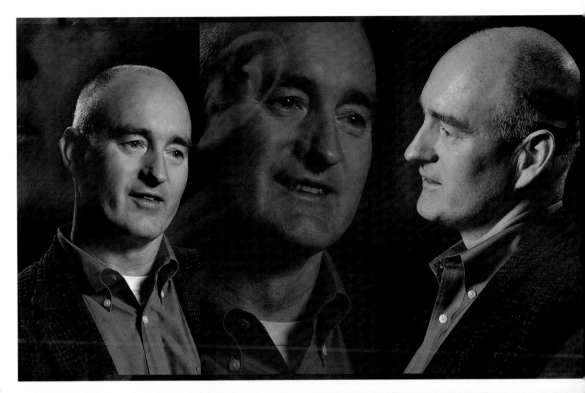

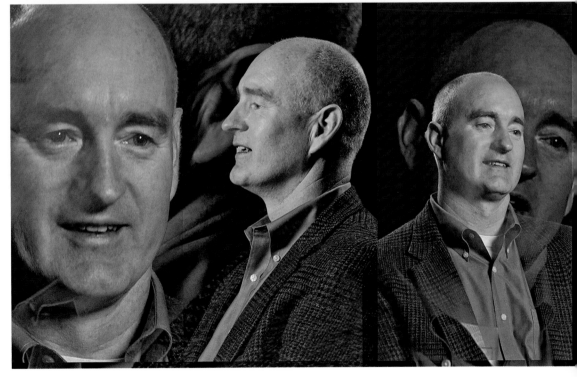

Lawrence Schuette
Trained as an electrical engineer, Larry Schuette is director of innovation at the Office of Naval Research. He works to identify new strategies, technologies, and materials to enable the Navy to increase its efficiency in all areas, recognizing that power of innovation is often about the incremental significance of attention to details.

the calculus of when they will or will not buy something new. All of the established processes have to change, and finally when they do, you usually get a moment when they look back at you and say, "So, we've been fighting this new paint, and now we love it." Industry, customers, scientists, all take that journey. We are the glue between all of those groups. We're the ones who pay the scientists to work on problems—about 70 percent of our research is done outside the government—and we're the ones who help industry get the techniques and the technologies that they then sell back to us.

As a leader of innovation, I end up listening a lot. I take a lot of meetings and phone calls. I'll give anybody thirty minutes, but when it's somebody coming in with an idea, usually I have to spend time scaling back their expectations of funding. We have a limited budget, and we say "No" 95 percent of the time. The challenge is right-sizing expectations and shifting them to where we actually think we can take an idea to market. Our job is to champion ideas that we believe are good ones and modify what we get in to come up with killer apps.

The future of the US Navy is unmanned. A manned platform is about putting people at risk. So if I can get an unmanned system out there, people aren't at risk to the same degree. My legacy will lie in getting technology to the fleet faster than we would normally expect, technology that's smarter and less expensive than we had originally thought. I don't like coming forward with merely good ideas. They have to be great ideas.

I'm Kathleen Sebelius.

I'm the secretary of the US Department of Health and Human Services.

My dad ran for office the first time when I was five. That had a big influence over what I wanted to do, what I thought about, the kinds of topics we talked about at the dinner table. Both of my grandfathers were involved in politics as well, one as a volunteer, the other as a judge who was active in party politics. My parents were both schoolteachers, and both were engaged and involved in the idea that you really had to give something back: "To those whom much is given, much is expected." That was always a theme in our family. We were encouraged to volunteer, be engaged, and know what was going on. I learned early on to go door to door and put up yard signs. I thought that's what every family did in the fall.

We lived in Cincinnati, Ohio, a conservative town. My dad was a liberal Democrat. He often was a voice in the wilderness. Even when we were young kids, he tried to make sure we understood issues well enough so that if people came at us with an opinion about how crazy our father was, we would be equipped not to defend him, but to defend ourselves. He understood that his positions on the issues would put us a little bit out of touch with our friends. Part of the discussion was to understand what was being talked about, why it was important, how it would advance things. He was engaged early on in civil rights efforts in a town that was just north of the Mason-Dixon Line and had a lot of racial tensions—and still has a lot of racial tensions. Later, he ended up being an antiwar leader, although he'd been in World War II. As my brothers came of draft age, he felt the Vietnam War was wrong and misguided.

My dad was willing to take chances. He won some elections and lost some elections. That also was a lesson to me. If your goal is to stay on safe territory, you might well not be able to accomplish anything. Some people run for office to be somebody, and others run for office to do something. He certainly fell into the latter category. I've tried to follow in those footsteps. You have to be willing to lose in order to ever win an office.

Taking a risk is a tough lesson for a lot of girls to learn. I don't mean "leaping-off-a-building risk," but the willingness to get hurt, to take a tumble, to not succeed the first time, but to step up and tackle something when you can't predict the outcome. Girls are taught to be a bit risk-averse, overtly or covertly. I went to an all-girls school and became a feminist, if perhaps an accidental one, because girls did everything. It never occurred to me that you couldn't be the president of the class, or on the sports team, or that you had to play only certain roles. In my world, girls were the dumbest in the class and the smartest. They were the ballet dancers and the athletes. It wasn't until I got to college and met women who had been in a coed setting, who were told that sports stopped in the seventh grade if you were a girl. You could be a cheerleader, but you couldn't be on the team. You could be the treasurer of the class, but you couldn't be the president. My world didn't have any of those boundaries and rules.

I met my husband in Washington, D.C. He had come from Kansas to go to Georgetown Law School. By the time we got married, he was already back in Kansas practicing law. I had never lived in Kansas in my life; I'd only visited for a couple of days. It was a big switch. I soon became engaged, though, as a volunteer in political campaigns. I'd taken my husband's name when we got married. His father was a Republican congressman, and suddenly there was a Democrat showing up in a very Republican state with this wonderful last name.

A neighbor and friend whose campaign I worked on was our state legislator. She said to me once, "Why don't you run?" My kids were two and five.

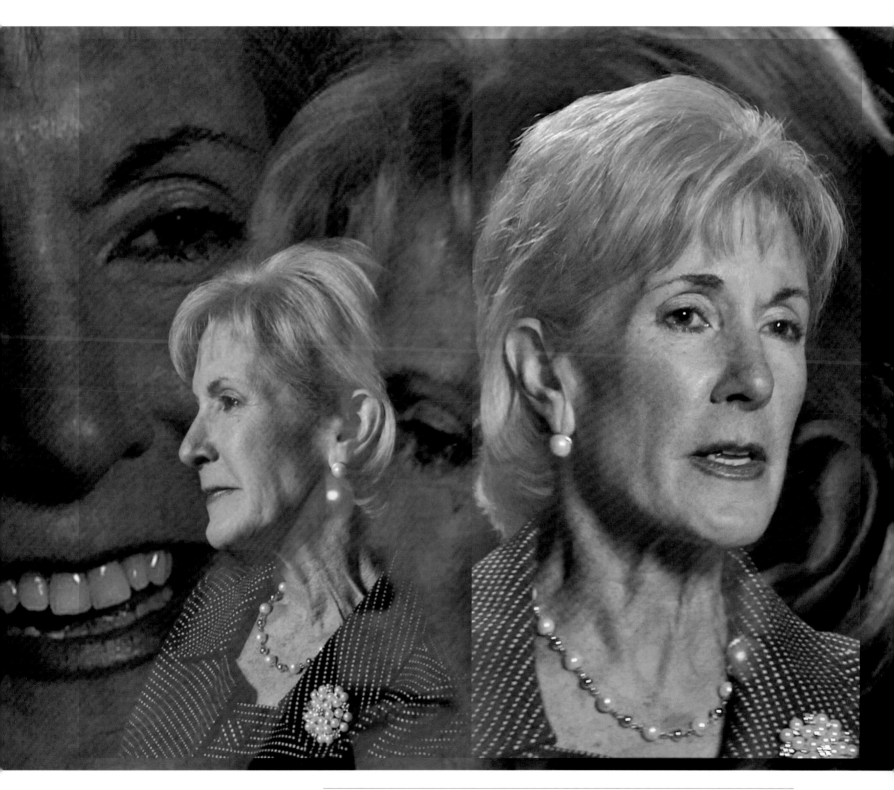

Secretary Kathleen Sebelius

After serving as a legislator, insurance commissioner, and governor of Kansas, Kathleen Sebelius became secretary of the US Department of Health and Human Services in 2009. Running one of the largest domestic agencies, she helped shaped the Affordable Care Act of 2010, widely regarded as the most significant healthcare legislation since Medicare and Medicaid.

The legislature in Kansas is part-time. It meets in January and goes for ninety days. We lived in Topeka, where I was running a state lawyers' association. I was working sixty hours a week and traveling, so actually the legislature was a much more family-friendly job. It gave me a lot more flexibility with my kids. We were off in the summer, and I was five minutes from the capitol.

As a mom with young children, I worked a lot on children's and family issues, especially education. Except for two years, my eight years in the legislature were spent in the minority party, but there were Republicans, particularly in the eastern part of the state, who were committed to high-quality education. I was careful to find Republican partners when I introduced ideas. Rather than have my name at the front of the bill, on one of the earliest bills I sponsored, I got the Republican majority leader to put down his name. I thought his endorsement would be helpful, and it was.

I then became the state's insurance commissioner, a consumer voice. I made a pledge not to take any money from the industry we regulated. That promise was something that actually resonated with a lot of Kansans. Then I ran for governor. The candidate who emerged from the Republican primary was the most conservative in the lineup. Democrats only represent about 37 percent of registered voters in Kansas, so I had to get all the Democrats, most of the Independents, and some Republicans. I was able to put together a broad-based coalition around the issues of education spending and moving the state forward.

I chaired the Democratic Governors Association in 2007. When I took that role, I promised to not endorse a candidate while I was chair. As soon as I could, though, I endorsed then-Senator Obama. He came to Kansas, where he has roots, on the anniversary of the state's entering the Union, in February 2008. I endorsed him there. We had some conversations back and forth when he was elected president about my coming into the Cabinet. He asked me to be the secretary of HHS. Health care was something that I'd worked on in

so many capacities: as a legislator, as insurance commissioner, as governor. I said yes. You don't turn down the president.

I hope we look back on the passage and then full implementation of the Affordable Care Act as the most pivotal health moment since Medicare and Medicaid were passed in the mid-1960s. It's the first time the United States has ever passed a comprehensive health bill that gives all citizens coverage. I think it will make a huge difference in terms of people's lives and prosperity. It's a huge economic challenge for lots of people who still are terrified that they will go bankrupt if somebody gets sick or that they will not be able to afford the care and treatment they need. It would be wonderful, too, if we looked at this moment as the moment when the tide turned and we started getting our youngest generation healthy and ready to be productive in this global society.

I'm Sonal Shah.

Until about a month ago, I worked at the White House, running the Office on Social Innovation and Civic Participation.

My parents always believed that they could do something to change the world around them. They were community activists at every level, from voting in local elections to doing work with the Indian community abroad. My brother and sister and I grew up in a dual-identity household. We were Indian at home and American at school. Trying to merge those two identifies and figure out how to be an Indian American who could do something in the world was our challenge. We founded a service program called Indicorps as a neutral way to allow people to figure out their

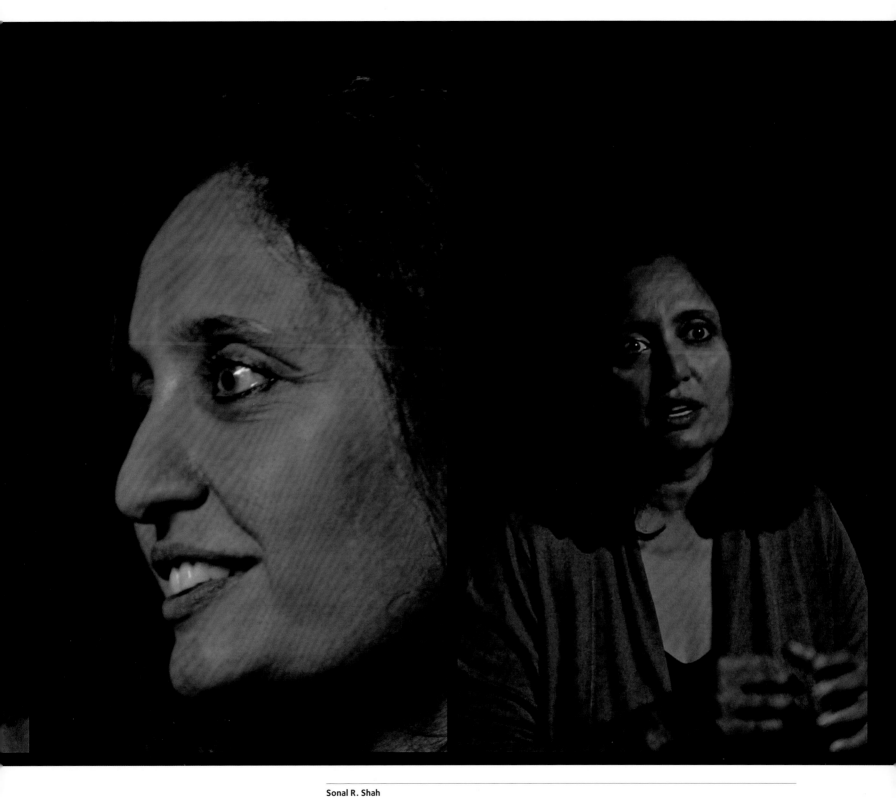

Sonal R. Shah

Economist Sonal Shah has focused on developing innovative strategies to fuel international economic development. She helped develop a currency for Bosnia and led Google's philanthropic Global Development Initiatives. She directed the White House's Office on Social Innovation and Civic Participation from 2009 to 2011.

own identity—for example, they could go to India to work in a village clinic or school. Young Indian Americans in the program said to us, "You know, now I understand my parents." They get to figure out what this country means to them and what their parents must have gone through growing up in villages in India.

I was good at math, but I didn't want to be a math major in college. I liked economics and how it can help frame theories. I went into economics wanting to understand what was happening around me through a framework, and the economic framework just seemed to work for me. I loved the math aspect of it, but I really thought that economics helped in understanding, in general, that the world has many constraints, and you have to live within them. It doesn't mean you can't change them, but they exist. How do you work within that, and how do you make those changes happen? I appreciate the way economics has that ability to help us think through that.

"In the social sector, at least in the United States, we've become afraid to try new models."

I worked in the Department of the Treasury in the 1990s. We worked through the Asian financial crisis. Then I lived in Bosnia from 1995 through 1997, helping create a national currency. From afar, it was easy to say, "It's not possible. You can't do this. You can't get the Central Bank to agree to create a currency. There are three parties to this, and no one wants to agree on anything." But if you're willing to get in a car and drive across the border, you'll find that they're willing to have a conversation. Bosnia taught me that monetary policy, in many ways, is about confidence in the currency, and this has a huge impact on the economy. We learned in Bosnia that, if people

start to use the currency, it didn't matter what it says on it. All you need is confidence in it.

After Treasury, I joined a think tank called the Center for Global Development, led by Nancy Birdsall. Ed Scott, the founder, gave $25 million to set up a think tank focused on development issues. How do developed countries' policies on aid, immigration, or the environment affect developing countries? We worked on figuring out how to create a policy agenda around that.

I also became interested in technology. With technology, the world opens up, and information is now democratized. I can get access to information anywhere. What technology offers is the opportunity to give people power to make changes that they want at very local levels. If you add up all those micro pieces of change, eventually it leads to a macro policy change.

I worked at both Google and Goldman Sachs, and I can tell you that they spend a lot of money on technology. You can do a trade in less than three seconds because somebody invested in creating the technological system behind it. That was an upfront, overhead cost that eventually made it cheaper over time. You have to make those kinds of investments. In some cases, it may be the government that's a sustaining factor at scale because it is a social good, a public good. The fact that you have a more educated society or healthier society is actually good for the country. You have more people who can work in industry. They're paying lower healthcare costs. When we're working in a developing country, we say that those are good things that government should invest in. Yet the same holds for us. Those are important public goods that we should invest in to make sure we have a healthier and a more educated society that can take us to the next level of productivity. In some cases, it's not going to be the private sector that takes over. In some cases, hybrid private and public models can help sustain long-term financing.

In the social sector, at least in the United States, we've become afraid to try new models. In the

developing countries, people are willing to say, "HIV/AIDS medications haven't been doing so well. Let's try mobile phones and see if we can send text messages about them." If it doesn't work, the problems are still the same. But when it does work, in that particular case, it changed the trajectory of where HIV/AIDS went in parts of South Africa. We don't have an appetite for failure in the social sector, but GE might try fifty products before they sell one, and they're willing to take that risk. We have to do the same in the social sector. We've got to be willing to test and say, "If we want to solve the education crisis, if we want to change the dropout rate, then let's take some risk." We're already at 50 percent dropout rate. If the worst outcome is the status quo, then why not take some risk?

If we want to change the trajectory of where the social issues are, then we've got to be willing to take some qualified risks in investing in new ideas and seeding those ideas. I give President Obama a lot of credit here. He has taken risk in such things as the Social Innovation Fund and nearly everything the secretary of education has been doing. Now, within agencies and across agencies, the conversation about innovation has become the norm. People are asking, "How do we do this differently? How do we think about changing this program?"

At the Veterans Affairs Department, Secretary Shinseki ran a competition in his first year on innovative ideas to reduce cost. In the first round, five hundred ideas came through. The last time they did it, six months ago, they had thirty thousand ideas from all kinds of people inside and outside the system. He funded three of the top ideas. It makes people believe that it's possible to make those changes happen.

What you're beginning to see is an ecosystem change. I am looking to figure out where the nexus between the public, private, and nonprofit sectors come together and how to blur the boundaries between them. Why shouldn't we push those boundaries out and look for new ways to solve old problems?

I'm Jim Shelton.

I'm assistant deputy secretary of innovation and improvement at the US Department of Education.

My dad would never drive by someone who was stuck on the side of the road and not pull over to help. I can't remember my mom when she wasn't doing something like working at the Northwest Settlement House here in Washington and dropping off clothes or food. We didn't have much money ourselves, but she always found a way to give to somebody else. From them, I learned about serving others. I also spent a lot of time with my grandmother, my father's mother. She grew up in rural Virginia, was fortunate enough to get some education, came to D.C., and raised five boys. She was always checking on neighbors, dropping off food, helping as she could. Her spirit of taking care of people as the right thing to do is the first memory I have of what it really meant to be a good person.

My parents sacrificed a lot to make sure I had a good education. I was very fortunate. I grew up in Southeast Washington, where the public schools were not very good, but I wound up going to private schools by the virtue of the fact that my parents were willing to work so hard to make sure I could. I could quickly see the difference between my life and the lives of most of my friends because of that opportunity.

I was good in math, and I loved to read. The more important thing was that I loved applying the math. It was easy for me to make sense of the world through mathematics and the relationships of things. My mom introduced me to some engineers at her work. I had no idea what an engineer was. I knew that they built really cool

things, and I knew you needed to do math to do that, and that's how I got interested in it.

I would go to my mom's office after school in the early 1980s. There was a computer room, and seeing it, I was amazed at the possibilities. When I went to junior high school, I got the chance to program. The very first thing I learned was flowcharts. There's a language for laying out your logic, and doing that made it easy for me to think about how to structure things, what the real if/then is in any situation, and how you set yourself up so that when you have multiple choices, you can figure out what they are most efficiently and use the logic to drive where you're going to go. I'm able to lay almost every problem out in that way and understand where the connections are, and that allows me to chop the branches off quickly and focus on what's important.

One of the best things about what I do today is that I meet amazing people. I had the opportunity to meet both John Seeley Brown and Alan Kay, two people at forefront of the development of new technologies. Kay developed the first laptop. They had a vision that technology was going to transform education. But early on, it was too expensive, too cumbersome. People weren't thinking through exactly how this was supposed to work for teachers to help them change their practice, and how to make use of computers. Now, everything has gotten to the point, finally, where very cheap devices, high-speed connectivity, cloud computing, digital content, and a culture that's used to using technology make it possible for transformation. Two- and three-year-olds are taking cell phones and iPads and playing games while they learn the alphabet and shapes and colors. They learn to engage with these devices and find exactly what they're looking for. They are also using them not only to consume information but also to create new things that would have been considerably out of their reach before, raising their expectations about what the possibilities are.

We need to give our teachers the tools that will let them transform their classrooms for each and

every student. I worked in business before going into government, and I got to see that high-performing organizations have the best systems. They have money to invest. They train their people. They have great managers and leaders. When I left the business sector to come to the education sector, I realized that we don't do that for education and that education doesn't operate relative to the basic systems and tools that you would expect to have in any other sector or industry. They just aren't there.

People get in trouble when they overanalogize business and education, but there are certain things that are the same. Dollars move. There's a huge human capital-intensive sector that is all about providing a service. People have been doing that in other sectors for a long time, and they do it with great tools, great resources, great management training, great opportunities for outsiders to come in and help them do things that are really difficult. In education, we don't have the structure to provide those resources, and we haven't structured the incentives to make it easy for people to focus on the right things. I spend a lot of my time trying to figure out how we preserve what is most important about the core of education and making sure it never becomes

simply a product, that the spirit of education is something that actually, as they say, lights the flame within the student.

We don't do that well. The systems that we've put in place weigh down the potential of the people who work and study within them. We don't make it easy for the students to be ready to learn when they come to school. We don't have good tools and systems. It's amazing that we spend $1 trillion across K-12 and higher education every year, but there are no cost-accounting standards. There's no one way that everybody knows how much they do spend and should spend on things. There are no well-known and well-studied human capital practices.

The question is: Do we want to problem-solve to give all of our young people the opportunity to be successful? It's hard, but it's not impossible. We're trying to be better at aligning incentives and thinking about how we use our resources to create the incentives for people to do the right thing—to focus on students and student outcomes. We need to set goals that matter, have the data systems tell you whether you're meeting them, and deal with the worst performers, the two thousand high schools that are responsible for 50 percent of the dropouts. Innovation happens in the context of an ecosystem. When you talk about education, almost every part of the ecosystem has a significant flaw or barrier in it. We underinvest in research and development. The utilities spend fifteen times what we spend in education today. We don't even have a coherent agenda about what needs to be done.

There's a tremendous amount of this low-hanging fruit that will transform the sector. It will change the way we think about what people can learn and how quickly they can learn it, and it can help establish our educational leadership again. This is the national security issue and the civil rights issue of our time, and we should be investing every penny that we can to make sure that we are in a position to lead in education in the future.

James H. Shelton III
Assistant Deputy Secretary for Innovation and Improvement for the US Department of Education Jim Shelton is dedicated to enhancing American education through the increased application of new technologies to the classroom and beyond. To realize this goal, he focuses on improving the systems through which education is evaluated and managed.

I'm Peter Warren Singer.

I direct the 21st Century Defense Initiative at the Brookings Institution, a think tank in Washington, D.C.

I grew up in a family with a military background. I remember in my house taking my model of the jetfighter that my uncle had flown in Vietnam and racing it up and down the stairs and targeting Legoland, taking medals that my father and my grandfather had gotten in service and putting them on my pajamas. That was always there in the background for me. I also had a fascination and love of science fiction and technology, and when I think back to my memories of being six years old, it's riding my bike to school and imagining I was flying a jetfighter, or going to bed at night under my *Star Wars* sheets. Those two things have stuck with me.

In academia, we try to place people into certain categories, and if you don't fit exactly, that's not seen as a good thing. As a political scientist, I was interested in something the field often tried to ignore: current events. Unfortunately, academics aren't that interested in what's happening today. Some of my professors up at Harvard would have been happy if the newspaper stopped arriving, because current events kept getting in the way of their theories of how the world works.

I wrote my doctoral dissertation on the rise of private military contractors in modern warfare, a topic my professors didn't quite understand, that represented just how much the modern world and modern war was changing. We had an assumption when we thought of war and who fights it: Our vision tended to be a man in uniform. If he's in a uniform he is in the military, serving on behalf of his nation. Why is he serving and why does his nation fight? Patriotism and politics. Now, look at the reality. It's not just men who fight, it's women, it's children—one out of every ten combatants in the world is a child. Look who the US military is fighting right now: insurgents, terrorist groups, drug cartels. Look who is fighting beside them: private military contractors. Look at the causes. It's not only politics or patriotism when you're talking about the wars of today. It's economics, social regions, culture, and religion.

Much of my current work is in robotics, another key change in the "who" of war. Robotics just a generation ago was science fiction. I grew up with R2D2 toys and the *Terminator* movies. That technology started to become more and more real, with some 17,000 unmanned systems now serving in the military today. The result is changes in everything from how we fight to where we fight from. I have a friend who flew a plane over Iraq while he was sitting in the United States. This is not just fascinating science fiction; this is fascinating in terms of history. We're living through a change like the Manhattan Project, or if you go farther back, the introduction of gunpowder onto the battlefield.

The legal questions that come out of this are absolutely immense, everything from the status of those in war to accountability. If something goes wrong with an air strike using an unmanned system, who do we hold responsible: the pilot who's seven thousand miles away, or the scientist who invented it?

As we use more and more machines, the cyber side of it also becomes critical. We're going into a whole new space of war, fighting in a domain—cyberspace—that didn't exist a generation ago.

For roughly five thousand years, humankind only fought in two places: on the land and on top of the sea. Then we had science-fiction-like notions of boats that could go under the sea, or flying machines, and we made them real. And then we had lots of questions to figure out, not just the military figuring out how to use these machines, but also the legal and ethical questions that come out of it. We're wrestling with this right now with cybersecurity and cyberwarfare. Is cybersecurity a place where the offense is inherently at an advantage compared to the defense? If that's the case, how can you create deterrent structures in this place? What does proliferation of capability look like in this space? Is it something where only states can act, or is it something where small groups might have huge impact? There are all sorts of things that we're just now starting to figure out in this realm of fighting in zeros and ones.

People talk about the idea that our technology keeps getting smarter and smarter, multiplying upon itself. At some point it becomes smarter than a single human, and then smarter than every single living human combined, and then smarter than every single human who's ever existed. This notion of what some call "the Singularity" is that point at which the machines become self-aware. That's when you get into the world of the *Matrix*, the true science fiction. This is not just fantasy. Serious people talk about it, and they're talking about not *if* but *when*. The dates they mention are probably going to arrive before I pay off the mortgage on my house.

But I don't think we even have to get to that point of robotic superintelligence to say, "We have hit *the* Singularity." We are already here, without the super smart robots of tomorrow. That is, the world and the issues that we're facing now are completely unfamiliar to those that came before.

The historic parallel would be someone taking a monk living right before the invention of the printing press and showing him this rickety device and saying, "This thing can allow you to write more than one thing at once. How do you think it's going to change the world?" He's not able to imagine all the things that the printing press changed, the singularity in terms of mass production of books, which helps lead to mass literacy but also to the Reformation, which in turn leads to the Thirty Years' War, which unfortunately leaves a third of Europe dead. It also leads to the awful tabloid magazines that you see at the supermarket. How could that monk imagine that world? We've got that same thing happening right now with our technology, particularly robotics, but also with all the other manifestations of information technology.

Take how our notions of "going to war" are changing. For five thousand years, going to war meant going to a place of such danger that your family might never see you again. That fundamental truth of history has now been broken by robotics and unmanned systems. People don't have to "go to war" in the old way; they are fighting, but then go home at the end day. The most dangerous point of their day is not the act of shooting but the drive to and from work. That's a breakpoint in history, a singularity, so to speak, and we're already there.

Peter Warren Singer
As director of the 21st Century Defense Initiative at the Brookings Institution, Peter Warren Singer focuses on the future of warfare, addressing the role played by new actors and technologies. He has written extensively about this question, with publications that include *Wired for War: The Robotics Revolution and Conflict in the 21st Century*.

I'm Hilda Solis.

I'm the secretary of labor of the United States.

I grew up in the small town of La Puente, California, in the outer suburbs of Los Angeles. We lived in a working-class neighborhood, known for orange groves. My father and my mother were blue-collar workers, doing different kinds of jobs. My father was a man whom you could tell put a lot into whatever he did. All you had to do was look at his hands. He was smart and thoughtful, quiet and kind, and he taught his children that you need to be responsible and independent and work hard, and always to hold your family close and respect other people for who they are and the work that they do.

He was born in Arizona but, as a young child, was taken back with his mother to Veracruz, Mexico. He came up again to work as a young man and found a lot of hardship and discrimination. He ended up finding his way to Los Angeles where he met my mother at a US citizenship class. He always was so proud to be an American and to have things that were American—all of his cars were American-made. When he came home from work, we'd all go into the living room and watch the news. He was an avid learner, and he would read constantly and keep up with current affairs. When he was young and growing up in Mexico, he had a priest who saw potential in him and made an investment in trying to help him get his education, so my father was able to get a little Jesuit training. Mostly my father was self-taught. He'd talk about Socrates and Plato, and he could speak Latin. Now as an adult, I think that was all pretty amazing for someone who didn't have a formal education.

My ideas about justice and public service came from my parents. When my father was a young man, people were coming out of the Depression,

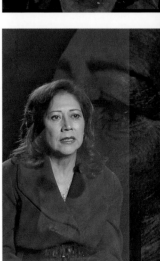

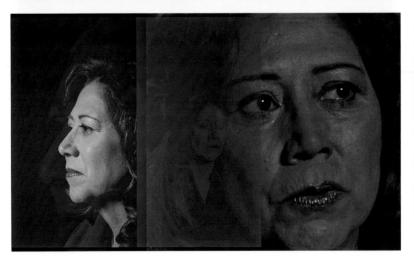

Secretary Hilda L. Solis

A native of California, Hilda Solis served eight years as a member of the House of Representatives. She became secretary of labor in the Obama administration in 2009. She is committed to providing opportunities for working Americans, particularly during a challenging period of economic transformation.

and there was a great deal of discrimination against Mexican Americans. He always talked about making sure that we not buy into that notion that we are less than who we are or that we should think less of ourselves. My mother was the same way. It was always about nurturing and giving back and doing service. My father taught us very early on to do not just our chores but also group projects, so every summer we would paint the house and do things that required some sweat. He was teaching us to be disciplined and to understand that those roles are important, teaching us about gaining responsibility and being accountable.

I remember when President Kennedy was shot, when I was a child. They let us out of school early. I was very young and did not fully understand what was taking place. My mother was sitting in front of the television, sobbing. I asked, "Mom, what's the matter?" And she said, "That man was just killed, our president, who was going to be our leader, someone who was fighting for us." I learned very early how important it was to have a good representation in government and public service. If you had good people elected, they would take care of other people who weren't as fortunate.

When I was in high school, a teacher, Mr. Sanchez, took me aside and said, "Hilda, you're in eleventh grade now. What are your plans for college?" I said, "You've gotta be kidding me, you know? This isn't something that can happen for me." I thought I was going to go to work. Another counselor had also told me that going to college was unrealistic. But Mr. Sanchez said, "No, you can do it. You have the wherewithal, and it seems to me, Hilda, that if you just put your mind to it you'll be able to get through this. I'll help you." I went home to talk to my mom about it, and she said, "Okay, let's go to talk to your counselor, your guidance counselor," and we went back to Mr. Sanchez, and he said, "Let's do this." I ended up applying, getting a scholarship and financial aid. That was a life-changer for me, as it was for many young people who come from neighborhoods like mine where you could count on one hand how many people went to university.

In the mid-1970s, when I was in high school, the Vietnam War was ending, and there was a lot of strife and civil injustice going on in places around the country. In Los Angeles, walkouts were occurring because people in our community were saying, "Hey wait, why don't enough of our young people go on to college or have a better education? Why are they all being drafted and coming back home in body bags from the war?" That sparked my interest to get involved in government or to do something to help bring about change. Now, I had never any idea that the way you do it is to run for office. I was interested in becoming a lawyer. That's where I started. In college, I was very active in student activities on campus, but I wasn't thinking about public office. That didn't happen until I started my graduate program, part of which required that I find an internship at some level of government. I was fortunate because I met people who told me to look at Washington. I thought it was a long shot. I wrote a hundred letters asking for internships, and I sent one to the White House. I'll never forget: One day my father said, "Hilda, somebody's on the phone for you from Washington, from the White House." I worked there as an intern.

From there, my journey led to the US House of Representatives. I served eight years, then was asked to join President Obama's cabinet. We were in the Great Recession, but I didn't have a doubt that whatever I did, I was going to put all my effort into it. I took it as a challenge and a privilege to be able to serve in the executive branch at that level.

I have worked hard to make sure that the Department of Labor holds true to protecting and helping workers, giving them all the rights and privileges that my jurisdiction has responsibility for and more. I have tried to be creative and innovative in doing and testing new things that lift people up and give them the ability to empower themselves.

I'm Joe Solmonese.

I'm the president of the Human Rights Campaign.

A lot of people like me who are in a relatively high-profile advocacy job working in Washington will talk about the journey here beginning in their youth, perhaps as a result of the influence of their parents, but for me it actually began in college in the early 1980s. I was a journalism major, and I needed a job—which was the case for a lot of college students in the early 1980s, a time that was not all that different from now. I had the desire to do something exciting and interesting, and something that would take me to a place that would mean I'd never have to go back to the small town where I grew up. For me, that was electoral politics. I worked first for Michael Dukakis, who was the governor of Massachusetts at the time. Just as I was graduating from college, he was stepping up to run for president. I became involved in the campaign, which ultimately got me involved in the rough and tumble of national politics for the first decade of my work life.

After Mike Dukakis lost, he went back to being governor of Massachusetts. When I went to work on his next campaign, he took me into his office one day and said, "Public service is the most important thing you can ever do." Even if you don't do it for a living, even if you go off and work as a lawyer or work in the private sector, it's what you always have to spend some part of your day doing, even if it's just your avocation.

It was through working for progressive Democratic candidates that I began to develop an interest in the issues of the day. I became exposed to the issues that I ultimately became passionate about: women's reproductive rights and LGBT equality. So on the heels of that period of working on campaigns and bouncing around the country and

Joe Solmonese
As president of the Human Rights Campaign, Joe Solmonese, former CEO of Emily's List, served as an advocate for women's reproductive rights and Lesbian Gay Bisexual Transgender (LGBT) equality. With extensive campaign experience, Solmonese was selected to serve as one of the national cochairs for Barack Obama's reelection campaign of 2012.

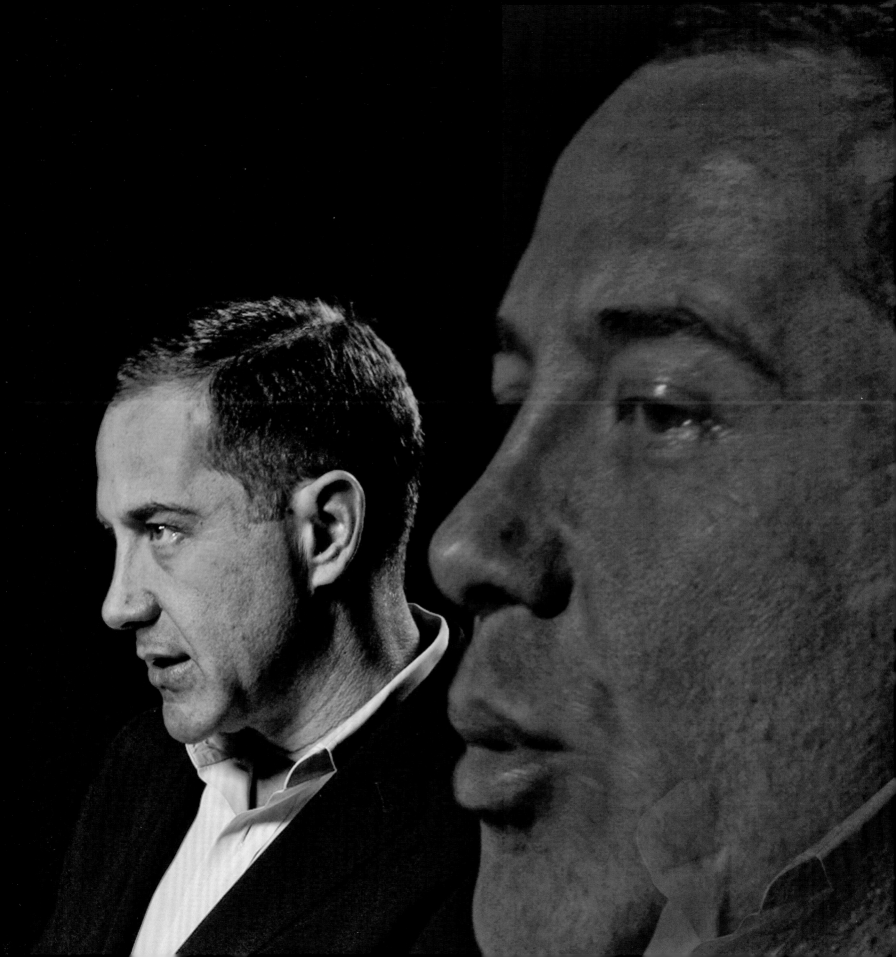

living on people's sofas and not owning anything except the clothes on my back, I went to work for an organization called Emily's List, an organization that supports women running for office. I walked in the door of Emily's List in 1993, just on the heels of the 1992 Year of the Woman, the year that effectively put Emily's List on the map. I was the only man working there.

"The pace of social change in this country ebbs and flows, so we tend to take three steps forward and two steps back."

I thought I knew a lot when I got there, but after the first week, I realized I knew nothing about the big weighty world of electoral politics on the national scale. In that first week, I thought I was interviewing a woman to be the receptionist, when she was actually a candidate for Congress from Arizona. I learned in short order that there is a lot to know at an advocacy organization. For Emily's List, it was the entire electoral arena. It was daunting, but it was one of the most fulfilling things I have ever done. When I walked in the door there were sixteen people working there. When I left thirteen years later, there were a hundred. The organization grew by leaps and bounds. The work grew. The need for the work, unfortunately, continues to grow. Just yesterday, for example, there was a fight in Congress over whether or not to fund the Violence Against Women Act once again.

If you were to speak to different people in the reproductive rights movement, they would tell you that it is a fight for a number of different reasons, and I suppose any or all of them may be true. It is a deeply difficult issue even for women who fight for the right to make their own reproductive health decisions. Like so many things, including LGBT issues, they are rooted in the dynamics of religion. Some people would say the fight for reproductive

rights began anew on the heels of *Roe v. Wade*. I suppose if we won marriage equality in this country in the Supreme Court tomorrow, the fight to take away the rights of same-sex people to be married would be energized not just on the merits of whether or not you believe in gay marriage, but in the way in which the decision came about. It is confounding that we still continue this fight and, quite frankly, that our opponents have been so ferocious in the way they have gone about their opposition. *Roe v. Wade* remains, but the work that they have done around access and at the state level is much more significant than people realize. Individuals are emerging who seem to be deeply passionate about denying women reproductive rights or denying LGBT people any form of rights. I often think that opposition has something to do with their own lives, that somewhere deep inside that's got to have something more to do with them than with me.

Still, we've accomplished more in this country in the name of LGBT equality in the last five years than we did in the previous fifty. It was not that long ago that Massachusetts was the first state through the courts to grant same-sex marriage rights. In very short order, we had constitutional bans in more than half the country, and yet less than a decade later we have marriage equality in eight states. I would suspect that before long we'll have marriage equality again in the state of California. If you look at population, you can see that an appreciable percentage of the US citizenry is living in states where there's full marriage equality. Just that metric in and of itself says to me that we're moving at lightning speed.

We have made enormous progress, but I think it's important to remember that half the battle is moving public opinion, while the other half is changing laws—and that is completely connected to who is in office. So if President Obama is not reelected or if we are to continue to erode the numbers in the House and the Senate of pro-LGBT members of Congress, there's the potential that progress will not just stall out, but go in the other direction. The fight against the federal marriage

amendment that we were engaged in less than a decade ago, and that seems so very much in the rearview mirror as we're starting to win battle after battle across the country, is a fight we may find ourselves right back in next year, with our opponents permanently enshrining discrimination against LGBT people and permanently moving against marriage equality in the US Constitution.

As a movement over the last decade, we've become sophisticated. We've become a powerful force for change. The pace of social change in this country ebbs and flows, so we tend to take three steps forward and two steps back. Regardless of how satisfied or impatient you may be about President Obama or Congress or the states or the pace of change, there's no denying that over the last few years we've been moving in a positive direction.

I'm Gene Sperling.

I was born in Ann Arbor, Michigan, and raised there in a family where our parents taught us to particularly honor University of Michigan sports, the Detroit Tigers and fighting for social justice. That's how I was brought up. I've been fortunate enough to be able to be the national economic advisor to both President Clinton and President Obama.

In that position, I essentially have two jobs: First, I am the top economic advisor to the president in the West Wing, and second, I am essentially

responsible for coordinating the economic cabinet, to make sure all the president's economic advisors, such as the treasury secretary and the budget director, are working as a team when we are making policy recommendations to the president. The key to the job is to aspiring to succeed at both levels: offering your ideas and opinions, yet always remembering that your first responsibility is to be the honest broker who makes sure that the process is well coordinated, so that we can come to the president with thought-through ideas and that we are all working together with a feeling of trust and camaraderie. That means that when we have a split opinion among the economic team on a key issue, that whether we are presenting our views in an Oval Office or Roosevelt Room meeting or through a memo, my colleagues on the economic team trust that I am representing all views fairly as opposed to tilting the presentation to favor my opinion. Indeed, creating that trust among the economic team may be the most important element of the job. And if that means meeting more often or editing and reediting a memo until everyone believes it represents a full and fair presentation of the facts and differences, then that is time well spent.

I had the enormous advantage of growing up in a loving family with two well-educated parents who set an example for their children of caring for others and fighting for what you believe in. Their example inspired me to want to use the advantages I was blessed with not just to pile on more and more advantages for myself, but to earn a seat at the policy table so that perhaps I could fight for those who too often don't have a seat or a champion there. I have never for a day considered that a sacrifice. I love the intellectual challenge of wrestling with difficult economic policy issues, and there are few things better than working with a team of dedicated colleague who wake up every day fighting for something, that as one of my former bosses, Mario Cuomo, used to say, is about something bigger than yourself.

While I had a strong interest in civil rights law when I was at Yale Law School, I was most focused on economic policy. I was frustrated with the way the economic debate in the United States in the early 1980s was framed as a false choice between economic growth on one hand and government policies designed to ensure greater fairness and opportunity on the other. It was if the public was being asked to choose between growth, free markets, and entrepreneurship or policies designed to give poor children a fair chance and help working families have a chance to move up and greater economic security. I focused on the view that you could be both pro-growth and progressive, that there is a coherent economic vision that recognizes the power of open markets, vigorous market competition, and risk-taking and entrepreneurship as well as the wisdom of public policies that seek to ensure that everyone has the tools and opportunities to contribute to and share in a more prosperous economy. Indeed, in the United States the very test of our economic success is not just GDP, but the degree to which growth promotes an economy in which the accident of someone's birth does not overly determine the outcome of his or her life, where everyone has a chance to move up, and where there is a growing and inclusive middle class that allows those who work hard a degree of security and dignity in their work and retirement.

When President Clinton was elected, he chose me to be first his deputy national economic advisor in his first term and his national economic advisor for his second term. On the whole, I think that was a period of years that showed the potential for pro-growth and progressive policies through a combination of balanced deficit reduction, investments in our competitiveness, and rewarding work policies. One was the expansion in the Earned Income Tax Credit that I and others fought so hard for, which helped lay the foundation for an economy with shared wage growth and millions of disadvantaged people who moved out of poverty by moving into workforce and supporting their families.

> *"I focused on the view that you could be both pro-growth and progressive, that there is a coherent economic vision that recognizes the power of open markets, vigorous market competition, and risk-taking and entrepreneurship as well as the wisdom of public policies that seek to ensure that everyone has the tools and opportunities to contribute to and share in a more prosperous economy."*

When I joined the Obama administration on January 20, 2009 as a senior counselor to my friend Tim Geithner, who had just been named secretary of the treasury, I was staggered by the depth of the economic hole President Obama was inheriting. I woke up every day with the

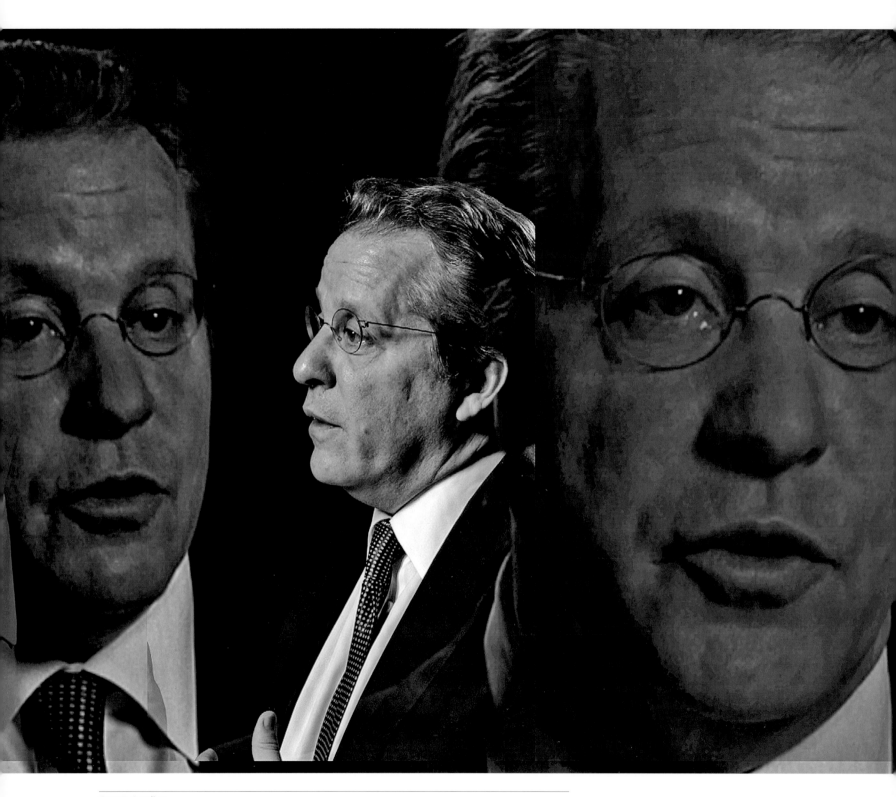

Gene B. Sperling
As director of the National Economic Council and assistant to the president for economic policy, Gene Sperling both advises President Obama and coordinates the president's economic team. He has played a key role in addressing one of the greatest economic challenges since the Great Depression.

gnawing pain in the stomach that if we failed to get it right in those first several months we could see the United States spiral into a second Great Depression. They were brutal policy times. I remember meeting after meeting in the Roosevelt Room of the White House where the president was forced to take decisions he knew were political losers to prevent a serious risk of the economy spiraling down into a deeper and deeper downturn.

Now, as national economic advisor, the constant focus is on anything and everything I can do at each and every moment to move the ball forward on jobs, on working training, on housing, on advanced manufacturing, on refinancing, on energy, on passing a balanced deficit reduction plan that still saves resources through entitlement and progressive tax reform while still investing in education and research and infrastructure. The president makes clear to us every day that the goal is not to just get back to where we were before the crisis; the goal has to be to make the economy stronger so that growth and prosperity are once again being shared by a growing middle class as opposed to a select few, and where we are able to attract middle-class jobs to the United States even in the midst of fierce global competition.

We're fighting to do everything we can, and I think it is important that people understand things are getting better, even though we've got a lot farther to go. If we're fortunate enough to have a second Obama term, we're going to spend those four years fighting every day on this, because when you have the worst recession since the Great Depression, you don't dig out of it in a month or a year or even a couple of years. The worst legacies of the Great Recession—millions of people who are facing long-term unemployment, communities who spiraled down with the housing crisis, young people who graduated from college into a tough labor market, older displaced workers struggling to find a new career—didn't happen overnight, and they're not going to be solved overnight. We're going to have to stay at it until we get the economy working the way it should for everyone.

I'm Kathy Stack.

I'm a career civil servant. I have worked in the federal government since 1978, most of that time at the Office of Management and Budget. I'm on the budget side of OMB and head three branches.

OMB is a uniquely powerful institution that works behind the scenes. We're an arm of the White House and review all the budget policies that federal agencies want to submit to Congress. We're about five hundred people, mostly career civil servants, a thin layer of policy officials who report to the president and the president's senior advisors. All legislative proposals, all regulatory proposals, every formal information collection or survey that a government agency does has to come through OMB for clearance. We have our hands in a lot of different activities.

We're often known as the agency of "No." Lots of different programs in government try to do similar things, and people inside an agency know their programs and functions. They know what Congress and their lawyers told them they're allowed to do. But they don't see the bigger picture and don't realize that there are three or four agencies that are trying to support similar activities. OMB is a place where we see those different agencies trying to make things happen, and if we can make connections and bring them together to work in partnership, we have potential to make dramatic progress. OMB can also shut down bad things and direct agencies to try different approaches. Because we have that power, we also can be the agency of "Yes."

For example, in the government we have a lot of programs—in the Department of Health and Human Services, the Department of Education, and the Department of Labor—that serve people with disabilities. The biggest source of funding for people with disabilities is the Social Security Administration. We had been frustrated over the years that these offices worked in isolation and that because of that we haven't done everything we can for these individuals. We're trying to improve, which is important, particularly in an environment where Congress is looking at entitlement programs, trying to bring the cost down.

In the 2012 budget, we proposed pilot funds for communities to create the best, most intensive set of wraparound services for the at-risk population of disabled teenagers to see whether we can get them off SSI assistance as they move into adulthood. There was a lot of acrimony between Congress and the administration last year, and not a lot of collaboration. To our surprise, the Appropriations Committee reached out. The program is launched. We're doing a big planning process this year, and we should have grants out next year to test this prospect.

To be effective at OMB, if you have a good idea, you want everybody to take ownership. This assistance program was, in fact, an idea that was hatched at OMB, but every single agency involved took ownership of it, and OMB is now in a position to step back and let it happen.

Most federal agencies are populated by career civil servants. OMB sits under the direction of the White House, which is a very political place. We see changes in administration and new faces, and we have to start all over again in building policy. But we are nonpartisan; frankly, I don't even know the politics of my staff members. They are people who are dedicated to using data and evidence to guide decisions. That gives us credibility as administrations change and new leaders come; instead of seeing us as people who shift with the political winds, we're the people who are going to

Kathy Stack

Kathy Stack is deputy associate director of education, income maintenance, and labor programs at the Office of Management and Budget. She reviews and coordinates budget allocations and program policies across agencies to improve effectiveness and efficiency. Although located within the White House, OMB provides nonpartisan analysis to administrations of both political parties.

tell it like it is. Being at OMB over the decades, watching administration after administration, has taught me that Republicans and Democrats are really much more alike than they're willing to admit in public.

There is a very interesting period after an election where the next president's transition team comes in and brokers a deal with the White House chief of staff for an orderly transition. Around mid-November, we get the call that we're supposed to meet with the new leadership of the transition. That sets off a period where we have two sets of bosses, working for our current bosses in the morning and in the afternoon working for the new team.

At the end of the Clinton administration, Congress had finally passed a program that he'd been trying to get in place for years, a $1.2 billion dollar school construction program that was supposed to push grants out to states to build K–12 schools. The Republicans had always hated it. Sure enough, the first thing that the Bush administration did in our very first meeting about the transition was to say they needed my help figuring out how to make sure not a single dollar of this program that had just been enacted went out the door. My Clinton administration bosses were saying, "Your job is to figure out how to make sure every one of these dollars goes out the door and isn't stopped by the next team." As an analyst, I had to give both of them the options and the choices for how to make that happen. It played out that the appropriation did go out the door, but for one year only. The Bush administration was successful in making sure that the program was terminated.

That's one example of where administrations have staked out very different positions, and you're in a position of having to flip. But then there's an alternative, and I think the last administration, going from Bush into Obama, was unique and provided huge opportunities for me on the issue of evidence building and evaluation. The Bush administration had been adamant that we needed to do a comprehensive review of every federal program, hold the programs to high standards in terms of what they achieved, and make sure that the means for measuring those results were valid. They strived to get agencies to adopt rigorous evaluation methodologies. Going into the Obama administration at OMB, we had our stars aligned on evaluation and evidence. Peter Orszag, who had a background of doing research, cared deeply about this. That shaped the creation of a new set of evidence-based initiatives, where we hold up rigorous evaluation as a goal for every agency.

At HHS we have a teen pregnancy program. Republicans care about teen pregnancy, but their solution historically has been abstinence programs. Democratic administrations had supported comprehensive sex education as the solution. In developing an evidence-based initiative, we declared our neutrality. We created a program that looked at all the models out there, and regardless of which end of the spectrum you were on ideologically, if a project or a model met certain standards, we invested in it at the federal level. Now that this process is in place, advocates for both sides seem to be coming together.

We build trust with people in the agencies, but we also build trust with political officials. There are policy folks who come in from administration to administration who have great ideas, but they have no idea how government works. I understand the culture and tools, and I know how to translate the big, visionary ideas that political officials have into action.

I'm John Stevens.

I'm a retired justice of the
US Supreme Court.

I was born and grew up in Chicago. Our family
lived in the vicinity of the University of Chicago,
where I received my grammar school and high
school education, as well as a bachelor degree in
English literature. After my graduation in 1941,
I took a correspondence course in cryptanalysis
offered by the Navy, received a commission as an
ensign, and spent most of World War II in Pearl
Harbor analyzing enemy radio traffic, from which
important information could be derived without
actually reading the messages. At the end of each
twenty-four–hour period that I was on duty, I
prepared a summary for Admiral Chester Nimitz
of the intelligence obtained on my watch.

After the war, I went to law school at
Northwestern. I graduated in 1947 and served
for a year as a law clerk to Justice Wiley Rutledge
of the Supreme Court. I enjoyed my clerkship,
but never considered myself a likely candidate for
judicial service. Instead, I began working at what
was then a large law firm in Chicago, spending most
of my time assisting Edward R. Johnston, a truly
great trial lawyer, with his work on antitrust cases.

In 1950 and 1951, I served as associate counsel
to a congressional subcommittee studying
antitrust issues. In one series of hearings, we
considered the possible illegality of the standard
contract that all Major League Baseball players
were required to sign; during those hearings, I
met and questioned a number of famous baseball
players such as Mickey Mantle and Ty Cobb.
When working on new legislation, the committee
members generally cooperated without regard to
their different political party membership. There
were occasions when they were satisfied to let
the courts answer questions about ambiguous

Justice John Paul Stevens

John Paul Stevens, a recipient of the Presidential Medal of Freedom, served on the US Supreme Court for nearly thirty-five
years. He heard cases on such critical issues as the constitutionality of the death penalty, affirmative action, the detention
of alleged terrorists at Guantanamo, and the possession of handguns.

provisions in a proposed bill. I remember one committee member's response to my detailed explanation: "We'll let the judges figure that one out." Like others who participated in the lawmaking process before becoming judges, I learned that the history of a proposed bill's development into enacted law can be very helpful in figuring out what the law means.

After leaving that committee, I joined two other young lawyers in the formation of a new three-person law partnership. We worked on trials and other work in many different kinds of cases, representing plaintiffs as often as defendants. In one case, I obtained the release from prison of a man who had spent seventeen years there, because I proved that police had brutally tortured him to get him to confess to the crime. In another case, I helped someone keep an elephant he owned, which someone else wanted to take to pay off the first person's debts. I also taught antitrust law, first at Northwestern and later at the University of Chicago. I very much enjoyed the practice of law and was reluctant to leave it. Nevertheless, I did so in 1970 because Senator Charles Percy, a college classmate, asked me to become a judge on the US Court of Appeals for the Seventh Circuit and convinced me that it would be a wise thing to do. I served on that court for five years and was selected by President Gerald Ford to become a US Supreme Court Justice when Justice William O. Douglas resigned.

At that time, the constitutionality of the death penalty was a major undecided issue for the Supreme Court. When I visited with the individual senators who were going to hold the hearings on my confirmation, I expected them to ask questions about my views on that issue. I had planned to tell them that I would need to study the briefs and hear the arguments of the lawyers before I knew how to answer because I did not have a firm view one way or the other. But when I met with Senator Strom Thurmond, he surprised me by stating: "Judge Stevens, I want to talk to you about the death penalty. I'm not going to ask you for your views about it, but I want to tell you how

I feel about it." He then gave me a long explanation of why he thought it important that the death penalty be upheld as constitutional. I thought it was entirely proper for him to tell me his own views without asking me for mine.

My views about the death penalty did crystallize after I heard the arguments. Like Justice Stewart and Justice Powell, I concluded that the mandatory death penalty was clearly unconstitutional. A statutory requirement that the death penalty must in all cases be imposed on a defendant who commits a particular offense, regardless of the possible existence of important mitigating circumstances, is much too severe and may lead to serious injustice in particular cases. Moreover, the more that I have thought about the issue in considering hundreds of death penalty cases during my years on the Court, the more I have become persuaded that the administration of the death penalty involves the unwise use of public resources and poses a real danger of executing an innocent person. Many people on death row have been found innocent based on DNA testing and other convincing evidence. In my view, the purposes of punishment are adequately served by a sentence of life imprisonment without the possibility of parole.

Another major issue that confronted the Court when I joined it was the constitutionality of affirmative action—that is, government policies that provide special benefits for members of racial or ethnic minorities. Many people believe that courts should apply a simple bright-line rule requiring the government to be completely color-blind in every case. Others are equally confident that past unfair treatment of certain minority groups provides an adequate justification for favored treatment in the future. In my thinking about the issue, I have found two basic distinctions to be profoundly important: first, the difference between programs that aim to provide future benefits and those that merely aim to compensate for past wrongs; and second, the type of benefit at stake. Diversity on school faculties and in school classes of students provide future educational

and social benefits, but giving preferences to construction companies based on the race of their owners is not likely to produce better highways.

During my last year as an active justice, the Supreme Court held that a Chicago city law that banned the possession of handguns was unconstitutional. In essence, that decision gave federal judges, rather than state officials, the last word on the validity of gun control laws. I find the result especially ironic because the Constitution explains that it protects a limited right to keep and bear arms because a "well regulated Militia [is] necessary to the security of a free State." It seems quite clear to me that the officials responsible for supervising that well-regulated militia should have the authority to determine what regulations of firearms will best serve that purpose.

I'm Steve Stivers.

I serve the people of Ohio's Fifteenth District in the 112th Congress. I'm a member of the Republican freshman class.

I grew up in a small town called Ripley, Ohio, on the Ohio River. My father served on the utility board. My mom was on village council. I was active in 4-H, played baseball, and became an Eagle Scout. Scouting was one of the biggest influences in my life, and it drove me toward public service.

I became an economics major at Ohio State University. I also joined the Army National Guard, not only to help pay for school, but also as a way to give back. When I joined in 1985, we were in the middle of the Cold War. I thought if anything ever happened, I wanted to be ready to serve my country. I deployed in Operation Iraqi Freedom and stayed in—I'm still a member of the Ohio Army National Guard. I'm now a lieutenant colonel.

While I was at Ohio State as well, I served as a page for a state senator named Snyder. I got a call from a family whose district was in southern Ohio. There are a lot of creeks down there, and their kids were walking through a creek every day to get to the school bus. They wanted a swinging bridge. The township across the creek was willing to pay for it along with the township in which the family lived, but under state law it wasn't allowed to do so. Senator Snyder helped change the state law to allow the two townships to work together. It stuck with me that you can make a difference for people through government.

I then spent fifteen years in the private sector before I came back to government. After college I worked in the financial services industry. In 2003, nineteen years to the day from when I started as a page, I was sworn in as a state senator. I served as a state senator for six years and then decided to run for Congress in 2008. I lost by two thousand votes, but I came back in 2010 and won. Now I'm a freshman in Congress, trying to focus on jobs, getting Americans back to work, reducing spending, and making America live within its means. It's been an interesting time in Washington.

When I first decided to go after the appointment to the state senate in 2003, I had to consider that it meant a 70 percent pay cut. My mom thought I was crazy, but I really had conviction then that not enough businesspeople go into public service. That's the interesting thing about the freshman class I'm serving in. Typically a freshman class in Congress is made up of people who have been state senators, councilmen, or the like. The eighty-nine members of the freshman Republican class are people who are straight out of business. There are military folks, and there are folks who've had no public office before. The freshman class is really a slice of America. It's been interesting watching all the folks who've had no legislative experience get their first taste of it.

There are always things that are hard to get done. I'm working on a bill now in Congress that I think makes a lot of sense. Today we fund roads by paying for them with a gas tax. It raises the

price of gas, but it funds our roads and bridges, our important infrastructure. I talked to Speaker Boehner about four months ago now and said, "I've got this idea. I'd like to pay for roads and bridges by supplementing the gas tax with money from offshore leases, expanding, drilling offshore for oil and natural gas. It will put people back to work drilling. It will put people back to work building our roads and bridges. It will reduce our dependence on foreign oil. And it will reduce the price of gas at the pump." I was excited about it, and I got Speaker Boehner excited about it. We've gotten it through the House, and we'll see whether it has any chance to get through the Senate.

All of us in the freshman class, whether we're Republicans or Democrats, came here fresh with a message from the American people: They want people in office who listen and will do the things that are important. Since I came here, my focus has really been on two issues: jobs and spending and financial responsibility. I've learned in the thirteen months I've been here that in Washington the only things that really happen in government are things that have to happen. Right now balancing the budget is optional. So we need to make it mandatory. That's not saying that it will all be spending cuts or all be tax increases. Each Congress has to decide what's right for the American people at that time. But twenty-six states have constitutional amendments that require their budgets to be balanced, including my home state of Ohio. It sometimes leads to painful decisions in the short run, but it doesn't lead to long-term irresponsibility. I'm forty-six years old, and Congress has balanced the budget only in three years during my lifetime. That tells me it's a systemic problem, and it deserves a systemic solution. If you make balancing the budget something that has to happen, it will happen.

On jobs, it's been a frustrating time to be here. Although the employment rate is starting to drift down, we have thirty jobs bills that the House has passed. They're all sitting in the Senate except one of them, the tax credit for veterans, which I supported and am proud of. Clearly there are a

Congressman Stephen Ernst Stivers
A Republican representing Ohio's Fifteenth District, Steve Stivers entered the US House of Representatives in 2011. A former member of the Ohio State Senate, he served in Iraq, where he earned a Bronze Star. Part of a wave of new conservative members of Congress, he prioritizes addressing economic concerns and balancing the budget.

lot of things that the American people and that members of Congress on the two sides of the aisle disagree on. The Democrats control the Senate, the Republicans control the House, and it is frustrating to know that there are things we could be doing that would move our country forward but are not able to get the House and Senate together on them.

"All of us in the freshman class, whether we're Republicans or Democrats, came here fresh with a message from the American people: They want people in office who listen and will do the things that are important. Since I came here, my focus has really been on two issues: jobs and spending and financial responsibility."

There are 435 members of Congress. I would say 80 percent of them are within one standard deviation of reasonable. But it's usually the people that are two, or three, or four standard deviations away who are on TV and driving what the media's talking about. It makes the political situation look worse than it really is. But I always try to keep a perspective on that. Our Founding Fathers set forth a system that works. The House is meant to pass bills, and the rules are such that the majority rules and bills are pretty easy to pass. The Senate has rules that are basically intended to kill bills. Our Founding Fathers set that up on purpose. They didn't want to make it too easy to pass new legislation, and they didn't want government too involved in every part of our life.

Still, as somebody who was sent here to try to get things passed, it can be frustrating.

I'm Geoffrey Stone.

I'm the Edward H. Levi Distinguished Service Professor of Law at the University of Chicago, former dean of the law school, and former provost of the university. My role is to be a teacher.

I was the first to go to a good college in my family. My parents, who were children of immigrants from Eastern Europe, always valued education and upward mobility, and there was never any question in my family that education was going to be central to my life. But my decision to go to law school was serendipitous. I was graduating from college in 1968. I knew I would have one year of graduate deferment from the draft, and that was it. I was interested in archaeology at the time. I was at the University of Pennsylvania, and I spoke to my archaeology professor. He said it didn't make any sense to start a PhD program if in a year I was going to be in either Vietnam or Canada. I was puzzling over what to do, and friends said that law school would be a good way to spend a year, "because you'll get a good education, which will stand you a good stead no matter you do later." I decided to go to law school for no real reason other than that I would have to figure out what to do after a year. It turned out I had an unknown medical condition that wound up giving me medical deferment from the draft, and I was able to complete law school.

I was fortunate to have the opportunity to serve as a law clerk to two really great judges. Skelly Wright was a judge in the US Court of Appeals for the District of Columbia Circuit. He was very liberal. He had been a Federal District judge in

New Orleans and was central in the desegregation of the New Orleans schools. When I came to work for him, I found someone who really helped me understand better than I had before the importance of thinking of law not only as an abstract analytical exercise, but also in terms of the impact that it has on real people.

My year with Supreme Court Justice William Brennan was also a terrific experience. Brennan was one of the great justices in history of the United States, also quite liberal. It was the term of *Roe v. Wade*, obviously a central event. I was also involved in a number of other opinions that had lasting importance.

I decided that the following year I wanted to work either with Senator Edward Kennedy, in the hope that he might run for president in 1976, or for the Center for Law in the Public Interest in Washington, D.C. In those days, though, most of the major law schools sent distinguished faculty members to the Supreme Court to interview current Supreme Court law clerks, to see whether they might be interested in teaching, either immediately or several years down the road. I met first with representatives from Harvard and Yale, and I said to them, "I have no interest in teaching now, and probably not ever, but keep me in mind for the future if things should change." Then I got a phone call from one of my professors at Chicago, Owen Fiss, who was chair of the Faculty of Appointments Committee, and he said to me, "I understand that you've talked to Harvard and Yale. Don't do anything without talking to us." I said, "Professor Fiss, to be honest, I have no interest in going into teaching, certainly not now, and almost certainly not ever."

In truth, it was worse than that. Even if I was going to go into teaching, I knew that it was not going to be at the University of Chicago, partly because I didn't want to go back to the Midwest, and partly because I'd been in law school during the Vietnam War. There were some real tensions among students and faculty during that time. I had a couple of strained run-ins with some of

Geoffrey R. Stone
Geoffrey Stone is the Edward H. Levi Distinguished Service Professor at the University of Chicago. Mr. Stone was a law clerk to US Supreme Court Justice William J. Brennan Jr. and is the author of many influential books on constitutional law, including *Perilous Times: Free Speech in Wartime (2004)*.

my professors about the role of universities and law schools in public affairs, about which I later decided I was completely wrong, but at the time I was sure I was right. But Professor Fiss was very persistent and persuasive, and I have never been very good at saying no to anybody. Reluctantly, after a couple of those phone calls, I finally agreed to go out to Chicago to interview. I went out there, and I was obnoxious and combative. When I got in the plane to fly back to Washington, I remember thinking, "I can't believe I blew this. This was a great day. I had a terrific time. This might actually be an interesting thing to do, and there's no way they're going to hire me now." So I was amazed when two or three weeks later, I got a call offering me a position. I later came to realize that I had inadvertently hit upon exactly the right strategy to get a job at the University of Chicago Law School: Mix it up with everybody.

I thought I'd stay three or four years. To my surprise, I fell in love with teaching and never left. I discovered the opportunity to challenge students, to push them, to enlighten them, to get them to understand how to think better and more clearly themselves, to clarify their thoughts in a Socratic way. I also fell in love with the intellectual life of a university, particularly at Chicago. There is a kind of absolutely no-holds-barred community culture about questioning one another, being pretty fearless about questions, and being pretty thick-skinned about being questioned. At the University of Chicago, the only appropriate response to even the most withering question is not resentment but gratitude. At Chicago, you're only as good as your last argument. Everybody has to justify their existence every day. It's a tough, demanding environment, but for people like myself, it's wonderful.

I'm working on a book called *Sexing the Constitution*. I got interested in the question of where our views about sex come from. I am also interested in the fact that there has been dramatic change constitutionally in issues like abortion, obscenity, in the rights of gays and lesbians, so I was curious to figure out what

the framers thought about these issues. Why weren't they included in the Constitution? This is a totally curiosity-driven enterprise. I just wanted to find the answers, and I thought that if I found the answers it might be interesting. One of the advantages of tenure is that you can spend a year or two on a project and say, "Well, okay, it wasn't a good idea after all." When I started doing research, I got driven much farther back in time than I expected, all the way back to the Greeks. Right now I'm up to about 1950, after a long haul. I hope it will be a fun and interesting book when it's done. I believe in honest, rigorous, clear-eyed thinking to try to figure out the best solution to problems. I believe in seeing problems from all sides. No one can do that perfectly, of course, but I always try to push my students to take the other position and to understand the world the way it's perceived by other individuals. Whatever conclusions I've reached, I am always trying to figure out how everyone else saw the problem and how it affected them. I want my students to do that, both as lawyers and as people.

I'm Dan Tangherlini.

I'm the chief financial officer and assistant secretary of management for the US Department of the Treasury.

Both my dad and my mom were teachers. I was raised in the Catholic faith with the notion that you're here on earth to do something more than serve yourself. As I went through high school, I did community work. I also worked as an intern for a friend of the family who was the deputy chief of staff to Governor Michael Dukakis of Massachusetts. That's where the mystery and magic of policymaking and resource allocation spoke to me.

At college, I had a hard time figuring out what to study. I started with economics at the University of Chicago. There was some level of disconnection between the study of economics in its pure form and the crazy, teeming, fascinating place that is the city of Chicago. I thought sociology might be a better way to understand the city, but it was more the study of patterns of numbers than of the way people interacted with each other. Political science was pretty much all about game theory. But then I stumbled on public policy, which allowed me to grab from these different sciences and ask questions of how they affect people in the ways they live, try to succeed, and try to organize themselves.

Along the way, I got an internship as a work-study project at the Chicago Park District. That's where I completely fell in love with the notion of this city as an evolving thing that could be made better. I thought about going to planning school, but my advisor said to me that planning was a nineteenth-century notion; we're done building cities, and now we have to figure out how to operate them. That had a huge influence on me.

I won a presidential management fellowship. With my interest in public policy and how people and things interact, I thought I had to go to Washington. So, having won the fellowship, I applied to a number of jobs, and I received several offers. I took the lowest-paid job because it sounded to be the most interesting, and the one through which I would have the biggest exposure to different kinds of programs. I went to the Office of Management and Budget. I went there in part because when I was working at the park district, we put together a project for the Army Corps of Engineers to help rebuild the Chicago lakefront. As I was working on it, I realized that the economic analysis trying to justify the value of this project was going to be evaluated by OMB, and I wanted to know who those guys were.

My first year at OMB I worked in something called the Budget Review Division, which was almost entirely scrubbed of policy and projects. We did

only the numbers, the math, the procedures on how to score different actions within the federal budget. I hated it, but it built certain skills and an appreciation for detail that I didn't have before I went in.

I learned a very interesting lesson at OMB. A senior official, an excellent manager, asked me if I had any questions. I asked him whether, since we were there to implement and ensure the delivery of the president's policy, there was a cheat sheet on what the president's policies and priorities were. He walked over to a bookcase, pulled a book off the bookcase, and put it in front of me. It was the federal budget. He said, "If it's funded, it's a priority."

I spent six years at OMB, working on a variety of things. I did a couple of years in natural resources, where I worked with the Army Corps of Engineers. I also worked with small agencies that interacted directly with the city, everything from the United States Holocaust Memorial Council to the

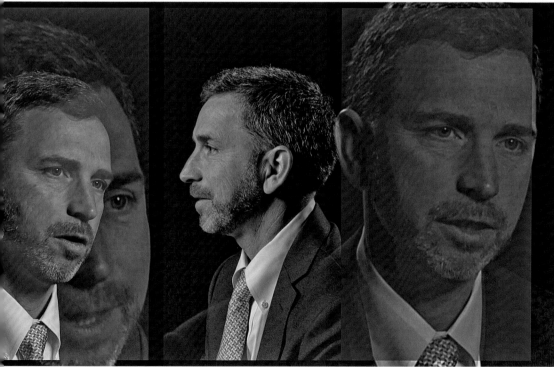

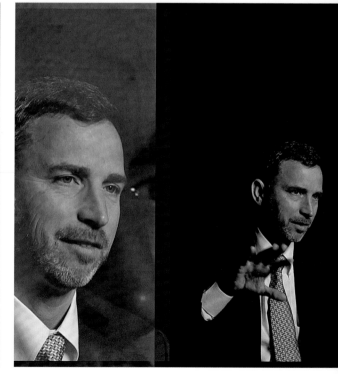

Daniel M. Tangherlini

With substantial management experience within the government of the District of Columbia and at the federal level, Dan Tangherlini has served as chief financial officer of the US Department of the Treasury and acting administrator of the General Services Administration. He has focused on cultivating collaboration and innovation between and within government bureaus.

Commission of Fine Arts and the National Capital Planning Commission. That was my introduction to how this city works and how the federal government relates to it. At the same time, my wife and I were buying a house here and getting involved in the local community. It was interesting to put down roots and understand a little more how this city came to be, how it works both as a private city where people live and raise families and as a very public city, a company town where we do the management of the federal enterprise.

"In many ways, what we have been trying to do is to set a tone for managerial excellence and resource management to reinforce the point that the Treasury Department isn't just going to talk about the sustainability of federal finances but is going to try to lead the way as well."

I went into a policy job at the Department of Transportation afterward. It didn't command any resources, and I discovered that policy without resources is just ideas. If you really want people to implement those ideas, you have to figure out a way to link them with the resources. That was a hard-won lesson.

I then went over to help out in the budget shop of the police department. The Metropolitan Police Department in 1998 was a fascinating enterprise—and a bit of a mess. Then, when Tony Williams ran for mayor, he asked me to stay on as CFO. Williams won, and I got to help out with the transition in the major's office. It just kept sucking me in deeper and deeper into city administration.

Sometime early in 2009, after the Obama administration came in, after they had appointed the secretaries and cabinet members, they got down to operational positions such as mine. The more they dug into it, I think they realized how hard it is to find people who are actually able and willing to do the job and have the kind of experience needed. There was a pretty short list of people around town who they thought could fit the bill, and apparently I was on it, because I got a call from a number of agencies asking me to go talk to them.

We were facing a global financial crisis, and the opportunity to work for Secretary Geithner and help out in the Treasury Department seemed like a no-brainer. The secretary is the president's primary advisor on all things economic and financial, the spokesperson for the administration on our financial policy. He's a negotiator with foreign powers and with big domestic markets and industries. The Treasury Department is vast: $14 billion a year in resources, with roughly 120,000 people. It goes from the IRS, this big thing that impacts everyone's life, down to our smallest agency, the Alcohol, Tax and Trade Bureau, which collects excise tax.

In 2009, we began to realize that we can't just keep growing our government at the rate we've been growing it. There was also recognition that we could be more efficient in the way we deliver services. So we started thinking about ways to manage the government enterprise based on data, based on goals and expectations, based on a clear vision from the executive and then clear accountability for those people who deliver on it.

In many ways, what we have been trying to do is to set a tone for managerial excellence and resource management to reinforce the point that the Treasury Department isn't just going to talk about the sustainability of federal finances but is going to try to lead the way as well. Working with colleagues who have similar positions in the Department of Commerce, Veteran Affairs, and the Department of the Interior, we've been able

to learn from each other and find ways to bring efficiency and effectiveness into the federal government. It's a very gratifying thing.

I'm David Tatel.

I'm a judge on the US Court of Appeals for the District of Columbia Circuit.

My focus on public service comes from growing up in the 1960s. I was a college student at the University of Michigan, and I was one of thousands and thousands of students who had summer jobs with the Kennedy administration. I was a GS-5 in the Department of Labor. I had friends who were in the Defense Department and the Justice Department. The summer began on the South Lawn of the White House with President Kennedy speaking to all of us. His message to us was, "There's nothing more noble than serving the public. There's nothing more important you can do."

I went to law school, and after I graduated, I went to work for a firm in Chicago. In the spring of 1968, the city was racked with devastating riots following the assassination of Martin Luther King Jr. Our first child was born at Billings Hospital. Edie and I could stand in her hospital room holding our two-day-old daughter, look out the window south and west, and see the city burning. It was a dramatic couple of days.

Shortly after that, Mayor Richard Daley created a commission to study what happened after the assassination. He wanted to know why things had gotten out of hand so badly. The commission asked the law firms in Chicago to volunteer young lawyers to be investigators. The commission assigned me to look at schools, businesses, and shops to see what happened in those places during the riots. I spent ten weeks prowling around the

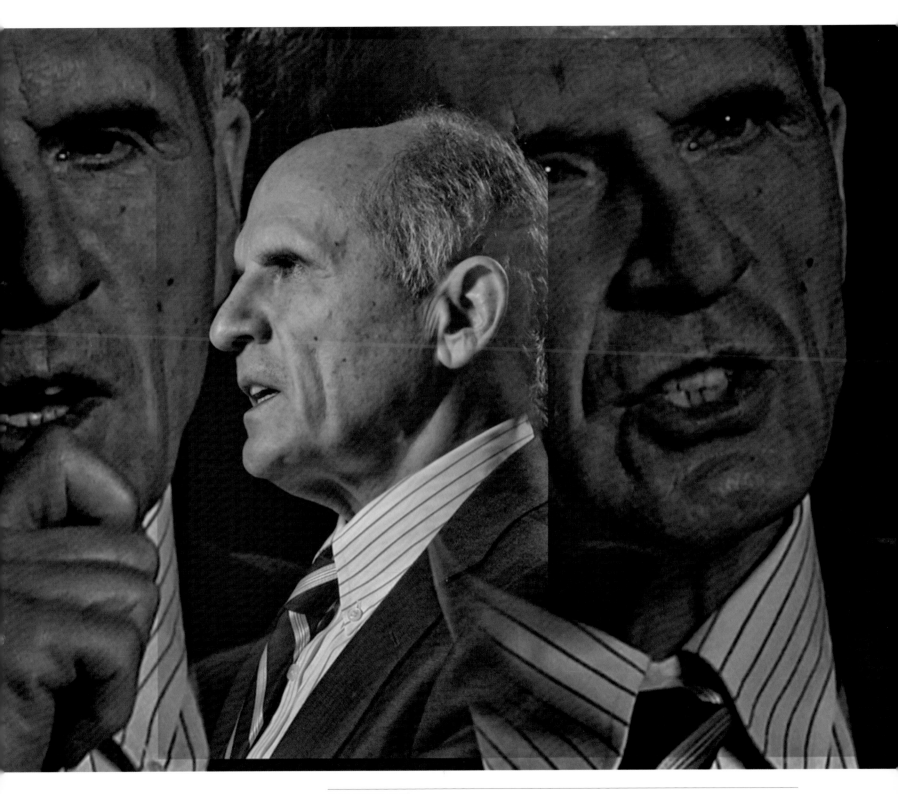

Judge David S. Tatel

David Tatel has served on the US Court of Appeals for the District of Columbia Circuit since 1994. Building on a career dedicated to the public interest, involving both government service and private practice, he has distinguished himself as a jurist, writing opinions involving the environment, civil rights, national security, and freedom of speech.

south and west sides, talking with people. It was an extraordinary experience, and it convinced me that I needed to get more involved in the city.

"I obviously have strong personal feelings. All judges do. The trick to judging is to discipline yourself to think about the case not through your own policy perspective, but from the perspective of the law. What are the neutral legal principles that should control this case? What are the facts of the case?"

The Kerner Report is famous for its statement, "The United States has become two societies, one black, one white, separate and unequal." It focused extensively on racial segregation. An organization called the Lawyer's Committee for Civil Rights under Law, formed at the request of President Kennedy to represent civil rights workers and demonstrators who were being arrested during the civil rights movement, created a Chicago office. Its goal was to bring the prestige and resources of the private bar to bear on the problems identified by the Kerner Commission. I became the first director of the Chicago Lawyer's Committee in June 1969.

That was the beginning of my public-interest career. After directing the Chicago committee, I became director of the national Lawyer's Committee. It was where I matured as a lawyer and learned to litigate. More important, I found my own mentors and heroes there: successful lawyers who believed deeply that lawyers have a professional obligation to make their talents and skills available to people who cannot pay for access to the courts.

During the Carter administration, I worked for the federal government as director of the Office of Civil Rights at the US Department of Health, Education, and Welfare. Then I returned to my law firm and created a core group of lawyers who specialized in education law. We represented school districts, colleges, and universities around the country, among them urban school systems that were operating under court-ordered desegregation remedies. Because of the demographics, they were unable to desegregate because the cities were predominantly African American, yet surrounded by predominantly white suburban districts. We represented a number of these districts—St. Louis, Kansas City, Milwaukee, all in litigation to require the state government to fund desegregation programs. We helped form magnet schools, improved early education programs, and established voluntary inner-district transfer programs that would allow minority students from the city to attend suburban districts and white students from the suburbs to attend city magnets.

I never expected that someday I would become a federal judge. That happened in 1994, when I was back at my law firm in Washington. One day I got a phone call from the White House asking whether I would be interested in filling the vacancy on the District of Columbia Circuit that was created by Ruth Bader Ginsburg's elevation to the Supreme Court. I went from being an advocate one day to being a judge the next. I actually found the transition not at all difficult. I think part of the reason for that was that I had spent twenty-five years as a litigator in the federal court system. I knew what the advocates' and the judge's roles were. I also knew that I was no longer an advocate. My job was very different: It was to apply the law to the facts of the case and to try to produce the most objective result.

Advocates play a critical role in the judicial system. When you're a lawyer and you're arguing your case, you're trying to make the best arguments you can. When you look at it from the perspective of the judge, you realize how critical those lawyers are

in the quality of decision making. The quality of our judging depends a great deal on having good lawyers argue both sides of the case, having good lawyers prepare a factual record on which we can decide the cases.

We see many cases that are important in terms of public policy. They raise important constitutional and statutory questions, and they involve issues over which I obviously have strong personal feelings. All judges do. The trick to judging is to discipline yourself to think about the case not through your own policy perspective, but from the perspective of the law. What are the neutral legal principles that should control this case? What are the facts of the case? You then try to produce a decision that is as faithful to those as you can. When I first pick up a pile of briefs right at the beginning of the case and start to read about the case and develop some views about it, by the time I'm done three or four months later, often my views have changed dramatically because of the process of reading the briefs, listening to the arguments, and applying the law to the case.

I'm an appeals court judge, and so I sit on panels of three judges. The three judges are often ideologically quite different. Yet, by trying to set

aside those views and apply the law as we best can, we are able to reach many more unanimous decisions than the public might anticipate. Two things produce that unanimity. The first is the judicial lens through which we look at the case. We don't just decide the case; we resolve the arguments that the parties raise. We are confined by our precedent. Judges have to be faithful to the language of statutes and the Constitution. Our standards of review require judicial deference to certain kinds of policy and certain kinds of fact-finding. That common lens results in judges agreeing on decisions that one or more of them would not necessarily agree on if they were just deciding it as a matter of policy.

The second is talking to colleagues and listening. My court is small. There are only at the moment eight active judges. We sit together very often. We know each other well and we listen to each other. We debate and persuade each other. One judge may have a different perspective. A different judge might point out some facts that you knew about but had interpreted differently. That's what makes the system work.

I'm Laurence Tribe.

I'm the Carl M. Loeb University Professor at Harvard University, and a professor of constitutional law at the law school there.

I was born a couple of months before Pearl Harbor, in Shanghai, China. My parents and grandparents were Russian Jews. The Japanese interned my dad in a prison camp after they occupied Shanghai because he had become a naturalized US citizen years earlier. My very early childhood was powerfully shaped by knowing that I had a

father who had done nothing wrong but was nonetheless imprisoned. I'm sure that his incarceration had a powerful impact on my sense of injustice and my commitment to a society that deals with people decently.

When my father was released from that Japanese camp a short time after World War II ended, we moved to San Francisco. I was five and a half, and I spoke only Russian. I resisted learning English. My brother found my report card from a Shanghai kindergarten, and it was very clear that I was a rebellious kid who wouldn't follow instructions. There were other Russian kids in the class, and I got their attention, which was not what the teacher wanted. The kids in San Francisco, who spoke only English, made fun of me, so I eventually became determined to learn how to speak the way they did. I went through a silent metamorphosis during which I didn't speak much at all and, when I emerged from the chrysalis, I started speaking English. I still understand spoken Russian, but my speaking vocabulary is limited, although my accent isn't at all bad.

My brother Al—we always called him Shurka—went to medical school and became a wonderful psychiatrist. I didn't become a lawyer immediately. I wanted to be a mathematician. I worked toward but never finished a PhD in mathematics. I was doing algebraic topology and algebraic number theory, and I still think it's the most beautiful thing in the world and marvel at the possibility of constructing an elegant mathematical proof of a deep result that one can conclude with a QED, but it wasn't a field in which I thought I could make any profound contribution. It's a field where either you're a genius or you're not, and I knew I wasn't.

I made a quick switch to studying law not long after graduating from Harvard College, after a year on a National Science Foundation fellowship in mathematics. Law was percolating in the background all that time, since I became convinced that law and justice were important to me. But I also liked other aspects of law. I actually like its relative ambiguity when contrasted with the

precision of mathematics. I like its indeterminacy. I like the fact that it's all about structure, the structure of things, the separation of powers and checks and balances. Legal arguments have an architecture, a structure that I like. And I liked the human dimension—the fact that you're dealing with human drama, human aspiration, human tragedy. It wasn't just a matter of solving intellectual puzzles for their own sake—something I still like to do—but of finding ways to help people improve their lives, to achieve just results.

"We made certain promises in the Declaration of Independence, in the Preamble to the Constitution, in the Gettysburg Address, in the Constitution and its amendments, and over time we've struggled to fulfill those promises. We haven't fulfilled them yet, by any means. And in the process of coming closer, of redeeming some of the commitments that the Constitution makes, we sometimes reformulate those commitments—it is a living process."

I treasure the time that I spent with people in the Czech Republic, helping Vaclav Havel and members of his cabinet work on the constitution. I spent some time in the Marshall Islands helping them write a constitution, too, although I didn't see myself as a "have-constitution-will-travel" guy. I don't really believe that we can plant American

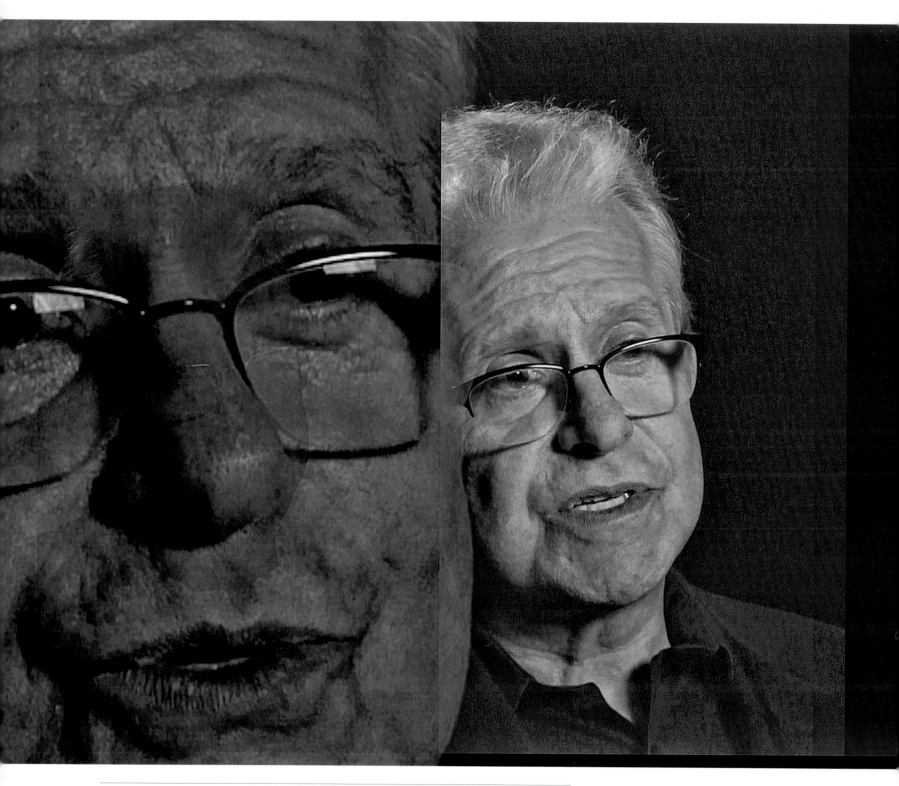

Laurence H. Tribe

Laurence Tribe is the Carl M. Loeb University Professor at Harvard University and a leader in constitutional law. He has studied how constitutions serve public officials and the public in establishing the parameters of government and has worked with several nations to help develop their constitutions.

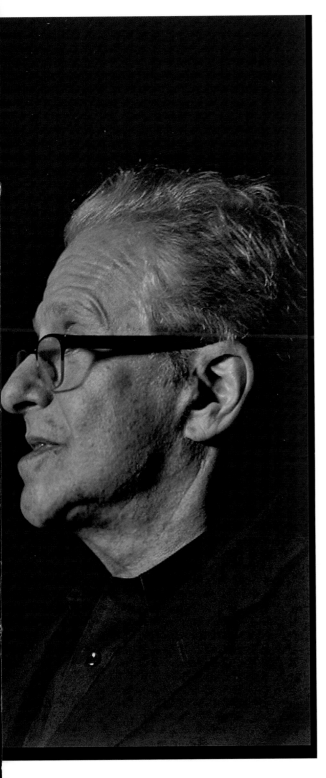

democracy in other places, but by the late 1970s I had learned enough about how constitutions work and what makes them succeed and fail that I could help people translate their aspirations and their different forms of government into their constitutional framework. In fact, probably my least-deserved but most-treasured memento from my professional life is a copy of the transitional constitution of South Africa, with a nice handwritten note on it from Nelson Mandela, thanking me for my help with their first democratic constitution. I say I didn't deserve it, because my help was pretty marginal. I helped work on the bill of rights, though I did it mostly by mail and fax. I still yearn to get to South Africa when I have the time.

Our own constitutional ideas have been filtered through the jurisprudence of an increasingly conservative Supreme Court that, until the 1960s, was beginning to find the seeds for affirmative rights. That dissipated when Richard Nixon became president and made increasingly conservative appointments. There are strands in our Constitution of affirmative rights, but mostly, it's a negative document. It's a document of "thou shalt nots," of prohibitions against various kinds of government oppression. That's important, but it's not enough. Constitutions elsewhere in the world increasingly have aspirational provisions that give people a right to insist that the government make at least reasonable efforts within available resources to meet their needs for health care, housing, nutrition, and education. There are provisions like that, for example, in the South African constitution. I was initially a bit skeptical about their inclusion, because they are not readily enforceable by courts. Courts aren't so good at mobilizing resources—that's really not what they're for—but they can prod and push an otherwise sticky system.

Constitutions in general ideally work that way, even ours. A constitution, at best, is a broad outline. And because it's a broad outline, it has to be filled in, and it can't be filled in by unelected judges alone. A constitution, as John Marshall

recognized early in the nineteenth century, is not just a lawyer's document. It doesn't just speak to legal experts. It has to speak to the people if it's going to be a document that, as ours says at the outset, is established by the people. And it's important to recognize that the people have an equal role to play in interpreting the provisions of the constitution. Take something like the right to bear arms. When you look at it in context, there's a vibrant and lively contest over whether it's an individual right of self-defense, or whether it's part of a collective right of a community to protect itself from an oppressive central government.

The Supreme Court has recently moved in the individual rights direction. When I teach constitutional law to my students, I celebrate the fact that there is no provably correct answer to many of these questions. It's not like Fermat's last theorem, where finally somebody gets an actual proof that can be indisputably verified. These are intrinsically open-ended questions, and what's great about our Constitution is that it structures a conversation over the generations. We made certain promises in the Declaration of Independence, in the Preamble to the Constitution, in the Gettysburg Address, in the Constitution and its amendments, and over time we've struggled to fulfill those promises. We haven't fulfilled them yet, by any means. And in the process of coming closer, of redeeming some of the commitments that the Constitution makes, we sometimes reformulate those commitments—it is a living process. That's one of the things that one of my most impressive students ever, Barack Obama, recognized right away about the Constitution: We are seeking to form a more perfect union. That was a phrase that he liked very much in the Preamble, not just for its eloquence, but also because of the self-governing process that it embodies. It means that we can overcome immense evils in our own history, not by forgetting them, not by erasing them, but by recognizing them and by gradually figuring out ways to reduce them.

I'm Richard Trumka.

I'm the president of the AFL-CIO.

I grew up in southwestern Pennsylvania, in the coalfields of Appalachia. My grandfathers were coal miners. My dad and his brothers were coal miners. My uncles were coal miners. And then I became a coal miner in the 1960s.

A mining town is a really rough place. People fight. On the other hand, people actually take care of each other. Other kids' parents would feel free to correct you if they saw you doing something out of line. Your neighbors would correct you, just like they'd correct their own children, and your parents would thank them for it. Everybody watched out for everybody else in the town. We were dirt poor. The mine worked five days a month when I was growing up, and they would work you Monday one week, Tuesday the next, Wednesday the next, Thursday the next, and Friday the next, so that you could never get another job anywhere else or collect an unemployment check. If the coal company needed five hundred miners, they would build a little town and bring in a thousand. Everybody paid rent and shopped at the company store. The company ended up making money off the people that lived there, and labor became almost free for them in the mines.

One day in my life bent the arc to where it lands today. I was about twelve years old, and I was sitting on the porch with my maternal grandfather. The miners were on strike. I asked him, "What can I do to help miners?" He said, "Well, look around you. Who are the people around you that can help people the most?" And the first thing I said was, "Politicians." He said, "No, think." And I said, "Well, lawyers." He replied, "That's right. If you really want to help miners, get yourself a law degree." He told me that I had to study hard, because the more

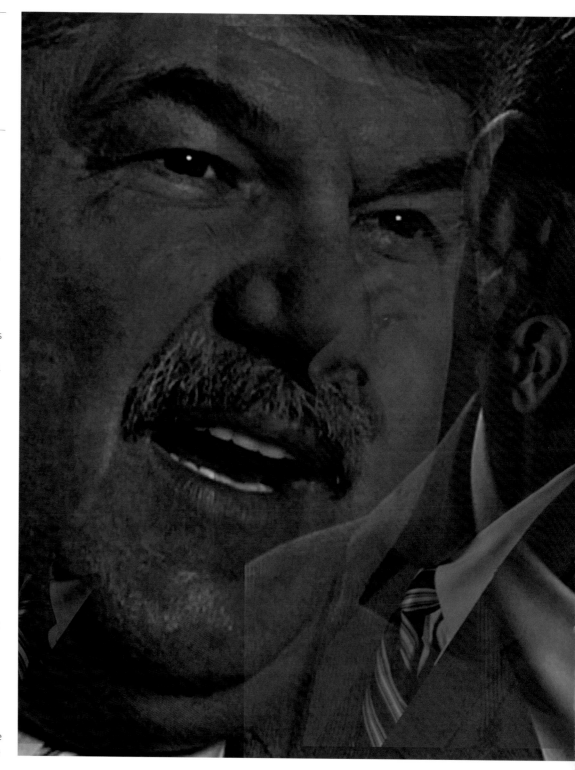

Richard Louis Trumka
Richard Trumka grew up in Appalachia and became a labor organizer there in order to improve conditions and preserve benefits for coal miners. Under his direction, mineworkers became part of the AFL-CIO, the labor organization of which he is now president.

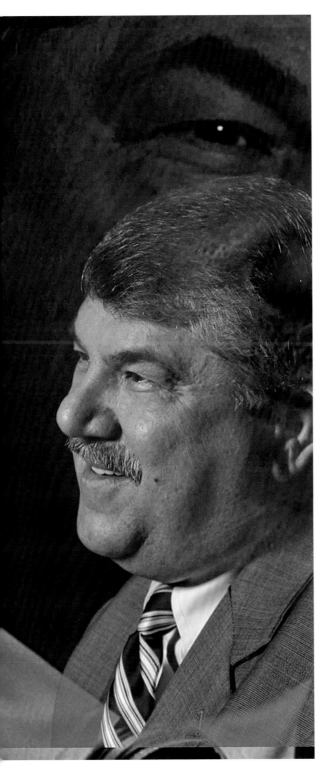

I learned, the better off I would be. My parents and grandparents told me this every day of my life. They said, "The coal company can take just about anything away from you. But they can never take an education away." I started being more serious as a student at that point.

The day I got out of law school—I already had a job lined up with the United Mine Workers and the legal staff here in Washington, D.C.—I came straight down and went to work on the national bargaining team. We made some good law and we made some bad law along the way. When I was in the mines, I had joined a group called Miners for Democracy. Our union had become autocratic, with a guy in charge named Tony Boyle who thought that the union was there to serve him instead of him being there to serve the miners. We ran a candidate against him. The candidate, his wife, and daughter were actually murdered, and Boyle ended up spending his life in prison for arranging the killing. We ran another guy, and we got him elected. Then we had a constitutional convention in Pittsburgh in the early 1970s and totally democratized the union—made it the most democratic organization out there. It was run the way it should have been run, by rank-and-file miners from the bottom up. I worked for the union president for a while and had philosophical differences with him, and I ended up resigning. I was in his office, pressing him about why he wasn't doing something, and he said, "Look, if you want to set policy, get your butt back in a coalfield and get elected."

So I went back to the mine. I got elected at the local level immediately, then ran and got elected to the international executive board, which is the policymaking body for the United Mine Workers.

There are a thousand ways to be killed, crippled, or maimed underground, and just about the time you think you have them all figured out, another one pops up. So my work was about safety, about being aggressive economically, about supporting politicians who actually supported working people and didn't just give them lip service. Sometimes it was about going out on strike.

A strike is always tough. One we went on, at a place called Pittston, turned out quite well, though. We had a company that wanted to take away health care from our retirees and our widows. Our credo has always been, "Cradle to Grave." We take care of our members from cradle to grave. My parents had mineworkers' health care. I was cared for as a child by it. My parents were cared for in their old age because of it, and the company wanted to take it away. Our contract expired. We didn't go out immediately. We spent fifteen months preparing for it, teaching our members how to do peaceful civil disobedience, getting community support, getting our neighbors to understand how important it was for us to be able to maintain health care in Appalachia. Then we went out on strike. In the end, 300,000 pensioners and widows kept their health care. It was an incredible show of solidarity.

After the Pittston strike, I brought the mineworkers into the AFL-CIO. I realized that it was time for us to be part of the entire labor movement, that no union, no group of workers should be doing it alone. In 2009, I became president of the AFL-CIO. We now have 13.5 million members from fifty-seven unions. We represent everyone from coal miners to teachers to doctors. I'm also the president of the Trade Union Advisory Council to the Organization for Economic Cooperation and Development, working to create an economy that works for working people. There are a number of things that we have to do to make that happen. First, we can start rebuilding our infrastructure. We have a $2.2 trillion infrastructure deficit for old infrastructure, and another $2 trillion deficit to get us into the twenty-first century with new infrastructure. It will also put us back to work. But there are other facets as well. Our trade policies encourage companies to move jobs offshore, and so do our tax policies. Every country out there that we compete with has a strategy, except the United States. We have this foolish notion that if you just leave it up to the market, everything will be great. Well, no other country does that, and we shouldn't be doing it either. We should think about how we

do manufacturing, which creates four or five other jobs for every direct manufacturing job. You can't be a world-class power unless you make world-class products, so we need to be making more world-class products.

Some 70 percent of the American people believe that all workers ought to have the right to collective bargaining. In this election, we're trying to make it part of the debate. Is the economy here to serve the people, or are the people here to serve the economy? What are your ideas to create an economy that works for everybody, not just the very rich? This election is going to be one where we decide what kind of America we want to have—the one where employees and employers say, together, "Give us a fair shake. Nobody can beat us. We can do it. We're the most innovative. We're the hardest working. We can do this." That's what we're striving for.

I'm Dennis Van Roekel.

I'm president of the National Education Association, but what I really am and who I really am is a high school math teacher.

I was born and raised in Iowa, on a farm, and then moved into town in elementary school. Somewhere around seventh grade, I decided I wanted to be a teacher. I didn't know which subject at first, but I loved math, so I became a math teacher. I lived that dream for twenty-two years.

In my small town, the value of education was evident and strong. I don't know of anyone who didn't graduate from high school. Even though it was a farming community, it was an expectation. And then, of course, at least in my family, there was an expectation that you would find a way to go to college. We didn't have much money, but through loans and working I found a way.

I taught for thirteen years, and then I served as president of the Arizona Education Association for six years. Then I went back in the classroom for nine years. I needed to go back into the classroom, and those last nine years were my best. I attribute that to a lot of the management training I received as president. People view teaching as an assembly line process, the teacher and student as worker bees. That's not what it is. You manage time, resources, and human resources. My principal had 110 faculty members on the campus whom he saw occasionally. I said, "I have 160 direct reports a day, and I see them every single day." Name someone in business who has that many direct reports—in my case, the students—with whom he or she interacts daily.

Parents, of course, are the students' first teachers. What makes all the difference in the world is the connection that the adults who work at the school and the adults at home can make. They know things that I'll never know about a student. But I know things that they won't see. Too many teenagers really don't have conversations with adults. I always say to parents, when you're in a car, make use of that wonderful time. The teenagers can't go anywhere. You have them for five minutes, or ten, or fifteen. Ask questions. Find out what's going on in their heads. It need not be about school all the time. Just talk to them.

Once in the classroom, the teacher has the most influence on students' learning and everything that goes with it. But that is not the only influence, and it's not the most powerful in their lives. There are so many factors outside of school, before they get to my classroom, that play a huge role in their lives. Parents, family members, community: All of them play a role. As we look at the challenges that face education, I believe that if you really want to make sustainable change for every single child in America, you're going to have collaboration. The administration, the school board, and the employees and their union need to sit down to talk about what we need to do together to change what's happening to kids. If they can't do that, then the probability of making real, sustainable change is very low. We all have a responsibility to do what we need to do to ensure that the younger people coming up are going to be the leaders we need for tomorrow.

In America, we have tremendous excellence and too little equity. In Finland, where interesting things are happening educationally, they have never focused on excellence. It has been on equity: No matter which school a child goes to, he or she will have highly qualified, well-trained teachers. In the United States, we do extremely well with some students, but it is not the same wherever you go to school. It makes a difference where you live, and that's wrong. We have to turn that upside down and focus on the equity issue.

In the United States we lose 47 percent of all teachers in the first five years. I look at that statistic and think, "There's something wrong with your recruitment, training, and hiring system to have that kind of turnover." The CEO of a business once said to me, "If any division in my corporation had a 10 percent turnover, I would go down there and say, 'What's happening? What's going on that's wrong that we're losing people that way?'" In education, we have to look at the system. It isn't providing what we need to build a real profession, to bring people in who should be there, to make sure that no one is allowed into a classroom of students until he or she is well-trained, certified, and licensed.

The education minister of Finland was asked, "What do you do about incompetent teachers in Finland?" He said, "We don't have any." The audience chuckled, but he said, "No, I'm serious." His point was that teachers are trained well before getting into the classroom. That's the focus we need to have. According to the US Department of Education, we're going to need 1.6 million teachers in the next ten years. Let's figure out a way to really build a system.

We made a big step in the United States when forty-some states agreed to a set of common core standards that establish what we expect students to know. The next step is to develop an assessment tool. We have to be able to measure what we want students to achieve. The third step is to develop the curriculum in the middle to say, "What do I need to give my students to ensure that they can meet these standards?" It isn't that difficult as long as we all agree on those standards, we develop assessments that actually measure the standards, and then we figure out a curriculum to get them there and to deal with the individual differences.

Teaching has been deprofessionalized. That's one of the saddest things. When you walk into a school and there's a clipboard outside each elementary classroom that tells you in fifteen-minute intervals what they'll be doing in that classroom, you're destroying the profession. When you say to a teacher, "I'm going to evaluate you based on one test given one day during the year, and then I'll know whether you're a good teacher, a bad teacher, whether your students are good students or bad students," you destroy the whole sense of what it means to be a professional. We've lost some of that respect for the profession, for the professional practice, and I want that back. You can't change a system if you don't involve all the people in it. The idea that someone on the outside is going to foist something on the system, that everything magically inside changes, just doesn't work. We've got years and years of experience to show that it doesn't work, and the price of failure is just too high.

Dennis Van Roekel
President of the National Education Association since 2008, Dennis Van Roekel heads the nation's largest union. A former math teacher, he is focused on restoring professionalism to teaching, setting high standards for entry into the profession, maintaining high standards of excellence, creating evaluation systems that improve practice, and establishing equity among schools.

I'm Harold Varmus.

I'm the director of the National Cancer Institute.

As a child in a public high school without strong science teaching, my only real connection with science was the presumption that the Jewish child of a physician would end up going to medical school. I spent more time reading novels than studying science, but I went off to Amherst College with the presumption that I'd be pre-med. I was also the editor of the school paper and an English major writing a thesis on Charles Dickens. I then attended graduate school in English literature at Harvard. But when I visited friends from Amherst who were at Harvard Medical School, they seemed much more enthusiastic about their career choice than I did. I felt I was neglecting a part of my brain by not pursuing something that was more contemporary, scientific, and practical, much as I liked talking about *Beowulf* and reading Anglo-Saxon.

I had a big decision to make in my final years of medical school: what to do about the draft. In the Vietnam era, some form of public service was required. Since I was deeply opposed to the war and was not going to take part in it, I was fortunate to be selected to work in the Public Health Service at the National Institutes of Health with Ira Pastan. Ira was a new member of the NIH staff and a superb mentor, so he got me excited about science quickly, despite my lack of experience. I walked in not knowing what simple laboratory reagents were or how to design an experiment, but within a few months, I was thrilled to have developed an assay to measure gene functions and answer important questions. As a result, I turned away from clinical medicine and toward a research career.

To pursue this new goal, I moved to California to work with Mike Bishop, who had also been trained at the NIH a few years earlier. Mike and his colleagues had started a small program at the University of California, San Francisco, to study a question that fascinated me as a trainee taking evening courses at the NIH—namely, how do certain viruses cause cancers in animals? These viruses, especially those now known as retroviruses, were particularly inviting at a time when molecular cloning, DNA sequencing, and other powerful tools were not yet available for studying the genetic basis of cancer. I had learned in my previous research with Ira Pastan that simple systems were often the key to understanding more complex ones. Cancer viruses, carrying only a few genes, could make a normal animal cell, with tens of thousands of genes, behave like a cancer cell. That seemed like a powerful starting point for understanding human cancer.

Most of my work at UCSF was dominated by two questions: How do retroviruses grow? How do retroviruses cause cancer? By pursuing the first question, we learned a lot about how all retroviruses enter cells, make DNA copies of their RNA genomes, and express their genes. By pursuing the second question, we discovered that many retroviruses can cause cancer because, in the past, they'd acquired an altered version of a cellular gene that is now cancer causing, or oncogenic. This suggested that normal cells contain genes that are one step away from being oncogenic, which has turned out to be true. Many new cancer therapies can be traced to earlier discoveries about retroviral oncogenes and their origins.

Our discovery produced a substantial shift in the field, and was later recognized (in 1989) with a Nobel Prize. Today, one of the National Cancer Institute's most significant (and expensive) programs is the Cancer Genome Atlas, which is a modern version of our earlier work—an efficient way to make a complete inventory of the genetic changes that occur when a normal cell becomes a cancer cell. This inventory holds clues to more accurate diagnosis, to new therapies

and prevention strategies, and to predictions about a cancer's aggression and metastatic potential.

The Nobel Prize offers a little piece of power that you can use or not use to work on behalf of the scientific community. Our prize arrived at an interesting time: Exciting things were happening in biomedical research, but a lot of young investigators were not getting grants. The National Academy asked me to speak up about this problem and about other issues, such as scientific integrity and indirect costs, and I stepped up. A few years later, early in the Clinton administration, when the position of NIH director became open, I threw my hat into the ring and then served as director for over six years, during a time of major expansion of the medical research enterprise. I found great satisfaction in leading the NIH, and I have continued to run major institutions since then, working as president of Memorial Sloan-Kettering Cancer Center in New York for just over a decade before returning to the NIH in 2010 as director of the NCI.

"One of the things I'm emphasizing at the moment is a communal effort to define big, 'provocative' questions about cancer that have gone unanswered for too long. For example, why does obesity place people at risk of cancer? This is an important question, especially since obesity rates in this country are increasing."

Near the end of my term at NIH, I was awakened to the power of the Internet to change the way scientists disseminate their findings to their colleagues and the public. Since then, I have

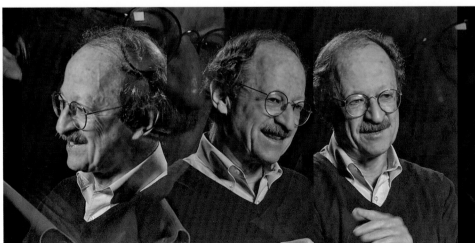

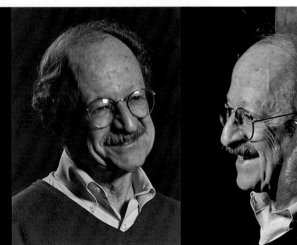

Harold E. Varmus

The director of the National Cancer Institute, Harold Varmus shared the 1989 Nobel Prize in Physiology or Medicine with J. Michael Bishop for identifying the cellular origin of cancer-causing retroviral genes. He has also increased the public's access to scientific studies and helped to bring more medical science to developing countries.

devoted much energy to developing ways to provide greater access to scientific work in two ways: by establishing a public digital library at the NIH called PubMed Central and by building with colleagues a constellation of open access journals called the Public Library of Science. All science should be transformed by these new ways of doing business. It is good for the public and for science.

In my new job at the NCI, I am living in a very different fiscal situation than the one I enjoyed as NIH director. Budgets are stagnant, not growing. There isn't enough money to provide grants to many of the talented young investigators who were attracted to biomedical sciences when the NIH budget was growing. Of course, I would like to see the budget increase, but we have $5 billion to spend each year at the NCI, and a lot can be done with it.

One of the things I'm emphasizing at the moment is a communal effort to define big, "provocative" questions about cancer that have gone unanswered for too long. For example, why does obesity place people at risk of cancer? This is an important question, especially since obesity rates in this country are increasing. The NCI is convening workshops to propose many other provocative questions. We have built a website to complement the workshops, and we will soon be funding research to answer at least two dozen questions. I think this initiative has convinced people that our minds don't have to be stagnant just because budgets are.

In the midst of all this, I have been fortunate to continue to run a small laboratory with the help of young scientists. As a result, I am able to remain engaged with two of the most exciting aspects of science: discovery and training.

I'm Melanne Verveer.

I'm the US ambassador-at-large for global women's issues.

I have been interested in politics since I was quite young. I think it came from my father's activism in the community. He was a Stevensonian—a supporter of Adlai Stevenson—while I was more enamored of John Kennedy. The combination of a parent who was very engaged in politics, even at the local level, and a charismatic, up-and-coming political leader who spoke to the best in any of us—"Ask not what your country can do for you, but what you can do for your country"—was very powerful. I came to Washington because of all of that. I wanted to be at the center of where it was happening.

"We know, from a mountain of evidence and data, that investments in women correlate with effective outcomes for poverty alleviation and a country's prosperity. We know that in countries where men and women are more equal in access to health and education and in political and certainly economic participation, those countries are far more prosperous and more economically competitive."

I came here to the nation's capital, enrolled at Georgetown, and became engaged in campus activities that didn't begin and end on the campus. I then worked for George McGovern's presidential campaign. I worked for him afterward, and from there I became engaged in a series of public-interest groups and other work on Capitol Hill. I then came into the Clinton administration. Bill Clinton and I were at Georgetown together in those heady years of the 1960s. I never really lost contact with him. Many of the issues that I had been engaged in with public interest work meshed with things that he continued to be interested in as a politician in his own state, and over the years he kept saying to me, "You've got to meet Hillary Clinton," realizing that we shared a lot of the same interests.

Finally, we did meet one day, and we started a conversation that has never ended. The incoming First Lady of the United States said to me, "Would you like to join my work in the White House?" I came onto her staff at that point. A lot of the work concerned domestic policy issues, from health care to childcare, and many of those issues continue to be something that I deeply care about. But it also was my introduction to international affairs, and particularly women's roles and women's rights around the world.

Certainly the First Lady had no idea that she would become such a large figure on the international stage. We were working on a series of issues, and at one point several advocates for human rights issues and America's place on the world stage came in to see me. They were pleading for someone at a high level to represent the United States at a UN conference that was taking place on social development in Copenhagen in 1995. The president wasn't able to go, and an agreement was reached in the White House that it would make sense for the first lady to go. This was a conference that focused on development issues—those core issues that we consider key investments that are made in people, whether it has to do with education or economic capacity building, the kinds of things that certainly undergird humanity

Melanne S. Verveer
US Ambassador-at-Large for Global Women's Issues Melanne Verveer advocates for women's empowerment, a critical strategic issue for the twenty-first century. She formerly served as chief of staff to First Lady Hillary Clinton. She is cofounder of Vital Voices Global Partnership, which promotes leadership by women.

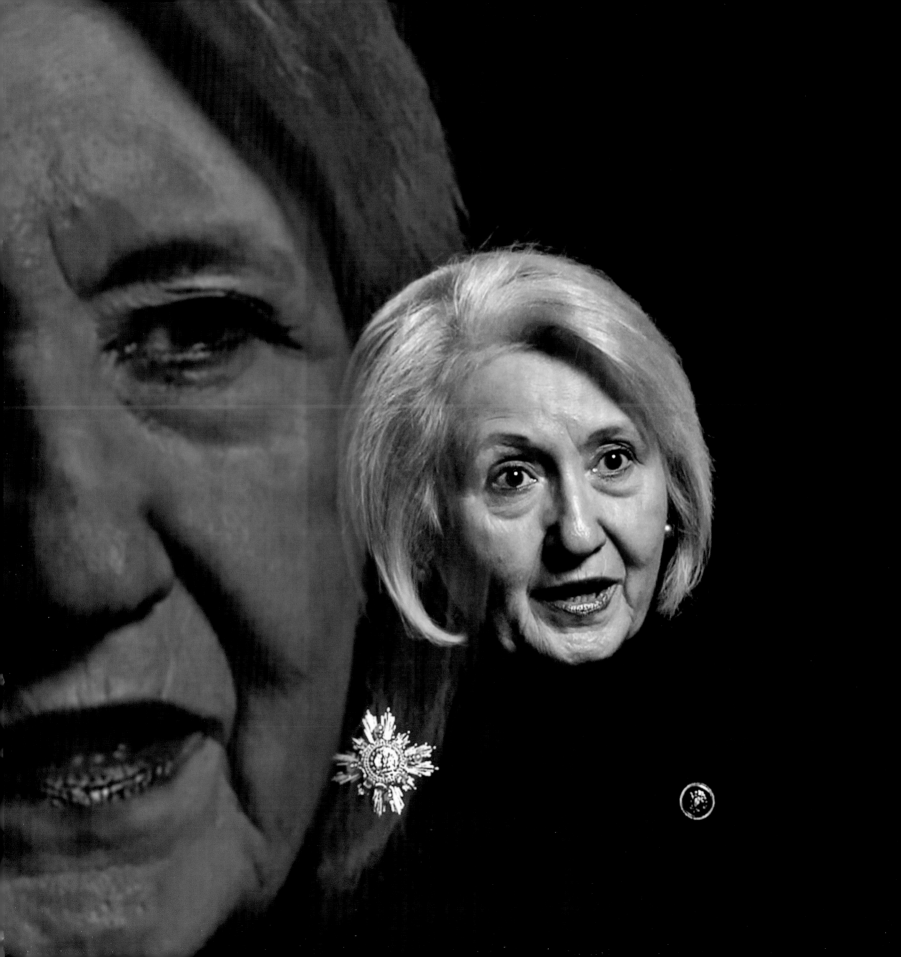

and enable people to be all that they can be and move their countries forward. To that end, it's very important for our own country.

I asked the presiding leader of the conference, "What did it mean that Hillary Clinton came and keynoted the social development conference?" He said, "She mounted the podium as the First Lady of the United States, and she descended that podium as a world figure." She was so compelling and smart in what she said, and much of it focused on the important role that women have to play in development.

We know, for instance, that one of the most effective investments that can be made is in a girl's education because of what that represents in terms of her life and how she conducts it. Education truly is the singular, critical investment. When a girl is educated, she creates better conditions for herself. Her future employability, for example, goes up dramatically, as does her future income. The conditions that she then creates for her family improve, too. Her children will have better nutrition. They will go on to school. Much better habits will be inculcated in that family. What we have to do, collectively, is help to ensure that the value of that girl is readily observant, not just

to her parents but also to everybody who comes in contact with her. Tremendous outcomes for that society, tremendous bursts of progress ensue.

Just months after that first conference came the fourth UN World Conference on Women, where Hillary Clinton issued a historic statement about women's rights being human rights, not something subsidiary to human rights. Her effort to attack violations of those human rights of women, as well as to begin to create conditions that would enable women to have access to education and health and participate fully in the economies of their countries and political life of their countries, became a cause that grew. She sparked a movement, encouraging a commitment to this issue on everybody's part— governments, civil society, the private sector.

Hillary Clinton went on to the Senate, while I went on to help found an organization, the Vital Voices Global Partnership, which in many ways continued the work that she had sparked in the White House. When she came into the government as secretary of state, I was named our country's first ambassador for global women's issues. My singular mission is to take these issues and work with my colleagues in the State Department to integrate them in everything that they do. There are people in the State Department who work on economic issues or human rights issues all over the world. There is much that is done to advance America's cause and create a better world in the work of the State Department, but we have not always worked on issues in a way that also ensured that the gender lens was applied, that we brought women into the solution process, whether in enhancing economic growth or trying to ameliorate conflict situations such as in the Congo and Afghanistan.

The great moral imperative of the twenty-first century is women's equality. It's also the smart thing to do. It's extremely strategic in terms of our foreign policy. We know, from a mountain of evidence and data, that investments in women correlate with effective outcomes for poverty alleviation and a country's prosperity. We know that in countries where men and women are

more equal in access to health and education and in political and certainly economic participation, those countries are far more prosperous and more economically competitive. The more women are engaged in the economic life of a country, the more productive that country is.

When we've got two hands applauding, we can produce greater results for our effort. That's true whether it's in terms of growing economies or a better political outcome, any of the kinds of endeavors that are beneficial in the long term for the kind of world we want to see created. You can't really expect countries to prosper if they leave half of their people behind.

I'm Mike Vickers.

I'm the under secretary for intelligence in the US Department of Defense. On behalf of the secretary, I exercise authority, direction, and control over all the intelligence agencies in the Department of Defense.

The National Security Agency does cryptological work and collects signals intelligence. The National Reconnaissance Office develops and operates our space systems. The National Geospatial-Intelligence Agency analyzes imagery that we collect. The Defense Intelligence Agency does operations and analysis. I also have oversight of the sensitive activities that we conduct with other government agencies.

I grew up in Los Angeles. I had dreams of being a professional baseball or football player. When I realized after a year and a half of college that

I wasn't going to be a professional athlete, I thought, "What am I going to do with my life?" I wanted to have an intellectually stimulating but also adventurous and physical career—I needed to do something with my brain, but still wanted to do something with my body. I enlisted directly into the Special Forces, which is rare. I made it through all the training and ended up spending ten years there, first as an enlisted man and then as an officer. From there I went to the Central Intelligence Agency, into what today is called the National Clandestine Service, the spy side of the CIA. I spent several years there doing some very interesting work during the Cold War.

I've always been motivated to make the biggest difference that I could at any given time. As the Cold War was coming to an end, I had spent six years at war and in intensive operations around the world, from Central America to the invasion of Grenada, from Lebanon after the bombing of our embassy and Marine barracks to Afghanistan. I wasn't the best student in high school, but I ended up getting more serious as I advanced in the military. I realized that I wanted some more stimulation or education as the Cold War was coming to an end, so I went to Wharton for an MBA and later received a PhD from Johns Hopkins.

Then I was called back into government service, first in the Bush administration and then in the Obama administration as a senior policymaker.

As I was working on my PhD and during my interlude between periods of government service, I cofounded a think tank that assisted the government with problems of how to adapt to the twenty-first century. There was a technological revolution well under way that was changing not just warfare, but also many aspects of society. There was the rise of China, and then, of course, after 9/11, the war with al-Qaeda. My interest in fundamental change informed a lot of my work with the government in those years.

I like working on some of our hardest national security problems, for which there isn't a set solution, for which one has to be creative but also realistic. Among the challenges facing us now, for instance, are threats to information infrastructure and intellectual property. Our enemies have the ability to exploit the Internet, by which they can not only steal things but also have destructive effects. We have to think, constantly, about how to defend the United States against people either trying to take our intellectual property or harm our infrastructure.

Strategy depends on understanding what is possible in the environment, not just how you'd like the environment to be. We live in an increasingly information-intensive world, but making sense of that information to make good decisions is critical. The way we do operations today, whether it's the war in Afghanistan or the war with al-Qaeda, increasingly depends on precise and accurate intelligence. We're dealing with terrorists, and the hard part is finding them. For example, the Osama Bin Laden raid was the culmination of a ten-year intelligence effort to locate him. We then face the challenge of making wise policy. In thinking about world problems—what to do about North Korea, what to do about Iran, how to deal with a rising China—intelligence is increasingly important in informing policymakers so that they can make good choices.

> *"I like working on some of our hardest national security problems, for which there isn't a set solution, for which one has to be creative but also realistic. Among the challenges facing us now, for instance, are threats to information infrastructure and intellectual property."*

You have to try to make speed and volume your friends rather than your enemies. That's hard to do, but we've done a pretty good job of staying ahead of the curve and learning how to process lots of information and find what we're looking for. Technology can help us, using search engines like Google that are adapted to the secret intelligence world.

It's critical that intelligence have oversight under our democratic system, but also that sources and methods and secrets be protected. Even more fundamental is that intelligence have the ability to speak truth to power, whether it's liked or not. There's broad consensus in our system that these matters are absolutely essential. Intelligence doesn't mean omniscience. We get things wrong. We try to do the best we can. Our job is to inform policymakers and let them make the choices, not to make policy ourselves, and not to slant intelligence to any policy outcome. Sometimes that can be very uncomfortable when a strategy isn't working, and people who are very invested in it don't necessarily like bad news, but it's important to deliver the intelligence as straight as you can.

We continue to face a number of challenges. The biggest one of all is restoring the health of the American economy for the long run and keeping America a vital society. Even though we

Michael G. Vickers

Mike Vickers, a former member of Army Special Forces and CIA intelligence officer, is under secretary for intelligence at the US Department of Defense. He is dedicated to defeating al-Qaeda and developing the intelligence capabilities the United States will need for the twenty-first century.

have a number of challenges that require a robust national security establishment, we want to make sure it's oriented in the right direction and not taking away from other work necessary to restore our country's strength. Over the long haul, national security will really depend on the innovativeness and the economic strength of American society.

Wild Bill Donovan, the founder of the Office of Strategic Services, the forerunner of the CIA, said during World War II, "The ideal operative is a PhD who can win a bar fight." What he meant, I think, is the ability to try to find advantage, whatever the problem might be, and then exploit that advantage in creative ways. That's what I try to do.

I'm Diane Pamela Wood.

I'm a judge on the US Court of Appeals for the Seventh Circuit in Chicago, and I also serve as a senior lecturer at the University of Chicago Law School.

At the end of college, I was about to go into a comparative literature career. At the last second, about ten days before I was supposed to start, I decided that I didn't want to do that after all, because it seemed too remote from the world. A friend said, "You really should go to law school." At first I didn't want to, but then I decided it might be exactly the right thing for me. I thought then, and certainly think now, that law is the place where all forces meet. That's where the rules we want to live by in our society are formulated, and where we apply them to people.

At the practical level, judges don't usually have the luxury of saying, "What an interesting question." We have to say, "You win, you lose. Your contract will be enforced. You're going to go to prison for thirty years." Real things happen with law. The law is a touch point between political science and theory and the actual lives of real people. What I may think about theory might be interesting, but on the other hand, it might not be, because that may not be what is written down in the law.

For that reason, I look to the law first. Nevertheless, cases don't come up in courts unless the law isn't particularly clear. People usually don't waste their money and spend thousands of dollars on litigating something that's obvious. Sometimes that happens, but it shouldn't. In relatively well-defined areas, I just follow the law. In areas that are not so well defined, any judge has to begin to ask what he or she understands the words to mean—say, words having to do with the Constitution.

I spend a lot of time with the Constitutional Rights Foundation Chicago. That's a slightly misleading name, in that it is an organization that is designed to teach elementary and secondary school children about social issues—about law, about structure, about dispute resolution, about civilized debate about tough questions. For an example, an elementary school program teaches about courts and trials through a hypothetical case based on the Three Little Pigs. There's a prosecution against the wolf for blowing down houses. His excuse is that he had a bad cold, but the pigs have another view of things. They testify that he actually had malevolent intent. The kids love it. I've worked with Justice Sandra Day O'Connor, and I agree with her concern that young people are not taking civics classes and social studies classes and don't know history well enough. Civics wasn't an area that the No Child Left Behind law covered, so school districts concerned about meeting thresholds for NCLB thought that civics was just a frill. It desperately needs to be brought back into the equation.

Civics—and civility—are important to the law. You really have to want to listen to what other people are saying and their concerns. Take the Asian carp case, which I heard a little while back. Some people are devoted environmentalists who don't want the Asian carp invading the Great Lakes. They think of the issue environmentally. Other people might think of it institutionally. What should the courts be doing? What should the Army Corps of Engineers be doing? We see through our different lenses, and I think if you're going to build consensus, you've got to be aware of all viewpoints and realize that different facets of the case are going to be of greater concern to different people.

One of my favorite cases is *Moore v. City of East Cleveland*, which had to do with whether a grandmother could have her two grandsons, who were cousins rather than brothers, live in her house in East Cleveland, Ohio. The city had passed an ordinance that had such a rigid definition of the term "family" that it excluded such a possibility. Under no definition I could imagine was this not a single family, but Mrs. Moore was cited for a misdemeanor for doing this. The case went all the way up to the Supreme Court, and the court decided that the law violated her fundamental rights of personal autonomy. Interestingly, the court couldn't agree on a rationale for the ruling,

Judge Diane Pamela Wood

Diane Wood sits on the US Court of Appeals for the Seventh Circuit and is senior lecturer at the University of Chicago Law School. She focuses on, among other things, the practical implications of the interpretation of the law, and she seeks to make her opinions accessible to the public as well as jurists.

but even so, I thought it was very important for us to recognize in society that there is a line between where the government can intrude and where it shouldn't.

That line is important. In a law review article I wrote after 9/11, I said, "Someone must be guarding the guardian, or else ultimately there's nothing but the rule of men." I was trying to appeal to our better angels. We've had a lot of challenging times in our country. During the Cold War, it might have been tempting to say that civil liberties are a luxury that we really just can't afford right now, because maybe the Russians will drop a nuclear bomb on us. Yet we didn't say that. The record isn't bad. In the post-9/11 world, it's important to remember that.

> "At the practical level, judges don't usually have the luxury of saying, 'What an interesting question.' We have to say, 'You win, you lose. Your contract will be enforced. You're going to go to prison for thirty years.' Real things happen with law. The law is a touch point between political science and theory and the actual lives of real people."

Even so, we face big policy issues today. We haven't really resolved Guantanamo and the detainment of enemy combatants on executive order, for example, and yet it needs resolution. There's certainly responsible debate about whether we should be going around the world killing people whom we think are combatants. What worries me the most is an apparent assumption that the civil courts cannot handle these cases. Our court

system is a strong, robust system in which public accountability is important, and it will normally be the better place for such matters.

At the Court of Appeals level, judges have several different audiences. There are our colleagues, immediately. In one recent case, for example, I managed to persuade my full court to come around to my position. Failing that, you have the other Courts of Appeals in the country, which is the second audience. The third, obviously, is the Supreme Court, because if you've written a dissent, you might show them through that dissent that it's an important case that needs to be resolved. The final audience is posterity—and if you're on the Supreme Court, you write for posterity.

What makes for a great judicial opinion is that, first of all, it be accessible. It's got to be well written, direct, and to the point. Some judicial opinions instead try to reinvent the wheel. They start from the beginning of time and move forward, and seventy-five pages later, you find out what the result is. Some opinions do need a lot of detail, but most do not. When I write opinions, I try to summarize what the case is about and give the facts that matter, but not every fact about the case. I try to explain in plain English. I want my husband, who is not a lawyer, to be able to sit down and read an opinion of mine and understand it. I would love it if the press read my opinions. For very prominent cases, it is essential to explain to people why you have decided a very important issue in a certain way.

I hope that I will leave a legacy of sound legal opinions. Most of what I write is going to be the law for a long time, so I very much hope that it stands the test of time, and that people perceive me as someone who has been fair, willing to listen to them, and open to all points of view.

"The Network" is a generative video portrait acquired for the permanent collection of the Smithsonian's National Portrait Gallery.

Acknowledgments

It was an honor to create portraits of the individuals in "The Network." I am grateful to each of the subjects for their genuine engagement in the portrait process. Through their participation, the project became a reality.

I owe a special thanks to the participants who helped bring their peers into this project. They include Norm Brownstein, Pete Chiarelli, Beth Dozoretz, Julius Genachowski, Peter Levin, Grover Norquist, Farah Pandith, Nancy Pelosi, Stephen Porter, Martha Raddatz, Cokie Roberts, Sonal Shah, Pete Singer, Geoff Stone, Dan Tangherlini, David Tatel, and Harold Varmus.

I am deeply grateful to fellow Chicagoans Adam Cooper and Stratford Shields, whose guidance, friendship, and assistance were invaluable. Thanks to Arun and Anu Sharma for helping us secure accommodations in Washington. I am also grateful to Teri and Steve Barnett, Susan Cahn, Leigh Conner, Jay Epstein, Jeff Frazier, Bob Kargman, Luke Knittig, Vivienne Lassman, Michael Lieberman, Ellen Malcolm, Joan Markman, Sharon Markman, Betsey and Dale Pinkert, Anne Popkin, Andrew Porter, Andrew Rasiej, Rob Schuler, Virginia Shore, Jamie Smith, Devon Spurgeon, J. D. Talasek, Sarah Tanguy, and Donna Victoria for recommending and recruiting individuals for the project.

Many thanks to the Musk Foundation for their support of the book.

Negotiating releases with each portrait sitter was a complex task. My attorney, J. P. Benitez, constantly fielded calls and emails as we navigated numerous federal legal departments and requirements, often moments before a portrait was scheduled to occur. Thanks to J. P., all were resolved, and the sittings took place at their scheduled times.

Thanks to Coco Soodek and Bryan Cave for providing us a venue to film in Chicago.

For any art students reading this, please take note. The successful execution and completion of "The Network" is due in large part to everyone in my studio: studio manager Beth Marrier, technology director James Murray, and assistant video editor Selden Paterson. James's and Beth's absolute and selfless commitment to getting it right during long hours in the studio and in Washington were crucial to the success of the project. James's technical expertise, critical thinking, and creativity carried us over all obstacles. Beth's organizational skills and tenacity insured that every project detail was attended to and every deadline met. Selden did the heavy lifting by editing several hundred hours of video from the portraits. All three are talented, creative, and hardworking people. I am lucky to work with them.

"The Network" would not have been possible without Anne Collins Goodyear. She played many roles in the project: historian, educator, curator, advocate, ombudsman, river guide, and friend. Over countless meetings, phone calls, emails, dinners, and drinks we discussed the challenges and possibilities for the project. Anne taught me how to navigate complex waters of Washington, and she used her personal and professional capital to insure the success of the project. Anne's husband, Frank Goodyear, also provided invaluable feedback and support in the project. I count them both as dear friends.

Alli Jessing coordinated both our and the sitters' access to the McEvoy Auditorium at the Smithsonian's National Portrait Gallery. I cannot thank her enough for this, and for making sure our gear was safe. It was a pleasure to work with everyone at the National Portrait Gallery.

In particular, I would like to thank Brandon Fortune, Wendy Wick Reaves, and Marty Sullivan for all of their support and guidance.

Gregory McNamee edited the full transcripts from each portrait into the short essays that make up the book that grew from the project, capturing the essence of our conversations. I am in awe of his editing skills. Steve Liska and Katie Schweitzer translated "The Network" into a beautiful book. They created a seamless merger between the images and text, bringing the project alive in print. Carolyn Gleason, Christina Wiginton, and Matt Litts oversaw the publishing of this book from start to finish. As a first-time author, I am grateful for their patience and ability to visualize the book before much of the content was created.

Jeanny Kim has been a tremendous advocate of the project since the day I met her. This book is a result of her belief in it.

My largest thanks go to my wife, Clare Pinkert. I was lucky to marry a smart, beautiful woman with a deep interest in the law, politics, and social justice. She was with me for every twist and turn in the project. We spent many late nights talking about politics, policy, and portraiture after getting the kids to sleep. She has a quiet intellectual gravity and chooses her words carefully. Her belief in me and her willingness to shoulder the responsibilities for two small children while I traveled made this project possible.

Last, I deeply thank my parents for encouraging me to be creative and for tying my identity to Abraham Lincoln and John F. Kennedy.

To Zade and Julius.
Don't forget to vote.

This book was published in December 2012 by Smithsonian Books on the occasion of "The Network" by Lincoln Schatz being acquired and unveiled by the National Portrait Gallery.

This book may be purchased for educational, business, or sales promotional use. For information, please write:
Special Markets Department
Smithsonian Books
P. O. Box 37012, MRC 513
Washington, D.C. 20013

Published by Smithsonian Books
Director: Carolyn Gleason
Production Editor: Christina Wiginton

Biographies by Anne Collins Goodyear
Edited by Gregory McNamee
Designed by Liska + Associates

Library of Congress Cataloging-in-Publication Data

Schatz, Lincoln.
The network : portrait conversations / by Lincoln Schatz.
 p. cm.
ISBN 978-1-58834-335-2
1. United States—Politics and government—2009- 2. United States—Officials and employees—Biography. 3. United States. Congress—Biography. 4. Politicians—United States—Biography. 5. Businesspeople—United States—Biography. 6. Lobbyists—United States—Biography. 7. Policy scientists—United States—Biography. 8. Elite (Social sciences)—United States—Biography. I. Title.
E901.S45 2012
973.932—dc23
 2012028134

Printed in China through Oceanic Graphic Printing
16 15 14 13 12 5 4 3 2 1